Arts, Pedagogy and
Cultural Resistance

Arts, Pedagogy and Cultural Resistance

New Materialisms

Edited by
Anna Hickey-Moody and Tara Page

ROWMAN &
LITTLEFIELD
——————— INTERNATIONAL

London • New York

Published by Rowman & Littlefield International, Ltd.
Unit A, Whitacre Mews, 26-34 Stannary Street, London SE11 4AB
www.rowmaninternational.com

Rowman & Littlefield International, Ltd. is an affiliate of Rowman & Littlefield
4501 Forbes Boulevard, Suite 200, Lanham, Maryland 20706, USA
With additional offices in Boulder, New York, Toronto (Canada), and Plymouth (UK)
www.rowman.com

British Library Cataloguing in Publication Data
A catalogue record for this book is available from the British Library

ISBN: HB 978-1-7834-8486-7
 PB 978-1-7834-8487-4

Library of Congress Cataloging-in-Publication Data
Arts, pedagogy and cultural resistance : new materialisms / Edited by
Anna Hickey-Moody and Tara Page.
 pages cm
Includes bibliographical references and index.
ISBN 978-1-78348-486-7 (cloth : alk. paper)—ISBN 978-1-78348-487-4 (pbk. : alk.
paper)—ISBN 978-1-78348-488-1 (electronic) 1. Arts—Study and teaching—Social
aspects. I. Hickey-Moody, Anna, 1977– editor. II. Page, Tara, 1971– editor.
NX294.A78 2015
700.71—dc23 2015025502

♾ ™ The paper used in this publication meets the minimum requirements of American
National Standard for Information Sciences—Permanence of Paper for Printed Library
Materials, ANSI/NISO Z39.48-1992.

Printed in the United States of America

Contents

List of Illustrations

Acknowledgements

We would like to thank all the contributors for their involvement and we extend our deepest thanks to Martina O'Sullivan at Rowman and Littlefield for her support and patience.

Tara Page would like to acknowledge and thank Bam of Bamage for being her constant and Anna Hickey-Moody for her collaboration and unwavering belief that everything is possible.

Anna Hickey-Moody would like to acknowledge the support of all members of the Centre for the Arts and Learning, Goldsmiths, especially the work of the doctoral students who continue to question and inspire.

Introduction

Making, Matter and Pedagogy

Anna Hickey-Moody and Tara Page

Practices, teaching and art production practices are modes of thought already in the act. Contemporary arts practices call us to think anew, through remaking the world materially and relationally. Building on this ethos of practice as thought already in the act, this collection from practitioner arts educators and cultural theorists responds to the increased attention being paid to matter and creativity in social sciences and humanities research, often referred to as 'new materialism' (Van der Tuin, 2011) and the often associated Deleuzian informed methodologies (Coleman and Ringrose, 2013; Springgay et al., 2008). Among other things, these approaches are brought together by a shared belief in the transformative capacities (or 'pedagogy') of matter. Such research practices posit affective, machinic, enfleshed, vital approaches to research in ways that embody ideas developed in Continental philosophy (Ahmed, 2006; Whitehead, 1926; Heidegger, 1962) and, specifically, through the work of Deleuze and Guattari (1985, 1987). New materialism (Alaimo and Hekman, 2008; Barad, 2007; Braidotti, 2013; Barrett and Bolt, 2012; Coole and Frost, 2010; Hekman, 2010) calls theorists to revisit a Marxist emphasis on materiality in research; it calls for an embodied, affective, relational understanding of the research process. So do theories of practice as research such as those developed by Carter (2004), Sullivan (2005), Smith and Dean (2009), Barrett and Bolt (2010), Manning and Massumi (2011) and Nelson (2013), who each, in their own way, argue that the intersection of making and thinking is important. In this collection, we show that the way making impacts on thinking is a material pedagogy.

In *Material Thinking* (2004) Carter argues that 'the language of creative research is related to the goal of material thinking, and both look beyond the making process to the local reinvention of social relations' (10). Building on the material transformation that Carter (2004) advocates through creative

1

processes of *material thinking*, Barrett (2007) proposes that 'artistic practice be viewed as the production of knowledge or philosophy in action' and specifically argues that 'the emergence of the discipline of practice-led research highlights the crucial interrelationship that exists between theory and practice and the relevance of theoretical and philosophical paradigms for the contemporary arts practitioner'. (1)

As suggested by the quote at the beginning of this chapter, Manning and Massumi (2011) also explore the many ways 'making' produces and requires new thought. These are but a few of now established debates around creative practice as research. In building on these debates, this collection brings some concerns raised in arts education practice as research as a field to bear upon recent developments in new materialist thought.

New materialism posits matter as agentive, indeterminate, constantly forming and re-forming in unexpected ways (Coole and Frost, 2010). Such a perspective abandons any idea of matter as inert and subject to predictable forces. Matter is always becoming. Matter 'feels, converses, suffers, desires, yearns and remembers', and since 'feeling, desiring and experiencing are not singular characteristics or capacities of human consciousness' (Barad in Dolphijn and Van der Tuin, 2012, 16), new materialism offers a redefinition of liveness and human–non-human relations. In order to incorporate such a perspective, Barad (2007) explains:

> What is needed is a robust account of the materialization of *all* bodies—'human' and 'nonhuman'—including agential contributions of all material forces (both 'social' and 'natural'). This will require an understanding of the nature of the relationship between discursive practices and material phenomena; an accounting of 'nonhuman' as well as 'human' forms of agency; and an understanding of the precise causal nature of productive practices that take account of the fullness of matter's implication in its ongoing historicity. (66)

Bodies and things are not as separate as we were once taught, and their interrelationship is vital to how we come to know ourselves as human and interact with our environments.

Exploring the porous nature of bodies and their co-construction through and with systems of meaning, Blackman (2008) maps a selection of concepts (and constructs) of the body including regulated and regulating bodies, communicating bodies, bodies and difference, lived bodies and the body as enactment. Blackman (2008) rejects naturalistic views of the body 'as entities which are singular, bounded, molar and discretely human in action' (131), arguing rather that bodies, knowledge systems, sociability and matter are co-constructed. Blackman (2008) explains that 'the psychological, biological and social are discrete entities that somehow interact'

(131). The body is pivotal to new materialism; it is a complex intra-action (Barad, 2007) of the social and affective, where embodiment is a process of encounters, intra-actions with other bodies (Springgay, 2008). Thinking about matter *matters*—if bodies and things are produced together, intertwined, then 'things' and how they act on bodies are co-constitutive of our embodied subjectivity.[1]

Bodies acting on things is, similarly, an important part of making subjectivity. Manning (2009) explains that sensing and feeling are acts that matter:

> A body . . . does not exist—a body *is* not, it *does*. To sense is not simply to receive input—it is to invent. . . . Sense perceptions are not simply 'out there' to be analyzed by a static body. They are body-events where bodies, senses, and worlds recombine to create (invent) new events. (212)

Thinking through events as the way that matter comes to matter, or matter impacts on bodies and futures, Whitehead (1926) theorizes bodies as the catalyst of events. For Whitehead, bodies are processes of senses and feelings that inform us about current but also past place-worlds, prehensions.[2] These prehensions involve the 'repetition' of the world, and it is through these prehensions 'that the treasures of the past environment are poured into living occasions' (Whitehead, 1926, 339). Manning (2009), in her research on touch, further explains Whitehead's (1926) prehensions as embodied through explaining that

> we sense on top of senses, one sense experience always embedded in another one: cross-modal repetition with a difference. We conceive the world not through a linear recomposition of the geometric vectors of our experience, but by the overlapping of the folds of sense-presentation emerging alongside pastness. (215)

Thus, there is a temporal folding embedded in the notion of prehension and in the materialist concept of the body that it mobilizes. Explaining this idea, Braidotti (2000) asserts that the 'enfleshed Deleuzian subject . . . is a folding-in of external influences and a simultaneously unfolding outwards of affects. A mobile entity, an enfleshed sort of memory that repeats. The Deleuzian body is ultimately an embodied memory' (159).[3] However, for Coole and Frost (2010), a new materialist approach to embodiment is more phenomenological than Braidotti's Deleuzian embodied memory, in the respect that it is not only concerned with how power is produced and reproduced by bodies, but emphasizes the 'active, self-transformative, practical aspects of corporeality as it participates in relationships with power' (19). Such a perspective clearly has implications for how we understand the politics and significance

of being a body, contemporary practices of art making, viewing, teaching and learning and, indeed, the constitution of thought.

A materialist ontology, concerned with matter and the processes of matter, and intra-action between human and non-human things and worlds, recognizes the intertwining of all phenomena—human, non-human, social, physical, material and immaterial. This intertwining, 'withness' (Whitehead, 1926) or 'mingle and mangle' (Bolt, 2013, 3), is where phenomena are entangled— 'the ontological inseparability—of intra-acting agencies' (Barad, 2007, 338). The concept of *intra*-action is central to Barad's (2007) new materialism and refers to the movement generated in an encounter of two or more bodies in a process of becoming different:

> The neologism 'intra-action' *signifies the mutual constitution of entangled agencies* . . . the notion of intra-action recognizes that distinct agencies do not precede, but rather emerge through, their intra-actions. It is important to note that the 'distinct' agencies are only distinct in a relational, not an absolute, sense, that is *agencies are only distinct in relation to their mutual entanglement; they don't exist as individual elements.* (33, original emphasis)

In other words, focus shifts from the subject and/or the object to *their entanglement*; the event, the action between (not in-between), is what matters. Building on this meaningful intertwining in relation to the research process, Taguchi (2012) details what she terms a

> 'diffractive' analysis, a 'transcorporeal process of becoming-minoritarian with the data, the researcher is attentive to those bodymind faculties that register smell, touch, level, temperature, pressure, tension and force in the interconnections emerging in between different matter, matter and discourse, in the event of engagement with data'. (267)

The empirical and conceptual nature of our engagements with knowledge are co-constitutive of knowledge itself:

> We do not simply respond to sense perceptions, we activate them even as they activate us. No two experiences can be exactly the same because they are always made up of different prehensions leading to new actual occasions (events). (Manning, 2009, 315)

Not only are we always *with/in* bodies, but we are always *with* matter. So, not only do we make matter and meaning, it also makes us; we are entangled, co-implicated in the generation and formation of knowing and being.

As a way of exploring the entanglement and co-constitution of matter and subjectivity, new materialism is a methodology, a theoretical framework and a political positioning that emphasizes the complex materiality of bodies immersed in social relations of power (Dolphijn and van der Tuin, 2012). Inventive methods (Lury and Wakeford, 2012), including arts-based (Jagodzinski and Wallin, 2013), visual (Pink, 2007; Rose, 2012) and embodied/sensory methods (Ingold, 2008; Pink, 2009; Page, 2012a,b) are increasingly being mobilized to explore the agency of matter and advance vitalist frameworks. Moving beyond the problem-focused approach that focuses Lury and Wakeford's (2012) engaging intervention into methods, this collection works the intra-actions of theory with practice to develop new approaches to materialist research and to position the agency of matter as pedagogical in its resistance. Matter teaches us through resisting dominant discourses, showing us new ways of being. Bodies resist dominant modes of positioning, political acts defy government rule, sexuality exceeds legal frameworks—resistant matter shows us the limits of the world as we know it, and prompts us to shift these limits.

This collection shows the pedagogical nature of matter, and catalogues different kinds of arts practice and arts pedagogy as material cultures of resistance, yet, we attempt to do so in a speculative rather than conclusive fashion. Furthering what we hope is a generative, evolving approach, rather than introducing all the chapters in this collection at the same time, we will introduce the chapters at different points in this introduction with the theoretical content that relates to the argument of the chapter. Each chapter can be read independently, and all chapters are intended as diverse responses to our initial provocation[4] that matter is pedagogical and resistant. There are threads of praxis (theory-thought with practice, Freire, 1970) that are entangled in this collection, and in mapping the intra-actions of these chapters throughout this introduction, rather than the usual separate section, we come to see matter mattering in new ways. We hope this is demonstrated in the chapter by Amanda Kipling and Anna Hickey-Moody, in which they discuss the materiality of learning in terms of the continuity of knowledge production and developing learning communities in drama education that operate through pedagogies of engagement, rather than being driven by curriculum and policy agendas.

THE AFFECTIVE TURN AND NEW MATERIALISM

The concept of affect, and what Brian Massumi (2002) has famously referred to as the affective turn, draws substantively on the work of Deleuze (1988, 1990a,b, 2002) and Deleuze and Guattari (1983, 1986, 1987, 1994).

Increasingly, over the last ten years, affect has been utilized as a conceptual resource in educational theory. Here, we consider some of the theorists who brought affect into education, because the conceptual moves that accompany this turn created space for embodied knowledges of art making to inform pedagogy. Affect validates emergent epistemologies, or subjugated knowledges, which all too often remain silenced from theorizations of education. Christa Albrecht-Crane and Jennifer Daryl Slack (2003), Megan Watkins (2006) and Elizabeth Ellsworth (2005) are theoreticians working in and across education who pioneered the use of affect for education. Other cultural studies theorists who take up the concept of affect in ways that are of use in considering classrooms include Elspeth Probyn (2000) and Anna Gibbs (2002). We would like to point towards their scholarship, as well as that of Brian Massumi (2002), Felicity Colman (2002, 2005), Gregory Seigworth (2003) and Melissa Gregg (2006), as resources of use in the theoretical project of taking up affect to consider the pedagogical nature of matter and culture.[5]

There has been work on Deleuze in education since the late 1990s, notably becoming part of dominant educational discourses with Lather and St Pierre's (2000) collection *Working the Ruins* pioneering feminist approaches of Deleuze in education. The concept of affect was not specifically introduced into educational practices until 2003 when Albrecht-Crane and Daryl Slack (2003) made the argument that 'the importance of affect in the classroom is inadequately considered in scholarship on pedagogy' (191). While the work of the theorists cited above moves to address the current gap in research on affect and education, the potential of affect to reconfigure materialist theories of education in significant ways is increasingly being realized. Julie Allan's (2013) work on the disabled body and arts practices in special education is distinctive in showing the potential of work in this area. Affect maps the micro political relations that constitute the beginnings of social change. In order to understand the lived politics of disability in education, and indeed to read disability as a kind of cultural pedagogy, we must begin by thinking through affect (Allen, 2013; Hickey-Moody, 2009; Lines, 2013). It is our contention that understanding, naming, illustrating and analysing the affective agency of material is imperative.

Albrecht-Crane and Slack (2003) provide a critical structure for thinking pedagogy through affect by establishing a framework well suited to educational research. They do so in a discrete chapter in a cultural studies style anthology of applied Deleuzian theory, titled *Animations (of Deleuze and Guattari)*. Taking Deleuze's Spinozist body as a point of departure, Albrecht-Crane and Slack (2003) note:

> In most pedagogical models, individuals are defined or positioned to take up posts or places in terms of who they are; that is, in terms of their social

identities, gender, race, class, ethnicity, and so forth, and they are seen as possessing varying degrees of agency—that is, an ability to act—as an attribute of who they are. In contrast, Deleuze and Guattari do not begin with the question 'What is a body?' but 'What can a body do?' and 'Of what affects is a body capable?' (192)

While Albrecht-Crane and Slack's (2003) reading of the body as affective is core to Deleuze and Guattari's work, this model for thinking of the body is not contra-agency. In fact, it is quite the opposite. Within Deleuze and Guattari's work, agency changes along with subjective experience and evolves in relation to the affects of which a body is capable. Agency is conceived as an inherent part of any body, be it a human body, a body of land or water, or a political party. Following Spinoza, Deleuze (1988) takes material bodies as a challenge to think through the physical dimensions of agency and states:

> Spinoza . . . proposes to establish the body as a model, 'we do not know what the body can do'. . . . We speak of consciousness and its decrees, of the will and of its effects, of the thousand ways of moving the body, of dominating the body and the passions—but we do not even know what a body can do. (18)

'What a body can do' is a material act and it is also a degree of agency. After establishing the affective body as the primary site—or origin—with which a pedagogy of affect would be concerned, Albrecht-Crane and Slack's (2003) focus shifts from the body of the subject and the micro-political realm to social machinations, and it is here that their theorization gains particular momentum. It is this positioning of Deleuze and Guattari's (2003) work as a tool with which to analyse the 'Molar lines [that] "overcode" dual segmentations that follow "the great major dualist oppositions, social classes, but also men-women, adults-children, and so on"' (194–5), which lends Albrecht-Crane and Slack's (2003) work to analysing affective movement of social bodies more than of individual bodies.

In contrast to Albrecht-Crane and Slack (2003), Watkins (2006) takes a micro-analytic approach to illustrating the possibilities of affect through a research methodology designed to evaluate pedagogy through the concept of affect. Watkins' (2006) research is of particular interest because the methodology she employs is designed specifically to record the embodied negotiations pertaining to—and arising from—affect in the classroom. Whereas Albrecht-Crane and Slack (2003) offer affect as a tool that will support a meta-analysis of classroom politics and discourses, Watkins (2006) takes up affect with a focus on learning and teaching literacy where in her fieldwork she maps affective negotiations between students and teachers that are central to the embodied affect occurring in the classroom, and are essential parts of constituting a kinaesthetic economy of knowledge exchange.

Learning becomes about the process of moving the margins of knowledge from exterior to interior locations and this process of movement, or folding, as an embodied act. This process also elucidates the kinaesthetic economy of relations between teacher and student that leads the student to 'invent' or arrive at the affective images that are part of learning to read and write, where the teacher employs affects in her pedagogic practice: 'She took on the character of the pirate she was describing using an exaggerated tone in her voice to heighten the impact of what she was saying' (278). Ellsworth (2005) also addresses pedagogy and affect as a material entity but also as a mode of cognition.

Elizabeth Ellsworth (2005) does not underpin her research with Deleuzian theory; however, her arguments pertaining to affect have strong parallels to those advanced by Deleuze. Deploying the word 'affect' to articulate a material state of affairs, Ellsworth (2005) says:

> Experience, of course, presupposes bodies—not inert bodies, but living bodies that take up and lay down space by their continuous, unfolding movement and that take up and lay down time as they go on being. When we begin to think of experience as an event in time that also takes place, we can see why a number of contemporary theorists are using media and architecture to help them structure their concepts about experience. . . . The visual experience of watching a film entails not only representation. It has a material nature that involves biological and molecular events taking place in the body of the viewer and in the physical and imagined space between the viewer and the film. Affect and sensation are material and part of that engagement. (4)

Regarding cognition and affect, Ellsworth (2005) develops a theory of pedagogy as an interleaving of the materiality affect and subjective processes of cognition where 'there is a difference . . . between the 'evidence of the ocular senses' in which one notices 'that the sensorium has been stimulated' and this other way of knowing, which he [de Bolla 2001, p. 49] describes as an interleaving of affect and cognition.' (4)

On one hand, Ellsworth (2005) conceives affect as taking something on, changing in relation to an experience or an encounter, and on the other hand, an affect is a material entity, an aesthetic compound produced in relation to particular assemblages of space-time.

As discussed by Hickey-Moody (2009) and Hickey-Moody, Windle and Savage (2010), there are parallels between the notion of affect as the concept of taking something on, of changing in relation to an experience, and the process of changing bodies that theorists such as Giroux (1999, 2004), Lusted (1986), Ellsworth (1997, 2005) and Mc William and Taylor (1996) call 'pedagogy'. Just as the readings of affect discussed above each differ, so too do

the theories of cultural pedagogy put forward by Giroux, Lusted, Ellsworth and Mc William. Affect can thus be considered an emerging point of intervention and analysis in education, pedagogy and schooling. It expresses the embodied experience of learning, the places in which we learn and the histories and desires we bring to learning. Affect cannot be brought to bear on a lived situation—it is the lived reality of the situation—the feeling of learning and the excesses not captured through academic frameworks for considering teaching, learning and making.

MATTER BECOMING ARTS

From a psychoanalytic perspective, in *Revolution in Poetic Language* (1984), Kristeva suggests that creative practice does not name, but rather enunciates, the very places of the material dialect that human science has yet to approach. She explains that 'practice is determined by the pulverization of the unity of consciousness. . . . It is the place where signifying *process* is carried out' (203, original emphasis). The political power of creative action is core to Kristeva's (1984) argument, just as it is to the work of Carter (2004), Barrett and Bolt (2010) and Manning and Massumi (2011, 2014), introduced above. Each of these theorists, 'with' the work of new materialists such as Barad (2007) and Dolphijn and van der Tuin (2011), argue that matter needs to be conceptualized as an active agent. We contend, with Carter (2007), Barrett and Bolt (2010) and Manning and Massumi (2011, 2014), that matter needs to be conceptualized as an active agent within discussions of practice as research.

This materialist approach draws on Marx's work in his 'Theses on Feuerbach' (1845) and Engels (1888), who stated that 'those who asserted the primacy of the spirit to nature and, therefore, in the last instance, assumed world creation in some form or other—comprised the camp of idealism. The others, who regarded nature as primary, belong to the various schools of materialism' (14). As Harper (1942) asserts:

> What distinguishes Marxism materialism from other schools must be learned from its various polemical works dealing with practical questions of politics and society. To Marx materialistic thought was a working method. In his writing he does not deal with philosophy nor does he formulate materialism into a system of philosophy; he is utilizing it as a method for the study of the world. (1)

because philosophers have only interpreted the world in various ways; the point is to change it. (Marx, 1845, 13)

This method of study or praxis, 'that concerning the relation of thinking and being' (Engels, 1888, 14) underpins our approach to contemporary arts practice, research, curriculum design and the pedagogy within the Goldsmiths University of London, research Centre for the Arts and Learning (CAL).

CAL is a practice-led research centre where knowledge is conceived as co-constructed through action, praxis. CAL's aims are to enable, explore and curate critical processes of socially engaged praxis that effect social change through a variety of ways and means. Extending and enriching CAL's praxis, this collection shares responsive, located research that draws on arts practices, modes of community engagement and collaboration. We do so with a particular focus, namely, we take matter as pedagogical, and focus on the *pedagogy of matter teaching the maker how they might make differently*. Matter calls us to respond to it, and this requisite responsiveness can rupture human ideology and human design. Building on this collective focus, various chapters in the collection engage with methodologies and frameworks that have not previously been considered within—or as part of—practice as research. These include inventive methods, arts-based research, philosophy, media studies and educational research. Hickey-Moody's chapter, a manifesto for arts practice, carries on the feminist tradition of the political manifesto to suggest that the materiality of making must be always already acknowledged as a political act. Anne Harris' chapter is an excellent example of the relationship between arts-based research and new materialist frames of thought, as Harris employs a video methodology to tell new youth narratives of subjectivity through creative practice that are resistant to the hegemonies of video-based methods.

Until now, arts-based research, media studies and educational research have not explicitly been concerned with matter as a post-human pedagogy, although this collection invites authors to explore the embeddedness of matter as post-human pedagogy within these fields. Elsewhere, Hickey-Moody (2009) has argued that the concept of post-human pedagogy posits a way of thinking about post-humanism that moves beyond the cybernetic models of thought. The work of Katherine Hayles (1997) is an example of this way of thinking, and was developed in response to Ihab Hassan's (1977) now famous statement that 'we need first to understand that the human form—including desire and all its external representations—may be changing radically, and thus must be re-visioned. We need to understand that five hundred years of humanism may be coming to an end, as humanism transforms itself into something that we must helplessly call posthumanism' (205).

Building on this idea of post-humanism, as Braidotti (1994), MacCormack (2012) and many others have done, some of whom we cite above, we are interested in Deleuze's (1988b) Spinozist concept of affectus and Deleuze and Guattari's (1994) perception of art as distinct from, yet produced within, an embodied cultural space. These tools offer valuable ways of

reconceptualizing the post-human, as art is a post-human project that acts on bodies within Deleuze and Guattari's (1994) thought, and affect is the means through which this post-human pedagogy occurs. Or to put it another way, affect is the way in which art speaks and the materiality of voice is part of the way art speaks. In this theoretical context, art has a politically effective capacity, the capability to rework a body's limits, to reconfigure individual arrangements of structure/agency, augment that which a body is or is not able to understand, produce, and to which it might connect.

Post-human pedagogy thus facilitates moments of contact with Other/s that enable thought and art to access what Deleuze and Guattari (1994) have called 'the people to come . . . mass-people, world people, brain people, chaos people', people who open up passages 'from the finite to the infinite . . . ' (180–1, original emphasis). People who, indeed, 'beckon a moment of the infinite . . . [of] infinitely varied infinities' (Deleuze and Guattari, 1994, 181). Such a process of materially reimagining constitutes a politically invaluable aspect of both art and everyday life.

PEDAGOGY OF MATTER

Pedagogy can be defined as the 'theory and instruction of teaching and learning' coming from the Greek 'to lead the child' (Pearsall, 1999, 1051). This definition resonates with Freire's (1970) concept of 'banking' where teaching and learning is conceived as concerned with processes of transmission, in which 'students are regarded merely as passive consumers' (hooks, 1994, 40). However, in opposition to such a conception, Freire (1970) and hooks (1994) critically conceive pedagogy as a 'union of the mind, body and spirit, not just for striving for knowledge in books, but knowledge about how to live in the world' (15); here, pedagogy is an entanglement. Explaining this notion of entanglement, Ellsworth (2005) states that 'specific to pedagogy is the experience of the corporeality of the body's time and space when it is in the midst of learning' (4), and with a focus on natural history, Barad (2007) reminds us that

'In an important sense, both the special and general theories of relativity are a part of classical physics' . . . and this comes to matter because 'Reality is composed not of things-in-themselves or things-behind-phenomena but of all things-in-phenomena. The world is a dynamic process of intra-activity and materialization in the enactment of determinate causal structures with determinate boundaries, properties, meanings, and patterns of marks on bodies. This ongoing flow of agency through which part of the world makes itself differentially intelligible to another part of the world and through which causal structures are stabilized and destabilized does not take place in space and time but happens in the making of space-time itself'. (140)

As stated previously, bodies and the process of embodiment are core to our ways of knowing-being. However, they are also fundamental to the entanglement of *matter and learning and teaching (pedagogy)*. This embodied entanglement of matter and teaching as pedagogy—the moments when materials and spaces impact on bodies and bodies impact on ideas—is our primary interest.

As stated at the beginning of this chapter, through bodies and with matter, we are always making, performing and learning. Therefore, we posit that new materialist pedagogy is embodied and is an intra-action *between* bodies and matter, as ceramic artist Edmund de Waal (2011) articulates:

> Centering the clay, bringing the small ball into perfect reactivity for throwing, involved a ripple of different movements from hand and wrist, an inclination, in the head and neck a slight tautening in the shoulders. It was . . . learning that I could not articulate. (1)

This creative act of learning with body with matter (clay, wheel, water) is what Van der Tuin (2014) asserts as an example of Barad's (2003) study of practices of knowing in being (262). Explaining the narrative of sculptor Souriau, van der Tuin (2014) says that through the relationships of the clay, the person, in the practice of working with, 'the hand, the thumb, the chisel that a statue comes about' (263), or in the case of de Waal, hand with wrist with head with neck with shoulder with clay learning comes about, intra-acting, entangled.

However, new materialism does not focus on the individual's practice but the relationalities of matter with bodies (sensation with memory), as stated by Haraway (2003), who explains, 'Through their reaching into each other, through their "prehensions" or graspings, beings constitute each other and themselves. Beings do not preexist their relatings' (6). Connerton's (1989) work on collective memory indicates that 'social memory is embedded in the performativity of commemorative ceremonies' (4) in which bodies are central and that through the repeated performance of acts such as walking, journeying, ceremonies and rituals, groups, communities and cultures can share sensory memories or, as Seremetakis (1994) calls them, 'mediation on the historical substance of experience' (7).

Seremetakis (1994) maintains that these sensory memories are not fixed in repetition, but are continually reconstituted through the practices of bringing the past into the present, and therefore become an inextricable element in our ways of learning, like Whitehead's (1926) prehensions, Manning's (2009) folds of 'sense-presentation emerging alongside pastness' (215) and Barad's (2007) concept of memory in which she maintains that

> memory does not reside in the folds of individual brains; rather, memory is the enfoldings of space-time-matter written into the universe, or better, the enfolded

articulations of the universe in its mattering. Memory is not a record of a fixed past that can ever be fully erased, written over or recovered (that is, taken away or taken back into one's possession, as if it were a thing that can be owned). And memory is not a replay of strong of moments, but an enlivening and reconfiguring of past and future that is larger than any individual. Re-membering and re-cognizing (sic) do not take care of, or satisfy, or in any way reduce one's responsibilities; rather, like all intra-actions, they extend the entanglements and responsibilities of which one is part. The past is never finished. It cannot be wrapped up like a package, or a scrapbook . . .; we never leave it and it never leaves us behind. (ix)

We fold the past back into the present every moment as we encounter 'the now' through our embodied histories. However, the pedagogy of matter is not about describing sensation, or memories, but is about the learning and teaching that these entanglements constitute (Page, 2012b). They are continuous processes of embodied learning and teaching that are relational by definition.

Wenger (1998) developed various theories of learning, including 'knowing in practice' (141), which was originally conceived by Lave and Wenger (1991) as 'situated learning', a process in which learning is no longer a passive absorption of factual information (after Freire, 1970) but is a social and participatory process where theory is entangled with everyday practice with others. This is demonstrated in Page et al.'s (2011) research with students enrolled on the Goldsmiths MA Artist Teacher and Contemporary Practice programme, in which students articulated that the sharing of practices with fellow artist teachers had an impact on their emerging artist-teacher identities but also increased their making skills, knowledge, understanding and confidence. Situated learning is, as Wenger (1998) state*s*, '*the ability to negotiate new meanings*' (226) that are '*fundamentally experiential and fundamentally social*' (227, original italics). Consequently, in Page et al. (2011), pedagogy is continually being created through the relationalities of the social and material. One student explains the pedagogical nature of this rationality through highlighting 'the excitement of feeling part of the creative process, along with the ability to begin to locate my work within critical theory and contemporary practices and making . . . moving from an isolated position on the periphery of the community towards feelings of inclusivity within the centre of a group of practitioners'. (Hyde, 2007, 298)

This 'group of practitioners', or learning community, ruptures the concept that learning is a passive process where information is 'acquired'. Learning is conceived as a relational process where theory is entangled with everyday practices, with others. However, pedagogy is not all 'conflict-free, caring and nurturing' (Rose, 1993, 56); there may be tensions, conflicts, oppression and domination.

The theories of critical pedagogy (Gallop, 1988; Giroux, 2003; hooks, 1984) and the work of Freire (1970) draw on anarchism, feminism and Marxism, and are a teaching and learning approach that attempts to enable the questioning and challenging of domination, and the beliefs and practices that dominate (Shor, 1992). Shor (1992) defines critical pedagogy as follows:

> Habits of thought, reading, writing, and speaking which go beneath surface meaning, first impressions, dominant myths, official pronouncements, traditional clichés, received wisdom, and mere opinions, to understand the deep meaning, root causes, social context, ideology, and personal consequences of any action, event, object, process, organization, experience, text, subject matter, policy, mass media, or discourse. (129)

The three assumptions of critical pedagogy are that praxis can enable social transformation, that learning and teaching are not neutral, and that society can be transformed by the engagement of those who are critically conscious (Grunewald, 2003). These assumptions resonate with Barad's (2007) distinction between critique, as an evaluative sensibility, and being critical as reactionary.

A critical pedagogical approach also enables thinking through the intra-action of pedagogized identities. Freire (1970) states:

> Through dialogue, the teachers-of-the-students and the students-of-the-teachers cease to exist and a new term emerges; teacher-student with student-teacher, the teacher is no longer merely the one who teaches, but the one who is himself [sic] taught in dialogue with the students, who in turn while being taught also teach. They become jointly responsible for the process in which all grow. (80)

Page (2012b) rewords Freire's statement replacing the word 'student' with 'learner', which results in the following:

> Through dialogue, the teachers-of-the-*learners* and the *learners*-of-the-teachers cease to exist and a new term emerges; teacher-learner with learner-teacher, the teacher is no longer merely the one who teaches, but the one who is himself [sic] taught in dialogue with the *learners*, who in turn while being taught also teach. They become jointly responsible for the process in which all grow. (160)

These intra-actions enable the continual reproduction and renegotiation of learner, teacher, learning, the meanings of which are not predetermined, therefore resulting in the creation of a 'shared place of discovery and learning' (Page, 2012, 73), that is not specific to an educational setting, but rather,

is entangled with wider, global, discourses and power relations. These wider, global, discourses and power relations are constitutive of pedagogy. Freire (1970) explains that this becoming-other is effected through intra-action as 'transformation', and although we disagree with the ruminants of theology echoing in this word, the marked, material change (or becoming) in capacity being signalled is important. Freire (1970) goes on to explain that pedagogy 'becomes the practice of freedom, the means by which men and women deal critically and creatively with reality and discover how to participate in the transformation of their world.' (16)

Therefore, this practice of freedom is 'about how we learn together and make changes together' (Page, 2012, 73), a practice in which learning as responsiveness to matter and to space-time-mattering occurs within the contingencies, differences and diversity of life.

This responsiveness, and the material aspects of responsiveness, is demonstrated in Maggie Pitfield's chapter, "*A Pedagogy of Possibilities: Drama as Reading Practice*". Pitfield examines the practices of a secondary English teacher with her pupils' in a London urban school, with a focus on the ways the teacher's practices resist policy-directed discourses. Drawing on literary theory, Pitfield analyses the ways drama, as an embodied art form, is integral to the pupils' and teachers' shared meanings in their intra-actions with literary texts. Pitfield argues that the dramatic activity, in which the teacher learners are materially and conceptually entangled, enables not only relationalities of criticality and creativity but also the emergence of teacher learners' becoming active in their readings and production of culture.

Pedagogy can therefore be conceived as an open, continuously created and recreated process that is specific to intra-actions of difference that make a difference, not grounded in existing knowledges that attempt to equalize, normalize or fall back on traditions of established values, concepts and practices. This conception of pedagogy is further explored by Esther Sayers, who worked as a gallery educator for Tate Modern (London, UK) for over ten years. Sayers' chapter explores the pedagogic entanglement of the audience with this unique contemporary art space. She considers how, through the intra-actions of learner, teacher and cultural institutions, the differences of matter and meanings emerged in ways that enabled the creation and re-creation of pedagogies and methodologies that responded to local ways of being and becoming.

Both Pitfield and Sayers do not perform an epistemology/ontology hierarchy but are both epistemological and ontological in their reconceptualization of the role of matter in processes of learning. These chapters show us that we may affect matter but matter also affects us in profound, although often subtle or hidden and inescapable ways, and that this is a necessary entanglement that is altered with the different intra-actions of sociocultural

constructions of matter, and here, matter is also constructed as part of human existence. It is the *action between* that matters; therefore, just as we know and learn matter pedagogically, we also know and learn matter just by *being*.

RESISTANCE AND RESONANCES OF MATTER

Matter can be inherently resistant, but as the works in this collection show us, matter can often teach us through *showing us otherwise*. Bodies resist instruction, ideologies and political boundaries, and in so doing they show the limits of political, educational and popular discourses and policies. Matter resists manipulation; it inspires and demands attention, and through engagement with matter, new modes of practice transpire. Yet, when the praxis of seemingly heterogeneous scholarship is entangled, as it is in this collection, 'the patterns of difference that make a difference' (Dolphijn and van der Tuin, 2012, 50), the very intra-actions of matter and meaning are made visible. In different ways across the works brought together here, we see that intra-actions of matter and meaning enable dissent, change structures and ask for new responses, but they also *generate resonances* and are therefore not only resistant to existing practices and ways of being but are also pedagogic.

This analytic focus on resonances, and the pedagogical nature of things and viral changes, is one of the ways the works collected here build on, and contribute to, existing discussions of critical pedagogy. To be plain, we are not just interested in how the pedagogical a/effects of objects change ideologies and popular practices, but in the rubbing up against each other, the resonances—the material cultural and affective dimensions of change that make subjectivities and make people aware of, and open to, change. More than this, as Charlie Blake and Jennie Stearns' chapter shows us, matter causes change and the matter of parasites transforms bodies and capacities, illustrating a material agency that interrupts consciousness and conscious choice.

As we stated at the beginning of this chapter, new materialism concerns itself not only with relationalities of power, constituted and reproduced by bodies, but also with how bodies participate in/with these relationships. Coole and Frost (2010) assert that there is

> 'increasing acknowledgment within theories of politics—and especially in theories of democracy and citizenship—of the role played by the body as a visceral protagonist within political encounters' . . . and 'thus reveals both the materiality of agency and agentic properties inherent in nature itself'. (19–20)

Everyday practices of democracy and citizenship are exactly such sites of political reproduction and production. This is highlighted in a recent issue of the Financial Times Weekend Magazine (24/25 May 2014) that aimed to 'give a sense of what today's Europe feels and looks like' (Kuper, 2014, 7). This commentary illustrates the ordinary, yet always political entanglement of bodies and matter and the intra-actions, the differences that make a difference, of how and 'Why Europe Works' (Kuper, 2014, 10–11) or at times does not work. The entanglements and intra-actions of bodies and the materiality of place, language and climate are pedagogic.

Kuper (2014) asserts that Europe works because 'little differences encourage cross-border learning . . . partly because European countries remain slightly different from each other' (Kuper, 2014, 10). The intra-actions of the transport networks, rail, commercial flight companies, climate and the proximal geography of Europe (higher ratio of coast to landmass than any other continent or subcontinent) have enabled mobile Europeans to share and exchange ideas and learn 'with' each other and place.

This place pedagogy emerges not only in the resistances of everyday practices, tables and chairs on pavements in London cafés, gay marriage, hybrid accents and languages, but also in politics. Through the founding of the European Union, European countries taught democratic systems across borders, 'from 1995–2013 the world's fastest growing middle-income economics were the Baltic states, Poland and Slovakia . . .' (Kuper, 2014, 11). Europeans transnationally debate different ways of knowing and understanding; employment, free markets and the environment are debated in ways that are prompted by the shared proximity of communities.

In a different capacity, the same principle of intra-action operates in geographies of art. Explaining this radical materialism, Deleuze (1988a) suggests that the arts have the capacity to operate in terms of general rather than fixed limits. In his book *Spinoza, Practical Philosophy* (1988a) Deleuze describes 'affectus' as 'an increase or decrease of the power of acting, for the body and the mind alike' (49).[6] So, to be affected is to be able to think or act differently, though, as responses, affects easily become habitual. Familiar responses are learnt in relation to bodies and subjects, and it is only through challenging a 'truth' that is acknowledged in an expected or popularly known response, or habitual behaviour, that we can create and adopt new ways of responding and being affected.

Contemporary arts practices can offer these new ways of knowing, being affected and new intra-actions between bodies. Systems of affect, kinaesthetic economies of relation, established through, or in response to, physical discourses effect pedagogy through intra-action. People establish *economies of relation* based on physical responses and world views. Deleuze and Guattari's (1994) thought on affect and sensation extends this position that ways

of understanding are a product of a system of knowledge and material beliefs, rather than a singular 'truth'. Such understandings enable alternative stories and knowledges of bodies, and ways of being a body, to be developed with dominant systems of knowledge. The concepts of corporeal and artistic affect developed in Deleuze's (1994) work and in Deleuze and Guattari's (1987, 1994) joint scholarship explicate the ways artworks emanate force and impact on bodies. Deleuze and Guattari's (1987, 1994) scholarship models understandings of 'minor'[7] knowledge systems and develops a particular perspective on the kinaesthetic economy of relations created within art as a minor knowledge system.

Duffy (2006) explains that Deleuze's idea of an affective limit, or 'threshold', has a specific meaning:

> for Deleuze, the term 'limit' defines a margin or threshold beyond which a mode's capacity to be affected ceases to be animated by active affections and therefore ceases to be expressed altogether, that is to say, beyond which a finite mode ceases to exist. (151)

Affective, bodily limits shape the material world—they are thresholds for what can be actualized. Additionally, the body is an extensive physical mass; it fills space. But the body is also a liminal space that connects context to subjectivity through a network of affective systems. As Graham (2004) notes, we cannot assume 'a clear boundary between objects and persons' (299). We must remember virtual[8] possibilities for body–space connections and changes, and an absolute belief in unambiguous boundaries 'must be abandoned . . . [as] persons do not finish at their skins' (Graham, 2004, 299, square parentheses added). The body and intra-actions between things form extensive spaces; bodies produce virtual spaces and inhabit shared spaces. Playing with notions of the body-in-space, the body as space and the possibilities of virtual space, the chapter by Camilla Stanger discusses the politics of choreographic techniques employed to devise the work around untrained dancers' bodies. Stanger develops a frame for thinking about bodily actions as (re)positionings of racialized embodied histories.

Barad (2007) has also highlighted the importance of in-between bodily spaces, those that we simultaneously inhabit and move away from unwittingly in the pedestrian experience of living. It is in, and through, proximal spaces that embodied histories are carried, performed and reframed. Indeed, as Anna Hickey-Moody's chapter shows in its discussion of the re-appropriation of the Fremantle Asylum, embodied histories of corporeality and spatiality can be re-territorialized[9] through creative work. Hickey-Moody shows that the space that bodies perform in becomes more than a given condition

of performance; space and place and traces of intra-action *in* space and place need to be acknowledged as historical and political artefacts. This is what Deleuze and Guattari (1987) call a 'smooth space', a place in which ratios between matter and virtual possibilities are reworked (488). Art can teach through challenging ready-made perceptions, slipping between cracks in consciousness, assumption and the 'known', through making new bodies and creating accompanying ways of knowing.

Collective arts practices redefine communities through articulating a virtual body of difference. As Colin Gardner illustrates in this collection through the employment of videotext, and the accompanying creative method of sourcing lived experiences of the Vietnam war and the affective experiences of war, proximal spaces become zones of corporeal learning, as viewers of the film text extend and embrace space as 'an intensive discontinuity in which the subject degenerates' (Braidotti, 1996, 74). Arts practices are, then, a form of material thinking:

> A thinker may . . . modify what thinking means, draw up a new image of thought. . . . But instead of creating new concepts that occupy it, they populate it with other instances, with other poetic, novelistic, or even pictorial or musical entities. . . . These thinkers are 'half' philosophers but also much more than philosophers. . . . They are hybrid geniuses who neither erase nor cover over differences in kind but, on the contrary, use all the resources of their 'athleticism' to install themselves within this very difference, like acrobats torn apart in a perpetual show of strength. (Deleuze and Guattari, 1994, 66–7)

Artists are also material thinkers, 'hybrid geniuses . . . philosophers but also much more than philosophers' (Deleuze and Guattari, 1994, 66). As material thinkers, artists give form to new aspects of the world. The 'very difference' to which Deleuze and Guattari (1994) refer is sensation, the aesthetic compounds created by artists. Such aesthetic compounds—sensations—are a material realization of a new aspect of reality. Indeed, as Aislinn O'Donnell's chapter shows us, philosophy and science have long understood material acts to impact on thinking, yet art has not always been conceived in such terms. The matter of thinking is thus as important an ontological question as the matter of making.

We hope this collection shows you some of the ways the materiality of the arts teaches. More than this, we hope the social and cultural changes that emerge through intra-actions between people and matter in processes of making, collaborating and observing contemporary arts seem more significant or are of increased interest after your engagement with this collection.

NOTES

1. After Deleuze (1995, 99), we read subjectivity as 'a specific or collective individuation relating to an event'. Human subjectivity is a collection of dividuations which are activated differently in various machinic arrangements.

2. 'Prehension is the basic, extrasensory awareness, or grasping, that all experiences have of all earlier experiences. One might call it the super intuition on which all conventionally recognized extrasensory perception and sensory perception are built' (Anderson, 2000, 1).

3. And here we also remember Bourdieu (1990), who asserts that

> The habitus, a product of history, produces individual and collective practices—more history—in accordance with the schemes generated by history. It ensures the active presence of past experiences. (54)

In other words, through the 'repetitions' or practices (habitus) of bodies (sensation with memory) with matter, we are constructing, performing, relating, knowing, learning and being.

4. Question-led, themed seminar series on material cultures of resistance for the Centre for the Arts and Learning (CAL), Goldsmiths University of London.

5. More recently, *Body and Society* have published a special edition on the turn to affect, see 16 (29) 2010. Of particular interest is Patricia Clough's 'Afterword, The Future of Affect Studies' (2010, 222–30).

6. Deleuze expands this definition through arguing that 'affectus' is different from emotion. 'Affectus' is the virtuality and materiality of the increase or decrease effected in a body's power of acting. Deleuze states:

> The affection refers to a state of the affected body and implies the presence of the affecting body, whereas the affectus refers to the passage [or movement] from one state to another, taking into account the correlative variation of the affecting bodies. Hence there is a difference in nature between the image affections or ideas and the feeling affect. (1988a, 49, author's square parentheses)
>
> 'Affectus' is the materiality of change, 'the passage from one state to another' which occurs in relation to 'affecting bodies' (1988, 49). In their collaborative work, Deleuze and Guattari work with a concept of affect, which has three specific iterations, corporeal affect, affect in art and affect in thought.

7. Politically marginalized.

8. Deleuze develops a specific notion of the virtual. After Henri Bergson, Deleuze characterizes the virtual as possibilities for the actual, as the non-material aspect of the actual world. The virtual has a different temporal structure from the actual, and as such it folds in upon the actual in ways that bring the past into the present and connect the present to the future. While the actual and the virtual are distinct, they are also two halves of a whole; one exists in relation to the other.

9. The act of re-territorialization changes the aesthetic tropes and bodies of knowledge through which a spatialized body is known. In so doing, re-territorialization augments what the spatialized body 'is' and what it can become.

Chapter 1

Experimental Philosophy and Experimental Pedagogy

A Single Vision

Aislinn O'Donnell

In a short essay in MaHKUzine, Irit Rogoff (2010) writes of the emergence in the seventeenth century of a society for the study of 'Experimental Philosophy'. Their commitment to 'take nothing on authority', combined with the value that they set upon 'experimental philosophy', constitutes, she argues, some of the features of 'creative practices of knowledge' that might serve to offer a form of resistance to the

> endless pragmatic demands of knowledge protocols: outcomes, outputs, impact, constant monitoring of the exact usefulness of a particular knowledge or of its ability to follow the demands and imperatives of cognitive capitalism—demands to be portable, to be transferable, to be useful, to be flexible, to be applied, to be entrepreneurial and generally integrated within market economies at every level. (39)

Rogoff (2010) acknowledges that the legacy of the Enlightenment is one that seeks to verify through experiment or argument and suggests that it might be rather better to think of singularizing knowledge and the ways that creative practices of knowledge might enable the contestation of truth regimes. It is useful to reflect more deeply upon this idea of experimental philosophy, both in terms of its trajectory through the centuries and its subterranean potentials in the present. The experimental philosophers to whom Rogoff (2010) refers were indeed mavericks in many ways, engaged in collective forms of inquiry (often through necessity), passionately curious and truth-seeking. Yet the legacy of Francis Bacon and others was one which created experimental philosophy as a practice enabling mastery over nature, abstracting phenomena from their 'natural' environments, privileging replicability, generality, and even universalizabilty, over singularity, locality or context. These practices

claimed the power to identify, classify and categorize. The complex relation-
ship between truth-claims and power has been well documented, yet the
co-imbrication of truth-regimes and power remains resistant to efforts to
demystify and dismantle them. This essay acknowledges this and looks to
uncouple truth and power through a more tentative, mischievous, oblique,
joyous and experientially oriented 'experimental philosophy', resonant
with the recent turn in research called 'new materialism'. The refusal of the
demand for explanatory force and the demand to give an account of itself,
as is commonplace in practices framed as research in art, philosophy and
pedagogy, is accompanied by resistance to both the imperialism of method-
ology and the hierarchy of theory. Experimental philosophy favours instead
material encounters, the genesis of ideas, creative methodologies and new
concepts that accompany and engender different more subtle sensibilities,
patterns of thought and singular knowledges.

Suspicion of all forms of hegemony, intellectual and otherwise, led Paul
Feyerabend (1993) to argue that science is an essentially anarchic enterprise.
His position was that 'the only principle that does not inhibit progress is:
anything goes' (5). In order to challenge the prescriptive notion that one first
has an idea or a problem, and only thereafter one acts, Feyerabend (1993)
pointed to the playful activity of young children as they explore the world. He
believed that 'general education should prepare citizens to *choose between*
standards, or to find their way in a society that contains groups committed
to various standards, *but it must under no condition bend their minds so that
they conform to the standards of one particular group*' (61). For the same
reason, Feyerabend resisted the notion that 'knowledge [should] be changed
so that its presence can be checked by a single algorithm' (218) and was criti-
cal of early philosophers saying that they 'do not enrich existing concepts,
but they void them of content, make them crude, and increase their influence
by turning crudeness into a measure of truth' (260). Moreover, Feyerabend
argues that the scientific and philosophical commitments and beliefs that
have shaped and informed the 'rationalist' imaginary, which offers an image
of itself as both objective and tradition-independent, constitute a 'secularised
form of the belief in the power of the word of God' (218). Such a rationalist
imaginary is impoverished, and its claims to identify the essential are pre-
mised on the elimination of the immeasurable or the singular. The idea of
objectivity as a form of secularization of theological belief is provocative, in
particular given the performative force of much of the language that circu-
lates in educational research, policy, corporations and institutions, academic
and otherwise. One example of this is found in the KEA report *Impact of Cul-
ture on Creativity* (2009) commissioned by the European Commission. This
report advocates for the development of a European Creativity Index (ECI)
consisting of thirty-two indicators with six central pillars—human capital,

institutional environment, technology, social environment, openness and diversity and creative outputs. It justifies the quest for creativity by arguing for its instrumental value in driving economic and social progress.

Philosophers Deleuze and Guattari (1987) draw upon *How to do Things with Words* by John Austin (1962) as well as Michel Foucault's (1973, 1984, 1986, 1991) corpus in order to locate different elaborations of performative speech. This informs their innovative concept of the order word. Unlike the examples given by Austin (1962) that embed particular utterances within social norms and practices, such as 'I now pronounce you man and wife', order words can include words or phrases that lack signification or content, while retaining the power both to command and to produce subjects and subjectivities. Examples today might include words like 'creativity', 'innovation' and 'excellence'. The material force of this pervasive though curiously empty, redundant, generic, abstract language that is encountered in many policy reports and reviews is resonant of both Orwell (1946, 1948) and Kafka (1989, 2009) as it aims to set standards, simplify, compare, effect outputs, designate outcomes, and design evaluations across a wide range of practice and activities of human existence, with little sense of the diversity of purposes or material practices of human activity across the long natural history of humankind. "'Is it not really strange", asks Einstein, "that human beings are normally deaf to the strongest argument whilst they are always inclined to overestimate measuring accuracies?'" (quoted in Feyerabend, 1993, 239). Instead of emphasizing operationalization and formalization of procedures across all spheres of existence, Feyerabend (1993) asserts that 'there are many different maps of reality, from a variety of scientific viewpoints' (245). Indeed, Ian Hacking (2000) writes in a review of his last book, a compilation of unfinished manuscripts, that what Feyerabend (1993) most resisted was what William Blake (1956) called 'Single Vision—Newton's Sleep'; the image of single vision is very different from an epistemological approach that values singularity, or is attuned to the specificity of diversity, capacities required to develop the acuity and sensitivity needed for conscious experimentation.

SINGULARITY AND EXPERIMENTUM

In order to foster an imaginary premised upon 'experimental philosophy', points of affinity or connection might be developed between practices of philosophy, art and pedagogy. These might include the seventeenth-century society of experimental philosophers described by Rogoff (2010), and the image of life as experimentation found throughout all the writings of Nietzsche (1984), Deleuze and Guattari (1987) and Spinoza (1996). Nonetheless,

Feyerabend's (1999) remarks on the use of experiments in the search for 'reality' offer a useful note of caution:

> But the search [for reality] has a strong negative component. It does not accept phenomena as they are, it changes them, either in thought (abstraction) or by actively interfering with them (experiment). Both types of changes involve simplifications. Abstractions remove the particulars that distinguish an object from another, together with some general properties such as color and smell. Experiments further remove or try to remove the links that tie every process to its surroundings—they create an artificial and somewhat impoverished environment and explore its peculiarities. In both cases, things are being taken away or 'blocked off' from the totality that surrounds us. (5)

The interference that Feyerabend (1993) outlines is only a symptom of the will to mastery guiding experimental science and he acknowledges that '*understanding a subject means transforming it*, lifting it out of natural habit and inserting it into a model or a theory or a poetic account of it. But one transformation may be better than another' (12, original emphasis). As Henri Bergson argued in chapter 1 of *Matter and Memory* (2004), perception is always a subtractive enterprise—to be able to act, to choose and to move involves blocking off and ignoring much of the rich variety of life. However, a concerted effort to deploy a unidimensional and reductive method that seeks to simplify the abundance of life is a matter for concern that has existential, political, pedagogical and philosophical implications. It is not, says Feyerabend (1993), that we do not need scientists, poets or philosophers but rather that their interaction with their material of inquiry involves a complicated interplay 'between an unknown and relatively pliable material and researchers who affect and are affected and changed by the material which, after all, is the material from which they have been shaped. It is not therefore easy to remove the results' (146). These subjective elements *create* conditions of existence, animating the dynamics of the world rather than just registering 'what is there'.

I am not averse to those practices of experimental philosophy and pedagogy that invite abstraction in thought or create artificial conditions, but with Hannah Arendt (1958), I resist equating experimentation with hypothesis testing. Arendt writes critically of the way the understanding of truth changed from *theoria* into the practical question of 'what works?' so theory became *hypothesis*, and the outcome of the hypothesis became 'truth', 'proof' or 'evidence'. As she writes in *The Origins of Totalitarianism* (1958), her fear was that the experiment *produces* reality and thus guarantees its own success. I understand her reservations; however, I do not wholly agree with her suspicions of pragmatism. I am inspired by the

subtle responsiveness of practices of empirical enquiry that are attuned to the matter or material of inquiry, and to the possibility of unexpected lines of enquiry and questions such as those opened up by Dada, Fluxus and contemporary art practitioners such as Thomas Hirschhorn, Seamus Nolan, and Fischli and Weiss. Rather than seeking the 'single vision' of truth, such an approach looks to create the conditions for new modalities of affective and existential engagement that can serve to punctuate habits of cynicism and *ressentiment*. Examples might include *Suddenly an Overview*, Fischli and Weiss' tender series of tiny clay figurines rendering the monumental events of universal history or the *Bijlmer Spinoza Festival*, or Thomas Hirschhorn's (2009) collaborative intervention in an estate South-East of Amsterdam, which he creates because he is a 'fan' of philosophy. My interest is not in the new field of 'experimental philosophy' that generates ideas to be applied by empirical scientists, in particular cognitive psychologists, but rather in the way in which Deleuze and Guattari (1987) take up the functionalist and pragmatist commitment to 'what works'. This, combined with their vision of experimentation, involves singular practices and situations, and a pluralistic approach to epistemology, entails the retrieval and assembling of an image of experimental philosophy that is more attuned to singularity and more open to rich descriptions of particulars, to practices of observation and to what Deleuze (1995) has called transcendental empiricism—an experimental approach that seeks to create the conditions for real, rather than possible, experience. This approach is both oriented by, and seeks out, passion, curiosity, interest and wonder in a manner redolent of early modern and medieval intellectuals. Thomas Hirschhorn's (2009/10) description of himself as a 'fan' of philosophy, in an interview with Birrell, captures some of the naivety, enthusiasm and excitement that can help to dissolve what William Connolly (2011) has called 'embers of resentment' (293). In that interview, Hirschhorn (2009/10) says:

> I am passionate about Spinoza because the lecture of *Ethics* had a real impact on me and I am passionate about Philosophy in general because I enjoy not understanding everything. I like the fact that, in Philosophy, things remain to be understood and that work still has to be done. (2009/10, 1) . . . Again, I am not illustrating Philosophy with my work. I am not reading Philosophy to do my Artwork and I am not reading Philosophy to justify my work. I need Philosophy for my life, to try to find responses to the big questions such as 'Love', to name one of the most important to me. For this, I need Philosophy—please believe it! But of course if connections, dynamics, influences or coincidences exist in my work—as you pointed out in 'It's Burning Everywhere'—I am absolutely happy. I want to be touched by grace, without belief in any correlation to genius or obscureness or that it has something to do with artistic ignorance. (4)

Such a sense of wonder, enthusiasm and fascination is vital to sustain and energize practices in philosophy, art and pedagogy. In Lorraine Daston and Katherine Park's (1998) mapping of the histories of wonder, we are reminded that it was seen as a 'cognitive passion, as much about knowing as feeling' (14), and are told that the cognitive passions of wonder and curiosity 'briefly meshed into a psychology of scientific enquiry in the seventeenth century' (20). They describe the scepticism of natural philosophers in respect of the possibility of a 'philosophy of particulars' because such phenomena were of the order of chance, quoting *De mirabilius mundi*, whose author says:

> 'One should not deny any marvelous thing because he lacks a reason for it, but rather should try it out [*experiri*]; for the causes of marvelous things are hidden, and follow from such diverse causes preceding them that human understanding, as Plato says, cannot apprehend them,' observing that 'thus natural wonders often overlapped with "secrets" and "experiments" (*experimenta*), another group of phenomena accessible only to experience; these craft formulas, or proven recipes for medical and magical preparations, often drew on the occult properties of natural substances, and they were excluded from natural philosophy for the same reasons'. (Daston and Parks, 1998, 129)

Openness to contingency and chance, as well as sharing of recipes, secrets, experiments and ideas, are key features of my re-envisioning of 'experimental philosophy and pedagogy' and in certain respects offer the possibility of what Sarat Maharaj (2009) calls a 'lab without protocol' following Hans Ulrich Obrist and Barbara Vanderlinden's (1999) exhibition/project *Laboratorium*.

An experimental philosophy lies outside the strict parameters of natural philosophy because of the value it places on the singular, in know-how, instructions, secrets and recipes. This interests me because it interrupts the image of knowledge, or what Deleuze (1994) calls the dogmatic image (or tribunal) of thought, that seeks to prove, show, identify, classify or justify. An experimental approach is more interested in creating opportunities for the sharing of ideas and practices that might enhance potentials for singularizing encounters and material engagement with and by students, situations, materials, disciplines, bodies, affects and ideas. This re-appropriates the mantra of 'what works' from its universalizing, ahistorical and foundational pretensions to the kind of toolbox methodology of 'trying it out', and thus seems to be more faithful to the nuanced responsiveness of pedagogy and the practices of inquiry of many scientists, artists and philosophers who try to cultivate fine attunements to the terrains of the materials and ideas that they are exploring. Wonder sustains attention and curiosity provokes questioning, yet these qualities are not mentioned in those learning outcomes detailed in course descriptors or funding proposals. Indeed, in my own

university the word 'explore' is prohibited from learning outcomes. This is primarily because such forms of engagement are unpredictable, and thus their outcomes are not guaranteed.

Avicenna observed that 'so to whatever object the eye first turns, the same is a wonder and full of wonder *if only we examine it for a little*' (original italics, Daston and Parks, 1998, 136). Over two centuries from about 1370, many people engaging in philosophical inquiry were not academic philosophers, but were involved in practical fields of exploration like alchemy, *materia medica* (pharmacology) and magic. A taste for the particular was essential in such empirical investigation because particulars cannot be known through theory or deduction. Daston and Parks (1998) call this 'preternatural philosophy' as it 'rehearsed new empirical methods of inquiry' (137) and forced an abandonment of the 'limpid certainty of *scientia* for the muddy waters of sensory experience and probable opinion' (141). They distinguish this epistemological model of natural enquiry from the demonstrative ideal, suggesting that it required a different sensibility. Later Belon would speak of the 'singularities' he found in the footsteps of Galen (Daston and Parks, 1998). The use of words such as 'wonder' and 'singularity' have a curious ring to the contemporary ear, yet creative and rich encounters with that which is new *for us* in the lines of inquiry that emerge in our disciplines and practices as students or teachers or apprentices or artists, or in our encounters with the ideas of our students, can echo that sense of wonder as the world is disclosed anew. After a long hiatus, they tell us, the language of marvels re-entered natural philosophy 'in the context of a new epistemology of facts and a new sociability of collective empirical enquiry' (Daston and Parks, 1998, 218) in the seventeenth century. While Francis Bacon in 1620 constructed a New Organon to discipline the mind's aversion to particulars and to shuttle between the universal and the particular, the early scientific journals, according to Daston and Parks (1998), abound with the language of 'new', 'remarkable', 'curious', 'extraordinary' and 'singular'. In contrast with Aristotelian empiricism, 'the empiricism of the late seventeenth century was grainy with facts, full of experiential particulars conspicuously detached from explanatory or theoretical moorings' (Daston and Parks, 1998, 237). Of interest were strange facts—and facts were themselves uncertain, unlike demonstrative knowledge.

In *Histories of Scientific Observation* (2011), Lorraine Daston and Elizabeth Lunbeck say that the history of observation in the sciences needs to be told, just as abstract terms like 'experiment' and 'classification' have been shown to be rooted in concrete practices; 'for example, how the first scientific laboratories drew upon the skills and furnishings of the workshops of early modern artisans, or how late nineteenth century astronomers employed women whose eyes had been trained to discern the tints of embroidery skeins to classify stellar spectra' (2). They argue that the coupling of observation and

experiment did not occur until the sixteenth and seventeenth centuries, and 'many practices that from a modern (or even early modern) viewpoint seem to be clear examples of the observation of nature were instead designated by the terms *experimentum* (a trial or test) or *experiential* (cumulative experience)—two words often used as synonyms, because they both referred to results that could not be deduced from first principles' (Daston and Lunbeck, 2011, 12). There is no sense with these stories that the diversity of the world might be reducible onto a plane of comparative equivalents. The rise of generalized monetary equivalence emblematic of capital, and the prevalence of discourses in education and culture premised upon formalization, measurability, standards and comparison are, it seems, the air that we breathe today; yet, a standard is, after all, an artificial affair, even if it has been reified to the level of idolatry. Knowledge itself has taken on the features of the commodity, as described by Marx in the *Grundrisse* (1993) and *Das Capital* (1906). For instance, the primary features of the Bologna Process that sought to reform and integrate European education systems are reminiscent of the commodity form. These include:

Generalizability (rather than singularity)
Transferability
Portability
Standardization (must be comparable)
Measurability (tied to some standard of measurement)
Homogenization (required for comparison and transfer)
Alienation (no direct relation to material practice)
Equivalence
Abstraction (no attention to genesis or process other than formal)
Simplification
Abstract and homogeneous labour time.

Data or outcomes are viewed as more legitimate sources of evidence if methods that have produced their 'truth' are replicable, comparable and verifiable, the process and methodology operationalized for securing such knowledge or information are 'transparent', the observational language 'neutral', and the findings measurable. An aura of objectivity accompanies the presentation of data secured in this fashion; however, the implicit metaphysics that accompanies claims that what counts is what is measurable, that we don't understand until we measure, and that 'the world comes as measurable' (Hacking, 1992, 50) is seldom acknowledged. This is not simply a matter of concern for epistemologists; it frames the ways practices of knowledge and creativity are valued or not, and it is inscribed in funding guidelines, policy documents, mission statements, module descriptors and

evaluative tools. Indeed, it seems that the idea of 'impact' as potentially progressive also owes something to the image of causal force or collision in mechanical philosophy because impact too must be measurable, differentiable and even predictable in advance of the intervention, event or exhibition. Interventions the effect of which may be ephemeral, intangible or involve a temporal lag, or might be better expressed in stories or images, or may be singular, anomalous or unclassifiable may be deemed, in comparison with the security, certainty and stability of quantifiable data, as just as occult and as ludicrous as appeals to magic or phlogiston. Yet these immeasurables are the ether of our practices.

CREATIVE METHODOLOGIES AND THE SINGULARIZATION OF EXISTENCE/THOUGHT

In part as a counterbalance to these trends, and in part because I think it would be more useful and more truthful, I suggest that we might return to other ways of thinking about both experiment and observation by looking at the medieval concept of experience as test or trial. I am curious about the idea of observation as inquiry, and associated ideas relating observation to meditation, consideration, experience, investigation and contemplation, a shift involving the slow evolution from the monastic writers to writers in the twelfth and thirteenth centuries. Park (2011) writes that 'the *experimentum*, a well-established genre of scientific writing in medieval Europe, was typically a set of directions—usually a medical, magical or artisanal formula—purportedly derived from and tested by experience, including both purposeful experience and trial and error. More broadly, 'experiment' corresponded to knowledge of singular, specific or contingent phenomena that could not be grasped by deductive reasoning as well as the process by which such knowledge was obtained' (Park, 2011, 17). This is distinguished from a concept of experiment understood in terms of artificial manipulation designed to identify hidden (occult) causes. Daston and Parks (1998) note that the meaning of *experimentum* changed in order to emphasize the elements of proof and spectacle, and causal inquiry, but also observe the lingering etymological affinity of *experiential/experimentum*. While I acknowledge the dangers of 'mixing and matching' concepts, such as losing the specificity of a concept, or misreading a concept, new ways of thinking and sensing might open up in the assembling of an eclectic collection of ideas that promote sensitivity to the singular and to trial and error, alongside an image of observation as a form of inquiry at once contemplative, meditative and investigative. These might offer conceptual resources to think anew about practices in philosophy, pedagogy and the arts.

In many respects, this chapter is trying to respond to a deceptively simple set of questions: What are we doing? What is the purpose of research and practice in pedagogy and in the arts and humanities? What matters to us in these practices? Are there ways of re-engaging with them so that they can become more alive, more vital and more creative? Are there ways of describing them that are more faithful to the diversity of practices, that value the singular potentials of different modalities of engagement, and that can share ideas like recipes, secrets—the experiments of five hundred years ago? Offering rich descriptions or sharing questions, tasks, ideas and experiments is not the same as offering proofs or evidence. Problematizing the thinness of discussion of practice in education and the abstraction of philosophical thought from the everyday, and offering rich descriptions of creative methodologies, material content and experimental practices, does not seek to inure philosophy or pedagogy to normativity. Rather, such a methodology can help us to notice the multiple constitutive flows that orient our practices, including those of a more reactive or visceral timbre. Practices of research in, for example, education that develop 'what works' theories, or that appeal to randomized controlled trials, which retain little sensitivity to the complex relational dynamics of the pedagogical endeavour or practice, arguably tell us little about the world, and even less about how to orient ourselves in those spaces as teachers and students. So too, philosophies that forget the world, forget the origins and genesis of the ideas that move us. Learning *with* both the matter of thought and engagement *with* others helps to foreclose the likelihood of objectification or reification. However, I think there is still scope for the more modern understanding of experiment in terms of the artificial creation of situations of thought or encounter. This does not aim to control either output or variables, but rather to temporarily suspend the habitual responses of the day to day, creating the potential for different modalities of attention through ostension or through practices that abstract ideas or experiences from their habitual unfolding, for example, in order to intensify or enrich the experience of them. Much can be learnt from ideas like Sarat Maharaj's (2009) Dada epistemics that draws upon Aby Warburg's Dada methodology. This methodology involves the assembling of components, non-representational thinking and the kind of feeling for the reality of relations, as William James (1912) elucidates in his descriptions of radical empiricism.

Ian Hacking (1992) has argued that the theories of laboratory sciences persist 'because they are true to phenomena or even created by apparatus in the laboratory and are measured by instruments that we have engineered' (30). As I indicate above, I am agnostic about the artificiality of the production of phenomena in pedagogical situations, which I distinguish from those pedagogical situations in the service of research agendas. However, I see that at times such artificiality can be a useful tool in the construction of what I call

situated thinking, as long as those practices are at the service of life rather than truth, understood as proof, evidence, demonstration or determinative judgement. Although I agree with Hacking (1992) that we should not equate 'laboratory' with 'experiment' (despite the popularity of such terms in recent contemporary art practices), I still think that the artificiality of the laboratory can be of service in creating a space that permits of the provisional suspension of the affairs of the world such that a different way of living the everyday might be permitted, even temporarily, offering a freedom that allows one to play with ideas, materials, knowledges, and different ways of imagining one's existence.

A practical example may illustrate this. In one philosophy class that I offer, most of the men have spent some time in prison, and a number are homeless. I mention their background because they are placed to the margins of society and are often without voice or access to those quasi-public spheres that allow for those difficult conversations that move between philosophy and life, navigating complex images of what it is to be a man, what it is to be human, and what it is to be a citizen. An interplay between philosophical ideas and existential preoccupations allows spaces to be opened in which we can explore the concept of melancholia or anxiety, the relationship between melancholia and philosophy, or anxiety and existentialism, the stories of Ancient Greece and Kant's long walks, lunar cycles, the humours, as well as the men's own stories and observations. This process is about venturing thoughts and allowing them to be suspended and held within the space as they are so they can play off against other ideas. It involves sitting with what emerges, rather than dissecting or analysing stories or digging to the roots of existential crises or problems. This is an artificial space that allows us to breathe without having to constantly react, as we must in the world outside. For these men, these classes allow for conversations, so they tell me, that they are ordinarily not permitted to have given the social norms of the worlds that they navigate as men, men who have often been marginalized at that. There is an experimental quality as we move our lines of enquiry in response to whatever emerges through our philosophical conversations. It is that 'suspended' quality of the laboratory that I wish to retain. However, I do not believe that it is the only kind of space that allows for surprise or engagement; many others might be constructed in line with different sensibilities, dispositions and territorialized identities.

SITUATED THINKING

Other voices that contest the hegemony of theoretico-experimental sciences and their counterparts include those of geologist, evolutionary biologist,

palaeontologist and zoologist Stephen Gould (1980) and philosopher of sci-
ence Isabelle Stengers (2000). Stengers writes that 'the science of evolution
learns to affirm its singularity as a *historical science* faced with experimenters
who, whenever there is no "production of facts", can only see an activity of
the "stamp-collecting" type' (2000, 141); however,

> in Darwinian histories, a cause in itself no longer has the general power to cause;
> each is taken up in a history, and it is from this history that it gains its identity as
> a cause. Each witness, each group of living beings, is now envisioned as having
> to recount a singular and local history. Scientists here are not judges, but inquir-
> ers, and the fictions they propose take on the style of detective novels, implying
> ever more unexpected intrigues. (141)

Stengers (2000) is attracted by the lack of a defined object and the impos-
sibility of judging *a priori*, saying, that in this case, 'it has discovered the
necessity of putting to work a more and more subtle practice of storytelling'
(148). She calls this a style or an example, but not a model. Something of
such an inquiring and singularizing approach to practice might be of benefit
in pedagogy, and it also might open up ways of doing philosophy that are
less reverential towards authority and more reverential towards the abun-
dance of life and the potentials for constructing other futures, more singular
knowledges, and more ethical and creative responsiveness. At play here is
not simply the notion of 'letting be' that we find in some philosophers but
a more active and delighted 'listening', 'sensitivity' and 'conversation',
alongside the exercise through artifice of finding oneself situated differently,
allowing for the experimentation with different ways of encountering the
richness of the world. Again, Stengers quotes the embryologist Albert Dalcq,
who wrote:

> In experimental biology, and in particular in the domains that touch on morpho-
> genetic organization, deduction often requires a kind of art, in which sensitivity
> has perhaps a place. . . . The very object on which the embryologist is working
> is capable of reacting, and the research readily takes on the appearance of a
> conversation: the riposte has all the unexpectedness and charm that one finds in
> the response of an intelligent interlocutor. (cited in Stengers, 1997, 124)

No divide need be forced between the existential and the 'objective'.
To refuse such oppositions might invite an ethos of engagement that could
inform a different interplay with the world, one involving the concomitant
cultivation of attention, wonder, curiosity and interest such that we might
even become attuned to the ways in which we are constituted by many forces
beyond the human, and the ways in which our affective lives often rumble at
a subterranean level.

It can be easy to close off to experience because of a visceral, pre-reflective reaction; however, this may simply indicate the genealogy of our singular histories, our beliefs, encounters, experiences, attitudes, dispositions, all of which were formed and oriented by a thousand tiny encounters which remain unnoticed until they rupture the threshold of consciousness and appear to have the quality of 'mineness' and 'chosenness'. If we wish to maintain the language of creativity in education, it must not be overcoded by the image of the created product or that all-pervasive slogan 'innovation'. Learning itself is a creative and a singular endeavour of understanding and attunement. Creativity lies in a disclosure of the world for *me* in dialogue with it, much as I might come to know another person somewhat more intimately. I learn *this*. I know *this* person.

EXPERIMENTAL ENCOUNTERS

I feel that the Idea . . . grows according to the needs of a new community, based on creative affinities, regardless of cultural or intellectual differences, even social or individual differences. I'm not talking about a community to 'make works of art', but something as a living experiment—every type of experiment we could develop in a new sense of life and society—a kind of environment constructed for life in itself, based on the idea that creative energy inhabits everyone. . . . It would be an open space, an environment for any conceivable or imaginable form of creative experiment. (Helio Oiticica in Lima, 2009)

Deleuze's (1995) writings on societies of control, Hannah Arendt's (1958) identification of the algorithmic turn, the rise of doubt and world-alienation in the *Human Condition*, and Deleuze and Guattari's (1987) examinations of the implications of the formal and axiomatic nature of capitalism which mean that the most diverse forms of resistance can be re-encompassed or quanti-fied, are all useful in helping us to understand our present condition. The surplus of information produced by algorithm-based exchange-flows of data and information exceeds any human capacity for assimilation or comprehen-sion. It verges on an experience of the sublime, paralysed, but without the moment of redemption or any sense of the power of one's faculties. I think here of Mark Curran's (2013) recent powerful work 'The Market' and his large teetering piles of A4 paper filled with the code of market transactions, and of Marx and Engels' (1998) prophetic statement that 'all that is solid melts into the air' (3) in the *Communist Manifesto*. This melting into code, information, algorithms and flexible rules is not confined to financial markets; the propaganda is that all activities and knowledges can be translated into for-mal language. Deleuze's (1994, 1995) concept of 'society of control' might better be renamed 'society of quality control'. I suggest that the didactic and

content-heavy image of 'banking education' described famously by Paulo Freire (2005) has been supplanted with Bologna by 'investment banking education', some of the features of which I sketched above, which incorporates the language of credit swaps, capital and investment. Paradigms that privilege formal and generic appraisals of practice serve to occlude and partially eliminate the significant and transformative elements of the arts and humanities and pedagogy in practice. Again, instead of appealing to epistemologies grounded in an image of knowledge that sees its role as one of provision of evidence, presentation of findings, justification of practice or exposition of argument, I argue for an approach to pedagogy and philosophy that is more attuned to life and to the materiality and situatedness of the practices of thinking, making and teaching. Moreover, in my view, this is also more faithful to what matters and the kinds of intuition and openness grounded in experience that govern such practices. Here I join Friedrich Nietzsche (1984), Baruch Spinoza (1996), William Connolly (2011), Jane Bennett (2010), and Tamsin Lorraine (2011) and others involved in developing research in new materialisms who seek to articulate visions of philosophy and pedagogy informed by an ontology of material vitalism, oriented by and through the richness and the abundance of life. Rather than the hierarchical aspirations of theory that serve to unify narratives, experimental philosophies and pedagogies seek out and value immanent lines of enquiry and encourage collective and collaborative practice. This, in part, is why Stengers (2000) speaks of propositions rather than theories.

Can practices such as these count as research? Are they are too singular, too situated, too aspirational to be of value? Where might they sit in terms of pedagogy? What possibilities are opened up by them? Can dissemination of an artwork to a public be to an audience of one, even just to the one who made the piece? Could an elaboration, even an institutional critique, of philosophy serve to open up other forms of philosophical practice? Most of my students in prison think a lot, and our conversations are sustained, engaging and dynamic, but most would not have a body of knowledge to show after weeks of discussion, though they may speak of existential shifts and openings. Neither they nor I could pin down what precisely is happening in our classes, and our interactions ebb and flow in their dynamics. I refuse to adopt a social-scientific or even ethnographic approach to research that would render those in my classes my objects of study, so my reflections on encounters in the site remain indirect and philosophical, focused on the matter of thought. Sometimes we collaborate, and when they write, their writings speak for themselves without need for further mediation and explication by a 'researcher'. They are the researchers and they speak in their own voice. Sometimes I/we make up tasks that undermine the pretensions of academic philosophy like the following: write the story of the *Communist Manifesto*

in the voice of a seven-year-old Marx and a five-year-old Engels, or do a list of questions in the style of Fischli and Weiss, or work through text and image to describe the disjunction between the description of meals and the sensory encounter with prison food. In a total institution, the sheer absurdity of some of the exercises helps foreground the surreal nature of the environment: a rather literal over-identification can operate as a critical form of resistance. Maud Cotter's question at a presentation of some of these ideas in the National Sculpture Factory in Cork was 'Is the prison your studio?' Perhaps this is the right way of thinking about it, this site that provokes my thinking and deepens my understanding of philosophical questions and the nature of our world.

I think also of the Young EVA International project co-developed with gallery educator and curator Katy Fitzpatrick, which aimed to introduce children to art and philosophy. We spent a good deal of time in preparation, trying to think up those questions, exercises and tasks for the children that might crack open clichéd forms of art making, drawing and responding in such a way that a more singular and imaginative response might be engendered. Sometimes it works and sometimes it doesn't. Asking children to respond to 'My journey to school' or 'My neighbourhood' precipitated a range of postcard assemblings of text and image, whimsical, poetic, humorous, all giving insight into not 'the life of the child' but the 'life of *this* child'. These ventures, tasks and exercises are little experiments, opening up spaces and interstices between stimulus and response, and trying to create the conditions for not just the singularization of knowledge but the singularization of existence. It is a process of trial and error. We found that thinking about our sessions in terms of rhythms moving between the discursive, looking and responding, and making work helped to sustain the aliveness of our encounters. We thought about the physical format of our bodies and objects in the classroom. One session was called 'museum in a schoolbag' in preparation for our visit to the Hunt Museum in Limerick. Having discussed with the children their ideas of memory, preciousness, history and collecting, we asked the children to bring an object or idea that could be part of our museum collection in the classroom. The intimacy of the stories of the children was revealed in the interweaving of their stories, of the journeys to live in Ireland, of leaving, or of being with, people they loved, of wit, wisdom or humour, and responses to the Koran, or Arabic scripts; each of their voices and little stories revealed the singularity of each child in a way that was deeply moving. Although museums and galleries often aim to celebrate diversity and the identities of children, we felt that by asking a child to identify himself or herself *as* X, the more nuanced, subtle and gentle forms of storytelling, observation and the relationship to their singular objects could too easily be coerced into a more heavy-handed and clumsy, albeit well meaning, framework.

Those genealogies of the children's lives involved a delicate interplay of a range of experiences, part of which involved neighbourhood, pets, country of origin (for some), ethnic or religious affinity, football, people they loved, people they missed, the sky, concepts like freedom or voice, and so forth. The artificial nature of the museum session and the creation of a different space and atmosphere allowed for different kinds of experiences to come into being. We did not aim to locate the 'truth' of the life of the child or to provide evidence for the impact or replicability of this approach. Given our commitment to an immanent and emergent method of pedagogical, artistic and philosophical enquiry, we hoped to offer the possibility for each child to find creative ways to manifest his or her singularity as well as to set up the conditions for collective engagement in the interplay of responses of the class. Following artist Garett Phelan's slogan for the zine co-produced with the class, our only principle was 'Everyone gets it right here'. One session focused on examples from contemporary art, and the children offered their responses to Marcel Duchamp's *Fountain*, the outrageous idea of the ready-made constituting a provocation to the inherited idea of art as drawing, painting or sculpture. Another session that required more thought and time than we gave it, as we learnt, was a 'Museum Curated by an Animal'. The danger with a more standard social-scientific approach that would require a research question or hypothesis to be posited in advance of our encounter with the children and their teachers was, in our view, that such framing of the territory could dampen the liveliness and interest of the children by prescribing what we wished to discover in advance of its invention. It would preclude the experimental composition of new lines of subjectivity and the assembling of different maps of existence, cartographies of desire, observation, perception, sensibility, techniques, relationality and thought. There is, oddly, an arguable precedent for this kind of approach, ethic and epistemological vision in elements of the evolutionary sciences as I described above.

One of the current terms used in regulatory discourses for evaluating research and knowledge transfer is impact, and the dissemination dimension of impact is supposed to be measurable. Were we to reflect on this question of impact through the lens of contemporary art practice, more latitude might be permitted, although arguably there would be pressure to document work and to tell stories about the process. But what does dissemination mean? And what if a singular encounter has a profound impact on only one, two or three people? Some time ago, I wrote a long review of a man's artwork that he made in prison. Only three of us have seen the film and review. Indeed, I am its sole audience in that I was not involved in its making. It seemed important that it would have a public, even if only a public of one. I watched the film with him in the studio, in his cell, which was also the space for his exhibition. The review was written both for him and to him, as a kind of gift, an intimate

gesture. I am not sure what, if any, value would be placed on this in terms of broader research parameters; indeed, only contemporary art practice might set some value on the anomalous nature of the process, the space and the encounter. I think of Hans Ulrich Obrist's reflection on the physical encounter with exhibitions and the possibilities of minor forms of curating like 'The Kitchen Show' (1991). Here is a lengthy quote from the piece that I wrote:

> What follows is the story of a film and the thoughts that awoke in its witnessing. This is a film about time, doing time and our existence as temporal beings. It reaches across decades and intimates the promise of a future, where time is not done or done with, but can take on the fullness of an existence in the world. The man who is the artist and the central character is seen episodically across decades, as younger, as ageing, and the film refuses a strict chronology as memory and perception skip back and forth through the years with a Proustian quality through the returning epiphanies through the piece as a series of ritornellos: pacing, boxing gloves, steel, vibrant paintings, television, sounds, the earth's atmosphere. Together we sit in the room, his room, his studio, watching this film. At this moment, *all* of this is what it means to watch this film. It must be something that happens between us, no longer an object, or a screen, but the ebb and flow of relations between me, him, the film, the room, the prison, our world. And so I bear witness.

The prison is a strange institution. It seems so solid in its tedium and routines yet beneath the repetition lies an air of menace. It is tightly coiled, wrapped in procedure, but so tautly wound that it can snap at any moment. Its universe is a precarious one. The Law is for the making. One day something will be prohibited, the next permitted, and nothing is permitted unless a rule has dictated so. This is the inverse of ordinary life where one ordinarily knows when one has infracted the law; here one has to presume that all is infraction. This is the world where arbitrariness rules, the bureaucracy where logic takes an implacable form but makes little sense. Truths are made, laws are concocted at whimsy, in the manner of other bureaucratic institutions, but with more severity and absurdity. The evenness of an atmosphere here is not grounded but hovers at crisis point—slow movements or reformations are less likely than sudden explosions. In the 1700s, David Hume challenged a human disposition that favours complacency and certainty by asking how can we *know* that the sun will rise tomorrow. Given its rhythm one may *believe* this will be the case, but one cannot know with any certainty. Prison life does not even permit of justifiable belief. One must be prepared for anything to happen at any time. For laws to be created and destroyed. For a thousand petty rules to pervade the fabric of the everyday, rules whose origins have been lost in the shroud of time while the force of law lies in its form rather than content. It is a Kafkaesque universe.

There was a time before, there is this time, and there will be another time to come. This piece is about this time, the elongated stretch of time that is the long 'now' and its temporality bears witness to the complexity of the impossibly stretched present with its bare circular temporality. The head appears framed by the window, younger, in silence, simply looking at the world and the camera contemplates with him in silence, sitting, staying, as though eternities pass with the gaze of the lens. What would Levinas say here? Not the face-to-face but the face in side profile that allows us to look without the challenge of the eyes, to observe with the tactile eye, just as I am observed as I watch the piece, from the side and behind. There is an intimacy to these shots in which nothing is said, in which the singularity of *this* face, this man, comes into view, a saying before anything is said, reminding us that humanity always arrives in the singular. He looks out the window and the bars vanish as the skies and space, the element of air, the only element not forbidden by the prison, levitates and offers a sense of the infinite. The sky. The infinite. This face. Infinity. The mood stays slow and meditative until the camera jerks back—bars, mesh, barbed wire, soldiers, rifles, a screw, another tower. 'Really not a lot going on,' the voice says talking past the camera, and the world seems full, saturated with nothing but images of confinement as the skies vanish and the tedium of policing an institution suffocates, overt symbols of power and violence are fore-grounded and the palette moves from the soft light of the skies and soft tactility of skin to concrete and steel. A siren sounds. I wonder whether it is from the film I watch or elsewhere. The senses go on alert in this space and only on the second viewing do I determine its source from the film. And the voice speaks, the head looks, observes. Nothing to be seen. *Ecce homo.*

CONCLUSION: WHAT GOOD IS PHILOSOPHY IF IT DOES NOT GIVE BIRTH TO THE WORLD OF THE FUTURE?

In their book of interviews, *Conversations on Science, Culture and Time* (1995), Michel Serres asks Bruno Latour, 'What good is philosophy if it doesn't give birth to the world of the future?' (79). This question raises concerns that are different from those interpretations of Dewey (1938) that emphasize preparation for the world of the future such that, presumably, we might be better equipped to respond to novelty. Instead, philosophy and pedagogy are here understood to be acts of creation, both in terms of inventing new concepts and engaging in the kind of de-selfing that encourages one to experiment with virtual relations rather than remaining stuck in habitual patterns of familiar lived experience. Tamsin Lorraine (2011) writes, '[Concept creation] is but one component in an art of skillful living that entails coming

into attunement with the world around us in ways that unfold our capacities for joyful living rather than engage us in deadening repetitions of what worked for us in the past' (28). These experimental practices open up the spaces and interstices required to nurture the capacity for creative responsiveness. Even the simple gesture of reading and understanding a text or thinking about someone else's idea invites habitual modalities of reaction to be suspended, allowing for new kinds of connections to be made. Lorraine (2011) calls these practices 'joyful participation' and describes how attunement to our thresholds and habits, feeling for 'resistances and resonances' and 'pursuing new connections' (159), can help us to reorient our attention and open up new lines of becoming. We need to make philosophy that gives birth to the world of the future. In pedagogy, in philosophy and in art, we cannot prove or show what does not yet exist, but we can follow the immanent lines of enquiry opened up through responsive engagement and exploration in the situations in which we find ourselves alone and with others.

Chapter 2

Probeheads of Resistance and the Heterotopic Mirror

Tiffany Chung and Dinh Q. Lê's Stratigraphic Cartographies

Colin Gardner

In a key passage in *What is Philosophy?* where Deleuze and Guattari (1994) discuss the differing viabilities of various planes of immanence, they pose the question of whether one plane is 'better' than another in responding to the requirements of a given age. 'What does answering to the requirements of the age mean,' they ask, 'and what relationship is there between the movements or diagrammatic features of an image of thought and the movements or sociohistorical features of an age?' (Deleuze and Guattari, 1994, 58). These questions can only be answered if we resist the dominant discourse of a strictly historical and/or dialectical approach conditioned by issues such as before and after, cause and effect, in favour of what they call a *stratigraphic* time, 'where "before" and "after" indicate only an order of superimpositions' (Deleuze and Guattari, 1994, 58). The result is a heterogeneous pluralism which transmutes itself, as different features of time switch transversally from one plane to the next through a series of developmental becomings. Thus, 'very old strata can rise to the surface again, can cut a path through the formations that covered them and surface directly on the current stratum to which they impart a new curvature' (Deleuze and Guattari, 1994, 58–9). This alters the strata and gives them a new order so that as Craig Lundy points out in *History and Becoming* (2012), 'When a historian engenders an historical event or culture (as opposed to "passively observe" historical "facts"), they do so in relation to others; their event is linked to other events in the same way as concepts are, and their culture is as interleaved and holed as a plane of immanence is' (161). In this way, historical-stratigraphy emphasizes the significance of lines that move *between* planes of coexistence according to an ontology of historical creativity—a fluid combination of intensive emergence and the universal-contingent.

This new materialist conception of a discontinuous, stratigraphic time is all well and good, but what does it have to do with pedagogy and perhaps more importantly, a pedagogical *aesthetics* of resistance? Clearly, what we need is a 'bridge' between history-as-becoming and cultural pedagogy as an auto-poetic intuitive event that might teach through affects, aesthetically crafting visceral and cognitive refusals in its individual and collective practitioners. In short, how might we link becoming with affect and aesthetics to create a new form of critical historical subject? As Anna Hickey-Moody (2009) points out, such refusals are innately material insofar as affect—derived from Spinoza's 'affectus'—refers to the 'virtuality and materiality of the increase or decrease effected in a body's power of acting' (273). More importantly, affectus is at the heart of pedagogy itself, 'namely a relational practice through which some kind of knowledge is produced. Such relational cultural practices need to be understood as occurring both within and outside places that are understood as being "educational" settings' (Hickey-Moody, 2009, 273). Hickey-Moody's (2009) argument thus allows us to radically redefine the very nature of resistant art as itself a material pedagogic practice (and ethics) that cuts transversally across and between conventional 'sites' of institutionalized subjectivity—embodied cultural spaces such as the gallery, the museum, the classroom, the lecture hall and the internet—but also between the human and the non-human (as a rhythmic trace of the world), whereby the material is taken up into the affective body through an expressive logic of sensations.

It is the latter that allows art to radically rework the body's limits (whether defined by the division of labour, confining nationalisms, convenient cultural pigeonholes such as West versus Non-west, colonial or postcolonial) and allows it to forge new connections, giving rise to the *idea of a people yet to come*. As Simon O'Sullivan (2012) convincingly argues, 'Contemporary art can operate on a cusp between the present and the future. It is "made" in the present, out of the materials at hand, but its "content" often calls for a subjectivity to come. This stuttering and stammering of existent materials and languages, this deterritorialization of existing regimes of signs, constitutes the ethico-aesthetic function of art' (200). More importantly, the artist doesn't necessarily have to be a specific product of his/her time or place, for as Deleuze (1989) notes, the pedagogic author 'can be marginalized or separate from his more or less illiterate community as much as you like; this condition puts him all the more in a position to express potential forces and, in his very solitude, to be a true collective agent, a collective leaven, a catalyst' (221–2). Following this 'untimely' logic, 'As affectus is a subjective change, and affect a product of aesthetic labour that may cause subjective change, affect in art is a vector of pedagogy' (Hickey-Moody, 2009, 274).

It is also, one might add, a vector of aesthetics (*aisthesis* as sensual as well as intellectual perception) which plays a key, constitutive role in subject

formation (albeit less as a stable Cartesian *cogito* than as a decentred multi-plicity). The philosopher and educator Alfred North Whitehead (1861–1947) acts as another useful bridge here (linking Deleuze and Guattari with Hickey-Moody) insofar as he associates affect with aesthetics, becoming *and* education. As Steven Shaviro (2009) points out, becoming, to White-head, 'is not continuous, because each occasion, each act of becoming, is unique, a "production of novelty" that is also a new form of "concrete togetherness", or what Whitehead calls *concrescence*. Something new has been added to the universe; it marks a radical break with whatever was there before. . . . An object can only endure insofar as it renews itself, or creates itself afresh, over and over again' (19). In other words, the subject gives birth to itself (autopoetically in Guattarian terms) in each fresh sensate encounter:

> The word 'object' . . . means an entity which is a potentiality for being a com-ponent in feeling; and the word 'subject' means the entity constituted by the process of feeling, and including this process. The feeler is the unity emergent from its own feelings. (Whitehead, 1978, 88)

More significantly, in his educational writings, most notably *The Aims of Education and Other Essays*, Whitehead stressed the importance of the creative imagination in generating the free play of ideas necessary to be a powerful catalyst for generating a becoming on the lines of Deleuze's 'people yet to come'. Thus, in 'Universities and Their Function' (1929), he writes:

> Imagination is not to be divorced from the facts, it is a way of illuminating the facts. It works by eliciting the general principles which apply to the facts, as they exist, and then by an intellectual survey of alternative possibilities which are consistent with those principles. It enables men to construct an intellectual vision of a new world, and it preserves the zest of life by the suggestion of satisfying purposes. (Whitehead, 1967, 93)

This affective, intuitive pedagogy as a wilful strategy of resistance is cen-tral to the work of Tiffany Chung (b. 1969) and Dinh Q. Lê (b. 1968), two Vietnamese artists educated in the United States who examine the scars of postcoloniality by interweaving actual historical situations—wars of national liberation, rationing, genocide, deindustrialization, enforced migration and natural disaster—with more virtual, sensate and heterotopic encounters, what Chung evocatively defines as 'an archaeology project for future remem-brance'. This *stratigraphy* of various strata of coexistence—what Nietzsche dubbed the 'untimely' and Deleuze and Guattari (1994) call *haecceities*—allows the two artists to dissect different historical and geopolitical levels with transversal flows, tangents and dynamic movements *between* different 'sheets of past' and 'points of present' that defy majoritarian (i.e., 'western-centric')

classification. 'We are in the epoch of simultaneity,' declares Foucault (1986), 'we are in the epoch of juxtaposition, the epoch of the near and far, of the side-by-side, of the dispersed' (22). Deleuze (1988) agrees, noting in his own book on Foucault that 'One must pursue the different series, travel along the different levels, and cross all the thresholds; instead of simply displaying the phenomena or statements in their vertical or horizontal dimensions, one must form a transversal or mobile diagonal line along which the archaeologist-archivist must move' (22).

TIFFANY CHUNG

In the case of Tiffany Chung, this transverse stratigraphy is most fully developed in her cartographic pieces, which were successfully showcased in her 2010 exhibition, 'scratching the walls of memory' at Tyler Rollins Fine Art in New York. Heavily inspired by her ongoing interest in bacteria and fungi, Chung works at both the micro- and macroscopic levels, weaving together spidery webs and intricate skeins of carefully rendered lines through a combination of drawing, embroidery and appliqué, often punctuated by clusters of glistening beads and metal grommets. Eschewing strict historical and geographical accuracy for a more expressive layering of spatio-temporal disjuncture, Chung generates topographic renderings of the twentieth century's most traumatic historical atrocities, including the rise and fall of the Berlin Wall, a tracing of the atom bomb blast zones in Hiroshima and Nagasaki, as well as a mapping of the demilitarized zone between North and South Vietnam along the 17th parallel.

There is of course a considerable danger in reducing such cataclysmic events to a form of decorative aestheticism. Indeed, as Theodor Adorno (1981) famously warned us, 'Even the most extreme consciousness of doom threatens to degenerate into idle chatter. Cultural criticism finds itself faced with the final stage of the dialectic of culture and barbarism. To write poetry after Auschwitz is barbaric. And this corrodes even the knowledge of why it has become impossible to write poetry today' (34). On the other hand, art can also act as a form of affective pedagogic catalyst for generating a new form of collective thought, for as art critic Zoe Butt (2010) points out, 'these artistic fungal growths seek to reveal the people who suffer and persist through the reality of these diagrammatical enigmas', to the point that the works' sheer lack of subjectification allows trauma to exist as a purely mental function. In other words, Chung eschews the false pieties of recollection and voluntary memory in favour of an abstract, impersonal and non-subjective cognitive mapping that produces undecidable alternatives between sheets of virtual past and the simultaneity of peaks of de-actualized present, what Deleuze (1989)

calls a crystal-image, 'the uniting of an actual image and a virtual image to the point where they can no longer be distinguished' (335). Following novelist and film-maker Alain Robbe-Grillet, Deleuze (1989) notes that 'what we will call a crystalline description stands for its object, replaces it, both creates and erases it . . . and constantly gives way to other descriptions which contradict, displace, or modify the preceding ones. It is now the description itself which constitutes the sole decomposed and multiplied object' (126).

This wilful, Nietzschean utilization of the 'powers of the false' is more fully developed in Chung's cartographic piece, *Dubai 2020* (2010) (see figure 2.1), where the artist constructs a sociopolitical palimpsest of the emirate city from the perspective of three different historical time frames. Starting with a 1973 map of the city, she overlays an updated 2010 satellite rendition before adding a fictional projection for the year 2020, thereby eschewing strict accuracy (and its associated historicist determinisms) in favour of a more heterotopic mirroring, whereby virtual and actual, reality and fantasy, here and there are mutually deconstructed as an infinite series of crystalline reflections that refer as much to an unknown future as to the historical past. Indeed, the mirror is central to Foucault's discussion of sites of encounter as deterritorializing points of connection with both a finite interior and an infinite outside. First we have utopias, 'sites with no real place. They are sites that have a general relation of direct or inverted analogy with the real space of Society. They present society itself in a perfected form, or else society turned upside down, but in any case these utopias are fundamentally unreal spaces' (1986, 24).

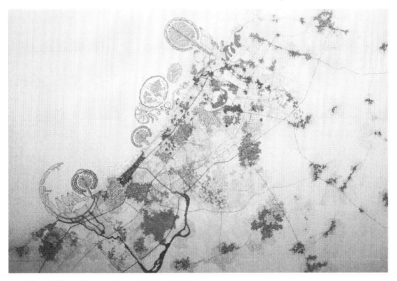

Figure 2.1 Tiffany Chung. Dubai 2020. 2010.

In contrast, there are places that do exist but which behave like counter-sites. The latter encompass all the other sites within a culture, but they are simultaneously represented, contested and inverted. 'Because these places are absolutely different from all the sites that they reflect and speak about', argues Foucault (1986), 'I shall call them, by way of contrast to utopias, heterotopias. I believe that between utopias and these quite other sites, these heterotopias, there might be a sort of mixed, joint experience, which would be the mirror' (24). For Foucault (1986), 'The mirror functions as a heterotopia in this respect, it makes this place that I occupy at the moment when I look at myself in the glass at once absolutely real, connected with all the space that surrounds it, and absolutely unreal, since in order to be perceived it has to pass through this virtual point which is over there' (24). More importantly for Chung, this archaeology of the mirror represents an 'excavation in advance', whereby the artist eschews the conventional *ex post facto* placement of peoples within already historicized places in favour of situating them as a Deleuzian 'people yet to come' for future remembrance, as an act of becoming that presupposes a projected collective agency.

Chung expands this strategy in her latest films and videos. Thus, in *Well-side gatherings . . .* (2011), she films a highly visceral, martial arts-style performance of young people lining up for rationed food and other necessities. This visually references two actual historical events but folds them together into a dual, *stratigraphic* emergence. On one hand, this 'line up' is temporally linked to Japan's 1918 Kome Sodo (rice riots) that took place during the otherwise stable regime of the Taisho democracy (1912–1926). Far from being a moment of collective solidarity, the self-interested, violent desperation of participants suggests that heterotopia and dystopia share common ground at similar moments of national crisis. On the other hand, the piece references a similar period of rice shortages and long queues for rationed food in Vietnam during its 'black hole' or subsidy period from 1975 to 1986. Although the latter assemblies were actually peaceful and well ordered, Chung makes the transverse historical jump by highlighting the subsidy period's most iconic object, the red brick that was used to mark a person's place in line in case he or she needed to take a break during a long wait. Even then, the person had to keep an eye on the brick in case someone moved it or jumped ahead in line. To this day, one can still see on the sidewalks of certain areas of Saigon a number of bricks topped with paper funnels to signify the presence of black market gasoline vendors. Like Chung's palimpsest-like maps, the confusion of Japan with Vietnam and the former's violence with the latter's ordered marking of place creates what Foucault (1986) calls the heterotopia's third principle, that it 'is capable of juxtaposing in a single real place several spaces, several sites that are in themselves incompatible' (25). Of course, this affective form of history

could easily be extended to any era of rationing in any country, including the United Kingdom in World War II (with the concomitant rise of black market spivs and Wide Boys) or *le système débrouillage* (resourcefulness) in France under the Occupation.

Interestingly, the violent struggle between the performers in *Well-side gatherings* . . . makes a brief appearance in slow motion in the right half of a split-screen sequence in the work's sequel, *Recipes of Necessity* (2014). However, in marked contrast to the earlier film's desperate competition for food, the latter sees a generous sharing of dishes (and personal histories) within the broader community as a means of overcoming the loss of Vietnam's basic rice staple as a catalyst for creating a new socio-economic, cross-generational dynamic. In alignment with our focus on stratigraphic markers, the film unfolds between two framing actions—the failed attempts to get a somewhat archaic period fan and a transistor radio to work—thereby creating twin planes of dystopic malfunction. In contrast, the main body of the film consists of several generations of Vietnamese coming together to sample the dishes that were created during and after the war to substitute for the heavily rationed food staple, that is, rice. First, the older generation were selected from many different backgrounds to share their stories of the collective hardship of the subsidy period, most notably their use of cassava root, coixseed (i.e., sorghum from China), wheat flour, powdered milk and yams, and the various ways they tried to make it edible, much like the ubiquitous use and doctoring of the dreaded Spam in Britain during the 1950s.

Meanwhile, individual vignettes tell terrible, gut-wrenching stories of malnutrition and hardship, exacerbated by the constant introduction of new currency which devalued everyone's existing savings and resources. However, the film also generates a heart-warming sense of community and mutual self-help. This culminates in a number of intercut scenes where every participant was brought together with the younger generation (who were born at the tail end of the subsidy period and thus have little or no recollection of it) to enjoy a meal made exclusively of these alternative recipes. However, Chung is careful to add a heterotopic twist; these 'recipes of necessity' are now being served in a period of relative economic affluence, so that there is a stratigraphic disjuncture between the two time frames as well as what constitutes political and economic necessity. Indeed, as one of the interviewees points out, the gap between rich and poor was much narrower during the tough times than it is now, suggesting a greater degree of camaraderie between the classes. The result is less a personal archaeology of past and present conditions in Vietnam (and the implied impact of US imperialism both on the ground and in the current context of globalizing late capitalism) than a future-perfect projection forward to what will be a

subsequent set of memories recalled by the young generation. This cyclical renewal as becoming is thus a classic example of Whitehead's concrescence or 'concrete togetherness' as itself an act of affective pedagogy, both on the part of the film's participants and Chung's film itself as a stratigraphic document.

Finally, utilizing on-site interviews, participant observation, anthologies and Chung's own fictional writings, the film essay *When the sun comes out the night vanishes* (2013) (see figure 2.2) explores the devastation and depopulation of the small industrial towns and coalmining villages in Japan's Yamaguchi Prefecture following post-war modernization. Chung's main focus is on the different personal experiences of two main characters from the younger generation. One has lived in the town of Isa-Cho his whole life and seems happily content watching baseball games and visiting friends while also noting the ubiquitous layer of dust that blankets the community, blown by the wind from the nearby Ube Cement works. The other undertakes what amounts to an archaeological tour through the region's past, telling tales of his parents and grandparents as we see the effects of deindustrialization on the landscape and the community's collective memory. Thus, what were once thriving streets and shrines are now forsaken and reclaimed by nature, while the entrance to mineshafts are woefully overgrown and boarded up to the point of being unrecognizable. These sequences create a tension between majoritarian signifying structures that attempt to 'explain' the transformation in causal and linear terms (post-war Japan's rapid growth has necessitated a Darwinian 'evolve or be left behind necessity') and a minoritarian, more

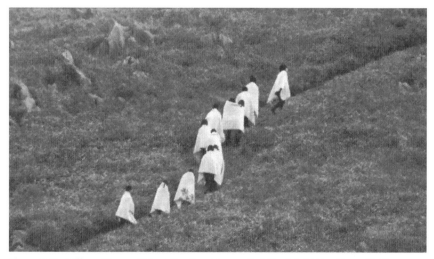

Figure 2.2 Tiffany Chung. When the Sun Comes Out the Night Vanishes. 2013.

empathetic stratigraphic mode that transgresses space and time, so that past, present and future are both intertwined and collapsed.

As is well known, Deleuze and Guattari (1987) condemn this majoritarian reading as a form of abstract machine which they call 'faciality'. This is based on two co-ordinating axes, that of *signifiance* (the white wall) and subjectification (the black hole)—two contrasting but complementary semiotic systems or strata which serve to organize and capture ephemeral phenomena into a tightly controlled representational system, much like the way we tend to 'see' faces in landscapes (or landscapes in faces) or transform abstract patterns into everyday phenomena, not unlike Rorschach inkblot tests. 'Signifiance is never without a white wall upon which it inscribes its signs and redundancies,' note Deleuze and Guattari (1987):

> Subjectification is never without a black hole in which it lodges its consciousness, passion, and redundancies. Since all semiotics are mixed and strata come at least in twos, it should come as no surprise that a very special mechanism is situated at their intersection. Oddly enough, it is a face, the *white wall/black hole* system. A broad face with white cheeks, a chalk face with eyes cut in for a black hole. (167)

Fortunately, there is a way out of this facializing dominance. Firstly, this takes the form of what Deleuze and Guattari (1987) call probe-heads (*têtes chercheuses*), a more primitive, pre-signifying, pre-subjective regime—collective, corporeal, plugged into new becomings—that allows us to 'go through faciality' to disrupt existing modes of organization from within the organization itself. Probe-heads thus utilize the basic fabric of the world but use it differently through alternative modes of organization: 'Here, cutting edges of deterritorialization become operative and lines of deterritorialization positive and absolute, forming strange new becomings, new polyvocalities. Become clandestine, make rhizome everywhere, for the wonder of a non-human life to be created' (Deleuze and Guattari, 1987, 190–1). Secondly, 'the face has a correlate of great importance, the landscape, which is not just a milieu but a deterritorialized world' (Deleuze and Guattari, 1994, 172). In terms of Chung's overall project, this raises the possibility that the landscape can 'see' us ontologically in much the same way that we can 'see' it. 'The landscape *sees*', confirm Deleuze and Guattari (1994), for 'the percept is the landscape before man, in the absence of man', and we might also argue that we, as human characters, 'have passed into the landscape and are [our] selves part of the compound of sensations' (169).

In this respect, the film's key trope is a group of white-robed 'nomads' who begin the film walking in single file through the barren countryside (Deleuze and Guattari's 'compound of sensations' searching perhaps for a

future community or Whitehead's 'vision of a new world') and who emerge at the film's end walking along the railway tracks in funereal attire holding umbrellas against the drizzling rain. Significantly, a locomotive moves in the opposite direction alongside them, so that these two probe-heads resemble a pair of boats cutting opposed, dialectical swaths through the shifting tides of history. For as Foucault (1986) reminds us, 'you will understand why the boat has not only been for our civilization, from the sixteenth century until the present, the great instrument of economic development . . . but has been simultaneously the greatest reserve of the imagination. The ship is the heterotopia par excellence. In civilizations without boats, dreams dry up, espionage takes the place of adventure, and the police take the place of pirates' (27). In this respect, Chung's films—fantastic psycho-geographical paeans to collective difference and transformation—are themselves like boats of intellectual and sensual discovery.

DINH Q. LÊ

Throughout the bulk of his career, Dinh Q. Lê has focused directly on American imperialist involvement in Vietnam and covert sanction of atrocities and pogroms worldwide. Born in Vietnam in 1968 and raised in Ha-Tien near the Cambodian border, Dinh was literally born in the middle of the War and eventually saw his own town fall victim to the Khmer Rouge invasion. Although he emigrated with his family to the United States in 1979, the artist returned from New York to Ho Chi Minh City in 1996 and founded San Art, an artist-run exhibition space and reading room. Dinh's early work falls into two main series. Inspired by the techniques of his aunt (who made woven grass mats), in *Persistence of Memory* (2000–2001) (figure 2.3) and the subsequent *From Hollywood to Vietnam* (2003–2005), he weaves together linen-mounted strips of C-print photographs taken by western photojournalists during the Vietnam War, pictures snapped from everyday life and stills from war films such as Michael Cimino's *The Deer Hunter* (1978), Francis Ford Coppola's *Apocalypse Now!* (1979) and Oliver Stone's *Born on the Fourth of July* (1989). The non-fictional images of the 'real' Vietnam—minoritarian because they are produced by the colonized themselves—are thus interlaced, like lattice, with images of majoritarian documentation and Hollywood fictions. In this way, Dinh economically expresses the constructed nature of collective memory (or amnesia) that the culture industry employs to help America 'deal' with the war (or, more accurately, rewrite a genocidal colonial conflict as the inoculating notion of a traumatic 'bad experience' that must be healed and rationalized). In this sense, the cinematic images are much closer to a contamination of collective memory than an aesthetic means of its retrieval.

Figure 2.3 Dinh Q. Lê. Persistence of Memory. 2000–2001.

The result of Dinh's rewriting of historicism as a form of pedagogical his-
torico-stratigraphy is simultaneously hypnotic and defamiliarizing, with the
competing images literally forced together to create a pictorial simultaneity
or double exposure that looks computer-generated rather than painstakingly
hand-wrought. This results in a rhythm of mutual revelation and concealment,
disclosure and contamination, a postcolonial hybridity in which the glossy
'beauty' of the Hollywood fiction becomes the conceptual framework for
releasing and recognizing the presence of the 'Other'. Dinh effectively takes
Gayatri Spivak's (1994) famous dictum that 'The subaltern cannot speak'
(104) and gives the subaltern a voice, but as a stratigraphic hybrid (whether
it be as an Asian-American, an artist-activist, or creator of the multiplicitous
contraction-cum-détente, the beauty-sublime).

 Inspired by the title of James E. Young's book, Dinh's *Texture of Memory*
series (2000–2001) consists of white thread on white cotton tapestries of
hand-embroidered portraits of Cambodian victims of the Khmer Rouge
and Pol Pot's infamous 'Killing Fields'. Like Dinh's earlier series *Cambo-
dia, Splendour and Darkness* (1998) and *The Quality of Mercy* (1996), the
source material is derived from archival interrogation photos of the victims,
meticulously undertaken by the Khmer Rouge just prior to the prisoners'
execution in the Tuol Sleng death camp (a.k.a. S-21), a former high school in
Phnom Penh where over 16,000 men, women and children eventually died.

The earlier series focused on the signifying classificatory role of faciality by either distorting and enlarging the faces by interweaving them with Cambodian monuments, such as Angkor Wat, or reducing the victims' personalities to letterboxed strips of their eyes, arranged in a thin frieze around the gallery space as if they were peering out of their prison cells into an interrogation chamber. As Dinh (2006) explains, 'Their eyes showed that they didn't know why they were brought to Tuol Sleng. They were the scapegoats of the Khmer Rouge's failed policies' (64).

However, Dinh subsequently explodes this black-hole/white-mask system in *Texture of Memory* by making both figure and ground a dazzling white, so that we lose all co-ordination of how to read a face as a specific cartography. As Patricia MacCormack (2004) points out, '"Thinking difference" requires the majoritarian face to represent a temporal, temporary face as only one of many facial forms' (138). Thus, Dinh sketched each portrait on the cotton cloth (white is a colour of mourning in Asian tradition, but it can also evoke white flags of surrender, creating an *aporia* between insistent remembrance and self-abnegation). He then commissioned a group of women in Ho Chi Minh City to embroider the outlines—sometimes singly, sometimes overlapping—in white thread. The sheets are then stretched over a frame, much like a painting. The overlapping images are often difficult to separate, forcing us to work hard at deciphering the mugshot, to the point of touching the surface, to bring the faces back to life.

The works also reference a group of Cambodian women who at that time lived in Long Beach, California, and these references were designed to evoke the hysterical blindness illness suffered by over 200 of the women, a symptom of post-traumatic stress disorder generated from the direct witnessing of the murder of their loved ones by the Khmer Rouge. Dinh always intended that the embroideries should be touched and read like a form of Braille, so that the spectator's privilege of vision defers to the victims' blindness as a form of emotional and psychological empathy. Over time, the oil and dirt from the fingers of hundreds of viewers builds up so that the raised sections of the embroidery are darkened, ensuring that the image becomes more pronounced with time. 'In a way, the more people who participate in the remembering process, the more these memories will become alive,' notes Dinh (2001, 19). The result is a reversal of the usual process of memory; instead of time fading the images of horror, as a non-linear stratigraphic phenomenon, it makes it clearer and more concrete, so that the process of mediation—rooted specifically in the sensate body—engages the aesthetic to reinforce the work's shifting ideological position. The series thus lies in the impasse between unfeeling aestheticism and tendentious propaganda, creating a space of simultaneous pleasure and outrage that makes the political content of the work more, rather than less, emotive.

Over the past eight years, Dinh has evolved from his signature woven pieces to a combination of on-site sculpture and video. However, the three intrinsic components of the weavings—documentary photography, indigenous imagery and Hollywood spectacle—are still an intrinsic part of the work but are now separated into two- and three-channel projections to set up a stratigraphic weave between past and present, war and peace, fear and reconciliation. Perhaps the most deconstructive of these works is *From Father to Son, A Rite of Passage* (2007), a two-channel video work that juxtaposes re-edited scenes from two seminal Hollywood films about Vietnam, Coppola's aforementioned *Apocalypse Now!* (1979), and Oliver Stone's *Platoon* (1986). Dinh isolates scenes featuring real-life father and son actors Martin and Charlie Sheen from Coppola's and Stone's films, respectively, so that they appear to be 'in dialogue' with each other across the gutter of the split screen. Stripped of their complicating subplots, the films' diegesis is now reduced to an Oedipal drama between two generations fighting the same war, as if each were witnessing the other's post-traumatic breakdown. Significantly, each film recycles familiar narrative tropes; both soldiers must kill an older comrade who has lost all sense of reason in the face of wartime horrors—Marlon Brando's Kurtz as he is driven mad by staring into the heart of darkness and Tom Berenger's scarred, sadistic, battle-hardened Sgt. Barnes—as if the Oedipal cycle can only survive if the younger generation kills its castrating fathers, thereby justifying a form of 'good' violence against its bad corollary. However, it's not quite as simple as that, because the personal Oedipal scenario is also the microcosm of a larger patriarchal structure, in which concepts of honour and duty are circumscribed into a larger, more timelessly hegemonic structure. The latter is dictated in turn by American capitalism's need to endlessly renew itself by transforming all linear time into a form of non-chronological universal history. Thus, it's completely appropriate that Dinh should rewrite the father–son dynamic between the two Sheens as a non-genealogical eternal return of the same pathology, because as Deleuze and Guattari (1987) argue, this is the 'deepest law of capitalism, it continually sets and then repels its own limits, but in so doing gives rise to numerous flows in all directions that escape its axiomatic' (472).

However, this deterritorialization can also be a strategy of resistance against specifically hegemonic historicizing tendencies. Made in collaboration with artists Phu-Nam Thuc Ha and Tuan Andrew Nguyen, *The Farmers and the Helicopters* (2006) represents an important step forward in Dinh's attempts to weave often incompatible lines of flight into a more multiplicitous braid. The video opens with all three screens filled with a seamless image of dragonflies fluttering in the sky to the accompaniment of a Vietnamese folk song describing how their flight patterns will predict

the weather. The idyllic scene is quickly interrupted by scenes of helicopters in combat derived from both documentary footage and Hollywood films such as *Apocalypse Now!* As Holland Cotter (2010) vividly describes the action, 'We first see a panning shot of forests and rice paddies in aerial view. Then helicopters arrive, swarming, landing, lifting off, buzzing and shuddering through the sky, spewing men and rockets, crashing explosively, then rising to buzz some more. Classic shock and awe' (2010). Dinh (2006) points out that

> in Vietnam, the helicopter has become somewhat iconic because the Vietnam War was the first time helicopters were extensively used as a killing machine. This video is about two guys who are trying to build low-cost helicopters in Vietnam. One of them [Tran Quoc Hai, a self-taught mechanic] has seen helicopters when he was growing up during the War and has since become infatuated with them. Nowadays, he runs a small shop repairing farming equipment. [Le Van Danh], a farmer who comes to his shop has agreed to help him. He hopes to use the helicopters to spray his crops. They also hope that the helicopters can be used in emergencies to evacuate people. More important, they want to show the world that the Vietnamese can achieve anything. (66)

Thus, the central concept of the piece is the transition of the helicopter from a death machine to a symbol of peace and reconstruction. The latter is particularly hard-won, because we learn that Tran's first helicopter took six years to build, and its development was vehemently opposed by the local government who disputed its safety and promptly seized it. Such was the ensuing public outrage that a number of scientists and engineers stepped in to lend their support and guarantee the machine's functionality, causing the government to back down. Perhaps more significantly, the end result closely resembles an American helicopter because the inspiration for its design is based on the close examination of wreckage left behind after the US evacuation. Dinh underscores the ambivalence of this outcome by intercutting the story of the two men with interviews with former guerrillas and civilians who were attacked by helicopters during the war. A former Vietcong fired back at one incursion and the helicopter flew off, while a woman was so disconcerted that she could only look up and smile at the pilot. For them, the helicopter will always be a killing machine, although the former guerrilla hopes that it will someday become a long-term enabler of peace and recovery as well as communal spirit.

In a fascinating coda to the piece, The Museum of Modern Art (MOMA) in New York acquired *The Farmers and the Helicopters* (see figure 2.4) and installed it as part of their Projects 93 series in 2010–2011. Dinh thus became the first Vietnamese artist to have a solo exhibition at MOMA. More interestingly, spectators also got to see the real-life product of Tran Quoc Hai's

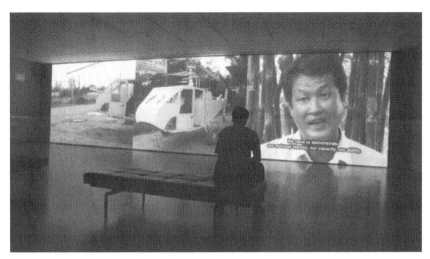

Figure 2.4 Dinh Q. Lê – The Farmers and The Helicopters. Installation view MOMA NYC. 2010–2011.

research—itself aided and abetted by the internet—for one of his helicopters, pieced together from scrap parts, was installed in a gallery next to where the video was playing. In many ways, this minoritarian appropriation and recolonization of the symbol of American imperialism—not least through its insertion into the context of the majoritarian art institution—acts as a form of exorcism *and* self-assertion as the younger generation of Vietnamese move beyond the limiting confines of historicism, where their identity is earmarked by two sides of the same postcolonial coin, either submission to western-led globalization or local indigenous resistance.

Among Dinh's most recent works are *Barricade* (2014) (see figure 2.5) (produced in collaboration with Hame, the French-Algerian rapper Mohamed Bourokba) and *Erasure*, which were showcased at a 2014 exhibition entitled *Residual, Disrupted Choreographies* at the Carré d'Art in Nimes. Both works transversally link different colonial and postcolonial conflicts across space and time to form a minoritarian narrative that is resistant to the hegemonic discourse of the prevailing archive, defined by Foucault (1972) as 'the first law of what can be said, the system that governs the appearance of statements as unique events' (129). Dinh's starting point in *Erasure* is to question why the uninvited arrival of Captain Cook on the eastern shores of Australia should be commemorated with a replica of *HMS Endeavour* in Sydney harbour, while the refugee boats bearing Iraqi and Afghan refugees are immediately quarantined and destroyed, their passengers refused entry and expelled. Dinh attempts to turn the tables by projecting an endless loop of a scaled-down replica of this symbol of colonial exploitation as it burns

Colin Gardner

Figure 2.5 Dinh Q. Lê. Barricade. 2014.

in a howling wind while beached on a desolate coastline. However, before the ship is completely destroyed, it is always resurrected as the video begins its loop again, snaring this hated colonial trope in an eddy of its own eternal return as if to express both imperialism's resilience and its inevitable transformation into a postcolonial hybridity.

Dinh expands the metonymic connection by including a real wooden hull, smashed against some strategically positioned rocks in the gallery space, surrounded not by sand but rather a 'sea' of photographs, each placed with its face down as if to hide its identity. It turns out that the images are part of a huge, undocumented archive of personal photographs left behind by thousands of South Vietnamese who took to the sea as 'boat people' in order to flee the incoming Communist regime in 1975. However, at the same time that visitors see the visible evidence of displacement, they can also hear the almost imperceptible whir of a computer scanner as an archivist painstakingly enters the images into a digital databank for access through a public website. As in the case of Cook's *Endeavour*, the hegemonic role of the discursive archive is turned against itself as the signifiers of forced emigration and anonymity become the lifeblood of a more interactive archive, a veritable pedagogical probe-head against a simplistic historicizing of events in favour of what Nietzsche called 'effective' history, a history based on discontinuity yet at the same time geared towards 'life'. As Foucault (1984) argues:

> 'Effective' history . . . deals with events in terms of their most unique characteristics, their most acute manifestations. An event, consequently, is not a decision, a treaty, a reign, or a battle, but the reversal of a relationship of forces, the

usurpation of power, the appropriation of a vocabulary turned against those who had once used it, a feeble domination that poisons itself as it grows lax, the entry of a masked 'other'. The forces operating in history are not controlled by destiny or regulative mechanisms, but respond to haphazard conflicts. (88)

In many ways, *Barricade* (2014) more fully exemplifies this 'haphazard' or transversal quality of conflict as a bridge between and across diachronic time. It consists of a pile of French-Vietnamese colonial furniture jammed between two gallery walls, thereby creating a visual and physical obstacle between the two halves of the exhibition space. The barricade also hides speakers that broadcast the sound of Hame's rapping and revolutionary propaganda. The work's most obvious stratigraphic connection is through its overt reference to the legacy of both the Vietnamese and the Algerian struggles against French colonialism. However, the links are far more generationally transversal than a common war for national self-determination, for the policing of Algeria during the 1950s was aided and abetted by military veterans returning home after the French defeat at Dien Bien Phu in 1954. Because Algeria was an incorporated part of France rather than a colony—the white population of Algiers were fully enfranchised French citizens—the war for independence was actually a civil war, not unlike the attempts of the western media to paint the Vietnam War as an aggressive incursion by the communist north into the democratic south rather than a war for national self-determination. In addition, the symbol of the barricade looks back to the revolutions of 1789, 1830 and 1848, as well as the abortive Commune of 1871, thereby linking the modern 'subaltern' struggle to the French domestic working class as transhistorical, 'Wretched of the Earth' cohorts.

More importantly, the barricades also look forward from Dien Bien Phu and the Battle of Algiers to the events of May 1968, when the students and workers joined forces against the repressive de Gaulle regime and consciously evoked—through slogans and banners—both the Charonne Métro massacre of 8 February 1962 and the 17 October 1961 murder of over 200 Algerians who were eliminated by Paris police on the direct orders of the former Vichy collaborationist, Maurice Papon, following a peaceful anti-war demonstration. Needless to say, Dinh's piece also encourages us to think critically about current racist attitudes that permeate not only France—witness the 2005 riots that swept throughout Arab and black African immigrant sectors in both Paris and the provinces—but also the European Union in general.

In this respect, Deleuze and Guattari's (1987) recipe for finding the appropriate line of flight for responding to 'the requirements of a given age' has considerable resonance for understanding both Dinh's and Chung's work as a provocative combination of *aisthesis* and affectus. 'This is how it should be done,' they suggest:

Lodge yourself on a stratum, experiment with the opportunities it offers, find an advantageous place on it, find potential movements of deterritorialization, possible lines of flight, experience them, produce flow conjunctions here and there, try out continuums of intensities segment by segment, have a small plot of new land at all times. It is through a meticulous relation with the strata that one succeeds in freeing lines of flight, causing conjugated flows to pass and escape and bringing forth continuous intensities for a BwO. Connect, conjugate, continue, a whole 'diagram', as opposed to still signifying and subjective programs. (Deleuze and Guattari, 1987, 161)

In short, bring on the (pedagogic) probe-heads!

Chapter 3

Dorothy Heathcote

Practice as a Pedagogy of Resistance

Anna Hickey-Moody and Amanda Kipling

This chapter explores the work of Dorothy Heathcote[1] as a material pedagogy of resistance. Taking the principles of Heathcote's (Bolton, 1998; Booth, 2012) work from the drama classroom into online teaching and learning practices, we explore contemporary pedagogies that are resistant to what might be considered neoliberal education (Giroux, 2012). We argue that such resistant pedagogies can be facilitated through e-portfolios, developed with an ethos devised from the work of Heathcote (Heathcote and Bolton, 1996; Booth, 2012). In order to consider the material nature of resistance and its impact on learners, we draw on Deleuze's notions of affect (Hickey-Moody, 2009) and associated theories of new materialism (Dolphin and van der Tuin, 2011).

CONTEXTUAL BACKGROUND

Dorothy Heathcote's practice was devised within the politically left-wing British Drama Education movement of the late 1960s and 1970s (Heathcote and Bolton, 1996). This period in education is not necessarily seen as resistant to innovation. The revolution of child-centred learning (Entwistle, 1970) was established as a particular set of practices and Heathcote's work was positioned as different to the norm. Her interpretation of child-centred, intra-active dramatic exploration of learning was in contrast to mainstream practices which, in the main, lay in the teaching of speech and theatre skills. In the first section, *Dorothy Heathcote: a Pedagogue of Resistance*, we consider Heathcote's work in a more finely grained context. Specially, we are interested in the varying ways she challenged the notion of the teacher being the 'one who knows' (Wagner, 1976: 38) and eroded the possibility of teacher expertise as her practice grew.

In the second section, *Electronic Pedagogies of Resistance*, we explore contemporary contexts, using examples of Heathcote's philosophy of practice in the employment of electronic portfolios in initial teacher education (ITE) at Goldsmiths, London. Heathcote challenged existing practices, such as the use of lesson plans. Her methods were based on the developmental work of practitioners like Piaget (Mussen, 1983) to uncover what was already within the child. In this respect, Heathcote can be considered as part of what Hornbrook (1998) describes as the 'revolution which profoundly altered ideas about teaching, learning and how education should be organised, and which had at its core the idea that the aim of education was to cultivate happy, balanced individuals' (10). In similar ways, elements of the mainstream practice of ITE are challenged by developmental models used by drama student-teachers at Goldsmiths.

In the third section, *Contemporary Pedagogies of Resistance*, we bring the two areas of drama education and technology for education together, through Heathcote's last pedagogical model, the Rolling Role. We examine the Rolling Role in two contexts, both of which involve the use of Information and Communication Technologies and have created a pedagogy of resistance. This shifts existing mainstream models of the teacher/pupil relationship, empowering pupils to be their own pedagogues. This change is primarily effected through replacing the superficial lesson plan with an intra-active class dynamic that shapes lessons, and breaks through politically driven restrictions through developing post-human practices.

DOROTHY HEATHCOTE: A PEDAGOGUE OF RESISTANCE

Dorothy Heathcote's developmental work followed Peter Slade (1954) and his protégé Brian Way (Bolton, 1998), who made major contributions to the field and whose work challenged what had been a well-established practice of teaching 'speech and drama' and theatre 'skills' on the curriculum. Working on performances and exercises designed to refine presentation skills had been the basic provision in schools. However, Slade (1954) introduced the idea of children's fantasy play and 'being' something as a valid art form in its own right, stating: 'Child Drama is an Art in itself, and would stand . . . alone as being of importance' (105).

In his book, *Acting in Classroom Drama* (1998), Bolton describes a class Slade taught, in which children were absorbed in being objects, animals and elements of the weather. Compared to the rehearsals for often humanistic school productions, this was a classroom with each child afforded creative agency. Process was foregrounded over product. There was no show, no audience, no finished product, simply the state of being and expressing. Bolton (1998: 125) explains:

Slade . . . is disposed to perceive in children's own drama the . . . 'language of gesture', the 'law of rhythm', and the 'contours of song', but, Slade would have us understand, their achievement of 'higher realms of drama' is . . . largely unconscious. Indeed it is the very lack of contrived artistry that contributes to its beauty.

This version of drama, based on imagining being outside one's self, requires scaffolding. Without some principles for intra-action, this exciting and revolutionary practice was at risk of being reverted back to the study of play scripts or narrative presentation for lack of 'definable' principles. Having observed Slade (1954) as a critical agent who broke from the existing views of 'what drama should look like' in schools, Way (Bolton, 1998) produced a model of practice robust enough to hold this freshly broken ground and communicate to teachers, in order to prevent this development from being subsumed by previous practices for want of a more concrete material basis.

Through his focus on improvisation and imagination, Slade shifted the emphasis of drama to empowering the pupil voice. Developing articulate communicators is an essential strand of the fight against social and political oppression, and this could now be taught in the drama classroom. While one could say the structure and guidance from Way was formalized, thus lacking the freedom which Slade's (1954) model enjoyed, it did address the learning of specific skills to increase pupil empowerment. It effected the communication of pupils' own text—not Shakespearean, nor the play written by an adult that the head of school had chosen, with all the hidden oppressions which lie therein; this pupil-generated content was vulnerable in Slade's (1954) model. Way's (Bolton, 1998) method enabled teachers to find and develop teaching styles that retained an investment in student imagination and student voice. This model encouraged a sense that the work in the classroom could grow up with, and be informed by, the pupils.

Referring to the work of Freire (1970), Giroux (2003) argues pedagogy can be 'either reduced to a sterile set of techniques or dressed up within the discourse of humanistic methods that simply softened the attempts by the schools to produce an insidious form of oral and political regulation' (Giroux, 2003: 6). Against the truth of this binary, Way was looking to cultivate a politically engaged, unregulated imaginary without the use of 'sterile techniques'. He faced the dilemma of how to move a progressive idea into progressive practice and in translating, he had to 'borrow' structures from the past in order to move forward. Teachers were still making the initial decisions, planning the lessons, planning the freedoms and defining the boundaries. In Freirian (1970) terms, even though the banking system of education was being challenged, the teacher still had to be seen as 'narrator'. While Slade's and Way's methods increase student agency, in institutional and

material terms, teachers and learners are still trapped by required intra-actions between 'lesson and classroom'. There was more to be done: the affecting bodies of classroom and lesson plan remained in their original positions.

The work of Slade (1954) and Way (Bolton, 1998) paved the way for Heathcote's revolutionary practices. Heathcote moved drama beyond decision making, being and voice finding, to enable learners of all ages 'to think critically, take risks, and resist dominant forms of oppression' (Giroux, 2003: 7). Heathcote reduced the presence of the teacher in the traditional sense: instead of being the 'one who knows' (Wagner, 1976: 38), she sat on the floor with her class and joined in with improvisation. Instead of a pre-planned session, she worked spontaneously, negotiating the subject of the lesson, responding to the class and their direction, while ensuring challenge and depth of content. Echoing the physical positioning in language, she referred to her class as 'we' and fell into role as a fellow 'worker' in the classroom. The role and function of the teacher was now under scrutiny. The status of the teacher as the knowledgeable 'one' in the classroom was being challenged, and this left the issues regarding the role of the learners under the spotlight for interrogation and exploration (Booth, 2012).

Heathcote decentred the concept of the teacher as an affecting body. Her model is one whose relationship with knowledge is that of co-discoverer; student-teachers and teachers are part of material networks that intra-act. Instead of being the active supplier of knowledge, Heathcote played her role in reverse, encouraging pupils to become *other than* themselves through processes of learning.

A good example of this becoming-other can be seen in the BBC documentary *Three Looms Waiting* (Smedley, 1971). The documentary features a number of projects, one of which is set in a primary school in the Hartlepool area. The class had been told the Bible story of Ahab, featuring the relocation of citizens to make room for the new queen's palace. The play, which was presented on numerous occasions but with any child playing any role, involved sociopolitical issues, such as the injustice of class division, and the pupils wrestled with these in drama and arrived at a flexible presentation. With no script and no cast list, school plays had never looked like this. Similarly unknown was the complete commitment to role and profound sense of becoming-other. Heathcote had no part in this play; she facilitated its creation by selecting it and telling it, but the transformation into a 'play' had been wholly owned by the children and effected through the children imagining life as a different person, through their becoming-other.

The Freirian 'banking' concept of education (Freire, 1970: 72) was really challenged by Heathcote, as she framed the learning about what is unknown both to teacher and class. The pitch has to be the job of the teacher, as does the frame in which work gets started. However, the

concept of letting the drama carry the teaching and learning (rather than the teacher) was revolutionary: 'Rather than being the subject of pedagogy, drama in education became a sophisticated form of pedagogy itself' (Hornbrook, 1998: 13).

The teacher as affecting body in this instance is quite different from the narrating or directing teacher of more traditional methods. The focus for the teacher is on the setting up of the affectus, which is operated by the affected bodies in the classroom. Here the pupils are both affected (by the Heathcote-initiated framework for the lesson—the affectus) and become affecting themselves (the usual role of the teacher) as the drama unfolds and the learning is shared and processed collaboratively: 'The *affectio* refers to a state of the affected body and implies the presence of the affecting body, whereas the *affectus* refers to the passage or movement from one state to another, taking into account the correlative variation of the affecting bodies' (Hickey-Moody, 2009: 273).

It is worth pausing here to consider the wider context of the times. In Sullivan's *Art Practice as Research, Inquiry in Visual Arts*, having traced the growth of empirical research and its need to hypothesize, measure, test and 'prove' a truth, he goes on to describe the movement in the mid-twentieth century, the time when Heathcote's work emerged:

> Despite its impressive record of constructing knowledge, empiricism has its limits. Theorists who question the assumption that the observed experience is the only viable basis by which phenomena can be studied argue that other dialectical or dialogical approaches provide more scope in using reason and argument to come to understand things. The primary task is the need to amplify and contextualize phenomena found in the empirical world and this means being responsive to external, situated concerns and internal, felt cues. (Sullivan, 2010: 38)

This challenge to the empirical practices of the time parallels the challenge Heathcote was making to drama teaching classroom practice. Her awareness that the matter to be opened up for scrutiny was the 'intra-action *between* bodies and matter' (Hickey-Moody and Page, this volume: 12) provided part of the arts education backdrop for the works of later scholars of arts practice as research, as examined in chapter one of this book (Hickey-Moody and Page, 2015).

The first of Heathcote's models which emerged from this way of working was called *Man in a Mess*. The class was confronted with some kind of dilemma; Heathcote would introduce them to the context, invite them to invest in it, say, by spending a day creating a fictional ancient manuscript which contained all the community records. Then she introduced a dilemma: for example, the students were under attack and the sacred place

which housed the precious scrolls was occupied. When the class was ready, Heathcote would slide out of the drama and watch the class resolve the situation for themselves. The affecting body was simply the designer of the frame. The pupils' intra-action and imagination created the affectus that constituted their own learning within this frame.

The next development was *Teacher in Role*. This involved Heathcote 'playing the role' of classroom teacher, becoming removed from the student's core creative activities. This is captured in *'Albert'* (Heathcote and Lawrence, 1973)—a class of children with Special Educational Needs who meet a tramp called Albert. Despite being branded as children with no social skills by the educational system, they demonstrate that they knew exactly what to do to improve his life situation. As Heathcote steered herself away to the edges of the lesson, keeping it contained as a teacher, but remaining disengaged, she allowed the drama to exist between the class and Albert. Albert was thrown a party and taught how to dance because the students felt he did not know how to be happy—so the class showed him. The oppression of labelling had been challenged by the children. The teacher as narrator was disappearing.

Heathcote's dismantling of the accepted structures in the education classroom became the careful designing of a resource—a teacher in role as a vagrant—to simply 'be' and generate, diffract and channel affectus. This teacher as an affecting, diffractive body made way for her subject, and dramatic energy, as the pupils took complete control. They were affecting bodies in a very positive sense, finding Albert some clothes and teaching him to dance. Albert, the children and Heathcote were all affected by the role play, in which usual roles had been reversed. Stepping outside the context of the lesson and considering the constructs of the time, pupils who had been considered incapable of relational social skills had proved the system wrong. The oppressive machine of labelling had been thwarted, and both teacher and pupils had become 'oppositional intellectuals' (Giroux, 2003: 7).

Mantle of the Expert is the next pedagogical strategy that grew from these two stages of Heathcote's work. Heathcote believed that pupils could become 'experts' and thus questioned the dominant values of knowledge that are embedded within ideas of expertise, and the forms of subjugated knowledge ideas of expertise produce. With carefully preselected research materials made available, in the *Mantle of the Expert,* children remained in role as workers: looking up information, and empathizing with the situation until the language and notions they were expressing became identifiable as creative acts. Heathcote played the 'I have no idea register' (Wagner, 1976: 38) and performed her imagined ignorance to a high level, so as to act as the perfect foil for pupils to become the 'knowledgeable' ones. Consequently, the class had to be the affecting and affected bodies at once. They became their own pedagogues, or more accurately, the process itself was pedagogical, the

intra-actions between ideas, bodies, feelings, senses effected change. The 'lesson', as well as teacher as we knew them, had gone.

It appeared to some that the traditional concept of theatre was being lost in this improvisational educational practice. Clearly what a play might be was changing in that the philosophy taught through performance did not align to previous school practices such as Naturalism, Realism, Absurdism, Dada, and so on. Heathcote argued that a play is 'an ordered sequence of events that brings one or more of the people in it to a desperate condition in which it must always explain and should, if possible, resolve' (Bolton, 1998: 177). This focus on group process expresses Heathcote's practice very well, in the respect that the very fabric of all her lessons matched an ordered sequence of events that brings one or more of the people in it to a desperate condition and calls for the group to resolve this trouble. What is of interest here is that while the discourses employed to communicate Heathcote's methods were very humanist, and linguistically centred on a human teacher and student, the pedagogical processes were about being more than oneself, imagining otherwise, and intra-acting with other objects and people in ways that changed how students machined their subjectivity.

While much child-centred learning acknowledges the natural development of children and makes suggestions as to how teachers might harness this to guide learning, Heathcote's model enabled children to make their own foundations and effect learning through process, rather than hijacking learning on top of a process already in progression. This was substantial empowerment made safe by the skilled use of an art form.

Heathcote moved on to the *Commission Model* of teaching, in which a real commission—like the designing of a hospital garden—forms the focus of a project, and the class thus spends time in roles as gardeners, botanists, horticulturalists, and so on. Pupils develop the knowledge and expertise so as to present their design to the hospital governors. At the National Drama Conference in York in 2000, Heathcote described the rationality between space, place and pupils that this method engendered, as gardens, soils, weather patterns were pedagogical in this context.

It could be argued that this challenged the notion of drama being about the 'make believe': drama is about *making anew* rather than making believe. Although the hospital garden quest was real, the children were not gardeners, horticulturalists and botanists—they had had to become versions of these in order to complete the task. This brought a previously unknown reality into drama and once again brought challenge and ownership and agency to pupils. Heathcote did not actively oppose existing models of practice but rather offered something else, something other, which would achieve the same ends and also affect post-human pedagogies of becoming other than human.

Ross (as cited by Bolton, 1998) argued the aesthetic in drama was sidelined in Heathcote's work when it was maybe truer to say that she was creating a different kind of theatre. Fleming (cited by Bolton, 1998), pointed out that this work pursued the idea of meaning making of an aesthetic nature. If children were increasing their understanding of meaning making and enriching the content of the work, then this was a critical part of the aesthetic dimension. Form and content are inextricably entwined. The affecting body was no longer setting up an imagined frame, but rather selecting a real one. The affectus occurring within this frame was being generated by gardens, weather, homeless people, pupils' memories and imaginations.

ELECTRONIC PEDAGOGIES OF RESISTANCE

Under the Thatcher government, 1979–1990, there was a sea change in education, not only in the classrooms of the schools, but also in the lecture theatres of training providers. The Education Reform Act 1988 saw the introduction of the National Curriculum alongside other provisions which tied schools more directly to government influence and this, in turn, saw the arrival of a rigid system in schools. Similar changes came into universities. Peter Wilby describes the legacy:

> The government's grip over higher education was never to be relaxed: it became, over the following decades, ever tighter and more bureaucratic, as mechanisms were invented to measure teaching and research 'quality'. (Wilby, 2013)

In ITE, the diktats of Special Educational Needs, literacy and numeracy, behaviour management, and so on replaced psychology, sociology, politics and philosophy. Student-teachers in the English system now have to 'gather evidence' (for which one might read 'gather qualitative and quantitative data') against the Teaching Standards as set out by the government. There are eight basic standards. If you meet these standards, you can become a teacher. The standards are lacking in depth, sophistication, political awareness and criticality. The crucial child-centred learning features are hidden in a subclause referred to as

> demonstrating an awareness of the physical, social, and intellectual development of children, and know how to adapt teaching to support pupils' education at different stages of development. (DFE, 2013: 11)

Ironically, just as the development of arts practice as research was finding its way, the education system was catapulted in reverse to a system reliant

on proving a teacher's worth by the gathering of hard data of experiences had, books read and lectures attended. There has been a distinct return to the 'banking system' (Friere, 1970) which is easy to measure and monitor, and therefore to a certain extent research, but is hostile to innovation and creativity, and criticality.

Despite the laudable work being carried out under the creativity agenda (Craft and Jeffery, 2008), much of this involves work within the existing educational and curriculum structures rather than exploring what could lie beyond them. According to Gibson (Shaheen, 2010), contemporary work within existing structures is accompanied by an awareness that creativity should be playing a key role in strengthening the economy. We propose that, while the economic commodification of creativity cannot be ignored, it should not overshadow its essential role in developing thinking and producing visionary practice within existing structures and most importantly, beyond. This point is acknowledged and considered by Julian Sefton-Green in his lecture 'The Creativity Agenda', where he highlights the need for 'new forms of measurement for attainment beyond the performance agenda' (Sefton-Green, 2011). Here the need for a serious reconsideration of the materialism we are discussing and ways of evaluating this in new non-empirical ways is echoed once more.

At the time of its development, Heathcote's pedagogy of resistance did not meet with much opposition. As the late 80s established themselves in statutes written in stone, the climate had changed. Resistance was considered foolhardy. The education system began to petrify. Drama is not a National Curriculum subject and therefore in a stronger position than others to follow its own lines of development. However, there are restricting oppressive structures which impinge on this, and it would be untrue to say that drama has been completely unscathed by these. One critical area which has had an impact is that of ITE.

Having worked in a number of teacher education establishments from 2001 to the present day, we detected a pattern. The teaching practice file that was required to demonstrate that a student could meet required standards was duplicated by student after student and covered in Post-it notes indicating standards which were supposed to be 'evidenced' by this document. Consequently, teaching standards appeared to be about amassing lessons plans, schemes of work and evaluations and observations. The files were massive—a lever arch file for each term for the tutor to go through at the end of the year, ticking off the standards as they searched. Most student-teachers sectioned their files standards by standard, copying the scheme of work they made from scratch themselves several times as 'evidence' against, what was initially, thirty-three different standards. Duplication was widespread, as was the amount of paper and time used. Student-teachers groaned under the

pressure of file production (duplication) as did the tutors as they went through the same lesson plan submitted by hundreds of different students. According to these evidence files, ITE was all about planning, lessons and delivery.

Student-teachers were not connecting their evidence file with what actually happened to them on teaching practice. The standards had been set as targets to 'improve' the level of initial teacher training, yet it was possible for student-teachers to present weak evidence and pass the standards. In this instance, the government became the primary affecting body—and the government had set up concrete directives as a vehicle for affectus. This was apparently done to raise standards of practice and to make measurable what had hitherto been difficult for the government to measure. However, it had the reverse effect, with student-teachers providing superficial evidence which could be easily 'ticked off'. It was failing to nurture the rich context for learning that was apparent in the earlier models, including the developmental work of Heathcote. However, it did succeed in wielding a great deal of power and control. Student-teachers were busily collecting artefacts about minutiae, and this did not encourage them to lift their heads up and look at the bigger picture. Student-teachers would relate inspiring accounts of how they had achieved a breakthrough in their relationship with a pupil in their form, and then submit a register with the names erased, as evidence of pastoral experience.

The teaching body became a vehicle of sad affect, as teachers started to behave in a disempowered way and were reduced to being a 'deskilled corporate drone' (Giroux, 2003: 7) as they busily collated scrapbooks to satisfy standards, instead of satisfying themselves and by so doing, satisfying standards. In addition, evidence had been misunderstood, universally it seems; what was in their files were artefacts. In order for an artefact to become evidence, some contextualization, evaluation and/or reflection is required. The example above would have been rich indeed, had student-teachers included copies of written accounts of pedagogical incidents; notes from meetings with the pastoral team; minutes from meetings with teams of specialists; and lessons which had been designed to feature some of this advice/guidance. In fact, such a presentation of evidence would have claimed a number of standards at once, achieving depth, an understanding of how teaching elements relate to each other, a development of practice in the light of learning and the new relationships formed in terms of expertise and support. Something had to be done to

> engage (authority) critically in order to develop pedagogical principles aimed at encouraging student teachers to learn how to govern rather than be governed, while assuming the role of active and critical citizens in shaping the most basic and fundamental institutional structures of a vibrant and inclusive democracy. (Giroux, 2003: 7)

At Goldsmiths, the process of building portfolios was redesigned to heighten the student-teachers' own personal learning, giving credence to the standards but using them as markers on their own journey rather than reaching them as goals. These are government-stipulated standards which have seen several changes since they were first created and lack the consistency that true good teaching should enjoy (Alexander, 2011).

Student-teachers should be enabled to take a Freirian perspective in this process and govern these standards, rather than be governed by them. Amanda Kipling trialled such a model, focusing on student-teachers' autonomous personalized learning. It acknowledged the authority of the standards, but the quality of the evidence collected became much stronger. Student-teachers were asked to collect 'episodes or chapters' about their own practice and then see what standards were covered, rather than the reverse. The files transformed. They became slimmer and were a truer, richer reflection of the student experience, rather than a scrapbook of disjointed paper artefacts. This was akin to Heathcote's practice in which all student-teachers were aware of, and were developing, their own drama practice. Once the learner-centredness had been established, the quality of the evidence soared, with the files taking on individuality and engaging interesting content and reflection. In so doing, the materiality of learning becomes a core part of what is perceived to be learnt and how the body becomes.

A couple of years passed and electronic portfolios were introduced. This opened up a few issues in drama; the software was rather clunky, but those who used Facebook, which was quite widespread in 2009, could manage to make attractive pages evidencing both the standards and their own learning at the same time, held together largely by reflective personalized writing about processes, learning and creating, problem solving and engaging in challenging issues. The artefacts still included lesson plans and evaluations and observations, but there were also photos, emails, memos, journals, extracts from books and websites, links and records of pupils' work, recordings and short pieces of video of their own work and their class. Files were attached—so tutors could open and read if they wished—while the really engaging and educationally valuable part was the evaluative text itself. There is a space for 'feedback' at the bottom of each page.

Handy, user-friendly digital cameras—flip cams and then go-pros—had become trendy—and the next two years saw a refining in the software which added to the increased fluidity of page production. As online literacy increased, the pages became pithier. In 2013–2014, student-teachers started to share their pages with one another and take each other's schemes of work to use and report back to the original designer under the feedback section hitherto used by the tutor in college and mentor in school. Student-teachers enjoyed this sharing practice and had previously had limited opportunity

to do so in the university calendar. So they share extracts in the university studio, and if the work is liked, others can go to their electronic portfolio to download the rest of the lesson or scheme. Hitherto this had been done by email. Now there is evidence that this portfolio is significantly more than a file of artefacts—this portfolio is an intra-active record of evidence which is fuelling and supporting other student-teachers: an online learning community (Wenger, 1998).

Reflecting on this, the online community is, in fact, initially framed by the tutor but is engaged with, grown and redefined by the student-teachers themselves. Once the frame is set up, the tutor 'lets go' and student-teachers use it as they please. Just as Heathcote spent time and consideration in setting up the learning frame for a drama class and 'let go' once they had grasped it, the work for the student-teachers went into designing the skeleton of the portfolio. Once they had taken over ownership, the tutor had to 'let go', and learning became quite improvised in the online environment that the student-teachers had developed.

Heathcote facilitated students accessing and uncovering knowledge and learning through group process, focusing on intra-active learning happening between pupils, environments and curriculum frameworks. In the same way, the electronic portfolios draw out collaborative intra-active learning between student-teachers, classrooms, cultures, user-generated net content, web platforms, machines, and so on. Material exchanges of teaching and learning processes placed the student at the centre of the learning process. In both cases, what was being celebrated and nurtured was group-led processes, intra-actions of the individual outside the individual, and child/student-centred learning.

Affecting bodies are more than human. In this case, the generation of materials, experiences of teaching and lesson accounts are affecting bodies made manifest through non-human technologies. Thus, the affectus exists in the interaction between the human student-teacher as writer/sharer and a fellow student-teacher receiving this through a non-human online channel, processing the material for themselves and projecting their imagined interpretation onto a class before preparing to go into the classroom.

The student-teachers are affecting the learning community (Wenger, 1998) and at the same time are being affected by it. This is a direct parallel to the Heathcote drama lesson model where the pupils had become their own pedagogues. In this case, the student-teachers are becoming pedagogues *of resistance*, as they enrich their own empowered learning and claim the standards as they pass them by. They collaborate so they enjoy more input from others and learning becomes about material exchange and collective process.

In recent messages to a forum discussion on the electronic portfolio system at Goldsmiths College, ITE students shared lesson designs, interview

questions and experiences and job openings. In participating in this forum, the student-teachers were helping each other find and gain employment. A structure originally designed to test, measure ('bank') and check their suitability for teaching had been turned into a tool of empowerment by these student-teachers. The affected body had overshot the demands of the dictating powers and transformed the affectus into something of their own making. The government frame and the tutor frame had been eroded and replaced by a new one forged by themselves. A structure which could be described as rhizomatic (Deleuze and Guattari, 1987) was beginning to emerge.

CONTEMPORARY PEDAGOGIES OF RESISTANCE

In the summer of 2013, the National Drama Conference in Greenwich celebrated a project called *The Water Reckoning*. This was based on Heathcote's very last model—Rolling Role—which was still being developed when she died in 2011. Akin to the processes outlined above, Rolling Role initially involved a drama teacher running a lesson whereby the material left behind by one class became the stimulus for the next. This required the teacher to be skilled and responsive in picking up the needs and interests of the group and shaping their learning—rather than teaching a lesson—around these factors, using not their 'own material', but working with whatever the last lesson left behind. The teacher again is squeezed out of the 'teaching' in the usual sense of the word, and all the teaching and learning energies are within the class.

Heathcote continued to move the teachers away from their dominant knowledgeable roles. This method encouraged interest in drama across year groups as classes wondered what the next class had done with their work and wanted to leave something 'good to work with' behind them for the incoming class. The focus was on the pedagogical link from class to class, connecting through the learning process, rather than a teacher's lesson plan.

In 2011 Heathcote delivered a videoconference about Rolling Role for the Centre for the Arts and Learning (CAL) at Goldsmiths. This was the last major event at a university before her death. By this time, the Rolling Role method of teaching had undergone some changes. In this, she described a version of the model she ran on the famous Burke and Hare murders that took place in Edinburgh, Scotland, in 1828. This involved a drama teacher—herself, a history teacher and a geography teacher. The system depends on intra-action between teachers. The material produced by the children is 'published' in some way, so as to be built upon in the next lesson. There is no presenting of 'the best work' on the wall. All products of the lesson have value and may be picked up as stimuli by another in the following class.

For example, in drama, student-teachers would explore what might have happened, and how, in a historically significant event. This, in turn, would raise more questions to be followed up in the next history or geography class. The teachers were largely information facilitators, ensuring the pupils had research resources in order to understand what took place. The lessons could not be planned in the traditional way, as the direction of enquiry sprung from what the children were interested in, while perusing questions arising from their previous lesson. The project culminated in a large sharing, where all the classes and areas were fused together making sense of one another in their context.

In this classroom, pupils are using maps, consulting documents, using literacy and numeracy in complex ways, and discovering by investigation. The requirements of the National Curriculum are being surpassed: boxes are ticked as they are being passed by. The same can be said of the teachers who were engaging with the art form as it emerged and supported it to maintain the chain of development. In the National Drama Conference of 2012, schools from around the world joined by internet link to create a Rolling Role which celebrated a new twist. These were all drama teachers, just as in the early version of the model, but the classrooms were not in the same school: these were many miles apart. The theme selected was the *Water Reckoning*— every school was near the coast, and so a geographical common theme could be enjoyed. Teachers ran lessons and classes produced sources which could then be shared electronically.

The link between the way these teachers were working and how the Goldsmiths student-teachers' electronic portfolios had developed into an online learning community showed that the perfect vehicle was already in place for carrying this kind of project for student-teachers. Drama teachers could now spread the impact of their students' work using the internet. Schools have increasingly become separated by competition, and the realm of teacher education has fallen more and more into the hands of schools who increasingly come under the pressures of a right-wing government. The universities who are still straining under the pressure of the obligations set by government to cover certain aspects of the curriculum—for example, the emphasis on phonics in the primary curriculum—fight valiantly to keep the sound, well-researched principles of child-centred learning alive despite the system itself firmly rooted in a 'banking' model described by Freire (1970).

Through Heathcote, and through our appropriation of Heathcote's work as a method for facilitating e-learning, teachers can now find a way of challenging isolation and working across cultures and countries. Once again, in a system designed to keep heads down and focused within the four walls of the classroom, teachers had found a way of breaking free, and technology had been the vehicle by which this could happen. After Heathcote's death, others were discovering the resistance in Heathcote's last model, translated into a new platform.

Up until this point, the pedagogy of resistance in the drama education course at Goldsmiths had been triggered or raised by the tutor. What happened next in this development lay in the hands of the student-teachers. Over the previous two years, teaching had seen the widespread impact of the 5-minute lesson plan (@Teachertoolkit.me, 2014). Launched on Twitter, it went viral very quickly and OfSTED (Office for Standards in Education) endorsed this practice shortly afterwards. This is a plan which contains a simple outline of what is expected to be covered during the lesson and can be shown as a flow chart. A flow chart is a quick and deep way of recording a plan to oneself. It is ideal when a new idea is being sketched out and the direction of the lesson could go in several ways, and the teacher needs to have considered a number of avenues to be prepared. The linear, fixed lesson plan does not help these common lesson circumstances. It can be represented using an electronic template of a flow chart or can easily be drawn freehand with a pen on paper.

Student-teachers had met this idea in schools and wanted to try it out. This would make massive demands on their spontaneous teaching skills, and yet the simplicity of the plan enabled them to prepare the kinds of activities they might do—but not be bound by them. It did, of course, leave the door open for the early Heathcote practice—'What shall we do today then? I have no plan. I can't plan till I've met a class' (Wagner, 1976: 16), and several were skilled enough to want to try this out without pre-designing the learning at all, leaving the work to the class and the sources to carry the energy and direction, leaving them to chance their arms and do the shaping—a new direction for them as student drama teachers. They were willing to 'let go' and trust the dramatic content to assist the class in being both the affected and the affecting bodies. In varying degrees, these student-teachers wanted to see if they follow the lead of their classes further, and do so without the safety net of a lesson plan. They now had two technology-based vehicles with which to work, and by putting the two together, the project took off.

Looking at *The Water Reckoning* project website (www.water-reckoning. net), the student-teachers could not see how the project's sessions went. There were the artefacts and beautiful, professionally made video sequences capturing the essence of the work, with stunning underwater shots of sea statues. There was no process recorded though. In their position as student-teachers, the process of managing the learning in the classroom held their focus; with the pressure of the next class coming through the door, they wanted to know more about classroom management. Heathcote left the student-teachers to figure out how to manage their classrooms on their own.

As student-teachers, they needed to share in order to learn, and so they set up a rota: each week, two of them would run a session in their schools and contribute something to a collective pool of resources grown from these

sessions from which they/their pupils could feed. Everything would be recorded on a shared page in their portfolio, so they would be collectively gathering evidence of their venture into new pedagogy as they went. They would provide an outline of what happened in the session, so there was a story behind the resources. A meeting was held with the online pedagogy specialist, who discussed the design of the portfolio and set it up for them. The original stimulus they chose was urban housing, and so they named the folio *Tower Block*. The stories they shared varied enormously. The tutor was not present for this meeting.

Mentors in the placement schools shared some frustrations; despite the freedom of not being on the National Curriculum, for years there had been pressure to have set schemes of work and to have assessment weeks with grades and comments and targets, some of which were incongruent with the drama and associated pedagogies. They had seen targets dwindle into a list pertaining to 'facial expression', 'body language' and 'levels' of learning. There was pressure in some schools for drama to conform to this dominant banking trend. In evaluations, pupils were saying more or less the same thing in year 7 as they were in year 11, that they wanted to learn 'because this is what gets them marks in GCSE examinations'. This not only thinned the quality of the work, while claiming to strengthen it, but also provided a very flawed sense of what theatre is. This superficial use of concrete indicators echoes the initial manner in which the teaching standards were being 'evidenced'.

Some teachers resisted this, such as Daniel Shindler. His workshop for CAL, Goldsmiths College, University of London, in 2009 utilized the archetypes as a vehicle for evaluating drama. Others who also demonstrated resistance grew their own theatre criticism language in their classes. This resulted in rich, interesting critique of theatre, examining content and the challenge facing the audience rather than the checklist-for-comment approach which had become a fail-safe way of gaining marks in the written component in the national public examinations.

The school-based drama mentors warmly responded to the idea of running with the Rolling Role project idea. However, most said they could not let student-teachers do this in a lesson—it had to be in a club. Initially disappointing, this in itself is an act of resistance. Mentors were not saying no—they needed to position this responsive and critically engaged pedagogy somewhere safe from criticism and scrutiny. Mentors were happy to support the idea, and student-teachers set up the new portfolio which would serve as the vehicle by which they could pick up resources and read about how these were arrived at in these semi-improvised sessions.

The student-teachers found a picture of a *Tower Block*, and this was the starting point. From this stage, the work became a fiesta of differentiated

learning. The interest in classrooms was huge in terms of where the work had come from and where it was going. Once again, it is evident that there is a desire to reach out beyond the claustrophobic realms of the school classroom and connect with what is beyond. One girls' school was happy for their work to go anywhere, other than the boys' school next door. Not surprisingly, there were a range of ways both pupils and student-teachers responded to the theme.

This rhizomatic classroom was an organizational structure based on lateral, intertwining connections across various contexts more than ordered, striated hierarchical organizational structures: 'a rhizome . . . is always in the middle, between things, interbeing, *intermezzo*' (Deleuze and Guattari, 1987: 25). This model was arrived at by the student-teachers, and it gave them precisely the kind of flexibility they needed. It manifested ownership among the students. Not only was this in keeping with the practice of Heathcote, but student-teachers were required to pursue knowledge and this was entirely sympathetic to the notion of arts practice as research.

Tower Block grew in many different directions. A few indicative examples have been selected. One student-teacher working in a privileged boys' school decided to allow the club free-flow response to the photo of a *Tower Block*. What resulted was some slick physical theatre, but the classist content developed showed prejudiced images of people unemployed and watching TV all day, with references to drink and drugs. At the end, the student reflected that despite what has been 'taught', somewhere along the line, this is what had been learnt. It is easy enough to mistake what is learnt for what is recalled or understood for examinations. This caused the ITE student and his peers to consider the nature of true learning and reconsider how far the slick lesson plan that covers material and delivers a curriculum can be truly seen as educational. The Heathcote practice that student-teachers had been following, and gradually learning about during the year, sunk in at yet another deeper level. Critical engagement needed to be facilitated continuously if classist and racist assumptions that are taught through the hidden curriculum of the school system are to genuinely be challenged.

Another student-teacher had his 'best lesson' with a very challenging group in a one hour and 40 minute lesson. He had prepared five layers to help structure the lesson but had no idea exactly how to use them in the lesson. Having not been able to do this at all in previous lessons, the class showed they could build a simple piece of theatre and show it making sense and having form, without conflict within the working group. He felt he had truly focused on the learning of the class rather than trying to get them through his lesson plan. He and his mentor (who was fascinated by the previous lesson) decided to 'just see what happens if' their challenging year 9 group played *The Great Game of Power*. This is a game invented by Augusto Boal, involving a set of

chairs, a table and a bottle, which are arranged and rearranged to try to make one chair carry the highest status in relation to the other items. Once this has been worked through and agreed, including people into the arrangement develops the game and the task continues (Boal, 1992: 150). This resulted in pupils taking over the game and playing it solidly for half an hour. Mentor and student simply watched. Uncertain of what was happening, it was clear that this was feeding some kind of learning need in the group, as they enthusiastically engaged with the game. Something about status was being worked out in safe and happy ways in that classroom, and they both knew that the traditional lesson plan would never have allowed this to happen. It became part of the basis of an experimental scheme of work on Boal's Forum theatre (Boal, 1992). These were small starting points, and larger things grew quickly from them simply because the comfort blanket of the oppressive pedagogy was dropped. Feeling somewhat insecure about this, student-teachers and mentors alike took a calculated risk initially but rapidly saw the benefits of taking this practice into the classroom. They also saw how the curriculum was covering cracks—rather than addressing them.

Another student-teacher had lines of text on paper on the floor. She asked which lines of text the pupils liked and invited the students to stand by the lines they liked. After negotiating with the class, it was decided that they would work in the groups into which they had fallen by text choice. She realized that one group had formed which she would never have allowed had she been in normal 'lesson plan and delivery mode' as they were likely to be poorly behaved if together. The group worked beautifully. On reflection, she asked when the classroom was ever going to be a place for really developing social skills if the groups are always pre-planned, and realized how she had actually been instrumental in forcing a negative template onto these girls who were, in fact, ready and willing to move on. In addition, she felt that the pupils had been invited to be the makers of artistic choice (offered the *Mantle of the Expert*) by selecting the piece of text which drew them in, and so shed the identity of pupils in a classroom 'who were kept apart'. This notion of how she proffered alternative identity adoption as a learner, she felt, was worth exploring further in her practice.

It is possible to see clearly that the nature of the ground being broken here bears resemblance to the varying aspects of new materialism as explored by Bolt (2014), who acknowledges that this has 'validated a rethinking of the relationship between humans and non-humans' and that 'the emergence of new human–technological relationships have decentred the subject' (Bolt, 2014: 3). In the instances discussed above, the humans involved both maintained and questioned their position as 'sovereign human subject' (Bolt, 2014: 3); for example, the racist boys maintained their sovereignty, and others questioned it, such as the girls who grouped themselves according to

sentence choices. Bolt draws on the work of Haraway (1991), who sees the human subject in new materialism as one who 'encompasses the human and the non-human, the social and the physical, and the material and the immaterial' (Bolt, 2014: 3). The Rolling Role clearly calls the students to be both human and non-human, to engage the materiality of worlds and become with them, at the same time as they are called by the school system to retain their identity as learners.

CONCLUSION

This chapter has examined the work of Dorothy Heathcote as a pedagogue of resistance. She introduced some models and principles which can and have been developed from improvised learning and based on the intra-action between people and objects. Having marked several new ways ahead for people to consider and no doubt flattered by her following, she was aware of the issue Hornbrook had raised about her 'devoted' and 'unshamefacedly messianic' following (Hornbrook, 1998: 13). We recall her words in an informal discussion at a conference: 'You don't need me—you need to go to your classrooms and get on with your *own* lives.' Above all, Heathcote was keen to free teachers and students to make processes of educational drama their own. We argue that her pedagogy of resistance went further than her own pupils and herself as teacher in her classroom; this penetrated into the profession itself.

Heathcote largely removed herself from pedagogical situations and allowed various kinds of affectus to affect the student-teachers themselves. This whole matter of being affected was key to her practice of resistance. This does depend, however, as the student-teachers discovered, on highly skilled teachers designing and critically directing the original frame.

In a very different climate today, drama educators are swimming against the tide. Resistance is more challenging. Student-teachers must show that they meet the standards, or they fail. Responsibility for initial teacher training is moving towards schools, reducing the role of universities and so making the influence of government control more direct.

However, when Heathcote's Rolling Role and the student-owned electronic portfolios fused together, this time in a frame more owned by the learners than the tutor, a whole variety of resistance-featured teaching and learning discourses took place. This went beyond the usual restrictions of the lesson plan and the student-teacher; it challenged mentors, curriculum design, the pupils themselves. Heathcote's focus on the learner rather than teacher is acutely pertinent in the current context, as well as her classroom of last century. At present, immediate concern lies with the disempowerment of

the teachers and the erosion of their role. However, by shifting focus towards empowering learners (in this case, either student-teachers or pupils) to be both affected and affecting bodies, and including non-human platforms and agents, pedagogies of resistance can emerge when critical engagement is facilitated by student-teachers. Internet technology can play a releasing and critical role, bridging isolation in schools by forging communication links and developing materials of resistance for teachers and pupils as affecting and affected bodies alike. At the same time, the internet can map, monitor and evaluate it as an essential tool in the development of arts practice as research. After Heathcote, we encourage drama teachers to facilitate critical communities online and to teach student criticality through very strategic intervention into student-led creative processes.

NOTE

1. Dorothy Heathcote was not a mainstream teacher. She carried out her work visiting schools that carved out days for her to run such projects.

Chapter 4

Art, Resistance and Demonic Pedagogy

From Parasite Capitalism to Excommunication

Charlie Blake and Jennie Stearns

This chapter may be considered a preface to and an exploration of how the concept of the parasite, along with related concepts—such as that of the host, the guest, the stranger, the invader, the alien, the demonic (or daemonic), and the possessor and possessed—allows for new configurations of art as resistance in a pedagogical environment, an environment increasingly conditioned and determined by the exigencies and machineries of neo-liberal capitalism. Within this exploration, there is undoubtedly a covert affiliation to and/or tension with a number of strands emerging from recent tendencies in critical and political thought, just as these tendencies are themselves responding to recent transfigurations of epistemological and ontological paradigms across a number of disciplinary fields. On this transdisciplinary evolution, and particularly in relation to the new materialism or materialisms that have of late come to increasing prominence, one of the authors of this chapter has provided elsewhere a summary which colludes in a number of ways with the discussion that follows (Blake and Haynes, 2014).

Suffice it to say in brief, however, that the notions of the pedagogy of the possessed, along with the intrinsic ambiguity of the idea of parasitism—for the latter both in terms of repression/oppression, on the one hand, and resistance/emancipation on the other—coincide closely with a number of the concerns of new materialism as investigated in Hickey-Moody and Page's chapter in this volume. Moreover, it is our contention that emergent pedagogies need to generate advocacy and resistance across the spectrum of the libidinal-material-ecosophical[1] economies emerging in response to the possibility of a post-Anthropocene world. The main terms of what follows here—host and guest, possession, resistance, art, pedagogy itself—thus orbit the problematic term 'parasite'—conceived as a spinning core of conceptual generation, adaptation and illumination. Thus, this chapter's first section will

define parasitism (and related concepts), following the work of Michel Serres in particular, both as a positive and a negative activism, and then move on via the anomaly of parasitism/symbiosis to the transitions of pedagogy from that of the oppressed (as exemplified by the work of Paulo Freire, 1970) to that of the possessed.

OUTSIDE/INSIDE—POWER AND PEDAGOGY

Half a century ago, Paolo Freire, in *Pedagogy of the Oppressed* (1970), argued from a broadly Marxist perspective for a pedagogically driven decolonization of the colonized through praxis and opposed what he termed a dialogics of cooperation to an antidialogics of acquisition, exploitation and control. Obviously, since then, the nature and reach of colonization, global capitalism, the state and the corporation, and communication networks have changed dramatically. Indeed, the expressive arts that emerge from this mesh are invariably seen now as inseparable from an infrastructure that has grown around the machinery of government, trade, finance and law, like a parasitic fungus. Parasitism in this understanding, however, is not given a purely negative denotation, as is often the case in political rhetoric or prejudiced and lackadaisical journalism. It is understood here, following the work of Michel Serres (2007), as a primary condition for the very possibility of communication, education and creative expression in emergent material, semiotic and libidinal economies. Serres's revaluation of the concept, in other words, allows for the parasite to be understood as a site of resistance to many current dominant modes of capitalist existence.

Elsewhere, we have argued that the current configurations of neo-liberalism and the libidinal affinities its pervasive rhetoric has with certain strands of paranoid thinking suggest that aspects of Gilles Deleuze and Félix Guattari's diagramming in *AntiOedipus* (1983) of global capitalism's future have indeed come to pass (Stearns and Blake, 2013). Here, we further argue that elements of current, ostensibly paranoiac thinking likewise indicate emergent forms of subjectivity and resistance. The problem of critique (which has so exercised political commentary that many have now dispensed with the use or notion of critique altogether [Latour, 2004]) hinges on notions of *outside* and *inside* that presuppose a position beyond or outside capitalism, a point from which it can be judged and from which resistance, rebellion or revolution can be initiated. This problem, we argue, needs to be radically reconfigured according to what we describe as a demonic pedagogy through which that which is inside yet radically other can be nurtured, through which this other, this parasite, is not ejected or rejected, but rather embraced as a condition of both positive existence and resistance.

In this, we are working in a broadly similar, though distinct, trajectory to that taken by Alex Galloway, Eugene Thacker and McKenzie Wark in their recent *Excommunication: Three Inquiries in Media and Mediation* (2014), which points to developing ways of understanding the inside/outside problematic as necessitated by changes in media flow and control—new ways of conceptualizing the divine, the ghost, the alien and the non-human—and, in our case, the parasitic, the demonic and the stranger—within our midst as agents of transition and resistance. Bearing in mind the various connotations of the term 'possession' from political theory to the horror film, we here begin to explore how, through a re-envisioning of concepts of hospitality, sacrifice and the parasite, a pedagogy of the oppressed might evolve into a pedagogy of the possessed.

THE MOBIUS OF MEDIA

In an episode of the BBC series *Planet Earth* (Fothergill, 2008), the writer, producer, naturalist and narrator Sir David Attenborough describes how the parasitical cordyceps fungus takes control of its anti-host's body, compelling it to climb higher and higher up an available stalk until finally killing it by bursting from its head as a constellation of spores which thereby repeat the cycle by infecting more ants. Like a number of similar accounts of so-called 'zombie parasites', Attenborough's narration, delivered with his typical sangfroid, characterizes this 'bizarre' phenomenon as 'something out of science fiction'. The parasitic fungus that has 'infiltrated their bodies and their minds', leaving the ants directed by their 'infected brain[s]', by the parasite within, by this seemingly alien and yet terrestrial invader, surely 'seems extreme', he tells us. And yet, in some important ways, the apparent extremity of this image is only extreme to us as viewers, as consumers of mass-produced visio-textual data streams, because it mirrors a cultural reality that we prefer to avoid looking at more directly.

Maybe 'prefer' is too soft a term here. Indeed, maybe it is more accurate to suggest that we are vigorously trained or instructed or even programmed from an early age via media and educational systems not to look at what such images encode too directly because they reveal the very process of instruction itself as a form of semiotic violence. Either that, or it is kind of semiotic slavery or dataslavery, which we have been programmed to embrace even as we view it with horror or disgust, or at very least, dismay. The parasite, the invader, the alien, the demon, the uninvited guest, personify the process for us so as to disguise the program beneath; in other words—to scatter its components semiotically, to mask this program—these programs—and then reconfigure them via a double encoding as entity and possession, or even as

ideology. Moreover, as a necessary and defensive corollary, whether in a piece of informative entertainment such as Attenborough's documentary or, in a radically different genre, John Carpenter's metaphorically 'prophetic' horror fantasy The Thing (1982), for example, this diversionary process adds a frisson of abjection, of horror, of fear, or at least of uncertainty, of discomfort to the mix to make sure that we focus on the process rather than the program itself.

This is, of course, both to simplify and to generalize the concept and consequences of parasitism. And of course, parasitism may be described and defined and taxonomized according to a variety of characteristics and determinations, but there is, nonetheless, between these characteristics and determinations, conceived as a pattern, a certain set of consistencies which extend beyond the natural sciences in how we deploy the notion of the parasite and the parasitic. It is a pattern of characteristics and determinations that merges nurture and violation, love and exploitation, in a unique manner. This is the case, we argue, whether one deploys the term 'parasite' or 'parasitic' in its negative and desultory political or social connotation, or through the more positive links with philosophical and creative noise, (dis)equilibrium or psycho-social catalysis associated with writers such as Serres, or in its more ambivalent use in relation to parasite capitalism in the work of Matteo Pasquinelli (2008).

The problem, of course, with simply debating who or what is the 'parasite' (as so many political pundits, for example, do) without attention to the concept's intrinsic ambiguities is that doing so reinforces a paternalistic discourse that works to prevent and deny the contributions of the marginalized (Stearns and Blake, 2013). Like sociologist Stephen Pfohl, whose *Death at the Parasite Café* (1992) identifies parasites as those who, from positions of privilege, 'feed parasitically off the flesh of those whose material chances they economically restrict and militaristically reduce' (11), we take from Serres (2007) the view that 'parasite' is a label often perhaps more logically applied to the exploitative upper classes than to the exploited poor and working classes: 'the crowd produces' and 'the master parasites' (59). However, like popular political pundits who toss around the insult 'parasite' without acknowledging, much less reflecting on, the fact that their opponents do the same, Pfohl (1992) gives inadequate attention to the metaphor's positive potential, including the ways in which the term as applied to the poor and the dispossessed at the same time as to the rich and exploitative may facilitate a new perspective on post-neo-liberal capitalism. In contrast to Pfohl (1992), however, at this stage, we emphasize the inherent ambiguities of this metaphor so that we might reclaim it to advocate a different vision of the public sphere. Serres (2007), after all, poses this counter-intuitive observation that 'the master parasites' as a foundational question: 'One day we will have to

understand why the strongest is the parasite, that is to say, the weakest—why the one whose only function is to eat is the one who commands. And speaks. We have just found the place of politics' (26).

However, Serres's (2007) point is not so much (as is Pfohl's, 1992) that power parasitizes the marginalized and the oppressed as it is the raising of the question how it is that the word or image 'parasite' can simultaneously signify both the lowest figure on the food chain (an ideologically driven metaphor if ever there were one) and those at the top who do nothing but consume. This ambiguity—among others in an almost endless series of overlapping ambiguities and contradictory associations—opens a space within which to theorize the parasite as a figure useful in reconceptualizing minor players and outsiders as productive forces in the systems and systematics of human relations and relationality. The Serresean parasite simultaneously problematizes the question of who is using whom and transforms the system constituted by the relationships between those involved, and this is its value as a transmitter of excommunicative potentiality and reconfiguration within the system of communication in and on which it feeds.

There are various levels to this diagnosis. On the most quotidian, the one associated with everyday social media, for example, one alternative to arguing over who owes whom what, to quibbling over who is the biggest mooching sponge, we would suggest, would be to embrace an ethics of generosity and self-consciously *perform* the role of host. As Pfohl (1992) asks, 'Instead of feeding off the sacrifice of others, why (k)not periodically suffer the mimetic shattering of our own parasitic identities? . . . Why (k)not exchange this desire for the more dangerous impurities and indistinctive co-minglings of a more generous mode of gift-exchange?' (147). However, whereas Pfohl positions this generosity in opposition to a parasitic economy in which the privileged exploit the disempowered, we position it *within*. Whereas others, such as Jean-Luc Nancy (2008) and critical art curators Post Brothers and Chris Fitzpatrick (2011), have focused on the parasite as a figure of intrusion or of the possibility of 'bring[ing] external or marginalized voices *into* the institution' (Post Brothers and Fitzpatrick, 2011, emphasis added), we highlight the parasite's potential to remind us that more often than not, the so-called outsider and the marginalized are *already inside* the social body they have supposedly invaded and that we thus might very well ask whether the intruders have *possessed* the state/institution or has the state and its institutions *taken possession* of them?

Too many accounts of the parasite, even ones as critically nuanced as that of Pfohl (1992) or of Pasquinelli (2008), ultimately fall back on the word's conventional use as a pejorative rather than giving adequate attention to the metaphor's positive potential (for instance, with his reliance on phrases such as 'the corporate parasite' [14] or 'the parasitic economy of advanced

capitalism' [27], Pasquinelli [2008] generally uses 'parasite' as a synonym for economic exploitation, albeit of an indirect and systematic sort, even while deploying a Serresean model of the parasite that he credits for being 'more a technical or neutral concept with no inherent political connotations' [60]).

Moreover, as Carl Zimmer (2000) makes clear in his highly readable and informative account of both the scientific and more generally cultural specifics of parasitism, there are further taxonomies within parasitology that need to be attended to, especially if we seek to extend this concept and its expression to areas of human experience and activity such as art, pedagogy and political resistance. To take just one example of the complex taxonomy of parasitism—as Zimmer (2000) observes—the so-called zombie parasite so dramatically portrayed in natural world documentaries and—via demonic or alien possession—the genres of horror and science fiction is but one form of parasite. Zimmer (2000) describes one extreme example—the Sacculina barnacle that enters certain crabs and establishes what looks like a root system throughout the crab's body, to the point that the crab's nervous system exists solely to serve the parasite. This act of possession is such that even though the barnacle effectively castrates the crab by making it infertile and uses it specifically as a vehicle for its own growth and reproduction, the crab will be reprogrammed to nurture the brood of the parasite, which now occupies the brood pouch where her own fertilized eggs would have otherwise been (Zimmer, 2000, 81).

There are evident links here with Post Brothers and Fitzpatrick's (2011) use of the parasite as an invasive form of resistance in the art world and the parallels they draw between three specific examples of parasitism and the subversive and anti-institutional forms of art practice associated with figures such as the artist Harvey. Among the three examples of the parasite as infectant and irritant they cite as exemplifying different strategies of guerrilla art, one is the so called 'tongue-eating louse', *Cymothoa exigua*, a crustacean parasite that 'latches onto a fish's tongue, drains it of blood, and then effectively replaces the host's tongue with itself' (Post Brothers and Fitzpatrick, 2011). This parasite, they suggest, for instance, 'offers a model for considering artists who mirror, redirect, or overtake the voice and authority of their hosts, and who insert "static" into communications of which they would otherwise not have access' (Post Brothers and Fitzpatrick, 2011).

The point they emphasize here is the necessary ambiguity of such activities in an art world that has come to anticipate gestures of vandalism or art terrorism as easily incorporated into the agenda of established art institutions. There is an element of what Silicon Valley entrepreneurs and their progeny call 'disruptive innovation' in this procedure, a form of subversive behaviour that, arguably, does little to destabilize the neo-liberal nexus of an art world that thrives on such incursions (see for instance, Leger, 2013). It is an

anomaly that Post Brothers and Fitzpatrick examine in some detail through
their examples and admit is a constant danger, in that if the subversive art-
ist, as Stromberg and others since have done, plants his or her work illicitly
in galleries, but in due course this act of supposed art terrorism becomes an
aspect of the brand of the gallery, then the subversion has been itself sub-
verted by the institution. Nonetheless, the creation of 'static' or 'noise', if
practised in a sustained manner, in the manner of the tongue-eating louse or
Sacculina barnacle, which actually replaces an organ of its host entirely and
radically alters its behaviour, can have interesting results, in that the 'tongue'
of the institution—its discourse of self-promotion and artistic context—has
been simulated and distorted.

Thus, and referencing Louis Althusser and Jacques Lacan on the voice, for
whom the voice of the individual is actually that of the ideological state appara-
tus or its psychoanalytical corollary, for example, Post Brothers and Fitzpatrick
(2011) note that the parasitic invasion can still unsettle the institutional body
itself: 'Inhabiting the tongue makes clear to the host not only that its own voice
can be appropriated, but also that its authoritative communication is not objec-
tive nor indifferent, but rather constituted by ideological decisions by specific
actors.' In this sense, the parasite effects a form of resistance similar to that
which Howard Caygill (2013) outlines in his On Resistance: A Philosophy of
Defiance, his celebration of the insurrectionary tendency over that of revolu-
tion per se in the age of neo-liberalism: 'Insurrection is resistant but not con-
stituent, opening spaces rather than constituting them and mobilizing a rhetoric
of action, even violent action, to inspire its uprisings. Perhaps it is now a more
salient term than revolution with its promise of completed action' (n.p.).

So—in contrast to the revolutionary action of Marxism or mass infec-
tion of neo-liberalism—both of which in their more disingenuous moments
pretend to deterritorialize the bad oppression and then leave its subjects
free—to effect a pure emancipation over a period of time or history—without
mentioning the inevitable re-territorialization to come—insurrection—resis-
tance—does not complete its movement. It deterritorializes just a bit—and
then moves on. This, at least, is one notion of resistance as permanent rev-
elation rather than revolution per se—as in Dada—as in Raoul Vaneigem's
quotidian revolutions—as in the purer aspects of punk in 1976—as in the
Metropolitan Indians of the Italian Autonomista movement who so influenced
that small strand of punk and so-called post-punk that emerged in the early
1980s—as in the tricksterism of the KLF in the latter days of rave culture in
the early 1990s. The zombie parasite, in this sense, is a more extreme form of
art or cultural practice, than that of insurrection per se, but it is nonetheless
an insurrection from within rather than a revolution or invasion from without.

Such extreme zombie parasitism as described by Zimmer (2000) and
deployed by Post Brothers and Fitzpatrick (2011), however, is of course

but one aspect of this extraordinary relationship between invader/guest and host, for the majority of parasites are content to allow their hosts to live and function as they would otherwise. Indeed, for most parasites, the organic and reproductive success of their hosts is a positive advantage. Similarly, the parasite might well develop some form of symbiosis with the host that is mutually beneficial, as is seen everywhere in the realms of organic life. And here, once the analogy is extended to the human, the inhuman, the ahuman, and what Deleuze and Guattari (1983, 1987) describe as non-organic life, we are caught in a play of ambivalence between the parasite as a destructive force and the parasite as the guest who entertains or adds some positive quality or value or sense of value to the life of the host, between the vampiric configurations of a brutal economism and the conceptual trickster or ghost in the machine who can force us to think anew about art, resistance, and pedagogy. And this, of course, has everything to do with politics too. For as John Brown noted in 1898 in Parasitic Wealth or Money Reform—A Manifesto to the People of the United States and to the Workers of the World, and as quoted by Zimmer (2000):

> Nature is not without a parallel strongly suggestive of our social perversions of justice, and the comparison is not without its lessons. The ichneumon fly is parasitic in the living bodies of caterpillars and the larvae of other insects. With cruel cunning and ingenuity surpassed only by man, this depraved and unprincipled insect perforates the struggling caterpillar, and deposits her eggs in the living, writhing body of her victim. (Zimmer, 2000, 1)

Thus, parallels begin to emerge between politics, economics, parasitology, art and pedagogy that will inform our discussion of the possibly liberating force of parasitism via art and creative practice as a form of political resistance.

For has not the goal of much conventional pedagogy—as well as of the 'big curriculum' that instructs us through everyday practices (Schubert, 2006) or the 'relational cultural practices' that occur 'both within and outside places that are understood as being "educational" settings' (Hickey-Moody, 2009, 273)—been a similar form of neurological control? Is this not one possible lesson of the cordyceps? For although far less overtly dramatic to the human eye, is this pedagogical apparatus of transmission not still an infiltration of students' bodies and minds that programs them to act and think as instructed in a manner not dissimilar—in effect if not in style—to the genetic choreography of the cordyceps fungus?

Clearly, there are presumptions here that require clarification—presumptions about the relation between biologics and mechanics and pedagogics, for example. The way to elicit these presumptions and lay them out, as it were, is

via the distinctions argued in general by Deleuzeans between affect, affectio, affection and affectus. Deleuze (1988) himself argues these distinctions in some detail in his lecture on Spinoza, and it has been developed by a range of thinkers as it applies to various aspects of the humanities and social sciences, particularly distinctions made between image affects and affect feeling. For our purposes, Hickey-Moody's (2009) summary applies this complexity to the specific issues of art and pedagogy with valuable economy. Here, Hickey-Moody (2009) defines affect as 'the concept of taking something on, of changing in relation to an experience or encounter' (273). Affectus, in this sense, is the process of modulation or change whereby one thing materially changes another, and as such is to be distinguished from affect, understood in its more conventional psychological sense as feeling or emotion. From this perspective, affectus is effectively pedagogy itself, understood as 'a relational practice through which some kind of knowledge is produced' (Hickey-Moody, 2009, 273).

The relation between affect and affectus as expressed through art practice, and as suggested by Hickey-Moody (2009), will form a central if largely unstated strand through this chapter, but its positioning in relation to the parasite is one that requires first a detour into older forms of pedagogical theory and very recent attempts to bring media theory into a place where it can deal more effectively with our contemporary medial realities in contrast to the by now redundant notion of 'new media'. The link here is between a notion of oppression—understood politically or personally—and possession, understood similarly, but with the added connotations of ownership, parasitism and demonology. To begin to trace out the ways in which these strands form a pattern, we begin with the work of Freire (2005) on pedagogy and the work of Serres (2007) on parasitism and noise.

TOWARD A PEDAGOGY OF THE POSSESSED

How can we—unlike the many political commentators who uncritically use the parasite metaphor to opposite ends—deploy the instability of this metaphor to investigate configurations of chaos and order, outsider and insider, student and teacher? If such instability can facilitate what Deleuze (1989) has called the 'shock to thought' (156) that derails habitual thought in creative and constructive ways, then what emergent modes of expression and what new contexts, new concepts and détournements might generate new forms of critical illumination of the pedagogical imperative and its practice? The disturbance that leads to thinking, to the production of new concepts, we argue, is parasitical in the Serresean sense of the parasite as an interruption that generates innovation and novelty.

As Michalinos Zembylas (2002) has noted, Serres's (1997) insistence that education be a process of creation and invention in many respects resembles Deleuze and Guattari's (1994) vision of philosophy as a machine for the creation of concepts, not only in his 'vision of the "educated third" [as] a nomad who is always becoming, moving across established categories' (496) but also because 'implicit in the notion of the "troubadour of knowledge" is the belief in the potency of imagination and invention that subverts fixed, steady knowledges (and curricula) and enacts his/her transitions across space and time without any teleological purposes. . . . In this respect then, the "troubadour of knowledge" is an example of a "rhizomatic" knower' (Zembylas, 2002, 498). Elsewhere, Serres (2007) says of the 'excluded third' that by 'nature and function' problematizes 'two poles', whatever they may be: 'We call it parasite' (150). Hence, the parasite might be said to be the condition on which Serres's (2007) 'educated third' depends—and this educated third might then be said to itself be an example of the parasitic function.

Serres's (2007) notion of the parasite as such interference, as what he repeatedly calls 'the third'—an 'excluded middle' (e.g., 110) that interrupts the dualism of host and guest, making it impossible to determine which is which—perhaps resembles, as Rosalyn Diprose (2002) notes, Emmanuel Levinas's (1969) concept of the 'third party':

> While I am obligated to welcome (and so remain open to) the other who contests me, the other is in relation to a third party to whom she or he is responsible and who treats me, alongside the other I face, as someone to be welcomed. By rendering the one who is contested as also one who is welcomed, the third party . . . tempers the 'inequality' of the relation to the other without either rendering the relation reversible or allaying responsibility. (207, note 9)

Diprose (2002) explicitly contrasts Levinas's model of learning with 'a Socratic model of the production of knowledge, where ethics is based on epistemology (the more you understand, the more virtuous you are), and genuine knowledge arises from within' (134). For Levinas (1987), Diprose (2002) explains, the Socratic model of autonomous thinking fails because

> in this exercise of reason, of power, there is nothing disturbing, at least not in the end. Hence, there is no teaching or learning, no production of new ideas, in such a model. One's mentor, student, companion, or rival is reduced to an intellectual midwife . . . someone who merely helps brings to consciousness 'the already-known which has been uncovered or freely invented in oneself'. (135–6)

If for Diprose (2002), Levinas's account of teaching and learning represents a corporeal response to that which 'gets under our skin' (a pedagogical

dynamic that we ourselves characterize as parasitosis, but one that symptomizes, not a paranoid resistance to the other, but rather a welcoming of the contagion that Deleuze and Guattari [1987, 232–309] associate with multiplicities), then the tradition, dating back to Plato, of 'privileging spiritual love over sex' is 'anti-body, promoting a politics of immunization, through egalitarian love and friendship, against the threat that the body seems to pose to freedom and autonomy' (78). Or, Diprose (2002) clarifies, 'put another way, in the words of Levinas, the error of colonization is the belief in a Platonic model of truth: that "the world of meanings precedes language and culture, which express it; [and] is indifferent to the system of signs that one can invent to make this world present to thought"' (152–3). In other words, any pedagogy rooted in such a Platonic model would be limited by its inability to respond to the Other, to the new, to the third—to what we might call the parasite. A Serresean pedagogy, as Maria Assad (2001) has written, seeks 'a luminous middle-ground where teacher and pupil become one in and on their passage toward an instructed immanence of knowledge' (46).

Serres (2007) critiques a 'prescribed curriculum content with pre-assigned roles for teachers (who "teach") and students (who "learn")' (Zembylas, 2002, 496) and thus even in a superficial sense might suggest a comparison to Paulo Freire's (2005) critique of what he labels the 'banking' concept of education and its polarized notions of the 'teacher-student contradiction' (72). But if Freire (2005) faults the banking concept for assuming 'a dichotomy between human beings and the world', one that imagines the mind as an empty receptacle in which knowledge of 'the world outside' can be deposited (75), Serres (2007) offers the parasite as a third possibility that undoes the dualism between inside and outside altogether. As noise, for instance, 'The parasite is everywhere. Its voice expands, filling the space, wherever he is and wherever he goes' (Serres, 2007, 96). As bodily invader, the parasite is in the most basic sense the outsider already inside—and sometimes, as in the case of such parasites as the behaviour-changing and likely schizophrenia-causing *Toxoplasma gondii* (a common parasite transmitted by cat faeces) (McAuliffe, 2012), it renders any notion of 'the mind' unstable, indeed. Noting a common tendency to regard the oppressed 'as the pathology of the healthy society', Freire (2005) argues, 'the truth is, however, that the oppressed . . . are not people living "outside" society. They have always been "inside"—inside the structure which made them "beings for others". The solution is not to "integrate" them into the structure of oppression, but to transform that structure so they can become "beings for themselves"' (74). Serres (2007) agrees that they have always been 'inside', but also suggests that one way to transform the structure might be to recognize the ways in which even true pests and pestilences might be beneficial.

A pedagogy of the possessed would not seek the 'philosophical autonomy' that Diprose (2002) connects to the 'economic rationalism [under which] the teacher and the student are reduced to vehicles for the consumption and rep- etition of familiar ideas valued for the utility in allowing easy appropriation of our world' (136) but would, rather, represent an openness to the teaching of the Other (an Other that, we would add, may include not only the inhuman as well as the human, but also the inhuman 'in the' human):

> This is a teaching because it breaks the 'closed circle of totality' . . . the impe- rialism and violence of self-knowledge that would limit the other through the imposition of familiar ideas. . . . The other's alterity is also a teaching, because it opens me to think beyond myself and therefore beyond what I already know. (Diprose, 2002, 136–7)

On the other hand, the negative possibilities of the parasite metaphor should also serve as a warning not to idealize or romanticize this openness to the other. As academics, we ourselves might be said to parasitically con- sume Others for personal and professional gain in the manner Pfohl (1992) describes:

> surrogate victims appear before the eyes/'I's of those (of us) who sacrifice them as no-thing but objects for logical contemplation and mastery. The measured skull of the prisoner, the opaque and racist image of the Arab, the nude female figure pinned upon the wall—surrogate victims are (literally) sentenced to the sphere of categorically dead matters. As objects, they are paradoxically dined upon by 'we' whose gaze they fascinate. (139)

Or, as Diprose (2002) puts it:

> The social imaginaries that have our bodies through habitual ways of being, and that are called upon in perception in response to the matter at hand, already memorialize the generosity of the privileged and forget and do not actively perceive the giving of others. It is this selective blindness that, for example, affords me the privilege of the position of respondent at an academic confer- ence, that . . . extends to me the right to judge what I am responding to, without acknowledging what it may have given me. (192)

Thus, we may all too easily be subsumed into a power play in which the privileged voice bemoans its privilege at the same time as it exercises that privilege as an open duplicity.

As a third term that destabilizes the host/guest binarism and, moreover, as a reminder that it is not always possible to be sure who is using whom, the parasite might be said to offer an opportunity to reconfigure a ubiquitous site

of possession as a possibility of resistance to the systematics of domination. The Serresean (2007) parasite makes ambiguous the inside/outside distinction and, more importantly, suggests the possibility of simultaneously being host/guest/parasite—the very sort of multiplicity that defines the expressions of parasitism as mutuality and creativity that we are suggesting. In other words, an ethics of hospitality, in its intrinsic, aporetic 'dispossession of identity' (McNulty, 2007, xix), might itself be said to be a rather different form of possession, more akin to an inhuman or ahuman version of Aristotle's eudaemonia (which might be positive or negative or neutral—a dysdaemonia or anadaemonia, in effect) than the form of vampirism with which it is more commonly associated.

The question of whether a particular parasite should be regarded as invading alien or as self (as in the case of the common, but personality-altering, schizophrenia-inducing *Toxoplasma gondii*) is not unlike the concepts of the 'prosthetic body' or 'skin ego' through which 'the boundaries between the body and its outside (the material world) are problematized and rendered ambiguous' (Tajiri, 2007, 42). The parasite is only an outsider or foreign body if one perceives it as such. As Post Brothers and Fitzpatrick (2011) note, quoting and elaborating on Nancy's (2008) observation that 'without "an element of the intruder in the stranger" or the parasite in the host, the intrusion is without the necessary "strangeness" to be perceived as such. In other words, an invitation or any allowance given to an intruding force would negate that very intrusion'. For example, they ask, 'When individuals ingest roundworms to lose weight, . . . does this willing introduction of the parasite negate its harmful potential? And, how does the act of voluntary bloodletting change the patient's relation to the leech, when that leech is put in service to medicine? What do the processes of regulation, invitation, and control, therefore, render?' (Post Brothers and Fitzpatrick, 2011).

In this sense, the parasite, both as an actual biological entity and as a rhetorical trope, undoes the logic of organization from outside that so frequently defines the paranoia and hostility that attend the notion of parasitism in both its biological and sociopolitical settings. At the same time, it operates from the inside as a kind of cybernetic governor, orchestrating various feedback mechanisms in the cause of its own survival which simultaneously recalibrate the outlines and identity of the host, as well as the host's orientation to the idea of life or mechanism or that of the creation of concepts to reconfigure life and mechanism and to adapt to changing conditions, whether technological or ecological or economic. In this sense, parasitism is related to but subtly different to excommunication in the sense teased out by Galloway et al. (2014), in that excommunication, like the gift, is a means of delimiting a community's boundaries, but it also reveals those boundaries as a social construct and points to their possible permeability, as Galloway et al. (2014) explain:

excommunication is different from other forms of boundary management. It is not quite banishment, which places an emphasis on the physical removal from the *topos* of community. It is also not quite exile—a term with more modern meanings—which implies the possibility of eventual return to the community or the place from which one has been exiled. The excommunicated Christian remains a Christian, but is barred from participation in Church ritual. His intermediary status is amplified by the public ritual of excommunication itself. (15)

Possession, especially parasitic possession, is neither intermediary nor liminal, but instead is absolute in its colonization of boundaries and all that lies around or within those boundaries, and, in its more extreme versions, its twisting of topological variables to effect a far deeper transition in the patterns of participant evolution and libidinal economics than the 'human' has thus far been able to systematize conceptually. Accordingly, exorcism or excision of the parasite from the host is also a welcoming of the parasite into the host as a kind of cybernetic messiah, a parasite messiah—in a populist and pedagogical and eminently reproducible rather than an eschatological sense—whose momentum both towards and against the future allows for a resistance through creativity that harnesses rationality and affect at the same time as it consumes them. It is an ejection and abjection which is also abduction for the future of our species, or whatever we create to replace ourselves in the post-Anthropocene landscapes that are already being mapped out in fiction and coding. We are ourselves both host and parasite, predator and prey, possessor and possessed, and we consume ourselves as we consume the future.

CONCLUSION

The parasite, through its ambiguity as both biological entity and as dissensual and disjunctive metaphor, therefore, destabilizes not only the conventional dichotomy between host and guest, predator and prey (Serres, 2007, 6–7), but also the construction of 'knowledge [as] a gift bestowed by those who consider themselves knowledgeable upon those whom they consider to know nothing' (Freire, 2005, 72) that characterizes the oversimplified or over-romanticized vision associated with the fundamentally monological form of education that Freire critiques with his *Pedagogy of the Oppressed* (2005). At the same time, through this dissensual quality, it provides a means by which figures and motifs of outsiderness (whether they be the poor and politically marginalized or students) become incorporated, parasitically, into our libidinal economies as signs of excess and transgression, thereby allowing the cruel reality of sacrifice back into the semiotic community in a form which

is disguised rather than merely symbolic, and strategically violent rather than merely hermeneutic, with all the potentially ethical complications that this might imply. This emergent parasitical economy implies, in a real and important sense, an understanding and use of the parasite as a destabilizing instrument in the far more urgent and immediate polylogical pedagogy of the post-human age, the pedagogy of the Possessed.

NOTE

1. The term 'ecosophy' here is used in the sense closer to that of Felix Guattari in *Three Ecologies* than that of Arne Nauess and others in the deep ecology movement. On this distinction, see Tinell, J. (2011). Traversing the ecological turn: Four components of Felix Guattari's ecosophical perspective. *Fibreculture Journal* 18, 35–64. Retrieved from http://fibreculturejournal.org/wp-content/pdfs/FCJ-121John%20Tinnell.pdf.

A Pedagogy of Possibilities

Drama as Reading Practice

Maggie Pitfield

In the shifting political landscape of education in England, the discipline of English has been particularly prone to the policy interventions of successive governments. Nevertheless, when pedagogy and critical learning connect with the experiences that learners bring, the classroom can offer a site not only of resistance, but of possibility (Giroux, 2003). Jones (2003) refers to this as the 'cultural connectedness' (145) of the English classroom and suggests that it is threatened by officially sponsored discourses of 'entitlement', a term which obfuscates 'the predominance in the curriculum of a single type of authorised knowledge' (149) and the expectation that a teacher's role is to provide learners with 'access' to it.

In this chapter, my aim is to explore how the pedagogy and practice of one teacher pays heed to cultural connectedness, unleashing the possibilities and potentials for reading in the English lesson through 'the entanglement of matter and meaning' (Dolphijn and van der Tuin, 2012, 50) during drama activity. In this classroom, learners, learners and teacher, and texts materially intra-act, demonstrating that effective teaching and learning always has an affective dimension (Lovat, 2010; Mulcahy, 2012), with affect 'used to refer to intensities or energies that *produce* new affective and embodied *connections*' (Mulcahy, 2012, 11).

The observations of and interview with this one teacher, Shona,[1] an English teacher in a culturally diverse, inner London boys' secondary school, give an account of the role that drama plays in her lessons and illustrate the integral nature of drama to learners' engagements with literary texts. Although the term 'literary text' is value laden, I am employing it to describe at the most basic level 'the texts most widely read within secondary English classrooms' (Yandell, 2014, 1). I am particularly focusing on learners' exploration and production of the re-creative text. At subject level the re-creative mode brings

together the processes of reading and writing and at the level of the learner links the role of critic with that of text creator (Knights and Thurgar-Dawson, 2008). The productive tension between critical and creative/affective engagement is mirrored in the interpretative position of the practice-led researcher who must consider how the 'materiality of a creative work impacts on both the content and the reading of that content' (Haseman and Mafe, 2009, 216), and how this is represented, explained, defined or amplified through arts practice as research. Similar questions to do with reading and representation are apparent in the context of Shona's English lessons. Whereas the re-creative text in English is usually produced in written form, it is my contention that in the observed lessons, the dramatic representation stands as the text produced. Therefore, the interaction between the source and re-creative texts is intertextual in nature, in that it draws on a 'network of textual relations' (Allen, 2011, 1) both within and outside the classroom and from beyond the written mode. In new materialist terms, the texts are not treated 'as preexisting entities, but as intra-action, as forces from which other texts come into existence' (Dolphijn and van der Tuin, 2012, 57). Thus, engaging learners in re-creative activities in response to reading a literary text is a means of supporting them to become active, self-aware readers and is a key part of Shona's practice as an English teacher.

In constructing my analysis, I define and amplify (Haseman and Mafe, 2009) the practices of the classroom by means of a series of illustrative vignettes which are typical of the teaching and learning behaviours on display in Shona's classroom. Her approach recognizes that drama is an embodied and material practice 'and that materiality of matter lies at the core of creative practice' (Bolt, 2013, 5). As drama activity employs the full range of representational and communicational modes, for example, metaphoric, symbolic, semiotic, discursive, evaluative, that are involved in the production of English (Medway, 2003/2004; Kress et al., 2005), it is useful to view the data through a multimodal lens (Kress et al., 2005). Therefore, in addition to my observations and interview, I draw on video recordings of the lessons, considering the spatial arrangement of the classroom setting, the learner-to-learner and learner-to-teacher interactions, gesture, gaze, movement, and so on, to interrogate and deepen my understanding of the practices that occur. While the multimodal perspective of the analysis acknowledges 'arts' very materiality' (Bolt, 2013, 4), it does not deny the importance of inquiring into the meaning of the language of the English lessons (Doecke, 2014). Neither does it make any special claim to researcher objectivity because as an ex-English and drama teacher of some twenty-four years and now a teacher-educator in the field, I construct myself as both insider and outsider in this context. This is a methodological approach not dissimilar to Swain's (2006) description of the 'semi-participant' observer (201). In my case I am both participant and

observer, implicated in the practice through my professional immersion in the field of enquiry, and bringing my insider knowledge to bear. This is how knowledge, ideas and resonances from the past legitimately interact with research in the present to identify new theoretical positions and create new knowledge (Nicholson, 2009; Dolphijn and van der Tuin, 2012). The new materialist scholar, Barad (Dolphijn and van der Tuin, 2012), calls into question the idea that researcher objectivity is achieved through distancing and proposes that 'Listening for the response of the other and an obligation to be responsive to the other' (69) is both necessary and ethically sound. Therefore, among the voices of the teacher and learners, my own can be heard, and my engagement with both is duly noted.

Through this approach I want to understand how Shona's use of drama realizes the aims of re-creation in 'promoting an exchange between critical and creative practice' (Knights and Thurgar-Dawson, 2008, 8) that is reciprocal, mutually enhancing, and enables learners' critical engagement with literary texts through this very particular kind of cultural production. From my experiences of her lessons, I argue that the drama is of itself re-creative and acts as the medium of composition, with the learners using the resources of mind with body to make meaning through their acts of re-creation and in a collaboration that is wider than that of one writer to one reader. It is this wider collaboration which addresses some of the inadequacies of reader-response theory in describing how texts are encountered, discussed and indeed read in the English classroom (Yandell, 2014). The resulting dramatic text stands as the creative, embodied composition that is in dialogue with the source text.

In one of the observed lessons, the learners experiment with dramatic representation to explore a poem, and the other lesson focuses on an event described in the Michael Morpurgo novel *Warhorse* (2007). Both demonstrate how Shona uses drama in 'a direct material engagement' (Dolphijn and van der Tuin, 2012, 52), to encourage learners to position their re-created dramatic text with the original. This engagement 'is not just a matter of interference but of entanglement' with the texts, serving to 'open up and rework the agential conditions of possibility' (52) in the classroom. Learners' creative and critical responses are viewed as neither distinct nor hierarchically connected, although the formal curriculum tends to foreground the latter type of response, but instead they exist in a symbiotic relationship. The lessons also demonstrate the ways in which Shona translates into practice her stated beliefs about the nature of English and the nature of drama in English. They show how the interpretation of the learners is encapsulated in their often playful responses to the tasks they are set. This playfulness is entirely in keeping with production through the re-creative mode in English, and demonstrates how Shona is reaching out 'after a more democratic, participative cultural practice' (Knights and Thurgar-Dawson, 2008, 33, drawing on Barthes).

THE RELATIONSHIP BETWEEN PLAY AND DRAMA

Shona, as an English teacher employing drama in her English lessons on a regular basis, emphasizes the importance to her practice of the relationship between play and drama, conceptualizing drama as a powerful extension of play-based learning (Bolton, 1979). She returns to this theme a number of times in her interview, variously identifying the purposes of play in learning English as engagement, motivation and fun; an imaginative stimulus (the what if-ing aspect of play); practice for action in different situations; and practice for language use. In the way that she links commitment to the fiction created and the 'what if' mental stance required in creating it, there are echoes of Heathcote's thoughts on 'the implication of "if"' (Johnson and O'Neill, 1991, 25) in drama practice and of O'Neill's process drama methodology (O'Neill, 1995; Taylor and Warner, 2006) in which learners are also 'active agents making theatre happen' (Bolton, 1998, 231). Similarly, Byron (1986) suggests that drama in the English classroom necessarily 'suspends or modifies the "real" context and social network of the classroom in favour of an "as if" context and network' (125). To facilitate this, Shona's planning and classroom organization focus on the social and the interactive, indicating that a social constructivist perspective on learning is integral to her pedagogical approach. Thus, the activity in her classroom recognizes that our 'making and experience of art is always and necessarily culturally and socially mediated' (Barrett and Bolt, 2013, 4). However, the embodied nature of the drama practices employed to explore texts ensures that in the meaning-making process, 'art's very materiality' is not subsumed by the 'the textual, the linguistic and the discursive' (Barrett and Bolt, 2013, 4). Shona describes the English classroom when learners are engaged in drama:

> I think it's noisier and less pretty to look at, it's messy, there's an awful lot of laughing and general kind of 'carry on', which I quite like, to some extent, although when I get tired sometimes I don't. But yes, overall I quite like that aspect of it. And then I think the connections that students make are much better. Yeah, I suppose that's what I think. There's something about . . . so I think with my Year 9s last year doing *Richard III* . . . well for one thing they loved it, but also they talked a lot, and some of them were interviewed for the Creative Partnerships work and they talked a lot about how much better they understood it because they played with it. (interview with Shona, 3 November 2011)

This is a perspective on learning that connects a certain anarchic 'messiness' in the atmosphere and conduct of the lesson with pupils' playfulness and their making of conceptual connections. Thus, embedded in Shona's comments is an understanding of the need to establish a classroom context in which learners can identify themselves as agentive, cultural producers.

In this sense, 'agency is an enactment, a matter of possibilities for reconfiguring entanglements' (Dolphijn and van der Tuin, 2012, 54). The types of conceptual connections that learners make and how these constitute learning in English are explored further in my account of the observed lessons. Shona's reference to Creative Partnerships,[2] an intra-action between artists, teachers and learners, is also relevant as her significant involvement in this large-scale arts project is a source of professional pride and achievement. Her commitment over several years to the project points to her genuine interest in working creatively in the classroom with young people and the implications of such an approach for her practice.

THE LEARNING CONTEXT

Shona's creative approach is apparent in her use of drama to engage learners with literary texts in English, suggesting her understanding of works of literature as 'creative media that prompt affective responses' and generate knowledge production through 'material changes . . . in the consciousness of the body' (Hickey-Moody, 2009, 274), and that 'bodily activity' is 'intimately connected with both affect and intellect' (Franks et al., 2014, 172). That drama employed in this way is not perceived by the learners as special or unusual but rather a normal part of what they do when reading poetry and works of fiction in English lessons is highlighted when Shona sets up the freeze frame[3] activity in the lesson on poetry. A pupil asks, 'is it drama work?', and Shona replies, 'yes, it's your drama work'. Her use of 'your' is indicative of the responsibility for the learning that she shares with the class, and suggests that she does not view agency as something that can be possessed but rather as 'response-ability . . . the possibilities of mutual response' (Dolphijn and van der Tuin, 2012, 55) through enactment—in a literal sense here, dramatic enactment. There is no ripple of surprise from learners, no discernible change of atmosphere in terms of learners' reactions or body language to suggest that this way of working is in any way atypical of Shona's English lessons. This is unlike the reactions of learners in English lessons I observed at a different school, when teachers unused to utilizing drama as a regular part of their practice sought to introduce a drama activity. Shona is able to draw positively on both the classroom culture that she has established and reaffirmed over time and learners' prior learning through drama, for example, when she reminds them of how impressed she was with their 'strong, sculptural, statue-like freeze frames' in a previous lesson.

Nevertheless, the influence of the wider policy context is ever-present, and Shona expresses concerns about the ephemeral nature of the drama work and whether it can stand as evidence of learning in English or add any discernible

value to the writing that learners produce. The complexity of the interaction between social relations and subject knowledge in the classroom ensures that it is no simple matter for the researcher to discern the extent of such external pressures on pedagogical beliefs and practices (Jewitt and Jones, 2008). However, both of Shona's lessons are planned to end with a brief writing task, despite the fact that she has already planned for learners to engage with an extended piece of creative writing at a later point, which will fold the experience gained from their embodied composition into written composition. This suggests the tensions between spending a considerable amount of lesson time on activities related to the drama work and the perceived need for her learners to produce a tangible lesson-by-lesson record, if not of their learning, then at least of the activities that have taken place.

As an experienced and confident teacher of English, she acknowledges the potential of drama in terms of deep learning over time and of leaving this to embed rather than insisting on an instant verbalization of what learners have learnt:

> I don't think in drama-based lessons I always get them to the point at the end of the lesson where we've really teased out that 'what did we learn?', but I think sometimes that comes . . . it's what they bring back to the next lesson from having done all of that is sometimes most powerful. (interview with Shona, 3 November 2011)

Her use of drama suggests a concern for 'the experience of the whole person, of thinking, feeling "bodies in space" and how active experience "settles in the body"' (Franks et al., 2014, 177), and this is at odds with the very strong need to log, record and account for, which, as Wrigley (2014) warns, 'can distort the curriculum' (19):

> How much time can we spend on the fun stuff and how full should the book be of long pieces of writing? (interview with Shona, 3 November 2011)

This somewhat dismissive characterization of drama as 'the fun stuff', when elsewhere in the interview Shona subjects the part that drama plays in her English teaching to a much more in-depth analysis, highlights that the relationship between classroom practices and imposed discourses on schools, teachers and learners is not always a comfortable one. Detectable here are echoes of the debate around what constitutes 'rigour' (Yandell, 2013, 10), particularly in the core subject of English, which is fed at policy level by concerns about England's ranking in the OECD PISA[4] comparisons of standards of literacy.[5] Thus, teacher and learners cannot remain unaffected by the constraints of policy, with such discourses often being instantiated in classroom practice.

However, it would be wrong to assume that the teacher, and indeed the learners, are wholly without agency (Yandell, 2014), even though 'Teachers are under siege all over the world like they never have been in the past, and schools are assaulted relentlessly by the powerful forces of neo-liberalism' (Giroux, 2003, 7). Thus, for Shona a concern to justify the time spent on drama in English is translated into a matter for professional inquiry about the efficacy of drama as a way of reading a text and as a precursor to writing about it:

> And I think overall the writing on it [the text studied] is better too, they write better about the things they've played with. And that was one of the things that I tried to do a little bit last year myself, was trying to make connections between writing and things that we'd done drama work, play-based work with, I suppose satisfying myself that the outcomes on paper justified the time. And I think time is a conflict. Even at key stage 3,[6] I think time is an issue. (interview with Shona, 3 November 2011)

Embedded in this comment is a belief that dramatic play as part of textual study and reading in the English classroom is linked to progress in writing. This is a connection that has been thoroughly explored in research at primary school level (Barrs and Cork, 2001; Cremin et al., 2006; Safford and Barrs, 2005), where in-role drama work has proved to be a powerful stimulus, allowing children to adopt different voices in their writing (Barrs and Cork, 2001). Work in the creative arts, including that around literature texts, has led to 'improved attitudes to school literacy' such that children 'write with more interest and commitment, because their creative arts experiences give them something to think, talk and write about' (Safford and Barrs, 2005, 192). In addition, the findings of Cremin et al. (2006) demonstrate that the opportunity for '"seizing the moment" to write' (288) as part of their drama work around fiction texts has a positive impact on children's writing development, such that 'imaginative engagement in the tense scenarios of drama appears to help them form and transform experience and create, cultivate and effectively communicate their own and others' ideas in written text' (289).

Another powerful discourse, that of assessment requirements, unsurprisingly finds its way into Shona's classroom and is overtly referenced when she reminds learners of the grading system for their profiles that will be reported to parents/carers on academic review day. Significantly, though, her mention of National Curriculum levels 'which you'll be familiar with' is brief and almost in passing before she spends time explaining the other aspects for which they will receive credit. She focuses on 'relationships with others, your group work, your cooperation' and 'participation in lessons . . . so it's not just about being quiet and good, although that's important too, but it's also about, did you

participate, did you come up with ideas, did you get involved?' This discourse runs alongside the formal ones to do with curriculum requirements and assessment, and contains more nuanced messages about what Shona believes is important in the activities planned and how the learners might approach these:

> Remember, my biggest rule with this type of work, if I don't speak to your group, you know you're doing a brilliant job. If I come past and I'm just making notes on you and I don't actually have to speak to you, you know you're already doing a great job. (lesson observation)
>
> I might ask you to, I might say stop and show me something, but what I'm not having to do is say, what's your job, what are you doing, I'm not having to ask you lots of questions about the work because you're actually getting on. So when you see me come round your tables you need to pretty much ignore me, you just get on with the work and let me listen in, assess and judge what you're doing. (lesson observation)

While she is reinforcing a view of the English classroom and the work that takes place within it as rule-governed, the rules are to do with cooperation, sharing, exchange and interaction. This is Shona's pedagogy, but it is more than that. By her explicit statement to 'pretty much ignore me', which at first glance might appear simply to refer to operational issues, she is implicitly communicating her belief that the learners must be allowed autonomy if they are to have agency. In sharing with them a degree of responsibility for the progress of the lesson as well as communicating the high value she is placing on the collaborative process in learning about the text, she is destabilizing her role as the affecting body (Hickey-Moody 2009). The time allocated to the development of their drama—50 percent of each lesson is taken up with improvising, presenting and discussing—also communicates its importance to their learning. There is no doubt, however, that Shona remains an influential presence as the listener, the assessor and the judge, but this is not the kind of 'authoritarianism in the classroom' which 'dehumanises and thus shuts down the "magic" that is always present when individuals are active learners' (hooks, 2003, 43). Indeed, there is still a powerful sense that knowledge is co-constructed in this classroom through a dialogic intra-action of text, self, group and teacher. Her practice, therefore, does not conform to a 'banking concept of education' (Freire, 1993, 53), as she accepts that there must be a partnership between teacher and learners to promote critical thinking, and she has trust in their 'creative power' (56).

One indicator of the 'learning community' (hooks, 2003, 49) being forged here, in which all, including the teacher, must have the opportunity to 'behave and feel like creative, expert, practising artists' (Hulson, 2006, 12), is the way in which the classroom setting is physically transformed into 'a site of social

semiotic activity' (Yandell, 2008, 48). With just a few exceptions, learners stand, move between desks, approach each other, gesture to each other, make eye contact (or not), make physical contact, and so on, as Shona circulates the room, occasionally engaging in dialogue with learners.

While she is not a totally unobtrusive presence in her work with different groups, she does not dominate the space and her body language is relaxed. She acts as both collaborator and the experienced other who provides 'adult guidance' in the dynamic relationship between development and learning which is characterized by Vygotsky's metaphor of the 'zone of proximal development' (Vygotsky, 1978, 1994). Shona's 'collaborative instructional practice' (Daniels, 2001, 55) acknowledges the ability of drama to 'foster a highly particular zone of proximal development' enabling learners 'to move between their actual developmental levels whilst they are both participant and audience' (Hulson, 2006, 6–7), as well as reflecting the heuristic nature of the re-creative mode in English.

THE ROLE OF PLAY IN THE RE-CREATIVE DRAMA ACTIVITY

The physical adaptations to the classroom context, the movement of the learners and their freedom to engage without constant teacher mediation of their interactions with each other and with the text also signal that an improvisational approach is integral to the process of making meaning. Play, of the type that is regulated by and contextualized in the classroom setting (Baker-Sennett et al., 1992), is an important aspect of this in the lesson on the poem *Stopping by Woods on a Snowy Evening* by Robert Frost (www.poetryfoundation.org/poem/171621).

Shona begins by reading the poem aloud to the class, asking one pupil to briefly explain what is happening in the poem, but her expectation is that learners will go on to demonstrate their understanding of what they have read through the re-creative drama activity. She delineates the form of their dramatic representations by specifying that learners will use a combination of freeze frame, mime and choral speaking or narration, and probes their existing knowledge of these tools for making drama. Learners' contributions suggest familiarity with the techniques and also an understanding that the 'language' they will use to explore the poem reaches beyond speech.

Ricky (on freeze frame): 'When the actors stop moving in a strong powerful moment.'

Nathaniel (on mime): 'Do the action in an emotional way. When you do an action you do it in a way of using your whole body.'

Jermaine (on chorus): 'It's like a group activity.'

Nathaniel (on chorus): 'It's like someone and someone else (indicating this by placing his hands on one side of the desk then the other), it's like everyone combining each other in action, speak, emotion and um emotion together to make one kind of piece of language.'

Tom (on chorus): 'It's not just humans speaking, sometimes it can be like birds and drums.'

Thus, the poem is to be experienced playfully, materially, emotionally and collectively, and all these will combine as learners work towards understanding, interpretation and shared cultural production. The learners' comments indicate that 'In thinking about domains of theatre and drama, the concept of physicality, "bodiliness"' (Franks et al., 2014, 172) is familiar to them and that they are aware that 'Literary affect' might become 'corporeal affect' (Hickey-Moody, 2009, 275). Shona also draws on another preliminary activity during which learners have considered the differences between a real horse and visual representations of horses in cartoon and CGI depictions. She asks for an 'expert' opinion on the leg movements of a horse when running:

Elias: 'the front ones go in and the back ones . . . the front ones go forward and it sort of puts them in rhythm . . .' (he demonstrates with his arms, and uses his fists as hooves beating out the rhythm on the desk).

This focus on the movement of the horse brings about some playful responses from learners. A group that includes Elias experiment, and he shows the others some hip hop-style dance moves he might include. Erik kneels and Elias sits on his back bouncing up and down until Shona approaches them and encourages all four group members to begin galloping on the spot. Their movements in response are uninhibited and for that reason are effective in representing horses galloping. Encouraged, Elias demonstrates a shimmying movement of his head, arms and upper body to coincide with the line 'He gives his harness bells a shake,' and Shona joins in as if she is 'a student among students' explicitly seeking to 'serve the cause of [their] liberation' (Freire, 1993, 56). This enjoyment in playing with the idea of a horse and its movement, encouraged by Shona's participation, is reminiscent of child play with imitation featuring as part of the learners' repertoire. There is clearly pleasure, signalled by the laughter, in the uninhibited nature of the playing.

However, a more deliberate move towards choreographed movement takes place as the learners work together to hone their presentation, which signals the 'change of gear' that moves the playing towards its 'dramatic art form' (Bolton, 1979, 32). This is not easy to achieve (Franks, 1997), as it requires collaboration, negotiation, attention to the poem and a collective desire to

create an imaginatively expressed horse and rider which will elicit recognition from others. However, when they present to the class, it is clear from their choreography and careful synchronization of words with movement that their playing with the text has, over time and without further intervention from Shona, acquired a discipline. The hip hop dance and the shimmy are included in the presentation, and Elias is grinning at other learners, the audience, as he dances. They in turn are smiling and laughing back at him as if in recognition of this shared cultural reference which has imposed itself on a very different type of cultural artefact, the poem chosen by the teacher, in the formal setting of the classroom.

To adapt terms coined by Gillham (1974) and used extensively by Bolton (2010), the learners' presentation is indicative of how 'play for the pupil' has become 'play for the class' and this 'play for them' is the 'children's angle of connection' (xvii). The 'play for teacher', has, however, involved Shona carefully 'weaving in the components of the art form' (xvii), which Hulson (2006) describes as the skill of the teacher to bind 'the formal, the expressive-interpretive and the productive strands' (12) of learning into their drama practice.

The activity leading to the group's presentation also has echoes of Bakhtinian 'carnivalesque' (Bakhtin, 1984), heightening learners' awareness of the materiality of their bodies in relation to the other bodies that make up the classroom community, as 'classrooms are clearly "bodied spaces"' (Franks et al., 2014, 172). However, for 'boys in their early adolescence, physical contact between peers tends to be problematic and is often confined to particular modes' (Franks, 1997, 140), but this activity has enabled a different physicality to emerge through the relationship of horse and rider. Furthermore, the sharing of the experience evokes a sense of belonging, in evidence in the communal laughter. By eschewing more conventional methods of studying a poem in English in favour of play and parody, Shona has provided the opportunity for new connections to be made. Thus, the drama activity and Shona's earlier encouragement of learners' playfulness with the text have paved the way for imaginative engagement, what Hulson (2006) refers to as the teacher's 'Imagination in conference with experience' (12). That the learners feel able to engage in this way says much about Shona's pedagogical approach, which holds with the idea that drama experience is at once aesthetic, empathetic, reflective, entertaining (for others) and pleasurable (Heathcote, 1980). The multifaceted nature of the drama activity therefore makes it integral to her teaching of a literary text.

In another group, Sammy and Fariq create a horse and rider combination that sees Sammy engaging in an animated set of horse movements. Unlike in the previous example, these two are in a group that appears to find it difficult to arrive at a way of operating collectively, with all four members of the

group communicating only sporadically. Their interactions are characterized by a lack of whole group decision making. This is emphasized by the physical distance between them, particularly Joel and Duane, who remain apart from the other two. However, jointly deciding on the horse movements allows them to briefly come together to play with and explore the idea of 'horse'. In any group pursuing drama work, there are likely to be inequalities in terms of input, and the power relationships may adversely affect interactions and the formation of ideas. Alternatively, the tensions may lead to creative acts, and it is not a simple matter for the observer to discern whether the former or the latter is occurring (Franks, 1997). However, Joel's mockery of Sammy does not seem to deter him, and he becomes increasingly goal directed, repeatedly practising his choreography. Sammy adds further recognizable movements to communicate 'horse', although his human facial expressions add an anthropomorphic slant.

Sammy is keen to inform me, as I observe the group practising, that Fariq is both horse and rider, his legs being the back legs of the horse and his torso, arms and head the rider, while Sammy is the front legs, torso and head of the horse. It is unclear as to whether this is his own or a jointly agreed representation of their horse/rider combination, but its shared embodiment is suggestive of a pantomime horse as well as of horse and rider games in the school playground, perhaps played at a younger age but nevertheless a reference point. It might also be influenced by the puppetry in the stage adaptation of Warhorse, the novel that the learners have been studying. These are cultural references for 'horse' that he can share with his peers. Sammy's commitment to and the pleasure he clearly gains from repeatedly practising his choreography indicate his deep involvement in this 'play for the pupil' in which his 'desire' acts as 'the force or drive towards expression and creativity' (Franks, 1997, 134). This is somewhat different to his attitude in other English lessons where I have observed his quiet disengagement from discussions and written work. Here, even when Shona begins to call the class back to attention, he excitedly indicates to Fariq that he wants to practise their routine one more time.

In both of these vignettes the learners' play is in alignment with the 'play for the teacher' which has been determined by her pedagogical goals and by the components of drama she has chosen for shaping and structuring the presentations. The literary study is approached with recourse to the affective, sensory and at times sensual nature of anthropomorphic tropes in literature, and the idea of searching for the humanity in the (ultimately unknowable) animal as a way of reflecting on the human condition. At the outset of the lesson, Shona has explained that learners will be working on ways to think like an animal, trying to get inside its head, to consider what it is like to be one, linking to their recent reading of *Warhorse*. To do so, she encourages them to try out evoking a horse through physical embodiment, for as Eagleton (2003)

suggests, 'our bodies are materially geared to culture—because meaning, symbolism, interpretation and the like are essential to what we are' (159). Having a body is 'like having a language' and 'is a way of being in the midst of a world' (166). In the lesson on *Stopping by Woods on a Snowy Evening*, the activity that Shona has instigated draws on the cultural reference points in the world of the young people, and it is largely through the body that these learners discover and signify a horse. This, in embryonic form, seems to be what Nathaniel is suggesting in his comments quoted above about the emotional nature of action, particularly collaborative action, and in his assertion that a type of language is created by combining action, speech and emotion.

RE-CREATION AND RE-ENACTMENT

Within the constraints of the dramatic form specified by Shona, the playfully re-creative relationship between the learners and the poem is demonstrated in different ways by the various groups in the class. The group comprised of Joel, Sammy, Fariq and Duane choose to adapt the narrative to satisfy their own desire to compose and to create character, making the shadowy owner of the woods an embodied presence, inventing dialogue for him and resolving the journey of the horse and rider in a way that is absent from the poem. Rather than viewing this sequence as a misinterpretation, Shona acknowledges it as an act of remaking, a challenge to the notion of sole authorship which is encouraged by the way in which she has actualized the study of the poem through affect as well as intellect. Playing physically with the text has engaged the learners with it, and has enabled re-reading and interpretation. This is demonstrated in both Joel's drive to create context through character and Sammy's blurring of animal and human gestures in a way that is entirely in keeping with the poem narrator's anthropomorphic attribution of particular thoughts to his horse.

However, in dealing with the different anthropomorphic approach of the novel *Warhorse*, in which the horse is the central character providing the voice of the narrator, Shona effects another way into the drama work. She focuses on an episode in which Joey, the horse, is trapped on his own in no man's land during a scene of trench warfare in World War I. Both sides raise the white flag to allow one soldier from each army to rescue him. A flip of a coin determines that the Welsh soldier will claim him. As her entry point into this scene, Shona asks for an affective response and does not mention re-enactment when she sets up the drama activity. Instead, she encourages learners to engage with the emotions that Joey would be feeling in this situation and asks them to create a freeze frame to represent these emotions from a list they generate.

This move to a more symbolic still image representation—of emotions rather than events—might suggest her concerns about the value of retelling simply to animate narrative (Byron, 1986). However, it is arguable that retelling can ever merely replicate (Bruner, 1986). This is illustrated by the response of Elias, Erik, Rudy and William. They immediately become very engaged with the scene as depicted in the novel, settling into the physicality of their roles. Erik folds a piece of paper with concentration, and holds it in the air as a white flag. He sinks to his knees then all the way to the ground in a very controlled manner, almost in slow motion, while holding the flag aloft and staring at it. As he is sinking, he allows the paper to flutter downwards in his hand. He immediately jumps upright and holds the flag high in the air again. He is very precise in practising these positions.

Rudy also wants to raise a flag, and so takes a piece of paper from me. He and Erik position themselves equidistant from Elias as Joey. The picture created is of the different sides in the war, with Elias trapped in no man's land between them. Rudy and Erik hold their flags aloft, taking great care over their positioning in terms of the exact distance between them and mirroring the way in which they hold the flags. Shona calls the class to attention, and they quickly practise the holding of their flags aloft one last time—the stretch of their arms is very exaggerated as if indicating that the flag needs to be high enough to be seen from a long distance away and the tension in their arms and bodies suggests the importance they attach to the action. When they later present the freeze frame to the class, William is positioned watching the scene and apparently recording it in a notebook.

This exploration of a scene from the novel through drama activity suggests the link between an affective and analytical response to literature in reaching an understanding of the power of narrative. Indeed, for these learners there is clearly something very powerful—symbolic rather than simply representational—in the act of holding the white flag aloft. The action, and the way in which it is meticulously reproduced and then presented, shifts the perspective from the horse (always present in the first person narrative of the novel) to the two soldiers holding the flags. Bruner (1986) notes the reader's psychological capacity to identify with the characters and relate them to characters we 'carry unconsciously within us' (4). Thus, when the other learners offer their readings of the freeze frame during whole-class feedback on the presentation, they imbue the characters with feelings and concerns that might be taken from the novel but also from their wider knowledge, for example, by suggesting that William could be an eye witness and that he is saddened, scared and wanting to get away from the anticipated violence.[7]

The compelling nature of the narrative that has so engaged Rudy and Erik demonstrates that the text is not inert; it has materiality and agency and 'a relationship of co-responsibility' (Bolt, 2013, 6) with the learners as

cultural producers. The narrative not only enables them to interpret 'the land-scape of action' but also brings them to an understanding of 'the landscape of consciousness: what those involved in the action know, think, or feel, or do not know, think, or feel' (Bruner, 1986, 14). Thus, texts are only fully realized in the moment of reading, and reading is therefore a dynamic act (Bruner, 1986, referencing Iser). The learners' 'telling back' (6) of the story melds the act of reading with the act of improvising as they develop their constantly shifting 'virtual text' (7). What emerges is a dynamic group read-ing rather than any one individual's intra-action with the text. The ideas of the different members of the group may jostle for dominance at different times (Franks, 1997), but eventually they converge and cohere.

CONCLUSION

The pedagogical approach apparent in these lessons suggests that Shona regards the classroom as an uncertain and dialogic space, in which art making is a 'socially and culturally mediated'(Barrett and Bolt, 2013, 4) act produced not just as a result of the linguistic turn but through practices, which 'engage the matter of bodies' (5). Here 'the formal curriculum' can encounter and even negotiate with 'the cultures of learners' (Jones, 2003, 145), resisting those aspects of policy which seek *'to redefine "culture" itself'* and con-trol 'from above' (145–6). Through drama, the learners in Shona's English lessons are able to draw on their own cultures in their engagements with character, linguistic effects, and the use of literary tropes such as metaphor, and in the case of the lessons I observed, anthropomorphism. These encoun-ters 'evoke zestful imaginative play' (Bruner, 1986, 4) as the wellspring of cultural production. Thus, drama is at the very heart of the learning that takes place, and as such has a fundamental place in Shona's understanding of the epistemological scope of her subject. Her realization of this has emerged over time through the praxis of her developing pedagogy. Although, she admits, she did not fully appreciate the importance of dramatic practices during her initial teacher education, what she has learnt since has subsequently become embedded in her practice. As Neelands (1992) has suggested, it speaks to the value system of the teacher who decides 'to adopt drama into her repertoire of teaching styles' (9) as an integral part of the shared creative and cultural resources of the classroom and as a way of enhancing language and literary learning.

The drama activity in the observed lessons indicates Shona's understanding of the complexities of literary learning and of 'the processes of reading and entering a story' (Bruner, 1986, 4), as there are multiple ways of reading a literary text. Her methods are suggestive of Barad's (Dolphijn and

van der Tuin, 2012) notion of diffractive reading, whereby such readings 'bring inventive provocations; they are good to think with' (50). The act of re-creation serves to stimulate the readers' interpretative processes, but through their imaginative responses to fiction, here externalized in the dramatic mode, the learners also have a means of expressing their rich emotional lives (Vygotsky, 1994). Dramatic activity lends an immediacy to the imaginative experience of fictional texts and is well placed to meet those aspects of the re-creative mode to do with 'restoring and licensing sensuous pleasure in engagement with text' (Knights and Thurgar-Dawson, 2008, 71). Pleasure and the role of desire in learners' dramatic engagements with text (Franks, 1997) are explicitly linked to the Vygotskian formulation of imagination in adolescence (Vygotsky, 1994). Franks (1997) suggests that drama in schools, by legitimizing adolescent play, externalizes and gives embodied form to inner desires which are dynamic, socially orientated and responsive to context. In these circumstances, the dramatic activity is simultaneously immersive and self-aware. The learners are emotionally engaged in the act of fiction making and as audience to their own creation are also critically engaged (Bolton, 2010) in a 'respectful, detailed, ethical' manner (Dolphijn and van der Tuin, 2012, 50). Immersion and self-awareness are both necessary components of the re-creative activity in Shona's lessons, and her practice encompasses the playful qualities of the learners' dramatic responses, utilizing these to pedagogical effect.

Thus, in playing with and re-creating the source text through intra-actions between self and text, learners are able to create a physical palimpsest, positioning themselves with the author in an authoritative way, as well as authorizing (Jones, 2003) their own shared knowledge and interpretations. The drama work encourages 'critical awareness and engagement' such that the learner is 'an active participant, not a passive consumer' (hooks, 1994, 14), and ensures that the reading of literary texts in this English classroom is an act not of cultural transmission but of cultural production, as learners are able to entangle their own experiences with those of the classroom to unlock the possibilities of reading.

NOTES

1. Name changed to protect identity.

2. The Creative Partnerships programme was designed to bring creative workers such as artists, architects and scientists into schools to work with teachers. It worked with over 2,700 schools across England from 2002 to 2011, at which point Arts Council England withdrew funding.

3. Also known as still image or tableau.

4. The Organisation for Economic Co-operation and Development: Programme for International Student Assessment.

5. See the foreword to the Government White Paper, *The Importance of Teaching*, November 2010.

6. Key stage 3 refers to 11- to 14-year-olds.

7. Protests in Tahir Square in the revolt against the government in Egypt were being reported daily at this time.

Chapter 6

'Let me change it into my own style'

*Cultural Domination and Material Acts of
Resistance Within an Inner City Dance Class*

Camilla Stanger

A clear and pleasurable experience of ethnic identification is apparent in this young woman's expression of her relationship to Nigerian dance. Indeed, a sense of belonging to and consciously performing a specific ethnic identity was visible for many students attending Egypt's inner-London college, the context for this study. This college is located in an ethnically diverse area of South East London and provides a number of academic and vocational courses for young people between the ages 16 and 19. During the time this research project took place (2009–2010), its student demographic comprised a majority of young people who identified as black, either of Caribbean or African heritage. Teaching in this college over the course of three years, I noticed a sense of pride and pleasure that many of the students took in displaying their particular ethnic heritage: from the clothes joyfully worn during Diversity Week celebrations, to the classroom quarrels that would erupt over which was the best team in the Confederation of African Football league, to the snapshots of music and dance that were often played and performed in the college leisure areas.

As Egypt's words indicate, however, the relationship between 'ethnicity', cultural practice and identity is complex: she suggests that the meanings of cultural practices are multiple, to be taken up differently by different people even within the same family; she also categorically asserts that Nigerian dance is 'something that was me', with connotations of an ingrained ethnic identity, while in her statement regarding 'contemporary' dance (to be elucidated later), she reveals how much she clearly values the opportunity to 'be anything'. This idea, and rhetoric, of being 'anything' could be read in terms of what Ringrose (2013) describes as a 'neo-liberal ethos' (3) within a particular 'theorisation of late modernity' (3): an ethos in which the project of the individual is one of necessary reinvention 'towards the goal of marketability

and consumption' (4), through which the desirable subject is marked by flex-ibility and capacity for (entrepreneurial) innovation. While such an impetus is traceable in Egypt's goals for herself as a young woman striving towards Higher Education and employment in the twenty-first century, I will be read-ing her desire to 'be anything' in a different sense: namely, as a desire to draw upon the variety of cultural resources available to her to enact a hetero-geneous cultural identity (and corresponding agency) that is unique to young people who occupy and create multicultural spaces and practices.

The research question to which this chapter responds then is: how can educators within ethnically diverse settings develop pedagogies that do not oppress a young person's need to be categorically 'me' (which Egypt asso-ciates with one particular ethnic heritage) but still grant them the creative freedom to be 'anything'—not the arguably unreachable 'anything' of the 'neo-liberal ethos', but the 'anything' of the multifaceted identity of multi-cultural youth?

In order to articulate the nature of this multifaceted identity, it is useful to turn to the work of Stuart Hall (1996), who argues that the concept of identity necessarily implies 'the question of *identification*' (12); for Hall (1996), identity is never a fixed category to which one unequivocally and 'naturally' belongs, but is a process of construction, 'a process never com-pleted' (10). Identification therefore leaves room for change, transformation and, fundamentally, difference; it also leaves the (often much desired) room for possibility—the possibility to 'be anything'. In alignment with this, Hall (Nelson et al., 1991) defines culture as a 'set of practices, representations, languages and customs' (57), and it is with this understanding of the word 'culture' that the phrase 'cultural identity' will be employed in this chapter to denote the idea of an ethnic identity as a process of participation. The term 'cultural identity' in this sense implies not a rooted homogeneity, but rather the possibility for a fluid and moving heterogeneity.

Theorists such as Bhabha (1996), Cohen (1997), Hall (Woodward, 1997) and Dash (2010) have discussed this understanding of a fluid cultural iden-tity in the context of our increasingly globalized world—one that is both deconstructed and (re)constructed by processes of migration and immigra-tion. In this respect, heterogeneity within cultural identity will be, if not more present, at least more visible in locations and subjects where more than one set of cultural practices and norms collide and so inevitably enter into some kind of dialogue. Indeed, Dash (2010) cites Gilroy in his reference to the 'travelling standpoint' of diasporic (specifically black) subjects, a stand-point which produces a 'cultural view predicated on the notion of fusion and mobility' (177). Here, the individual's participation in cultural practices in addition to those of their heritage culture leads to identification processes such as 'hybridity, collage . . . bricollage[sic], creolisation . . .' (Dash, 2010,

citing Morley, 2000, citing Ignatieff, 1993). Within this understanding of cultural identity, young people such as Egypt can be in a position to identify as Nigerian if they choose, but at the same time have room to explore being 'anything' else.

So what are the implications of this for how we should view the cultural status and educational needs of young people, particularly those who participate in diasporic as well as dominant cultural practices, and live in culturally diverse areas? It is useful here to draw on Cohen's (1997) citation of Vertovec:

> Aesthetic styles . . . and other cultural phenomena are more globalised, cosmopolitan and creolized or 'hybrid' than ever before. *This is especially the case among youth of transnational communities*, whose initial socialization has taken place within the cross-currents of more than one cultural field, and whose ongoing forms of cultural expression and identity are often self-consciously selected, syncretised and elaborated from more than one cultural heritage. (128, my emphasis)

The young people[1] to whom Vertovec refers can be viewed as cultural producers—major players in generating hybridized, and therefore new, cultural practices. These young people are not just participants in culture, but are ideally placed as transformers and creators of culture. This is facilitated through their early encounters with a variety of cultural practices as inhabitants and 'natives' of culturally diverse geographical locations, and through a consequent ability to move in the 'in-between' spaces (Bhabha, 1996, 54) created by the collision and intermingling of 'diasporic' and 'dominant' cultural practices. It is also facilitated, more generally, through their use of globalized forms of media communication and participation in teenage subcultures (McRobbie, 1991; Hickey-Moody, 2013). Such young people then are potentially placed as cultural arbiters and creators, who can draw on a variety of different resources and make use of a wealth of cultural capital. The role that material cultures—especially arts practices—play in all this is significant: as Hickey-Moody (2013) states within her exploration of youth, arts and education, 'young people live through art . . . the ways young people make and consume art articulate their voice' (1). If the 'voice' some young people have to articulate is rooted in a heterogeneous and globalized cultural identity, it will be the case that their arts practices can 'become intelligible [and powerful] as a form of global cultural citizenship' (91). Ideally, then, the design of pedagogic practice within schools acknowledges this multiple and creative cultural agency, and the (often aesthetic) ways in which young people tend to express it.

The reality of social life for many of these young people, however, does not always indicate a state of empowerment regarding the contributions

they make and the cultural status they hold. In the wake of the August 2011 riots across England, there emerged increasing rhetoric concerning the idea that young people from economically deprived and largely minority ethnic areas[2] did not have a 'stake' in society (Miliband, 2011). Furthermore, there is extensive research indicating that the British education system and its distinctive culture disadvantages young people who do not identify as White British and middle class (Mac an Ghaill, 1988; Gaine and George, 1999; Youdell, 2006; Archer et al., 2010). One particular proponent of this view-point is David Gillborn (2005), who refers to a state of 'white supremacy' within British society and its education system (485), namely, the institution-alization of white (and I would add middle class) advantage through wide-reaching structures such as assessment procedures and criteria, curriculum content and ethnic diversity within teaching staff. In light of this body of research, it would seem that the British education system may offer a largely homogenized version of knowledge and learning that does not cater for a heterogeneous creativity and cultural agency. With this in mind, it would be the task of educators within this system to find opportunities to facilitate and support the expression of such agency in the face of dominant, and potentially dominating, homogeneous discourses.

A pedagogy of resistance then, one that enables heterogeneous cultural agency without oppressing minority cultural practices, is what this chapter seeks to engage with. I explore this via the analysis of one young woman's learning experiences in her first year of an A Level Dance[3] course at the col-lege referred to earlier. I read her experiences in light of Paulo Freire's (1993) concepts of oppression, liberation and dialogics within the development of a 'pedagogy of the oppressed' (35). I read Freire's (1993) terms 'oppression and the oppressed' here in terms of a situation of cultural 'white supremacy' within British education, in which the diversity and fluidity of some students' identities can go unacknowledged, or worse still, suppressed. I argue that throughout the dance course, Egypt moved through an initial stage of (partial) oppression—in which she was at times trapped by a homogenized and 'white' version of knowledge—to a stage of (partial) liberation, where this homog-enization of culture was resisted, and her unique creative cultural agency was drawn upon and freed. The pedagogic practices which led to such a pattern will be analysed with reference to Paul Dash's (2010) work on critical art education for black, inner-city students, and theorized in light of Rebecca Coleman's (2009) work on the relationship between girls' bodies and images. This discussion will be developed by ideas in the field of feminist new mate-rialism regarding the material agency of the (raced) body, and nuanced by the work of Sara Ahmed (2002). In this, I seek to articulate a dance pedagogy that can be seen as a material act of resistance against—and a space for transfor-mation in the face of—a dominant (colonial) aesthetic discourse.

THE CASE STUDY

One student was interviewed for this study in July 2011. Egypt (a pseud-onym of her choice) was 18 years old at the time of interviewing and studied AS4 Dance in the academic year 2009–2010. She describes her ethnicity as 'Black British African'. Her parents are Nigerian nationals and she was born in the United Kingdom, and living in East London at the time she was studying at college. There were two teachers on the A Level Dance course at this time: myself and Etta. We describe our dance and ethnic backgrounds as follows:

> *Camilla:* I describe my ethnicity as White British. I trained mainly in classical ballet with the Royal Academy of Dance and have more recently started attending short courses in contemporary dance styles. I have also started to learn techniques in street dance and West African dance styles.

> *Etta:* I describe my ethnicity as White European. I trained primarily in forms of contemporary dance, focusing on Release and Limone techniques at the Laban institute of contemporary dance.

The AS Dance course was structured into two halves. Up until Christmas, the students studied a (brief) history of the key North American and Euro-pean theatrical dance styles, which was delivered via theory and practice. We spent 4–5 weeks on each style, moving in (a somewhat artificial and implicitly colonial) chronological order: classical ballet, contemporary styles[5] and (a shorter time spent on) North American jazz and tap. We studied two existing dance works: Petipa and Ivanov's (Nears, 2006)[6] and Bourne's (Bourne, 2008)[7] versions of *Swan Lake* (classical ballet and ballet–jazz fusion styles, respectively). The students were also introduced to various choreographic techniques. After Christmas, the students continued having regular technique classes in contemporary dance styles, but also started experimenting with their own choreographic practice. They each devised a 3-minute piece of solo choreography in response to a stimulus question. They then rehearsed and refined this piece in preparation for their practical assessment.

Our aims in designing the course were not only to increase the students' enjoyment of and proficiency in dance studies but also to allow them to access the highest marks possible in assessments. It became apparent after working the parameters of the A Level Dance syllabus for two years that it, to a certain extent, benefitted students whose experience was rooted in white, 'Western' theatrical dance traditions: this something that Egypt experienced quite acutely, and painfully, during the first part of the course.

THE FIRST HALF OF THE YEAR:
A PEDAGOGY OF OPPRESSION

A key way Freire (1993) characterizes oppression is as the lack of freedom and power to draw one's own meaning from and bring one's own meaning to the world: a world that has already been defined by the oppressor. For Freire (1993), the oppressed should be engaged in a 'struggle to have meaning' (26) but also to 'create meaning' (50). Learners will therefore become oppressed when they are disempowered within the process of meaning making that constitutes learning—especially in a context of cultural domination. Throughout the first part of the course, Egypt experienced a lack of opportunity to bring cultural meanings and interpretations to dance class because 'dance' had already been, to a certain extent, defined and homogenized within the context of a white, 'Western' theatrical tradition—a tradition to which she had not had much access. This can be seen as she discusses the gap between her expectations and the reality of the course:

> *CS:* 'What were your expectations of A Level Dance? What did you think you were going to be studying in it?'
>
> *E:* 'Um, I thought there would be African elements to it—but I just really wanted to open my eyes to all types of dance . . . I kind of got what I expected to be honest.'
>
> *CS:* 'And what main styles did we learn in A Level Dance?'
>
> *E:* 'Oh God, we done ballet at the beginning, oh God *[laughs]* and I think our main styles were ballet and contemporary. . . . But I would really hate [the ballet technique classes at the start of the year] because I thought other people in the class would be thinking "What's she doing in the class? She doesn't know how to do ballet!" Because if you're going to be a really good dancer, you should, not be able to do ballet, but be able to do the basics, right? And I just really hated that lesson because I felt really, like, silly . . . like, "did I really actually pick dance—I think I should have picked something else". . . . I was kind of like, embarrassed.'

Egypt came to the course expecting to study dance that she knew and that made sense to her. In reality, her concepts of dance were not represented on the curriculum in any recognizable form. Freire (1993) discusses the perils of ignoring students' 'views of the world' in designing educational programmes for the oppressed (74–5), and Dash (2010) gives an example of just this in what he calls the 'Eurocentric model' (64) of teaching art history. This entails the chronological (and so neatly homogenized) presentation of artistic movements/styles, all 'tethered' to a Western 'anchor point' (Dash, 2010, 64), in a way not dissimilar to the 'history of dance' these students received early

in the course. This Eurocentric and homogenized presentation of dance was antithetical to Egypt's diasporic, urban and heterogeneous cultural identity on every level. Indeed, it appears that at certain points, Egypt's response to this 'perspective on truth and reality' (Dash, 2010, 71) was a sense of disenfranchisement as she identifies moments of embarrassment early on in the course where she questioned her decision to study and even carry on dancing.

Egypt also exhibits a concerning perception that the course was still what she 'expected' as an introduction to 'all types of dance', despite the fact that it did not provide any direct study in the 'African dance' she had anticipated she might learn. This comes as little surprise when we see her notion that she had no knowledge of dance prior to the course, or that the knowledge she already held was not of value:

CS: What was your experience of dance before you started the A Level Dance course?

E: It was nothing really, just little things I did with, like, secondary school, I done stuff with contemporary but it wasn't that technical. I came with no proper dance experience at all really.

CS: What about your experience with African dance styles?

E: Oh. Well, when it comes to *African* I done it since primary school, in after school classes, and I just done it whenever I could, like in the holidays and sometimes by myself . . . oh and I done a performance in Hackney for Nigerian independence. Yeah, it wasn't really African as in whole African, but it was Nigerian dance. . . . I did it with my family when it came to parties—but I also always done it separately.

Here I had to ask Egypt directly about her experience in African dance styles before she realized this even counted as a valid answer. Freire (1993) discusses the definitions and perceptions of knowledge within oppressed communities, stating that '[the oppressed] call themselves ignorant and say the "professor" is the one who has knowledge and to whom they should listen. . . . Almost never do they realize that they, too, "know things" they have learned in their relations with the world' (45). Egypt was faced with not only a curriculum but also teachers who represented and embodied dance practices that are rooted within white western traditions; we can see how her perception of what counts as dance knowledge and experience has become shaped and somewhat bounded by this. In this respect, her ability to both 'have meaning' and 'create meaning' was certainly hindered.

This state of perceived ignorance was compounded by one of the main teaching approaches taken in this first term, one that left little room for different forms of knowledge to be counted and new forms of knowledge to emerge, and is similar to what Freire (1993) refers to as the 'banking' concept

of education (53). This has also been articulated by Atkinson and Dash (2005) in relation to art education in British schools: 'A major emphasis is upon the acquisition of skills. . . . The teacher often demonstrates the skills to be acquired and guides pupils as they attempt to achieve them'. In this traditional approach, the teacher is considered to be 'the subject supposed to know' (xi). In the context of dance teaching, this relates to the dance technique classes, which rely heavily on teacher demonstration followed by student imitation. It is these classes that Egypt expresses quite vivid memories of:

> *CS:* Were there any classes you remember doing and feeling that you weren't enjoying it?
>
> *E:* Oh [laughs] I remember these evening classes we did on, like, a Monday, these long lessons and we were doing ballet—we were doing technique, holding onto the side of a chair. . . . I, like, hated that lesson so badly. I felt so stupid, like 'I don't know how to do this—this looks really silly on me.'
>
> *CS:* Could you explain that more?
>
> *E:* I felt really silly—I, like, hated it because I felt like, oh my gosh [my movements look like] the worst thing ever. Ballet was kind of like—you had to look—that was what I didn't really like, that you had to look a certain way. . . . You'd have to be really skinny and have very straight posture, you have to um be very elegant and very calm—I definitely didn't fit ballet [laughs] . . . at the beginning of last year, I was trying to imitate [other students in the class who had received prior ballet training] because they were the best dancers—so I was always trying to dance to their way of moving, like to do ballet.

It is clear that at this point in the year, she felt she should embody a balletic model in order to be 'good', citing other students to whom she should aspire, or even 'imitate'. Indeed, Freire (1993) highlights a common desire of the oppressed to seek power and success through 'identification with the oppressor' (28), and a metaphor he employs to articulate this is extremely apt for the context of dance teaching: [the oppressor] imposes his own contours on the vanquished, who internalize this shape and become ambiguous beings 'housing another' (119). Egypt felt 'uncomfortable' in her attempts to embody the 'shape'—the precise bodily configurations and movement styles—that she had been shown as an ideal form. Furthermore, Egypt's use of language suggests a real sense of physical dissociation from these 'contours' when she states 'this looks really silly *on* me' (emphasis mine).

This does not, however, lead her to question the symbolic value associated with this bodily configuration, but rather leads to a sense of self-loathing directed towards her body—taken in isolation, Egypt's words do not explicitly communicate feelings of negativity towards her own body, but they should be taken against the backdrop of certain behaviours I remember her

displaying in ballet technique classes, for example: looking at herself in the mirror and groaning, or exclaiming in frustration, 'Miss, I just don't look right'; holding and once even slapping herself on the behind, then referring to the fact that it was too large, or 'stuck out' too much. Egypt's experience of her body here can be elucidated with reference to Coleman's (2009) work on the relationship between girls' bodies and the images they are confronted with daily (with Coleman's key examples being photographs, mirror images and images circulated within and by mainstream media). Central to Coleman's (2009) findings here is that 'bodies are becomings' (48), namely, and in alignment with the notions of diasporic identity discussed earlier, no body is fixed in one material and semiotic state, but is rather always in a process of change and development—in and through its relation to other bodies and, crucially here, to images. As emerges clearly in Coleman's (2009) research with young women, 'bodies and images are not independent, bounded beings but . . . are constituted through, their transformative relationality' (48–9). This analysis certainly sheds light on Egypt's experience of her body in ballet class.

In this context, Egypt was surrounded and confronted by a number of images of bodies: that of the (ballet-trained) teacher, those of other (ballet-trained) girls in the class, those of the professional dancers on the ballet DVDs she had been shown—and then the mirror image of her own body, schooled primarily in Nigerian dance styles. In the context of—and in interaction with—these images, Egypt's body, as viscerally experienced by her, 'becomes' something uncomfortable, something inadequate, something not 'right'. This is because Egypt's dancing body here is 'known, understood and experienced through images' (Coleman, 2009, 19) of an idealized body—an ideal defined by the corporeal aesthetics of classical ballet. Through these specific corporeal aesthetics, Egypt's bottom in particular takes on a negative significance—it becomes not a muscle group to employ in the achievement of a dance movement nor a contour to employ in the achievement of a dance aesthetic, but rather something that just 'sticks out too much'. Ultimately, this leads to a sense of Egypt—her body, or this particular image of it—being 'out of place', a phrase she uses elsewhere to describe her feelings in this class. This is reminiscent of Ahmed's (2002) vivid discussion of the construction (and deconstruction) of the black female body via the normative white male gaze, taking the commodification and objectification of Sarah Baartman[8] (specifically her bottom) as an example. Ahmed (2001) explains a process through which this body becomes not only a collection of body parts to be gazed upon, but a 'grotesque and monstrous' (53) body, rooted in a notion of its 'excessive sexuality' (53), in contrast to the 'purity' (52) of the white, female ideal. Ahmed (2002) goes on to discuss the resulting ways in which black bodies can become ejected from white-dominated spaces: spaces that are shaped and legitimated by the white gaze, and images of whiteness,

through which black bodies become objects of fear, desire and disgust. Egypt's emerging feelings of disgust at her own body and subsequent feelings of displacement within the ballet class can certainly be understood in these terms.

The ways in which Egypt talks about her body here—as the site in which she experienced these processes of cultural oppression—are significant. In order to further theorize this, it is useful to turn to the ideas of feminist new materialism, as articulated by Van der Tuin (2011) and Bolt (2013). Both theorists explain how a recent 'material turn' (Van der Tuin, 2011, 1) in academia has seen the welcoming of analytical frameworks that place the material (and lived) reality of the body as a central concern when exploring the operation of social and political processes. Van der Tuin (2011) critiques the conceptualization of this turn as a movement opposed to the linguistic turn, and reviews a number of texts in this field that grapple with ways that matter and human semiotics inter(and intra)act to produce bodies and meanings. Bolt's (2013) text is one of these, and in it the author takes up this discussion to boldly assert that 'at the core of the material turn, is a concern with agential matter' (3), that is, matter that is not passively and inertly marked into definition by human discourse, but matter that inter-acts with and indeed shapes social and political modes of understanding. In this, subjectivity is both corporeal and constructed linguistically, and so the 'I' is to be conceived of 'as a material-semiotic actor' (Bolt, 2013, 3). This useful phrase can be traced back to the work of Haraway (1988) in her seeking of a feminist epistemology—one that theorizes 'how meanings and bodies get made, not in order to deny meanings or bodies, but in order to build meanings and bodies that have a chance for life' (580). This effort to deny neither the discursive ('meanings') nor the material ('bodies') leaves spaces in-between—spaces in which we are able to understand Egypt's experiences in this dance studio, in alignment with Coleman's (2009) ideas about the 'enfolding' of images and bodies. The material reality of the bodies surrounding Egypt in this class, with their specific contours and comportments produced through a particular cultural aesthetic, acted upon Egypt's (image of her) own body, producing its meaning as inadequate ('I didn't fit . . . I should have picked something else'), and also limiting its physical capacities ('I don't know how to do this'). In this context, each body was both 'structuring and structured', each body here was a 'material-semiotic actor' in so far as, it was simultaneously an 'object of knowledge' but also 'an active, meaning-generating part of apparatus of bodily production', producing itself and other bodies around it as 'right' or 'not right' through its corporeality (Haraway, 1988, 589–95).

In these respects, the earlier notion of 'cultural identity' as determined by one's participation in a 'set of practices, representations, languages and customs' (Hall in Nelson et al., 1991, 57) needs to make room for the physical,

material body's role within this process: not only the ways in which the body becomes (actually and physically) marked by its cultural practices, but the ways in which cultural practices (and therefore subjectivities) are produced in and of the materiality and agency of bodies. Through Egypt's interviews, we can see this interaction between her participation in cultural practices and the material reality of her body: in how her understanding of ballet as a cultural practice ('you'd have to be very skinny and have very straight posture'), her sense of cultural alienation ('this looks silly on me') and a final sense of cultural inferiority and shame (slapping herself on the behind) are all experienced through her own and others' bodies. Indeed, Hames-Garcia (2008), also writing in the field of new materialism, discusses the need to reconfigure the ways in which we understand the impact of racial identity on an individual: he proposes that 'race' should not be merely dismissed as an abstract linguistic classification arising from colonial discourse, but that it could be understood as 'something complexly arising out of interactions of biology and culture' (313). This understanding leaves room for 'the material-economic', 'social and psychological' and 'physical' reality of race (Hames-Garcia, 2008, 321) and therefore the ways in which it is lived. Indeed, understanding how 'race' is actually, corporeally lived is of key concern to a number of black feminists (Ahmed, 2002; hooks, 2004). As Ahmed (2002) makes clear in her discussion of the racialization of bodies, to deny the lived reality of 'race' in light of it being a historical and discursive construct, would be to deny processes of racism that many experience. In alignment with these concerns, it is clear to see how Egypt viscerally lived (and suffered) her racial identity as a young black woman in the context of the classical ballet class.

So how can these feminist new materialist understandings make way for the concepts of cultural domination and resistance, key to the pedagogic practices analysed in this article? Hames-Garcia's (2008) work certainly takes up the ways in which the material reality of bodies both produces and is produced by historical power struggles—specifically ones concerning 'race'. To elucidate this further, it is useful to turn to the words of Barad (2008), who discusses 'the body's historicity, in which its very materiality plays an *active* role in the workings of power' (128). Barad (2008) draws on the work of Foucault to assert that 'crucial to understanding the workings of power is an understanding of the nature of power in the fullness of its materiality' (128). For Barad (2008), this 'fullness' can only be grasped through attendance to the 'host of material-discursive forces' that 'materialize' (128) subjectivities in certain power-imbued ways. Indeed, we have seen here how the material reality of Egypt's racial identity, experienced in the context of a curriculum marked by 'white supremacy' (Gillborn, 2005), led to feelings of alienation and disempowerment, despite her desire to transcend a fixed racial identity and have the freedom and power to become 'anything'.

WORKING TOWARDS A SOLUTION

Freire (1993) states that 'when they find themselves unable to use their faculties, people suffer' (59). There was certainly a sense that early in the year, Egypt was unable to use her cultural faculties and even appeared to forget she possessed them at certain points. We can also see that she suffered—especially in her experience of her body (through a particular image of it) as a burden of sorts, anchoring her into the position of 'out of place' in the ballet class, and thus thwarting of her desire to become 'anything'. So, what could a pedagogical solution be? There is clearly a need for some explicit deconstructive work here in relation to the curriculum, in alignment with an anti-racist approach to education (May, 1999). However, the following conversation with Egypt is interesting in this respect:

> *CS:* Do you wish we hadn't done all those ballet technique classes?
>
> *E:* Oh no no no no. I'm glad we learned ballet because it helped, like, it all helped—it helped with your posture and with making different movements look structured and elegant. I've never wished we didn't do it, I'm glad we did it—it's good that we learned about different things. As I know about African, and I know about contemporary now and I know about ballet.

Here, Egypt proudly articulates her dance knowledge as something that is varied and diverse. She does not seem to subscribe to Freire's (1993) idea that she may be falsely 'housing another', but has, to extend the metaphor, made room for this bodily configuration within her repertoire and bodily capacities. So, a method of deconstruction needs to be found that doesn't homogenize racism into a 'white-black dichotomy' (May, 1999, 2), with cultural practices being situated in one of two camps: practices to be dismantled and practices to be valued. It would not do to prevent students from ethnic minorities from learning and drawing on 'white' dance practices as sources of cultural capital within the composition of their heterogeneous cultural identities.

The need for more varied cultural representation within this dance curriculum is also clear, in alignment with a multicultural approach to education (Dash, 2010). However, critics of this approach have highlighted its potential for a superficial and homogenized treatment of cultures and a somewhat token approach, which does little to address and dismantle power inequalities (Dash, 2010). Indeed, Egypt expresses major dissatisfaction with the fact that she and another student performed a piece of (in her words) 'commercial' Nigerian dance at a college performance:

> I thought—ok, yeah, I got my little piece . . . but I really wanted to do a big, proper, fast-paced African thing, and for it to be a proper little story of different

types of dancing and the dance we done was so commercial, I wasn't really happy with it. I really wanted to do a big . . . thing, taking lots of different elements, so everyone would be like, wow.

I interpret Egypt's frustration here as directed not only towards the token role a Nigerian dance style played in the show, but also towards the lack of heterogeneity within it. So, for a pedagogical response that does not homogenize culture and ignore the students' multiple cultural agency and creativity, I turn to Freire's (1993) ideas for a liberating pedagogy through dialogics.

THE SECOND HALF OF THE YEAR:
A PEDAGOGY OF LIBERATION

When asked whether there was a turning point within the year, a point at which she started to enjoy classes more and feel more confident, Egypt quite emphatically stated: 'I loved my solo . . . I think that was the point where—that was the turning point.' So what was it about this part of the year that felt so different? I argue that the answer lies ultimately in the more centralized role of the students' embodied creative agency and autonomy within the learning process.

Freire (1993) cites Fromm in suggesting that the oppressed 'must realise that they are fighting for . . . "freedom to create and to construct, to wonder and to venture"' (96). In the process of choreographing, the students selected a stimulus task and were encouraged to find a unique way to respond to it. Egypt selected the poem 'Lady of the Lake' by Sir Walter Scott, which she was free to use as a narrative, thematic or stylistic stimulus for her own choreography; other than this, the assessment criteria were quite abstract, so she really had (a framed) space within which to generate ideas and make them material. The students spent three months exploring their stimulus material in a variety of ways, playing with movement ideas they had collected in class (and elsewhere) and developing them to articulate their new ideas; this lead to the careful construction of a three-minute piece which they then painstakingly rehearsed for a performance. In this process, they interacted with their teacher/s and other students, seeking both critiques and creative collaborations, but were clearly the owners of their work. This is evident in the way Egypt talks about the choreographic process:

> E: Ooh, I loved my solo—it really meant a lot to me. I made something. I really made the choreography—I was like, oh my God. . . . You were helping me with it, but you weren't doing it for me . . . we had to think about it for ourselves. And that's what I liked. I enjoyed it when it came to the end of the year—I kind of didn't want to stop—I wanted to do it again and again.

Egypt's sense of pride and enjoyment is clear, and it seems to stem from the fact that she became autonomous and productive as a learner. Freire (1993) explains that within and through a liberating education, 'students-of-the-teacher' become 'students-teachers' (61), and in this second part of the year the students were not receiving learning from authoritative sources, but were generating their own learning through the choreographic process. As a teacher/facilitator in this context I often felt as if I was going on journeys of discovery with the students (at times carried by them!) rather than delivering and setting the terms of knowledge. This was largely because the students were experimenting with 'established' movement ideas in ways that were so fresh and unique, that they began to develop their own dance styles.

The style in which someone choreographs can be interpreted as a material language, and Freire (1993) states that 'it is in speaking their word that people, by naming the world, transform it' (69). In their choreography, these students started to develop their 'voice' (a material one) and a way of articulating their ideas through a movement style, not a style that had been imposed upon them—'a situation where some name on behalf of others'—but a style developed as 'an act of creation' (70). Freire (1993) rejects the notion that a person can truly 'name' the world in the absence of other voices, and proposes the centrality of dialogue: 'dialogue is an encounter among women and men who name the world . . . dialogue imposes itself as the way by which [people] achieve significance as human beings' (69). And he asks, 'How can I dialogue if I regard myself a case apart from others . . . how can I dialogue if I am closed to—and even offended by—the contribution of others?' (71). It is in this respect that Egypt was finally able to draw upon and express her heterogeneous and fluid cultural identities and agency. She was not taking on the rather homogenized 'shape' of the dominant culture nor presenting a homogenized, 'commercial' version of her 'heritage culture'; rather, through various encounters and exchanges with different dance practices, she was able, in a dialogue of sorts, to exercise her creative cultural agency by generating hybridized dance forms. In this respect, she was able to 'transform' the world as it had previously existed. Indeed, Bhabha (1996) cites Bakhtin's opinion that 'hybrids have been . . . profoundly productive historically: they are pregnant with potential for new world views, with new "internal forms" for perceiving the world in words' (58).

It is crucial at this point to refer to Egypt's own descriptions and analyses of her choreography to elucidate this idea:

CS: What about the dance style that you used. Could you describe, or what could you say your dance style was?

E: Well, it was weird because sometimes I'd do, like, a ballet move—I'd try and do, like, a very balletic movement but, it was weird because I just think

I like, used a normal way of thinking, just a normal pedestrian way of moving, of being—being normal. Natural movement . . .

CS: Did you bring any of your experience of Nigerian dance into that do you think?

E: Oh no, I don't think I brought any of that into it at that point because the choreography in itself was quite soft so I had to bring a different type of strong feeling—like a contemporary kind of strong and with African it would have been too—powerful—too—seen as aggressive rather than strong and yeah, I didn't really bring those movements in. . . . When you do African dance you have to put every single emotion into it and that's why I really enjoy doing African dance, but with contemporary, the reason why I love that as well is because of the emotion you can put in it. . . . I like to express myself in my movements and that's why I like contemporary.

CS: So did you leave your African dance styles behind?

E: Oh no, but because we started doing lots of other different dance styles I started thinking like . . . let me incorporate what I know, let me add to it, change it, manipulate it into my own style.

Dash (2010) articulates an understanding of 'the discourse of diasporic style'. He describes this primarily as an 'aesthetic sense [which] is oblivious to firm categories and traverses divisions normally regarded as separate and discrete' (176). This approach to creativity and aesthetic expression is visible in how Egypt describes her work. She resists defining her style in a singular and homogenized way and instead refers to combinations and manipulations of style. She discusses the way she transformed balletic movements, made them 'weird', by employing the 'natural movement' of pedestrian actions. In this she disrupts and then redefines the dominant cultural form which had previously made her feel so 'silly': instead of the style 'looking silly on' her, she seems to have taken the style within and onto her body and re-embodied it in a way that suits her artistic purpose, in a movement from oppression to liberation. Returning to Coleman's (2009) work, we can observe the second side of the reciprocal and transformative relationship between images and bodies: as well as Egypt's body 'becoming' inadequate through the corporeal images and aesthetics of classical ballet, Egypt is also able to develop a new corporeal aesthetic—a new dance style, and thus a new (moving) 'image'—through the cultural mechanics of her own body. Egypt's words suggest she also developed her 'heritage' cultural practice to suit her artistic purpose: she feels she has found a style, 'contemporary' which facilitates an expressivity which is similar to, yet appears 'softer' than, her 'African' style. This can be seen as an example of what Freire (1993) refers to as 'cultural synthesis', where the 'world views' of the oppressed and oppressor 'enrich' and 'support' each other (162).

Indeed, in supporting the students in their development of choreographic style, the tables had turned: within this dialogue and creative exchange, it often became my turn to learn dance movements devised by another— someone of a different age, cultural background and body. During the times I worked with Egypt on her choreography, I remember noticing these differences: in our bodily comportment (with me tending to hold my spine quite straight, in comparison to Egypt's more fluid use of her lower back); in the locations of strength and flexibility in our bodies (e.g. the strength of Egypt's thigh muscles in comparison to the strength of my calf muscles); in our movement dynamics and rhythms (with my movement intentions having more of an upward trajectory on the beat and Egypt's tending to have more of a downward trajectory, often on the syncopated 'off-beat'). These particular ways in which our moving bodies differed can be read in terms of the dance styles in which we had most experience (classical ballet and Nigerian dance styles, respectively) and the ways they had marked our bodies. It was a fun, exciting but extremely challenging experience for me to learn Egypt's dance movements and style. I also sensed that it a joyful and empowering experience for her to teach me her work—to help her teacher perfect movements that she (through the unique interaction of her body, her ideas about the piece's meaning and her embodied knowledge of different cultural dance practices) was the authority on.

Again here, we can turn to the ideas of new materialism in seeing how through the body (and material acts of creation), social and political processes can emerge and also, importantly, be challenged. Indeed, Bolt (2013) discusses how, within a 'materialist aesthetic . . . the "I" as an articulation of a material-semiotic actor, situates the aesthetic as a relationship "between"— between . . . the material and immaterial, the physical and social' (6). It is with this understanding of aesthetic practices—especially those such as dance that so visibly take place through the body—that we can understand Egypt's choreographic practice thus: as a physical, corporeal act of resistance against the oppressive, Eurocentric discourse that structured and dominated her earlier experiences of learning dance. To draw again on the work of Ahmed (2002), through her innovative choreography and the confidence of her dancing body, Egypt had carved a new space within this white space: she had pushed at the boundaries of this space to open up a (quite literal) stage on which her body was no longer an object of disgust, or felt as 'out of place', but instead thrived and belonged.

However, it would be a mistake here to see this process as a simple and harmonious cultural exchange, or view Egypt's creation of her own dance style here as a simple, unqualified act of agency—particularly in light of the need she felt to 'soften' her 'African' style in the concern that it might be

'seen as aggressive rather than strong'. It would seem that Egypt's sense of the (white) institutional context for her choreographic process remained and perhaps even limited her choreographic agency here; furthermore, it is clear in Egypt's discussions that she develops and *retains* an ambivalent view of the (balletic) corporeal aesthetic that filtered her body as inadequate earlier in the year, even after the transformative choreographic process had finished. To find a more complex way to understand the pedagogic process here, it is helpful to turn again to Coleman's (2009) notion of bodily 'becoming', this time in relation to her critique of the concept of 'agency':

> According to a model of structure/agency, the specificities of . . . girls' bodies are understood as the result of either [their] active agency or of their enforced passivity against social and cultural structure. Understanding the becoming of girls' bodies . . . instead, sees the social and cultural as folded into the specificity of the girls' bodies. (138)

Coleman's (2009) analysis here provides a model for understanding the complex interaction between the dominant (white) aesthetic of the curriculum and Egypt's dancing and choreographing body: not as a simple act of domination by or resistance against 'white supremacy', but neither in terms of a simple cultural exchange or 'synthesis' as Freire (1993) suggests. Through the lens provided by Coleman (2009), Egypt's choreographic process and output occur through an 'enfolding' of social and cultural discourses (and so aesthetics) with her material, moving body, in a way that resists a simple sense of antagonism or harmony between the white curriculum and her heterogeneous cultural identity. Coleman's (2009) conceptual framework allows us to see the spaces that are left for *transformation*: of not only the cultural discourses and aesthetics that shaped the initial processes of teaching and learning, but also for the transformation (the 'becoming') of Egypt's body itself—into that of a confident dancer, an applauded choreographer, a producer of the new.

> Again this leads us to the notion of a heterogeneous diasporic style. The transformation of Egypt's body (and its meaning) in this way was not through a straightforward assimilation of the domination dance aesthetic, nor through a presentation of a homogenized and token version of 'commercial' Nigerian dance, but instead through a more complex and hybrid 'voice' made material through dance: one consistent with her position within a community of urban and globalized youth. In fact, the closest Egypt ever gets to a singular definition of her work is in using the phrase 'my style', a singular style, that is, paradoxically characterized by its heterogeneity. Indeed, Dash (2010) calls for 'educators [in progressive pedagogies] to look beyond . . . hegemonic practices and take

cognisance of grounded aesthetics generated by "ordinary" people who appro-priate, adapt and invent new stylistic and expressive forms in asserting their subjectivity' (177). It is only through an appreciation and facilitation of Egypt's 'diasporic styles' that she was finally in a position to assert herself within the classroom. It is also interesting to note that the two areas in which Egypt (and a number of other students within this ethnically diverse class) received almost full marks in the exam were originality and development of style.

CONCLUSION

Through her experiences of choreography, this student was able to 'name the world', 'transform it' and therefore claim ownership of it, specifically through the employment of a creative, fluid and essentially heterogeneous and very material cultural agency, 'rooted' in her diasporic identity and corresponding capacities of her body. Through this, Egypt drew not only enjoyment, but strength:

> *E:* This course really made me see that I love dance. . . . It can make you feel so high. . . . But it can also, like, make you feel like uncomfortable and out of place. But if you do really love something, then you want to better yourself in it.

Egypt shows the resolve to carry on in the face of the difficulties and oppression she faced throughout the course (particularly at the start). This seems to stem from the way her experiences later in the year ultimately legitimized and gave her a renewed pride in her (heterogeneous and fluid) 'self' and allowed her body to 'become' that of a successful choreographer: in this, she was able to glimpse the possibility of being 'anything'. Processes similar to Egypt's choreographic one can enable young people to produce work which resists the simplistic discourse of antagonism between dominant and minority cultural practices; in this, young people like Egypt can be in a position to draw on a wealth of cultural practices in order to assert their fluid, urban subjectivity.

However, the question remains for practitioners: how to draw on the more liberating pedagogic processes which characterized the second part of the dance course throughout an entire curriculum. Within learning tasks that do not require young people to produce a 'piece of art' (such as a dance solo), how can a practitioner best facilitate a young person's unique, heterogeneous, and undeniably material cultural agency? An answer can begin to be found in seeking opportunities for forms of dialogue, encounter and creation in every learning experience.

NOTES

1. This argument is by no means only applicable to young people from minority ethnic backgrounds, although such young people will be the focus of this chapter, as their experiences of this cultural 'intermingling' may be more acute.

2. For elucidation on the relationship between socio-economic 'access and power' and ethnic group, see May 1999, 4.

3. Advanced Level is a UK post-compulsory qualification, generally taken between the ages of 16 and 18. Students generally take between 3 and 4 discrete A Levels which serve as key entrance qualifications to UK universities.

4. Advanced Level qualifications are divided into two years: AS (year 1) and A2 (year 2).

5. The phrase 'contemporary dance styles' is employed throughout this chapter. It refers to a fusion of contemporary dance techniques which the students learnt, drawn from the following: Laban, Graham, Cunningham and Release/Limone techniques. In broad terms, these techniques can be located within a North American and European theatrical dance tradition, one which ultimately has part of its roots in classical ballet. However, there are aspects of these styles which resist the bodily configurations of this balletic tradition.

6. The students studied a recording of The Kirov Ballet's production of Maurius Petipa and Lev Ivanov's *Swan Lake*. This was a version by Konstantin Sergeyev, filmed at The Kirov Theatre, Leningrad, in 1990.

7. The students studied a recording of Adventures in Motion Pictures' production of Matthew Bourne's *Swan Lake*, filmed at Sadler's Wells Theatre, London, in 1996.

8. Ahmed (2002) discusses the treatment of Sarah Baartman, a woman from the Eastern Cape of South Africa who was 'exhibited' around Europe in the 1800s and was famed for her what were perceived to be unusually large buttocks and genitalia. She was nicknamed 'The Hottentot Venus', and Ahmed (2002), among others, discusses the ways she was objectified and dehumanized by the white patriarchal society that 'displayed' her.

Chapter 7

From Art Appreciation to Pedagogies of Dissent

Critical Pedagogy and Equality in the Gallery

Esther Sayers

This chapter explores the pedagogy of the gallery, specifically the pedagogy of a youth learning programme for 15- to 23-year-olds, *Raw Canvas*, at Tate Modern from 1999 to 2011 where young people were empowered to engage with and form their own opinions about contemporary art and culture. The programme aimed to disrupt the dominant discourse of the institution and create opportunities for new ideas about art to emerge. This programme was underpinned by critical pedagogic theory and emancipatory ideologies. Through the exploration in this chapter I use critical pedagogic theory, notions of equality and conceptualization of new materialism to determine how the arts and pedagogy provide opportunities to resist dominant conservative attitudes to discourse and the mechanisms by which cultural value is ascribed.

This research comes from my period of employment at Tate Modern, where I was an artist educator and a programme curator working in partnership with peer-leaders from 1999 to 2011.[1] Tate is a family of four art galleries housing the United Kingdom's collection of British art from 1,500 and also international modern art. It is a group of galleries linked together within a single organization. From 2000 to 2012, Tate's priorities were to create a more stable financial position, to enhance the collection of artworks and to represent a greater number of international artists (Tate, 2011). Tate is funded in part by the UK government, trusts, foundations and private donations along with successful income generation from retail and leisure, shops and restaurants.

Since its inception as a gallery for modern and contemporary art in 2000, and to this day, Tate Modern's learning and interpretation strategies have been inclusive, enabling multiple voices to be heard talking about art (Walsh, 2008; Jacobs, 2000). Therefore, the pedagogical approach adopted by this

specific gallery has been learner centred and embracive. The traditional approach of appreciation where young people are taught to accept what they are served up in cultural organizations is not enough. Rather than engaging new audiences, as is the intention, such an approach is more likely to turn visitors away (discussed in Kockel, 2000; Moersch, 2007; Graham, 2010). This pedagogy of mere appreciation has been challenged in recent years, and gallery educators have looked and are looking for new ways to pedagogically engage new audiences with the very materiality of modern and contemporary art. This engagement therefore aims to be discursive and enable multiple but also dissenting voices to emerge.

CONTEXT

Pedagogy in the Gallery

From my two decades of experience as an educator in a variety of contexts, I have found that learning in art galleries is unlike other educational situations. Schools, colleges and universities are bound by curricula, course outlines and assessments. The art gallery setting does not produce qualifications, and therefore attainment is not measured in this way. It is the art that determines the subject matter for learning and the funding agendas that determine who learns and how. These factors impact the mode, aims and content of the teaching and learning that takes place. In addition, educators do not usually know who they are going to be working with in advance, and learners are not all at the same level of attainment when they arrive. As a result, educators must be flexible and equipped to teach beginners and experts together. The goal of the learning is to provide catalysts for conversations in which learners share ideas, tackle assumptions and form opinions. 'Education' in the gallery is therefore aimed at building confidence, so that learners can unlock their own ideas about art. Learning or attainment in this context is not measured by the institution or by the government; instead, a programme's success is measured by its popularity and the participant feedback, often gathered informally and conversationally during or after an event. Participants are usually seeking self-fulfilment and personal growth rather than qualifications (Falk and Dierking, 2000; Freire, 1970; Hooper-Greenhill, 2000a, b).

As a result, the usual language used to describe educational activity is inadequate for this context. Words like 'teacher', 'learner', 'education', 'student', 'study' and 'teaching' usually speak of activity in the formal education sector, schools, further education colleges and universities. Fundamentally different to the gallery in a number of important ways, this sector is bound by curricula set by government through the National Curriculum or by exam

boards. Outcomes must be decided in advance and written into schemes of work or syllabi, and all activities lead in some way to an assessment where the progress of the student is measured. A context constrained by assessment, creates a particular relationality between teachers and students. Although inspiring examples of alternative knowledge relations do exist where educators subvert overriding ideologies (Fletcher, 2011; Rancière, 1991; hooks, 1994), predominantly, the system is designed to construct stereotypical relations between teachers and students in which teachers 'know' and students 'learn' from them.

These conservative hermeneutic approaches are where fixed meanings are reproduced by experts on behalf of learners (Hirsch, 1965). However, the gallery pedagogies that I explore come from a moderate hermeneutic approach where meaning is negotiated *with* learners (Gadamer, 1960) and enables situations in which young people form their own ideas about art and therefore resist the above conservative attitudes to learning in which young people are filled with knowledge by an expert teacher (Freire, 1970). I have written previously about the tensions that exist at Tate where both of these hermeneutic approaches are employed and the ideological challenges that can occur because of such tension (Sayers, 2011), and that to understand such learner-centred approaches, pedagogy needs to be constructed from the perspective of the gallery educator but also that of the learner/s.

Funding agreements often drive pedagogy in the gallery context, and the curriculum is controlled by the agenda set by them. However, it is education curators, artists and gallery educators who decide what to do: what to teach and how to teach it. It is the programme curator who dictates the parameters, such as whom the project or event is for, how many, how often and how much it will cost. While there is a lot of autonomy in how the aims of such agreements are interpreted by the programme curator, the activities are governed by the underlying value system of the gallery. At Tate Modern, this can be characterized as a progressive approach to learning that sits alongside a traditional, conservationist backdrop to the Tate Collection (Walsh, 2008). I will return to these themes throughout this chapter, as I explore the ways in which the constraints of the inclusion agenda attempt to construct a curriculum for gallery educators. Many choose to resist this by creating pedagogies for the gallery that enable dissent rather than using education as a tool by which a consensus of opinion is sought (Rancière, 2010).

Youth Programme Pedagogy

Contemporary pedagogical approaches have been developed over the past forty years in the United Kingdom, during which time there has been a shift in the way in which gallery professionals think about relations with the audience

(Charman, 2009). In the past, attitudes to learning in the museum were more about information-based transmission models in which the public would be filled with facts about an object. In recent years, there has been a shift of recognition towards the background and personal cultural history of the public as a vital part of the way in which they encounter works of art. These ideas fit within the social constructivist framework where learners drive their own learning process as discussed in Claxton (1999), Falk and Dierking (2000), Hein (1998) and Hooper-Greenhill (2007). New materialism provides a useful counterpoint here in the fact that it argues for the agency matter, in this case the art object, and, rather than silencing matter as social constructivist theories might, it enables new configurations within which the material and the discursive combine (Barrett and Bolt, 2013; Haraway, 1991).

The shift in recognition of what the public bring to their interpretation/ enjoyment of an artwork is permanently contested. The shift towards the audience's reading of the work as socially and ideologically constituted is particularly pertinent to gallery youth programmes because in this context learning is voluntary, open ended, learner centred and loosely structured. It could be described as 'informal' learning, although in using that term I would stress that 'informal' here relates to the nature of the learning *and* to the environment in which it takes place and does not simply describe the context as discussed in Hohenstein and King (2007). New pedagogies have been developed that are not didactic but conversational, peer-led and social. The peer-to-peer approach means that language that is familiar to young people is used and workshop activities are delivered informally. For example, one activity can flow into the next, the tasks are not separated and targets are not explained at the start but rather emerge through the process; young people enjoy the open-ended feeling that apparently 'random' activities provide. Such learner-centred and dialogic approaches have been attractive to new audiences as can be seen by the popularity of programmes like *Raw Canvas* whose audience grew from 500 young people a year to 10,000 per annum over a five-year period.

As the audiences' role in meaning making evolved at the gallery, a number of pedagogical issues emerged from *Raw Canvas* activities. The most striking is the rejection of strategies that are strictly about the object and that could be associated with a didactic, canonical approach (Bal and Bryson, 2001). Instead, pedagogy of relations 'between' participants and 'around' art objects is emphasized (Rancière, 1991). This relational pedagogic approach is more in keeping with current trends in art practice in which the role of participant is transformed from viewer to collaborator (Graham in O'Neil and Wilson, 2010). By attending to the relations between participants and the art object, during workshops, the facilitators' task is complex as looking at and talking about art is a social process where ideas are formed through interactions

between people, and new meanings emerge in the *intra*-actions between participants, educators and artworks. This conceptualization of relations follows Barad's notion in which the '*intra*-action conceptualizes that it is the action *between* (and not *in*-between)' (Dolphijn and Tuin, 2012, 14). The artwork must remain in this exchange of ideas; some youth progs are entirely about relations, not about matter, and this is problematic. One aspect of this pedagogic approach is to build meaning around an artwork by harnessing the ideas of the group; conversely, yet equally important, is the decision to stand back and say nothing at times, allowing the relations between the art and the people to operate independently (such strategies are discussed by Moersch, 2007; Charman and Ross, 2006). The resulting negotiation regarding the interpretation and value of the art in question can take a material form through the fact that meaning is constructed and it then materializes through discourse. Bringing a new materialist framework to this exchange enables relations between artwork and viewer to be more productive. By not mediating the work through constructivist scaffolding, the art has the power of affect. I understand from Barad (2007) the notion that the artwork is not agential; it does not have its own individual agency. Barad's reworking of the notion of agency is useful here and in particular her assertion that 'Agency is not held, it is not a property of persons or things; rather, agency is an enactment, a matter of possibilities for reconfiguring entanglements' (Barad interviewed in Dolphijn and Van der Tuin, 2012, 54). In not ascribing the specific ownership of agency to art object or viewer, it is possible to articulate a co-constructed meaning where artists and audiences work together in relational ontologies, each having 'response-ability' to the other (Barad, 2012, 55).

This meaning making is as much a product of those doing the looking as it is a reaction to the art, and as such the materialization emerges through what Braidotti (Dolphijn and Van der Tuin, 2012) refers to as the 'complex materiality of bodies immersed in social relations of power' (21).

PARTICIPATION

The aforementioned social relations are characteristic of the participatory nature of recent gallery youth programmes and informed the thinking that led to *Young Tate* and *Raw Canvas* where participants discover their own areas of interest in art, and these personal points of interest are developed into events and activities. This creates an inclusive pedagogy where, rather than providing activities that are *for* young people, the events programme is designed and delivered *with* young people (Freire, 1970). Therefore, the peer-leader must learn about the artistic and cultural interests of the young people that they are working with (Eglinton, 2008) resulting in peer-leaders

and participants working together to construct an understanding rather than the 'experts' enlightening the 'other'.

This is in keeping with notions of new materialism (Braidotti, 1994) and the importance Barad (2012) places on the action *between*. The critical pedagogies and hermeneutic theory that I have used to explore gallery education pedagogy, where the actual relation between participants and educators can be interrogated, find form in the conceptualization of new materialism through which the relation between participant and artwork can be better understood. Barad's (2012) *intra*-action provides us with a model by which we can examine the process of creating locally produced meanings from artworks in the gallery. Mezirow (1991) talks about the role of the educator in the learner's transformation, and Clements (2011) talks about the educator as mediator:

> The reduction of learner dependency on the teacher is a prerequisite for student self-determination and underpins creative participation and radical cultural activism which thereby enables transformation. (27)

And Clements (2011) asserts that

> The focus within participatory creative education is on inclusion and developing a sense of community which then becomes the ideal forum for decision-making, debate and identity construction. Here the educator is the mediator (rather than the determinant) of participants cultural needs and their creativity, facilitating individual and collective potential which can then be explored in a non-authoritarian manner. (27)

Such mediation is critiqued in new materialist thought. Barad (2012) refers to 'agential entanglements' (56) where the human and non-human subjects are not seen as pre-existing entities but as *intra*-actions. Following Haraway's (2003) ideas, the learner subjectivity cannot be constructed in advance and rather than mediating, which risks Othering the audience, connections and contingencies should be sought. As Haraway (2003) asserts, 'there are no pre-constituted subjects and objects' (6); 'beings constitute each other and themselves . . . [they] do not preexist their relatings' (6). By examining the engagement with art and with each other through Barad's (2012) *intra*-action, the notion of inclusion takes on a new form, one in which inclusivity can be seen as a process, an action *between* people, rather than something that happens *to* individuals. Here, a shift in pedagogy is possible, from the desire to include the Other to an acknowledgement of the pre-existing relatings and subjectivity of all beings. This creates the possibility of culture happening *with* people rather than *to* them.

Key features of successful pedagogic approaches in the gallery are as follows: the extent to which young people gain ownership of the programmes that they attend and are given the support needed to realize their ambitions. Along with the freedom to make decisions comes knowledge about the structure of the organization where they learn about how to deal with the constraints and compromises associated with working in a national gallery. As Clements (2011) describes, the educator is mediator, in this instance, between the young person and his or her cultural experience. This describes a dialogic relation where the learning that takes place is negotiated, and the educator strives to make the engagement authentic and meaningful for the learner. But in order to achieve this, there must be opportunities for young people to express negative as well as positive opinions. By rejecting cultural inclusion strategies that seek to mediate and instead seek opportunities to connect and collaborate, we open up the possibilities of young people becoming 'the products of their relating' (Haraway, 2003, 7). So then they are developing skills as discerning consumers of culture, 'cultural omnivores' as Peterson (1992) describes. In enabling young people to form their own opinions about art, educators are attempting to challenge the existing hierarchies that control who can be heard speaking about art (Jacobs, 2000; Biesta, 2010). For this kind of learning to be authentic, it must NOT be focused around achieving a consensus of ideas about art works. Instead, opportunity for debate and disagreement must be created (Rancière, 2010; Mouffe, 2013) where young people are supported and encouraged to form their own opinions or to disagree with the authoritative voice of the gallery or the educator (Charman and Ross, 2006).

ENGAGEMENT

New Audiences

That cultural organizations are now valuing the personal responses of their visitors and striving to make the gallery experience meaningful to all marks a significant departure from previous attitudes to cultural learning. However, regardless of this shift, contemporary youth programmes do experience difficulties in engaging new audiences. This may stem from a historical construction where during the mid-nineteenth century, museums and galleries were newly constructed as social places in which

> The working class—provided they dressed nicely and curbed any tendency towards unseemly conduct—might be exposed to the improving influence of the middle classes. (Bennett, 1995, 28)

This hope of improvement through cultural inclusion still underpins cultural institutions, and government and funding bodies, where galleries and museums are encouraged, supported and financed to engage new audiences from 'hard to reach' groups, who do not normally engage with such types of cultural activities, and encourage greater diversity in attendance. Because even though museums have been 'open' for 150 years, recent research suggests that they are still predominantly attended by the 'highly educated' middle class and the elite (Bennett et al., 2009; DCMS, 2007). For governments this participation in culture is connected to the desire for people to engage in civic life. Chris Smith, MP, UK Secretary of State for Culture (1997–2001), connected the arts with notions of a civilized society,

> because [the arts] lead us, sometimes gently, sometimes forcibly, sometimes imperceptibly, to self-knowledge, they also inevitably help both to shape and to characterise a society. The arts are a civilising influence. (Smith, 1999 in Wallinger and Warnoc, 2000, 14)

The view that the arts make 'better' people is a popular one and one that has been widely critiqued (Selwood et al., 1994; Bennett et al., 2009; Bourdieu, 1984). There is much interest in self-improvement through the arts, but this is fundamentally different when the focus is to improve *others*. This constructs learning subjects who lack the necessary cultural attributes to engage with contemporary art on their own (Biesta, 2010). The private funding received by cultural organizations is a form of modern day philanthropy, and the public funds are a benevolent gesture intended to include those who rarely participate in gallery activities. Attendance by certain 'targeted' individuals is essential to the funding agreements with government and private benefactors; it is therefore prized by the museum. The selection of these people is normally done by their demographic information and targets those who do not tend to visit the gallery independently. The encouragement for some groups to become involved, rather than being embracive, can be restrictive because newcomers must learn to abide by institutional rules and codes of conduct. As such, it is often the learner who is asked to develop as a result of this experience, while the museum remains largely unchanged (Walsh, 2008). Despite considerable effort to welcome a diversity of young people, the emerging pedagogy is often ambivalent towards the new audience as they are simultaneously welcomed and controlled (Sayers, 2011).

In Foucaultian (1991) terms, 'the instruments of government' (48) in the nineteenth century were aimed at bringing about acceptable norms of conduct, not by corporal punishment but by manipulating behaviour through specifically built environments. In *The Birth of the Museum* (1995),

Bennett describes museums as the kind of regulatory environment that Foucault (1973) talks about. In relation to pedagogy, the museum function could be described as a cultural governor of the populace that relies on attracting people from all walks of life. Introducing new audiences to the museum environment creates a problem: Do you teach the newcomers how to behave 'correctly' or does the institution adjust its idea of appropriate conduct? The multitude of activities within galleries have insisted on correct behaviours being observed, while others have attempted to influence cultural change within the institution so that notions of 'appropriate conduct' are adjusted. As a result, the institution can become pedagogically divergent by occupying elitist and populist positions simultaneously and therefore creating tension and ambivalence in the way that the gallery approaches the audience. The space of resistance between high and popular culture has enabled opportunities for remodelling existing ideologies, where the purpose and potential of the gallery is renegotiated by participants *with* facilitators.

Young People With Art

Engaging young audiences is considered to be an effective way to achieve cultural inclusion (Harland and Kinder, 1999). The conventional approach (pre-1985) to working with young people in a gallery was to provide specially designed activities, events and services, designed, that is, by adult specialist staff. Increasingly, organizations in the cultural sector have introduced planning and delivery processes that involve consulting with young people from the outset. The role of the staff in this approach is to facilitate the process whereby young people can voice their opinions and take charge of their own learning. Consultation, peer leadership and participation in planning and delivery have superseded traditional approaches in which gallery staff creates events *for* young people (Horlock, 2000). However, effective strategies to engage young people in art are ones where meaning is negotiated, in a moderate hermeneutical sense (Gallagher, 1992; Hooper-Greenhill, 2000a, b). This directly challenges the dominant ideology of the gallery as 'expert' and empowers visitors to formulate meaning based on their own life experiences rather than the traditions of art. This pedagogical approach is predicated by a number of projects including Young Tate, Liverpool; Room 13; WACTAC, Walker Arts Center, Minneapolis; Tim Rollins and KOS, South Bronx, New York, USA. *Raw Canvas* is indebted to these groundbreaking initiatives.

The above-mentioned Young Tate programme originated from Tate Liverpool in 1994 where, from the gallery's inception in 1988, new approaches towards the audience had been trialled:

The inclusion of voices other than the authoritative voice of the museum was one of a series of projects in which we opened up the Gallery and its collections to critical debate. (Jackson in Horlock, 2000, 24)

Jackson, who was Head of Education at Tate Liverpool at the time, cites the 1988 Surrealism display as a good indicator of the importance of the visitor to the gallery:

In 1936 Roland Penrose invited the public to exhibit their own 'surreal' objects; Tate Gallery Liverpool repeated this invitation, advertising in the local press and in the Gallery. Every surreal object was accepted—from young children's to international artists' submissions—and the results were displayed in the galleries and celebrated at a private view attended by participants, their friends and families. (Jackson in Horlock, 2000, 24)

What is significant with this approach to exhibition making is that the invitation to contribute went out in the local press, therefore addressing a local and potentially non-art audience, as the larger national galleries rarely used local media for advertising at the time. To accept all of the work and display it in the hallowed halls of the gallery was unusual, as this space was usually reserved for professional and highly reputed artists.

Tate Liverpool pioneered a model in which education and exhibition curators worked together, collaboratively, in project teams akin to the 'ecological museum structure' described by Jung (2010, 2011). Jung (2011) draws on Rancière (2010) when she presents an alternative to the traditional hierarchical model of museum structure in which the director sits at the top and passes directives down to exhibition curators who then pass them to the education team. This illustrates the relatively low status of education in relation to curatorial and conservation activities. The low status of public engagement means that it has been unusual for galleries to ask for the public to contribute to the art on display. By inviting a contribution from the audience, the gallery refuses the usual hierarchy in which artist and public are separated. This creates a number of ethical issues to be negotiated by programme curators about the ownership of the work. Jung's (2011) proposal is a less hierarchical model in which dialogue and exchange characterize the relations between gallery departments. Jung's (2011) discussion is an attempt to refuse the hierarchical models that already exist in some museums and to reimagine some non-hierarchical structures through which learning and the public voice can be brought to the centre of the organizations' activities:

By failing to embrace diverse perspectives, museums may limit their potential audiences, creating an intellectual hierarchy between them and their audience. (Jung, 2010)

Tate Liverpool used a collaborative approach to programming again in the 1990s. Such collaboration is particularly interesting when considered in relation to discourses of new materialism (Bolt, 2013). Bolt (2013) describes the modernist notion of 'truth to materials' (4) that exists between and separates from the two dominant strands of Western philosophical discourse. She urges an acknowledgement of 'the material facts of artistic practice' (5). The collaborative artwork produced at Tate Liverpool has the potential to refuse the usual museum hierarchy and seek to create new intellectual material. Meskimmon (2003) talks about the recovery of the most eccentric and marginal meanings in even the most canonical work. The fact that feminist aesthetics has always operated resourcefully in the margins and across disciplines makes new materialism ideally configured to accept the refusal of dominant discourses in constructing pedagogies that enable new publics to engage creatively with modern and contemporary art (Hickey-Moody, 2014). Such engagement often takes material forms, in the following example through the creation of interpretative labels for the work:

> The Gallery also attempted to show that modern art has many readings; using the 'Modern British Sculpture' display, young people were encouraged to research issues around 'primitivism' and the representation of women in twentieth-century art, and presented their findings in extended labels placed adjacent to selected sculptures. (Jackson in Horlock, 2000, 24)

This pedagogical approach draws from ideas discussed by philosophical theorists such as Barthes (1977), Derrida (1987) and Spivak (1976), in which meaning is not fixed, for example, Derrida's ideas about the frame in *The Truth in Painting* (1987) in which he famously asserts that 'there is nothing outside of the text' and Barthes's *Death of the Author* (1977) in which he asserts that an image or text doesn't possess an essential meaning, and 'to give a text an Author is to impose a limit on that text, to furnish it with a final signified, to close the writing' (147). Although the artist/author has an intention, it is the reader or viewer who creates a proliferation of meanings around the work. The reader who reads the text brings to it other voices and reads into it textual material which transforms this area of meaning far beyond the author's intention (Olsen, 1990), or as Spivak (1976) asserts, the text belongs to language and not to the sovereign and generating author. Therefore, what the viewer brings to the work will play a significant role in any readings that are made. It therefore follows that if you introduce more people to art with a range of different backgrounds, then you will get a plurality of readings. Hall (1980) elaborates on the theoretical context of audience studies, rejecting a linear model for the transmission of meaning from author to audience and posits the idea of two parallel processes working simultaneously, encoding and decoding:

The moments of 'encoding' and 'decoding' though only 'relatively autono-mous' in relation to the communicative process as a whole are determinate moments. (129)

This idea of plurality is an important precept for group work, in which participants are discussing meaning in art works. Different interpretations are made and with them an acknowledgement of different viewpoints; it is up to the facilitator to summarize by repeating the range of views back to the group. And in order to establish a pool of possibilities that are relevant to all the interpretative agents, a peer-to-peer approach to discussion is particu-larly valuable. These ideas were important cornerstones in the pedagogical approaches that I developed with *Raw Canvas* from 1999 to 2011.

CRITICAL PEDAGOGY AND THE PROBLEM WITH INCLUSION

The theoretical framework of critical pedagogy (Freire, 1970; Duncan-Andrade and Mowell, 2008; Darder et al., 2009) underpins Raw Canvas and other projects that are negotiated by participants with facilitators and enables an understanding of the barriers that disable some young people from par-ticipating in culture. Educators must engage critically with the impact of an unequal society on young people from disenfranchised groups. Strategies that acknowledge the subjectivity of the learner contribute to positive outcomes where participants are empowered; conversely, those requiring participants to develop new cultural tastes can be reductive (Sayers, 2014). In talking about the pedagogies employed by youth programmes, I keep coming back to the difficulty of a pervading ideology of inclusion where the 'Other' is welcomed in but are expected to change/learn in order to appreciate the new culture that is on offer to them once inside the museum. I have termed this 'ambivalence' (Sayers, 2011, 420). Rancière (1991) makes a forceful intervention into this aforementioned ambivalence through the axiom of the equality of intelligence (Bingham and Biesta, 2010). Rancière (2010) distinguishes between the two aims of 'inclusion' and 'equality'; he sees them as oppositional and not complementary. This opposition begins to explicate the tensions that I have experienced in my role as educator and programme curator where the dual purpose of the job has been to create learning programmes for young people and to build new audiences. This drive for inclusion has led to the creation of an inconsistent pedagogical approach that was, at times, in opposition to the aims of equality on which the programme was founded.

Rancière's (2010) ideas resonate strongly with the aims of *Raw Canvas;* however, he illustrates a fundamental pitfall for pedagogies that attempt to be

inclusive in that we should start with equality rather than aim towards it. With all good intentions, youth programmes at Tate were grounded on an idea of 'equality' where 'young people can be heard speaking about art' (*Raw Canvas*, 2001, marketing material): an aim which makes the visitor's own experience, prior knowledge or schema into a contingent part of his or her learning. In this view, everyone's opinion is equal: 'your opinion goes here' (*Raw Canvas* publicity, 2003). This was effective in terms of group management and open discussion where equality between contributors was foregrounded, and focusing on the potential for young people to have an equal relationship with the gallery was an effective way to encourage a new audience to get involved. Once *Raw Canvas* became more integrated into Tate as a whole, young people's ideas and methods did begin to affect the activity and public programmes that were offered by the Tate. However, deep-seated knowledge hierarchies and powerful ideas remained unchanged. For example, *Raw Canvas* created a skate park in response to Futurism (an avant-garde art movement and major exhibition at the time). Although this was hugely successful in terms of attracting new audiences to the gallery, it was not seen to be core programming as the idea had not come from an established artist. To create collaborative opportunities like those at Tate Gallery Liverpool, curators have to go against the dominant ideology of the gallery which values conservation, display and scholarship around the cultural products of established artists. To provide space for young people's cultural ideas is to resist the dominant ideology and to enable new cultural materializations to take place, and as Meskimmon (2011) asserts, art cannot 'oblige us to act' (8) but it does have the power to effect change:

> By materializing concepts and meanings beyond the limits of narrow individualism, art enables us to encounter difference, imagine change that has yet to come, and make possible the new. (Meskimmon, 2011, 8)

The reception of the skate park raised significant questions for me about who and what Tate was for. Was the opportunity, the equality of intelligence, offered to young people in creating the skate park ideological rather than practical? If so, it failed to achieve its emancipatory aims, as it did not afford greater power to young people in relation to the institution. In order to address this problem of inclusion, I needed to develop a critical pedagogy for working with new audiences. I considered that a critical pedagogic approach could empower young learners because of the emphasis on preparing the educator to teach by heightening their critical perceptions of the world and the inherent inequalities that are often taken for granted or left unseen by the educational establishment (Darder et al., 2009; Dewey, 1938). I wondered: What is the purpose of learning programmes at the gallery when the aim is to encourage participation from communities who are not traditional gallery users?

Youth programme curators in galleries have much in common with Duncan-Andrade and Morrell's (2008) definition of critical thinkers who believe 'that any genuine pedagogical practice demands a commitment to social transformation in solidarity with subordinated and marginalised groups' (23). For example, youth curators do not create activities for young people but instead work very closely with participants to devise programmes that are inclusive and that represent the views and ideas of the young people at whom they are aimed. This creates opportunities for learning *with* not delivering information *to* learners as described by Freire (1970). In this respect, peer-led work is similar to critical pedagogy because facilitators and participants are committed to the concept of 'praxis' where teacher and student are learning and teaching together.

Learner-led pedagogies aim to emancipate the learner and the teacher, freeing them from the inequality and restrictions that many have encountered enabling them to achieve what Rancière (1991) describes as an 'equality of intelligences' (87). Youth programmes in contemporary art galleries encourage young cultural consumers to critique the dominant cultural establishment, the 'sensible' in Rancière's (2010) notion of the 'distribution of the sensible' (12). They do this as members of the young people's advisory group and through the events that they organize which draw artists from street culture into the rarefied space of the gallery. At advisory group meetings, there is an ongoing critique of the hegemonic processes at work in the gallery. Artists and curators who work with young people gently rock the status quo and seek out counter-hegemonic alternatives to gallery programming. Luis Moll (2000) refers to 'funds of knowledge' that 'draw from the knowledge that students bring with them to school, knowledge that is often not in their textbooks but is acquired from the streets, family, cultural traditions, youth culture and the media' (Duncan-Adrade and Morrell, 2008, 9).

Pedagogies that seek to establish productive relations between teacher and student encounter specific problems in the territory of a collection-based gallery or museum. There exist some contentious ideas in relation to conservative attitudes towards cultural objects that are conserved in houses of high culture. Hein (1991) takes the radical step of stating that 'constructing meaning is learning; there is no other kind' (1). This idea seems straightforward in contemporary gallery education, but it has two major implications for how we think about learning. Traditional, conservative conceptions of learning posit the idea that 'meaning' exists outside of the learner; an object or artwork is thought to contain its own unique 'truth' (Hirsch, 1965). In order to understand the intended meaning, the learner is expected to break out of their historical situation in order to objectively connect with the 'truth' about the work. Hein's (1991) view radically opposes such an idea and any suggestion that a learner can be *given* meaning rather than making it for

himself or herself. In his conception, the assertion that the *learner* constructs meaning in order to learn is key.

These two concepts can then enable young people to bring their stories to the table, to take an active role and be valued as part of the discussion. The fixed nature of the gallery where *pre-selected* objects of cultural value are put on display for the public causes a problem for teaching and learning conceived in this way as the gallery and the art it contains are used as a resource for learning about art rather than as the subject in its own right. Hein (1991) supports this construction by asserting that knowledge is active and is created by the learner, therefore, opposing traditional views of learning. Hooper-Greenhill (2007) also asserts that 'learning always involves the use of what is known already, and this prior knowledge is used to make sense of new knowledge and to interpret new experiences' (35). This then results in the pedagogy of youth programmes being in conflict with the pedagogy of display.

In the past, and in some places still, a gallery had an authoritative voice, one that represented the institution, offering a single reading of a work or exhibition (Jacobs, 2000). This has been termed the 'transmission model' (Hooper-Greenhill, 2000a, 141). Pedagogically the methodology of the *Raw Canvas* programme contrasts with the transmission of culture model, as it is learner centred. This approach can be said to be in tune with current developments where galleries have opened up interpretation to other voices and offer plural readings. This stems from the philosophy that meaning is unstable and that the viewer is capable of handling several, often unresolved, propositions (Bal and Bryson, 2001). Voices from other fields of knowledge, in addition to art history, feature in text, audio and multimedia interpretation. A learner-centred approach builds on this, placing the learner at the centre of an endeavour to understand a work of art through a range of approaches. Young people learn the tools to acquire and process information and knowledge (Hein, 1998; Hooper-Greenhill, 2000a, b; Falk and Dierking, 2000).

To prepare them for the peer-led process, young people have to engage with different kinds of knowledge. Artist educators introduce them to art historical knowledge initially accessed through Tate resources and research facilities, but alternative points of view are also researched, some of which may be at odds with Tate's view. These are often critical of the art museum, describing it as a commodifier of culture, a gatekeeper reflecting narrow values. It is important that young people come to know the critical landscapes that help to define the role of the museum.

Meszaros (2006) provocatively discusses the tension between knowledge about the object and strategies for interpretation in her keynote address, *Now THAT is evidence: tracking down the evil 'whatever' interpretation.* She argues that moderate hermeneutic thinking leads us to 'a persistent paradox: we can only see and find what we already recognise and know' and that this

paradox leads to an abundance of personal meaning making and a lack of received or cultural knowledge (Meszaros, 2006, 12). However, I disagree and assert that successful pedagogic practices are those that start with personal meaning making, and go on to enable people to become critical, which leads to empowerment where young people take action in the world. This is aligned with Rancière's (1991) argument for 'the capacity of anybody' rather than Meszaros's 'whatever interpretation' (Ruitenberg, 2011, 220). Although this is not an easy task, the conviction that each intelligence is equal opens the door for new knowledge to materialize and for learning to be acknowledged as embodied by the individual and not given to them by the institution. In this way, we seek alternatives to reductive forms of cultural inclusion.

The *Raw Canvas* programme attempted to do this by enabling young people to plan events for their peers. The focus was the creation of an event by young people, and to do this they have to be taught to take an alternative stance in relation to the 'normal' models of display and consumption of culture, to try something different. In relation to critical pedagogy, this turns around the conservative and more common model of interpretation where young people learn from their elders and take on existing ideas. Youth programme activities link with young people's own cultural interests as a way to recontextualize the work on display in the gallery and to encourage young people to experience the space. The importance of establishing a link between art and youth culture has implications for the pedagogy that is adopted. The knowledge that is produced about art needs to be open and negotiable so that the development of the programme can be steered by young advisors. Young people sometimes perceive traditional education to be restrictive. This is often when they feel that they are following a course of learning in which the teacher holds the knowledge, it is delivered in a predetermined way or they are expected to respond to it in ways that feel alien to them. When developing programmes for young people, it is important that they are offered experiences that take them beyond the target-driven parameters of attainment—where some have felt alienated.

Formal education, in its more traditional didactic form, teaches young people to accede to the authority of experts. This conditioning is counterproductive when attempting to empower young people to make decisions and formulate their own opinions. The aim of peer-led pedagogies is to disrupt the hierarchies between teacher and pupil, the 'expert' and the 'learner' and create a self-supporting learning community with a 'shared history of learning' (Wenger, 1998, 87) in which the group engage in a shared endeavour and form a community which can increase the confidence and engagement of all those in the group. Such an approach provides young people with the skills they need to take part in debate and to get their opinions heard.

Many young people have not been taught the critical skills required to take part in such debates. Although 'consulting young people' is a popular mantra in contemporary educational and cultural circles, the skills to take part in consultation are rarely developed (DCMS, 2003). As a result, some young people are comfortable to speak their minds, while others have to learn and develop the ability to see the world critically and to share their views.

Foucault (1973) talks about social control as conducted through regulating environments that are the development of an alternative to corporeal systems of control involving physical confinement and restraint. The Frankfurt School focused on issues of how the subject is constituted and 'how the spheres of culture and everyday life represented a new terrain of domination' (Giroux, 2001, 11). Youth Programme Curators challenge existing hegemonic structures through the programmes they construct, the methods they adopt and the outcomes that young people and artists produce in the form of events.

In the gallery, learning activities employ pedagogic strategies which attempt to maintain equality between education curator, artist and peer-leader: the curator knows little about urban youth culture, and the young people know little about modern and contemporary art; working with artists enables a sharing of knowledge in order to create successful events and activities. In contemporary Britain, it goes without saying that public art galleries continually strive to engage the broadest number of people in looking at art. Since the establishment of CEMA (The Committee for Encouragement of Music and the Arts), in 1940 they have tried to be inclusive to everyone (Art Council papers, 1939–1945). The slogan 'arts for all' sets out a mandate for change as a means to break down the exclusivity that has surrounded many arts and cultural venues. For many reasons, museums and in particular their learning departments have taken on the view held by the education sector that if more people were included in culture, then society would become more equal. In this view, inclusion is a predetermined end point through which, it is hoped, equality can be achieved.

Bingham and Biesta (2010) explore the distinction between 'equality' and 'inclusion' in Rancière's 'Ignorant Schoolmaster' (1991). Inclusion exists as an institutional and governmental ideal and is seen as 'the' core value of democratic society. Conversely, striving for 'equality' is not about searching for an end result but is about establishing an equal starting point:

> [inclusion], in a sense, knows where it wants to go, [equality] only knows where it wants to start. (Bingham and Biesta, 2010, 73) (my parentheses)

The emancipatory aims of the *Raw Canvas* programme are connected to 'inclusion'—to recruit and engage a diverse group of young people. The strategies that govern the approach to the learning and personal development

of participants strive to create 'equality' between group leaders and young people so that the young people can learn in accordance with their own agenda. The two aims are interconnected but they are also in conflict. Consequently, there are tensions between the aims of the programme and the pedagogical approaches that I have described:

> Inclusion is not only the main point and purpose of democracy, it is also one of its main problems. (Bingham and Biesta, 2010, 74)

There are some significant similarities between the governance of the gallery within the cultural sector and structures that exist in government within democratic society. In its drive to include the public in the shaping of programmes, the gallery shares the democratic will to include the demos in the ruling of society (or the gallery itself) and 'the insertion of those outside of the democratic order into democracy' (Bingham and Biesta, 2010, 82). In this respect, the notion of 'deliberative democracy or decision making by discussion among free and equal individuals' (Elster, 1998, 1; Bingham and Biesta, 2010, 76) is an important consideration.

However, Rancière (2010) would argue that this notion of 'democracy and inclusion is actually about the creation of a particular police order and of the insertion of those outside of this order into the order' (Bingham and Biesta, 2010, 82). Rancière's (2010) notion of 'police' in relation to democracy is the idea of police equated with the 'law'; law here means all those unwritten laws that define 'modes of being, doing, making, and communicating' (Rancière, 2010, 89). Rancière's (2010) concern is that democracy conceived in this way becomes about numbers—those who are included and those who are not—and that this kind of democratization is about extending the existing democratic order. He reveals the limitations of this approach to democracy and urges us to adopt a less quantitative view of inclusion and instead to look to reconfigure the 'distribution of the sensible' in order to achieve equality (Rancière, 2010). 'Rancière's (2010) insistence on equality is precisely not a plea for inclusion *if*, that is, we think of inclusion as the insertion into an existing police order' (Bingham and Biesta, 2010, 84). Rancière's understanding of democracy is essentially a disruptive process where those with no voice acquire one.

CONCLUSION

This chapter throws light on the depth of work that youth programme curators and young people engage in as they continually rethink and reshape the cultural offer in order to engage new audiences in meaningful ways.

The exploration of issues in this chapter is *not* intended to detract from the wealth of fabulous projects run at Tate and at other galleries. By conceptualizing learning in galleries in terms of critical pedagogic thought and new materialism, I seek to identify new strategies for engaging with new audiences around modern and contemporary art that are creative and productive for those individuals. This therefore requires careful thought about the situation of the learner and the outcomes of the learning to enable new narratives of both to emerge.

The context of youth programmes in art galleries requires pedagogical approaches that enable all the authority to speak and create conditions for empowering learners through participation. Pedagogies that emerge as a result of moderate hermeneutic practices are intrinsically dialogic and have the potential to be inclusive to all; however, there are significant pedagogical complexities in running new programmes for new audiences in an ideologically laden institution. Critical pedagogy requires that educators learn *with* participants, and as I have highlighted, this can lead to complex relations and tensions.

The issues that arise when engaging young people with art mean that care must be taken to avoid the construction of an 'other' through philanthropic gestures. To establish an approach in which an equality of intelligences can be achieved, learners must be empowered to construct their own identities as educational subjects. Following discourses of new materialism (Bolt, 2013; Braidotti, 1994; Barad, 2012), we can see that collaborative learning outcomes refuse many of the usual knowledge hierarchies and offer the potential to create new, locally negotiated intellectual material. For such outcomes to be achieved, it is important to enable debate because art is a contentious subject.

Pedagogies need to leave room for discussion and argument to take place, allowing for a range of ideas to be expressed, not just those that are in agreement with each other. Rancière's ideas about 'dissensus' are useful here (Rancière, 2010) as they give us a framework in which disagreement is profitable. These ideas are extremely useful in the context of cultural learning where there is a marked difference between 'community' and 'publics' in which the former suggests harmony and the latter allows for individuals. What needs to be encouraged is a dissensual space within which publics 'come together' around issues, which are debated. This is close to Mouffe's (2013) ideas about 'agonism' in which she demarcates the importance for disagreement in public relations. The cultural space is a place where representational practices or 'ways of seeing' can be challenged in order to open up new or modified ways of seeing: not for the purpose of conversion but to open up potentials and to question how and by whom cultural value is ascribed.

In recent years, in London and in certain parts of the United Kingdom, there has been a significant increase in the number of young people who come from racial and cultural backgrounds that are not reflected in the public institutions of the dominant culture. This predicates an urgent need to re-examine 'culture': what it means and for whom. Many people who work in museums and galleries are committed to opening the doors to everyone, but if programmes are to be for all, then pedagogies need to reflect the diversity of starting points and enable the dominant culture to be altered by its new audiences. Methods of display, public performance and participation are being re-conceptualized by artists and arts organizations across the United Kingdom; how the arts and therefore arts education will evolve remains to be seen.

NOTE

1. I started working at Tate Modern as an artist—a gallery educator (1999–2003). In 2002, I became Curator for Youth Programmes (2002–2011). I also took the role of Curator for School Programmes (2003–2005).

Chapter 8

Ethnocinema and Video-as-~~Resistance~~

Anne Harris

Visual cultures have come to dominate at least the expression of other inter-secting[1] cultures globally, including ethnic, gendered, racialized and geo-graphical. In research contexts, Hughes (2012) and others continue to grapple with standards in sociological enquiry, and video- and film-based research presents the most robust challenge to these standards in recent times (Colman 2014). Hughes (2012) reminds us rightly that 'Both Elias and Bourdieu, most interestingly, struggled against the sociological habits of their time' (xxix) to consider the kinds of 'concerns that underpinned both authors' analysis, albeit *via* reframed and reimagined theoretical objects embedded in the minutiae of human social life' (xxix). I follow Hughes (2012) in this chapter to consider the ways in which visual and digital cultures have been on the rapid ascendant over the past ten years, and what their relationship to culture may be.

Young people and others now experience life at the nexus of several 'competing sites of cultural production' (Levinson and Holland, 1996, 26, in Dimitriadis and Weis, 2008, 82), and video and digital self-representation is certainly one important stream in this nexus. Video-based research can be considered *cultural resistance* (in problematizing or rejecting static defini-tions of culture itself) and *scholarly cultural resistance* (an act of protest against the mainstream culture of academic knowledge production—what it is, how it happens and who gets to do it), but can also be considered a *culture OF resistance* by those who see the intersubjectivity and intersectionality of this tool.

Video alone is not a method or a methodology, as it can and is being used in countless ways in the doing of research. Yet it is a tool, and in this chapter I will argue that it is still most powerfully a tool of resistance, yet

that is rapidly moving towards hegemonized notions of what 'counts' is interdisciplinary research. This chapter makes a case for retaining the resistant power of video as a democratizing research tool, seen in a range of uses from digital research such as vlogging (Boler et al., 2014) to technology and youth studies (Dimitriadis and Weis, 2008), to ethnocinema (Harris, 2013, 2014a). The uses of video are rapidly proliferating, and here by using the single method of ethnocinema as a particularly transparent video-based research methodology, its culturally and politically resistant capacities can be disentangled from its materiality (Stewart, 2007) and from the related field of film theory (Colman, 2014). Like researchers and artists since time immemorial, video methods help us make sense of our lives by making a record of our 'ordinary attention to things' (Stewart, 2007, 36). The big data information-based cultures we now attempt to make sense of are increasingly screen-captured by visuality, by static and moving images, and in ethnocinema a jointly materialized movie. Like those everyday people in Stewart's (2007) landscape, many of us are growing accustomed to taping every move we make (and usually posting it online without editorial pause). These everyday actions, and the affects that cling to and accompany them, and the digital residue that remains, are profoundly affective cultures of scholarly research. Ethnocinema is one video-based research method that offers an alternative to this accelerating visual research cultures, and like Hongisto's (2012) concern for the 'transitional moments between the interviewer and the interviewee in testimonial video' (in Barret and Bolt, 10), for ethnocinematographers these 'materialities of experience' (10) are embedded in its collaborative nature. At times this collaboration is between what used to be called viewer versus maker, consumer versus producer, but which now is always already both at once. That is, in visual cultures we are never far from a consideration of audience, because that audience is always at least ourselves. This reflexive and culturally situated nature of arts practice as research, pedagogies and creativity have been intersectionally informing research as resistance for some time, as I will explore in the next section.

MATERIALIST CREATIVITY, NEW AND OLD

Creativity pioneer Morris Stein (1953) claimed that the level and adaptability of creativity was enhanced or suppressed by each cultural group's ability to tolerate and incorporate the ambiguity of individuality, original thought and expression. The relationship between culture and creativity overall has increasingly been the focus of much interdisciplinary and intersectoral research (see e.g., Glaveanu, 2014). Stein (1953), Gardner (1993) and others

(Kaufman and Sternberg, 2010; Craft et al., 2007) also famously remind us that creativity is socially defined, and culturally contextualized. This is true also with scholarly research and evolving notions of validity, as far as emergent methods like ethnocinema are concerned.

Creativity and resistant 'making' cultures include the broad (and ever-expanding) fields of visual methodologies, visual cultures and digital ethnographies, all of which offer new forms of cultural and knowledge production. In all such emerging methodologies, co-participants work more or less together to problematize notions of 'culture' and 'cultural difference', but are not limited to traditional definitions of it. As research is changing, so too are definitions of culture, its hybridization, its flows and social functions. For example, British 'cautious anthropologist' Shawn Sobers (2008) explores both methodological and cultural border-crossings, in his film-based ethnographies of slave histories, masculinities, illness and embodiment.[2]

Collaborative arts practice as research methods like ethnocinema suggest that as notions of culture are changing so too must research and pedagogical practices. As Hickey-Moody (2009) has theorized word, sound and movement as 'posthuman pedagogy' (279), here I claim the becomings-video of ethnocinema as similarly potent post-human and creative pedagogy. For ethnocinematic co-creators, 'posthuman pedagogy thus facilitates moments of contact with an Other' (279) in both embodied and virtual contexts, in corporeal and digital educational entanglements. As global mobilities muddy the waters of articulable cultural values and subjectivities, emerging research methods present an urgent imperative to engage more 'real world' practices and epistemological frameworks for cultural and discursive transgression. This chapter addresses the im/possibilities and implications of moving beyond 'cultural' identities and practices in visually representative research, for researchers who approach collaborative work as informed by thought that is 'patchy and material' (Stewart 2007, 5).

New materialism challenges the centrality of the human and human agency in 'new configurations [in which] the material and the discursive mingle and mangle' (Bolt, 2013, 3). This mingling and mangling can be discursively manipulating in representational and post-representational ways in video-based research. From aesthetics to the agency of the filmic form itself, video and their online circulability are extending the possibilities for visual contexts and discourses.

Ethnocinema and ethnovideo refocus on 'the materiality of film' in which 'moments of affection come to replace the recognizable testimonial moment with a material experience of affection' (Bolt, 2013, 10). That is, it is not primarily concerned with more traditional testimonial aspects of narrative or ethnographic film, but is rather focused on the making process a

intersubjectivity between human co-creators and the emergent characteristics of the film itself. As Bolt (2013) has argued, 'Film-making is an intense relationship between a myriad of human and non human actants—lights, cameras, editing machines, actors, editors, film-makers and directors' (5), and ethnocinema multiplies this relationship by the multiple makers involved in its creation, from idea through filmic tools to production.

Ethnocinema fuses techniques and theoretical perspectives from its ethnographic film origins with participatory and collaborative research methods, and invites researchers and co-participants to creatively come together to resist its more traditional anthropological disciplinary and methodological origins. Ascendant neo-liberalism in both pedagogical and research contexts marks them as sites of the enactment and politics of identity construction (Bhabha, 1994). Thereafter, in which the work of dismantling notions of authenticity/fallacy, hybridity/purity and a media-driven fictive unity, the 'volatile logic of iterability' (Butler, 1993, 105) in the ways we think and learn about, research and teach culture, identity, and materiality, in embodied and virtual practices and spaces is more urgent than ever.

Ethnocinema's discursive trajectory incorporates anthropological and critical theoretical discourses that extend mediascapes by articulating how 'private or state interests' (Appadurai, 1996, 35) become conflated and increasingly 'fuzzy' in global visual cultures and virtual scapes. The ideas and practices that underpin ethnocinematic research may produce different mediascapes that suggest both new processes and products, and serve different social functions. If ethnoscapes, as Hickey-Moody (2013) argues, are co-constitutive of the groups that they come to represent, ethnomethodologies such as ethnocinema offer ways of perforating the skin of such intersecting 'scapes' in multiple ways, using multiple methods. One such difference is the way in which ethnoscapes (as explored through ethnocinema) are shifting, globally mobile, and newly material sites—as they remain fixed and circulatory pedagogical and performative products, processes and 'rogue intensities' (Stewart, 2007). The proliferation of ethnomethodologies like ethnocinema represents research and subjective hybridities that offer new aesthetic, critical and affective lenses to those using visual methods and exploring visual cultures. The next section will address some forms of video-based methods and their resistant potential, highlighting the multiple ways in which ethnocinema in particular achieves this aim.

VIDEO-BASED METHODS

Before offering a more nuanced discussion of ethnocinema (and ethnovideo), first it may be helpful to briefly define other ways of using or incorporating

film and video in scholarly research including non-ethnographic documentary (Nichols, 2010), video ethnography (Pink, 2012; 2007) and visual sociology (Banks, 2007; Harper, 2012), and how they approach the role of video in research differently.

VIDEO-BASED RESEARCH

Bill Nichols (2010) has stressed what he believes are the differences between ethnographic film and non-ethnographic documentary, namely, that 'all these [ethnographic] efforts tended to categorize individuals in ways that minimized individuality and maximized typicality' (226). These days the lines between individual and collective, culture and strategic assemblage are more blurred than this neat definition, and therefore the possibilities for video-based research have similarly blurred and widened. The flexibility of video refers to both its uses as well as its options in theorizing, writing up and disseminating. The speed with which video methods are proliferating and evolving attests to its value in this digital culture as an effective tool for researchers in almost every discipline—not only as method, but as methodology (Spencer, 2011; Pickering, 2008).

Film- and video-based research, however, differs from those who are increasingly using video only to data capture (with no attention to aesthetics) or to disseminate (Goldman, 2007). The use of visual methods in more emergent areas such as the study of aesthetics in creative methods, applied video and hypermedia, micro-video-based science and medical research, digital 'making' cultures, and interactive online video-based research all represent the ever-expanding ways in which video is being used to contribute to and to lead research project design. Interdisciplinarily too, it is proliferating: areas like cultural geography which range from the uses of videotaping landscapes to interactive mapping to cultural sociological cartography of communities, and corporeal cartographies of the body, are increasingly common. Throw into this methodological mix a proliferation of video-infused methods such as social media, vlogging, YouTube, Instagram, Google Sketchup, Scantech and Skratchit. Some of the most exciting video research is only beginning to emerge within immersive 4D simulation technology in medical and education research areas. The methods associated with such disciplines and discourses are equally varied, including, for example, virtual visual methods like video games (Fielding et al., 2008), applied video research in developmental psychology (Shwalb et al., 2005), creative social science research using video (McIntosh, 2010; Heath et al., 2010) and visual ethnographies including ethnocinema (Harris, 2014a), to name just a few. Exciting yes, but just as rapidly hegemonizing as it is

proliferating, and if video's shape-shifting role for critical theory or resistance research is to be retained, greater reflection is required as this chapter seeks to do.

VIDEO ETHNOGRAPHY

Ethnographic film and video too is proliferating as the means of production becomes increasingly accessible. This accessibility itself presents new challenges, as Pink (2012) and other visual ethnographers have made clear over the last ten years, the need for limiting the research focus and question in order to avoid large video data sets that can quickly become unwieldy (Goldman, 2007). As video's strength is its ability to provide multiple layers of data about subjects and their environments at the same time, it is crucial for researchers to clearly identify which aspects and features of the captured data are most relevant to the research project and its analysis. While video data is still most often (but not solely) used for qualitative social science research, its strength can be to newly reinforce the core qualitative tenet of foregrounding the perspectives and lived experiences of the participants. Video researchers' success in good design and analysis depends upon specificity in relation to these multiple perspectives, especially when integrating self-generated video data as part of the approach. That is, in both design and writing up, video researchers must be absolutely clear about the audiences, uses and analytical approaches through which the data is gathered, interpreted and disseminated. This will avoid the kinds of instrumental video uses from which early video-based research suffered—and still does at times (think researchers who simply use a static camera to do what audio recording used to do, a gross underutilization of video). Innovative design can enhance video as a tool for establishing new protocols and research relationships, beyond simply new methods that replicate in digital form familiar traditional approaches. For nearly forty years now,

> there have been ongoing debates about the definition, methodology and audience of ethnographic films, and how the subgenre of ethnocinema may or may not fit in . . . as it might (or might not) be distinct from more traditional ethnographic documentary. (Harris, 2011, 336–7)

Visual ethnography today is many things. It is not the visual anthropology even of post-World War II (Guindi, 2004), which sought to examine social systems through visual methods, most innovatively, through video as ethnographic documentary. It was a big shift which in its own way democratized the methods of video-based research from big documentary teams[3] and

restaging of seminal culturally stereotyping events and rituals to the kind of cinema vérité that Rouch (Rouch and Feld, 2003) became known for. Yet, it has continued to evolve at an accelerating rate since then. As I have detailed elsewhere, this evolving ethnographic video research is characterized by a range of multiplicities, not only by intercultural ones,

> 'characterized by multiplicity . . . [in which Rouch's] shared anthropology is dialogic . . . suggesting a new kind of fieldwork that might entail staying at home in the field. This deconstruction of traditional ethnographic documentary includes the emergent discipline of intercultural cinema,' which recognizes 'the disintegration of master narratives and a growing conceptualization of knowledge as partial and contested'. (Marks, 2000, 2)

Such troublings of master narratives challenge traditional ethnography to expand its scope to include not only diverse perspectives 'but more collaborative endeavours that resist knowledge-construction solely for Western audiences' (Harris, 2011, 338). These changes in visual ethnographies resist more than this—they resist singular stories that make truth-claims of master narratives, not just interculturally but in troubling singularity itself. Indeed, James Clifford (1988) has argued that 'all ethnographic representations are partial truths' (Clifford in Harris 2011, 340). MacDougall (1998) too has cautioned against 'imagining an ethnographic documentary that can be considered "truth"' and asserts, 'the representation of anything is by definition the creation of something different' (MacDougall, 1998, 48, in Harris, 2011, 336).

The same has been argued about video representation and visual cultures more generally (see Gubrium and Harper, 2013, 1986). Indeed, definitions of culture and by culture can themselves be included in this 'something different' by the nature of its generalizing function: Contemporary 'visual interventions' (Pink, 2007) are a hybrid offshoot of collaborative image-making and digital approaches to participatory action research. Visual interventions may include photography, film or digital media. Collaborative methods of participatory film-making and photography . . . [and] In practical terms, participatory visual researchers should be critically aware of the multiple facets and uses of photos, maps and film as documentary evidence; as a prompt for eliciting responses; and as a form of material culture, as a source of power, and as social capital (Banks, 2007). . . . Banks writes: 'European and American society has constructed photography—and in due course, videotape—as a transparent medium, one that unequivocally renders a visual truth' (Banks, 2001, 42). 'It is not merely a neutral document or record of things that took place before the camera, but a *representation* of those things, persons, and events intended to explain society and its processes' (Banks, 2007, 12–13)

(in Gubrium and Harper, 2013, 1986). This range of interpretations, forms and functions of video ethnography is characterized by its resistant potential, and stands in some distinction from the more mainstream and growing field of visual sociology.

VISUAL SOCIOLOGY

Banks (2007) and Harper (2012) in sociology are advancing discussions of the theoretical tensions between visual, embodied and digital cultures and their implications for creative, activist and more traditional forms of research. Reflecting this, the role of video (like other digital methods and methodologies) is rapidly and significantly changing, and this section addresses some clear theoretical trajectories affecting video-as-research, but also the inchoate theoretical innovations present in current scholarship.

As Banks (2007) has stressed, effective and robust video-based research approaches represent different ways of meaning making, 'which can be reconstructed and analyzed with different qualitative methods that allow the research to develop (more or less generalizable) models, typologies, theories as ways of describing and explaining social (or psychological) issues' (Banks, 2007, xi) and which will allow video data to be used in limitless ways. Using video as method has no limiting implications for the methodological approach to the research design, nor any inherent aesthetic imperatives. Indeed, it is well suited to a range of sociological analytic approaches (Knoblauch and Schnettler, 2009). More importantly, video in social science research is adaptable, and speaks back to discursive cultures in the academy: through form, function and the nature of participation (Haw and Hadfield, 2011). For social scientists, the blurring of 'raw' versus 'edited', 'primary' versus 'secondary' and the potential for video-centralized research is an opportunity that requires unpacking. Haw and Hadfield (2011) acknowledge the 'ambiguous status of video within the research community' (29) as well as 'what constitutes an appropriate analytical process' (29), in which 'the researcher recognises the extent to which it is technically, theoretically and culturally laden, in contrast to data that are collected and handled with little recognition of these influences', and importantly they ask, 'Is video then affected by these influences in ways that distinguish it from other forms of data?' (29). Like Stewart (2007), Haw and Hadfield (2011) wonder about the affective dimension of what claims space as research, in a scholarly landscape that still mostly suffers the epistemological emaciation of unidirectional collaboration in research work. For methods like ethnocinema, decentralizing the nexus of research work is core to the co-constitutive nature of the video collaboration.

ETHNOCINEMA

In recent times, scholars have highlighted the exciting potential in new and emerging social science methods and methodologies (Banks, 2005; Spencer, 2011), including performative and digital ones. The power of visual methods (including video) is increasingly well known (McIntosh, 2010), yet its impact on critical research, and more broadly its implications for a conceptual paradigm shift regarding research approaches and dissemination, is yet to be deeply understood.

Ethnocinema can be a radically collaborative or participant-led method in which digital technologies facilitate links, in some cases, with others like participants across the globe in 'home' countries or communities, but also other diasporic locations.[4] Ethnocinema draws from a range of sociocultural theorists including Appadurai (1996, 2004), Massumi (2002, 2011), cultural materialists like Anderson (2006), postcolonial visual ethnographers such as Rouch and Feld (2003) and Minh-ha (2011), and post-humanists (Appiah, 2010), and takes a diverse approach to thinking about creative methods and culture as neither defined nor bounded by geography. Therefore, intersubjectively, culture comes to include or be considered as communities of practice, rather than ethnically or geographically defined. Such emergent 'cultures' are informed by what Anderson (2006) has articulated as imagined communities that increasingly replace nation-state, corporate and other anachronistic cohesion principles.

Yet ethnography remains persistently linked to colonial and anthropologized notions of subaltern and dominant subjectivities and discourses for those who see ethnography as a mono-directional and representational endeavour. Today, ethnography—and visual ethnographies in particular—are freed from these origins (see Pink, 2007, 2012). Ethnocinema and other arts practice as research approaches have the power to transcend traditional political strategies and can also address the multiple subjectivities of race, gender, sexuality and religion that play so deep a role in the contemporary call to action. As co-creators in arts practice as research, researchers and their participants discover, perform and document new knowledge products and pedagogies in collaboration not only with one another, but with the materiality of video and digital tools themselves. Through the self-curation entanglement of ethnocinematographers, cultural producers are indistinguishable from consumers and distributors. Thus, ethnocinema demands that audiences become an additional iteration of sense making. Importantly for ethnocinema, Appadurai's (1996) notion of the imaginary and its field of five scapes provides a conceptual geography in which the playing out of ethnicity, performativity and identity coincide in powerful ways. Such digital intersubjective performance and its role in the maintenance of collective and

individual memory is troubled between the works of Appadurai (2004) and
Anderson (2006), and the nexus of these ideologies is present in both post-
human (Appiah, 2010) and post-nation-state perspectives, and constitutes
'posthuman pedagogies: met-subjective material forces of change' (Hickey-
Moody, 2009, 274).

Appadurai (1996, 2004) articulates a social imaginary that is generated by
a collective imagination process, a tool for creating and accessing publics in
which diasporic citizens can come together in new kinds of communities.
Through circulable video-enhanced social media (Appadurai's mediascapes)
and other online technologies, ethnocinematic co-participants are keenly con-
versant in cosmopolitan conversations with their counterparts in all reaches of
the globe, radically dismantling traditional processes of scholarly knowledge-
construction and dissemination. Ethnocinema problematizes simplistic narra-
tives of culture and identity as constructed in the west for marginalized others,
in which notions of embodiment/virtuality remain binarized, and culture/cos-
mopolitanism move beyond diversity into a functional notion of 'semblance'
(Massumi 2011). His attention to creative relationality holds more possibili-
ties than aesthetics or outcomes, including as a critical lens. However, Butler
(1993) and others have criticized Massumi's (2002) distance from attention
to the body, but for Massumi (2002), interactive *'making seeming being'*
(2002, 64) is intrinsically affective and as such is an exchange that invites
the Other in each of us to engage with the centre and margin simultaneously.
In order to address any contemporary notion of ethnomethodology as a resis-
tant term to traditional sociology (Garfinkel, 1967), in the way that Rouch
and Feld's (2003) visual ethnography is resistant to anthropology, I will first
briefly address social constructivism as opposed to situational co-constitutive
research activity.

ETHNOCINEMA AND ETHNOMETHODOLOGY

Garfinkel (1967) originally articulated ethnomethodology in almost anti-
sociological terms, and in some respects it still remains defined in contrast
to sociology. I don't see it this way. Rouncefield and Tolmie (2011) make a
correlation between ethnomethodology and social constructionism, but draw
heavily on science and technology. They characterize it as an 'interpretive
sociology' (211) and agree that it is less concerned with meanings than the
situationally oriented nature of the work.

Ethnomethodology remains an enigma: for Giddens (1993) and other
historical materialists, ethnomethodology 'is readily construed as a study of
social praxis' (Lynch, 1993, 31), and despite some disappointments with the
approach (such as the ways in which it has 'sometimes been argued that the

approach is "conservative" because ethnomethodologists rarely talk about power or coercion' [31]), it promotes an 'avowedly "radical" agenda' (31). Yet in the end, 'The most serious problem that Habermas, Giddens, Bourdieu, and others find with ethnomethodology is that it disavows structural determinism' (Lynch, 1993, 31).

Despite its pivotal role in widening sociological and anthropological approaches to sociocultural research, ethnomethodology remains sidelined and controversial, still widely regarded as 'primarily a theoretical position that fails to answer to the need to provide a strong basis for confronting a larger set of structures' (Lynch, 1993, 32). Whether it is primarily concerned with social structures or social relations remains contentious, but for the purposes of this chapter, ethnomethodology does offer some possibilities for extending traditional sociological expectations of video. 'Habermas, Giddens, and Bourdieu each take ethnomethodology seriously, but each tries to transcend its limitations by retaining elements of rationalism, objectivism, and foundationalism' (31), and in the end ethnomethodology does remain informed by both phenomenology and the 'linguistic turn' due to its inextricability from linguistic representation, and language, so that in ethnomethodological terms, the social order or intersubjectivity is co-created or co-constitutive, even in film-making—so there is never any 'subject' and 'researcher', but rather a set of co-creators who make sense of one another and their experiences in the exchange between them, including—centrally— the use of language.

Ethnomethodology is based on both indexicality and reflexivity. Indexicality is the constructed nature of all knowledge, that it is situational and contingent, even precarious we might say, and like language, it is contextual. This is crucial to research, which still exists in a positivist academic structure in which 'truth-claims' are taken for granted and 'expert knowledge' is still narrowly (and usually Westernly) defined. 'For ethnomethodologists, to describe a situation is at the same time to create it' (Marshall, 1998, n.p.). It questions the ways in which we constitute the world, and the problematic nature of meaning. However, as previously asserted, it is strongly tied to linguistic and conversation analysis, and in this way ethnocinema is somewhat of a mismatch with ethnomethodology, due to its primary visual representational focus (for more on this see Pink, 2012, 2007).

Yet, we return again to the need to unpack the notion of culture in evolving ways for our moment, a need to ask whether indeed it can usefully be defined at all any more, and whether it is useful for us—as researchers—to even seek to define it with any sense of authority from the 1 percent of higher education and public intellectualism. Dimitriadis and Weis (2008) claim that 'the role of ethnography as a tool for understanding and acting upon our contemporary global moment needs rethinking in very fundamental ways' (82), a point

acknowledged within anthropology for some time. Their urge to 'deterrito-rialize' ethnography is tied to a deconstruction of 'the idea of culture as a neatly bounded and discrete entity [which] has been called inextricably into question by a host of contemporary social, cultural, technological, and material imperatives' (82).

If we accept a static definition of culture (which Dimitriadis and Weis (2008) would encourage us not to do), we might consider Lubart's (1999) claims, as stated at the start of this chapter, that 'culture encourages creativity in some situations and for some topics but discourages it for others' (342). Even without ascribing a static set of definitions to 'culture', Lubart's (1999) observation is compelling that 'given the divergent conceptions that different cultures may have for the same term, it is interesting, however, that creativity is generally viewed as a positive construct' (340).

Ethnovideo/ethnocinema can be considered an ethnomethodology, but one which is not used to define sociocultural groups (social order), rather to highlight the 'ambivalent negotiations' (Bhabha, 2001), between/across 'cultures' and 'identities'. It signals a shift from static to mobile notions of culture, and reflects changing enquiry at the heart of ethnographic research, including 'What if the work of documenting cultures becomes the work of documenting movement?' (Harris, 2014a). As such, it uses performative 'communities of sentiment' (Appadurai, 1996), or other theoretical lenses (see figure 8.1).[5]

Figure 8.1 Adiba. Still image from 'Sailing into Uni'. 2013

ETHNOCINEMA AS CULTURAL RESISTANCE

'Cultures of resistance' in general are on the rise; we see as much through global resistance movements like Occupy, Arab Spring, Femen, and other decentralizing assemblages that seek to dismantle the structures of the 1 percent. Contemporary cultures of resistance define themselves in contrast to neo-liberal, capitalist consumer cultures that pervade the contemporary global mainstream. They are alternately characterized as 'DIY cultures', global youth and activist movements, and 'slow' (embodied) versus consumerist civic engagements and citizen enactments. They are characterized by hybridity and welcome other formations and practices of networking, hacking and collectivizing—whether digital or corporeal (Boler et al., 2014; Hickey-Moody, 2013; Massumi, 2011).

Ethnocinema resists identity fixity (Hall's 'fictive unity', 2000; Bhabha, 2001) by remaining more focused in the local and intersubjective, rather than the translocal (there is no 'real me' in video, only the 'me' in relation to 'you'). But ethnocinema equally resists cultural fixity—'Culture as a necessary impossibility' (Bhabha, 1994)—through its resistance to ethnographic assemblages based on culture, or ethnic practices or identities. In other words, ethnocinema does not seek to represent any kind of generalizable truth of an ethnic or cultural whole, based on an investigation and visual representation of that whole or its constituent parts. That is, ethnocinema seeks only to investigate and comment upon cultures of belonging, based on individual definitions of such in a collaborative, intersubjective relationship with self and co-researcher. For this reason, while it is ethnographic, neither the ethnographic nor the video-based aspects of the method make truth-claims; ethnocinematic films are less 'self-as-culture' representative, and more 'self-in-culture' as contextualized identities-in-motion.

Ethnocinematic research resists epistemological fixity, notions of 'truth' versus 'fiction', and favours multiple subjectivities. These expressions of ethnographic resistance are not new: perhaps most famously, Trinh T. Minh-ha (2011) and Jean Rouch (Rouch and Feld, 2003) redefined video-based ethnography in the 1960s, but others have continued to do so since then. Ethnocinema additionally directly draws from and extends the notions of ethnoscapes and mediascapes (Appadurai, 1996) and in turn their ability to inform accelerating global flows, flows that are cultural but simultaneously resist fixed notions of culture.

Rouch's (Rouch and Feld, 2003) notion of *ethno-fictions* highlighted the value and possibility of co-constructed partial truths in working cinematically in ethnographic contexts. Collaboration and participatory methods became irrevocably part of the anthropological new moment through his approach (Rouch and Feld, 2003), and his total rejection of ethnographic truth through

collaborative creative work is at the core of ethnocinema, specifically the first two process steps of:

1. Form a small group or pair with whom to work
2. Brainstorm what cultural concerns/practices will be addressed in this collaboration.

Minh-ha (2011) extended the notion of ethno-fictions further through her attention to subaltern subjectivities, and by using film as cultural resistance in scholarship. Her training as a composer and her activist/scholarly commitment to aesthetically focused political works set in the anthropological paradigm enact an arts practice as research scholarship of resistance to previous eras of ethnographic film. Her postcolonial and practice-based approach to her work strongly influences these aspects of ethnocinema in the following two steps of an ethnocinematic project development:

1. Choose what topic the project will address
2. Who is your audience?

The process of selecting the focus of the film in a given project depends not just on the culture/s identified within the team, but its intersection with affect, conceptual frames and social context. For Minh-ha (2011), these considerations come together in the work's conversation with the audience. Unlike some contemporary 'making' cultures who claim the irrelevance of audience (the making is defined as a critical reflexive process without consideration of product), ethnocinema (drawing from Minh-ha, 2011) sees audience as an integral part of the dialogue of film-making. For Minh-ha (2011), the audience was always both the subaltern producer/consumer and the hegemonic mainstream consumer (scholarly, popular and critical were always still defined as western and white). The films are made and distributed as an act of speaking back to hegemonic notions of knowledge creation and subjectivity.

Appadurai (1996) and his focus on global flows facilitated (and in some cases precipitated) by intersecting ethnoscapes and mediascapes offers a new way to think about the value of collaborative practice-led approaches like ethnocinema. By requiring researchers and co-participants not only to work together, but to co-research one another, ethnocinema creates new social imaginaries through participation, and extends cultural enquiry beyond the static 'who we are' landscape into a 'where are we situated, where are moving to/from' more open horizon. These new horizons are limited only by a DIY ethic, in which knowledge (and product) creation no longer remains in the hands of the few, but rather through guerrilla production and circulation techniques are available to all. These new social imaginaries (visually represented

but interculturally enacted, even post-production) are inherently resistant, in their ability to provide experiential social commentary and critique for both the co-makers and the audience who consumes them (more frequently one and the same). This aspect of the ethnocinema approach is characterized by

- SharING roles—all participate in filming/filmed with simple technology (a DIY ethic)

The 'how to' (or method) part of this methodology therefore sits in resistance to method-cultures which still largely demand validity as tethered to large data sets and objective distance (ironically, video-based research does produce sometimes unmanageably large data sets, but of a type still not satisfying to the quantitative research paradigm). For ethnocinematographers, nothing could be further from the methodological truth. An important part of the conceptual contribution of ethnocinema is enacted through its doing. Mitchell (2011) and others have articulated the potential of collaborative video to 'help equalize power relations' (170) and encourage a 'reassessment of the nature of self in relation to social context' (91). Mitchell (2011) notes too the materiality of both still and moving visual images and their evocative nature in research relationships (especially interviews and self-reflection). Ethnocinematic research design too is always materially oriented: it cannot be abstract once moving images of self and others populate previously empty space. It is context specific and generated by the co-researchers and their question.

CONCLUSION

As I have claimed here, video alone is not a method or a methodology, as it can and is being used in countless ways in the doing of research. It retains a unique type of resistant possibility, and the power of that possibility is appearing online and in research contexts in a multitude of ways. Yet its compatibility with an increasingly 'big data' research culture makes video vulnerable to abuse and assimilation, and there are signs that it is moving rapidly towards more hegemonized notions of what 'counts' as research interdisciplinarily.

In this chapter, I have articulated the resistant agency of ethnocinema, and contextualized it within other video-based research approaches and methodologies. Ethnocinema as a particularly transparent video-based collaborative research methodology and is ripe for culturally and methodologically resistant applications, enabling an important critical disentanglement from its neoliberal material life as 'research product', and return to a more innovative,

and certainly more useful, subversive research praxis. Yet importantly, video-based research like ethnocinema can be resistant both creatively, culturally and representationally as what Massumi (2002) has called '*making seeming being*' (64), the technologies that create the 'regime of the visibility of seeming being' (65). Through the co-constitutive act of video-based research, an arts practice as research-based pedagogy of making between human and non-human co-makers problematizes static definitions of culture and identity itself. Ethnocinema and ethnovideo offer potent possibilities for an emergent scholarly cultural resistance (acts of protest against the mainstream cultures of academic/expert knowledge production), but can also be considered cultures of resistance in the intersubjectivity and intersectionality of this tool.

NOTES

1. *Intersectionality* refers to the study of the ways in which individuals, collectivities, institutions and discourses can only be understood through the intersecting set of sociocultural oppressions and discriminations that remain inextricable at both the macro- and micro-levels. While there is no one theoretical or epistemological framework for addressing intersectionality in research, it is widely associated with the pivotal essay by Kimberle Crenshaw (1989), and has had renewed attention through contemporary challenges to solidarity in social movements.

2. For examples of Sobers' work, see www.shawnsobers.com/films/.

3. Robert Flaherty, one of the founding fathers of ethnographic documentary film, has come under contemporary scrutiny and criticism for his alleged staging of the early film *Nanook of the North* (1921), which he claimed documented the lived experiences of the Inuit in the Arctic north pole, but which was later found to have been largely staged by Flaherty and his local collaborators.

4. For more on this, see the Creative Research Hub, www.creativeresearchhub.com.

5. For two examples of these emergent refocusing of ethnographic concerns, see the short film clips: LINK #1: Nyadol, http://www.youtube.com/watch?v=rIqwNA8-AE4._LINK #2: Adiba, www.creativeresearchhub.com/#!sailing-into-uni-film-clips/ct99, see figure 8.1.

Chapter 9

Manifesto

The Rhizomatics of Practice as Research

Anna Hickey-Moody

Practice as research is a phrase I use to refer to an entwining of contemporary creative practice and academic research landscapes. The phrase is typically employed as a differentiation of terms such as practice-led research and practice-based research (Haseman, 2007: 147). Bolt and Barrett (2007) characterize a particular iteration of practice as research as an approach which draws on 'multiple fields and pieces together multiple practices in order to provide solutions to concrete and conceptual problems' (12). Focusing and extending this definition, I use the term practice as research to refer to practical *invention* and *evaluation*, via processes that draw on 'multiple fields' and which piece 'together multiple practices' (Bolt and Barrett, 2007: 12), across academic and contemporary arts contexts. My practice as research is philosophically informed making, and thinking about making, which unfolds with a focus on invention and evaluation. In order to explicate this perspective, I adopt a materialist lens.

As noted in the introduction to this collection, increasing value is being placed on matter and creative methodologies in social sciences and humanities (van der Tuin, 2011; Coleman and Ringrose, 2013). New materialism (Barrett and Bolt, 2013) and Deleuzian informed methodologies (Coleman and Ringrose, 2013; Springgay et al., 2008) are starting to be valued for offering curious, affective, enfleshed, vital approaches to research (MacLure, 2013). New materialism, or what Sara Ahmed (2008) has perceptively called white feminist materialism, is clearly not free from political and cultural issues pertaining to the history of black feminism and materialist thought. However, new materialism does advance a very useful framework for thinking about the agency of matter in the materiality of making. New materialism calls for research inquiry via practice, via materiality—it calls for embodied, affective, relational understandings of research process. Such contemporary

feminist materialism abandons the idea of matter as inert and subject to predicable forces. It posits matter as always partially indeterminate and as constantly forming and reforming in unexpected ways (Barad, 2007). A materialist ontology recognizes the interconnections of all phenomena (human and non-human, actual and virtual).

Coleman (2008) and Lury and Wakeford's (2012) work on 'inventive methods' is also now starting to be mobilized (see Coleman, 2014) to explore the agency of matter and advance vitalist frameworks for empirical research. Inventive methods are a performance of materialist ontology, although an ontology largely informed by science and technology studies. In this chapter, I strengthen the nascent connection between new materialist feminism and inventive methods with a focus on ontology and creative practice as research. Drawing primarily on the collaborative work of Deleuze and Guattari (1985, 1987), this chapter engages with recent work from the Arts Practice and Learning PhD Programme at Goldsmiths, University of London, in relation to frames of possibility opened up by Lury and Wakeford's (2012) suggestion that inventive methods extend and remake the 'happening of the social' (2).

To develop new approaches to materialist research through experimental methodologies for empiricism, I investigate the rhizomatics of practice as research. This builds on the suggestion of Springgay et al. (2008) that 'three ways of understanding experience—theoria, praxis, and poiesis—are folded together and form rhizomatic ways of experiencing the world' (xxiv). The rhizomatics of practice as research is experimental and materialist because it values responsiveness to context and recognizes agency in the material world, which matters because it means research is always acknowledged as a process of making and value is placed on the research process as well as the product. As Gardner (2015, this volume) states, materialist research methods, which, after Deleuze and Guattari he calls historical-stratigraphic methods, emphasize 'the significance of lines that move *between* planes of coexistence according to an ontology of historical creativity—a fluid combination of intensive emergence and the universal-contingent' (this volume: n.p.). Therefore, processes of investigation, whether statistical surveys or creative practices, shape the worlds they map through their methods. With arts practices, engagements with chance, accident and error can enable material agency to shape work in ways that are explicit. This is of interest when thinking about the happening of the social as a process of invention and exchange between the non-human and the human. Social worlds and research processes are contingent, and this contingency needs to be acknowledged as a form of non-human agency.

While Lury and Wakeford (2012) are interested in inventive methods that respond to 'problems', I suggest that by taking a more ontologically focused, and postcolonially aware approach to why and how inventive

methods matter, we might further shift and enmesh distinctions between what it means to 'do' research and to 'make' through contemporary practices or arts-based processes. As Lury and Wakeford (2012) demonstrate, art and social science are more entwined than UK-based Research Assessment Exercises (RAEs) and our current Research Excellence Framework (REF)[1] might have us believe. I suggest a feminist materialist reading of Deleuze and Guattari's (1985, 1987) rhizome as an inventive materialist research methodology. In developing rhizomatic frameworks for practice as research, we can develop reflexive, intra-active, postcolonial themes through writing our subjectivities into our work in varying ways, employing different textual forms to create space for changing reader-writer-maker-consumer-watcher-watched relationships, and writing in the different spatialities and temporalities which fold-in to constitute practice as research.

MOVING SIDEWAYS: IMAGING AND GROWING METHODS

> Unlike a structure, which is defined by a set of points and positions, the rhizome is made only of lines; lines of segmentarity and stratification as its dimensions, and the line of flight or deterritorialization as the maximum dimension after which the multiplicity undergoes metamorphosis, changes in nature. (Deleuze and Guattari, 1987: 21)

Outlined in *A Thousand Plateaus: Capitalism and Schizophrenia* (1987), Deleuze and Guattari's rhizome is a method of conceptual arrangement and a method of practice, a methodology, that is 'anti-genealogy' (21) and uproots ideals of linearity, singularity and hierarchy. As a framework for practice as research and practice-based PhD projects, rhizomatics, and inventive methods as a performance of rhizomatics, offer an engaging ontological frame for thinking through practice as research. In many respects, all practice-based projects are rhizomes (or 'plateaus') that explore space, time, territories, locations, points of stasis and lines of flight, movements of deterritorialization and destratification.

A plateau is 'any multiplicity connected to other multiplicities by superficial underground stems in such a way as to extend or form a rhizome' (Deleuze and Guattari, 1987: 22). A plateau forms an accordion-like compression of spaces, times, experiences, memories, [that are] sclerotic and intra-active (Barad, 2007) collections of being, in which movement and disciplinary change occur. Materialist and (intra) disciplinary changes and developments are movements of deterritorialization and destratification, becomings, both of which can be collective and progressive or singular and static. The

work of practice-based PhD students, such as Clare Stanhope and Amba Sayal-Bennett, discussed in this chapter, destratifies existing boundaries in knowledge through bringing together sets of practices and bodies of academic knowledge not usually aligned. For example, Sayal-Bennett's work reads video art through the philosophy of Karen Barad as a methodology for developing drawings and projecting drawings in three dimensions. This performance of diffraction as a methodology 'is not a self-referential glance back at oneself . . . [rather, it is a method] drawing on optical phenomenon for . . . inspiration in developing certain aspects of . . . methodological approach . . . diffraction does not concern homologies but attends to specific material entanglements' (Barad, 2007: 88).

Movements and entanglements of diffraction and swarms of deterritorialization occur largely through lines of flight, an a-signifying rupture: 'The function of deterritorialization: D is the movement by which "one" leaves the territory. It is the operation of the line of flight' (Deleuze and Guattari, 1987: 508). Movements of destratification, becomings, are material, conceptual, corporeal transformations undertaken through the movement of incorporeal powers.

Change, chance, dissent and disagreement are core parts of the ecology of rhizomatics: 'Outside the strata, or in absence of the strata, we no longer have forms or substances. We are disarticulated; we no longer even seem to be sustained by rhythms' (Deleuze and Guattari, 1987: 503), but the act of leaving the strata—a-signifying rupture or deterritorialization—eventually folds back into a larger body, and as Barad (2007) reminds us, 'Existence is not an individual affair . . . time and space, like matter and meaning, come into existence, are iteratively reconfigured through each intra-action, thereby making it impossible to differentiate in any absolute sense between creation and renewal' (v). The iterative reconfiguration to which Barad (2007) refers suggests that practice as research, and inventive, practical ways of remaking subjects in and through research, are of value in the social sciences and humanities because they *change subjects*. Practice as research remakes/remaps/reconfigures how a given subject is constituted. It reinvents subjects, and spaces, as Sullivan (2008) asserts, 'When artistic practice is used within the context of inquiry, there is an investment in the potential that insight may emerge as a reflexive action sparked by a creative impulse that can help to see things in a critically different way' (242).

As an ethos for practice as research, a folding back of the 'map', or creative practice, into tree knowledge or hierarchical, academic practice, I think through the concept of the rhizome which Deleuze and Guattari (1987) establish through using the example of two types of books; each of the two types of book has a different structure and intent, distinguishing what they call a 'root-book', or a 'classical' book, from a rhizome, which they suggest is the

'second figure of the book' and a 'radical system' (5). Deleuze and Guattari (1987) outline this radical rhizomic system as a multiplicity that aborts the concept of unity, as having multiple roots which 'shatter the linear unity of the word' (16) and as including the 'best and the worst: potato and couch grass' (7).

A Thousand Plateaus: Capitalism and Schizophrenia (1987) begins by outlining the concept of a rhizome with a sketch, Sylvano Bussoti's *Piano piece for David Tudor 4* (Deleuze and Guattari, 1987: 3) (figure 9.1). The typically contained, autonomous musical lines are connected by crazy scribble. The overall feeling of the score is erratic connection, divergence, and the disruption of regular patterns. The frenetic scribbles of the music notes have impacted on the bars on which they are scrawled: some of the usually ruler-straight lines of the musical score have taken on wild diagonals, cutting up, down, across and behind the unorthodox musical notes. This score gives Deleuze and Guattari's (1987) rhizome a visual form, and it is as if, through disrupting the exterior, by performing irregularity, the rhizomic notes have altered the foundational structure of the music. It is an enactment that was required when the 'system used to express a particular practice fails to provide the sufficient means required to carry out the demands of this practice' (Palmer, 2013: 189).

More importantly, the function of this musical text has also changed, and here we have the purpose of the rhizome: it is an intra-action. Rhizomatics is a method of conceptual and practical arrangement that initiates change. Making a rhizome is about generating questions, pulling things apart to see

Figure 9.1 Sylvano Bussoti's Piano piece for David Tudor 4 (Deleuze and Guattari, 1987, 3).

how they work and putting them together again in a different way to see what else they can produce, what *different purposes they might serve*. Rhizomatics is a remaking of the social through paying attention to happenings, and making new happenings: reinventing, with a focus on functionality, on how and why things operate. Indeed, Deleuze and Guattari (1987) suggest that we 'never ask what a book means . . . we will not look for anything to understand in it. We will ask *what it functions with*' (4, my emphasis). Through developing Deleuze and Guattari's (1987) concept of the rhizome into an inventive materialist method of textual construction for practice as research, I have worked with, and assembled a series of lines of development for making, a text that invites readers to ask what the text 'functions with' (4) and enabling happenings to ask questions (figure 9.2).

Figure 9.2 Touch me—Series of lines for making a text. 2014.

In adopting Deleuze and Guattari's (1987) concept of the rhizome as a research ethos for practice as research, I construct my pedagogical practices and my own body movement and visual art practices, as entangled with dominant discourses of contemporary creative practices, dance performance and academic research, and through these entanglements, I attempt to uproot some of the presumptions upon which these discourses are based. I offer my praxis as self-reflexive, continually questioning the assumptions on which the disciplines that frame it are based.

THE SIX PRINCIPLES OF THE RHIZOME: SIGNPOSTS FOR MAKING SPACES

For those unfamiliar with the work of Deleuze and Guattari (1985, 1987), the six principles around which they structure their discussion of the rhizome are connection, heterogeneity, multiplicity, asignifying rupture, cartography and decalcomania. These qualities reflect a broader concern with the disruption of totalizing discourses; 'the rhizome is an acentred, nonhierarchical, nonsignifying system without a General and without an organizing memory or central automaton, defined solely by a circulation of states' (Deleuze and Guattari, 1987: 21). The six principles are 'approximate characteristics' (Deleuze and Guattari, 1987: 7), different articulations of similar concepts, *themes* and an analytic of practice concerned with what something 'functions with' rather than specific points of definition and modes of diffraction. This thematic focus on modes of operation has a relationship with the thought of Karen Barad (2007), who also emphasizes the relationship between form and feeling: 'Significantly, the agential nature of the iterative reconfigurings of spacetimematter relations makes clear the need for an ethics of responsibility not only for what we know, how we know, and *what we do* but, in part, for what exists' (243, my emphasis). Through making new mixtures and moving between things, practice as research changes what exists; it changes disciplines.

For example, practice as research in the field of art education remakes both what art education is and how it works. Clare Stanhope (2011), a current Arts and Learning PhD student, delivers a materialist critique of life drawing through changing what it is life drawing practices 'function with'. Rather than drawing a completely nude (and thus, objectified) woman, Stanhope (2014) maps women's skins with glue as a way of making maps of live bodies (figure 9.3). Shedding the glue skin, the woman's body is imprinted in dry glue rather than objectified by this process of visually reproducing her body. Rather than 'functioning with' the naked female body, and the objectification of the naked female form, this method of 'life drawing' functions

Figure 9.3 Clare Stanhope. Glue skin. 2014.

with visceral imprints of live women's skins, which Stanhope (2014) refers to as feminist skins. Other methods for 'life drawing' which function with non-objectifying methods that Stanhope has developed include drawing maps of day-to-day routes walked and stitching the patterns of daily routes and glue skins into paper. The former visually draws life day by day and the latter maps feminist skin; both methods function with the vernacular lived experience of a woman's body and day-to-day life. They intra-act between traditions of masculinist practice and contemporary feminist practices. Here, art practice teaches feminism and critiques masculinist histories of Arts education—practice as research is remaking art education.

Re-presenting and understanding practice as research and inventive methods, and creating spaces for different reader–writer relationships, is a form of rhizomatic thinking that creates a site of convergence between my involvement with inclusive movement practices, the work of Restless Dance Theatre, my visual arts practices and my students' contemporary creative practices through a range of textual technologies (Morgan et al., 1997) such as images,

practices and theoretical analysis. My development of rhizomatic texts
facilitates the inclusion of a range of practices and methods. After the work
of Felicity Colman (2014) and Alice Fox and Hannah Macpherson (2015),
I grow this emergent manifesto on the rhizomatics of practice as research
through considering each of the six principles of rhizome and considering
some ways they reinvent research for my students and my own practice as
research.

LOVE YOUR OTHERS: CONNECTION AND HETEROGENEITY

> Any point of a rhizome can be connected to anything other, and must be. This is
> very different from the tree or root, which plots a point, fixes an order. (Deleuze
> and Guattari, 1987: 7)

A rhizome makes connections between a diverse range of material. Specifi-
cally, Deleuze and Guattari (1987) suggest that this principle is an explora-
tion in decentring the written word. A rhizomic method makes connections
between a diverse range of material in abstract, non-linear ways, and in so
doing, highlights some limitations of written representation, or tree-knowl-
edge. Language is contrasted to 'a method of the rhizome type . . . [which
can] analyze language only by decentering it onto other dimensions and other
registers' (Deleuze and Guattari, 1987: 8).

Taking linguistics as an example of 'tree-knowledge', Deleuze and Guat-
tari (1987) suggest that even 'when linguistics claims to confine itself to what
is explicit and to make no presuppositions about language, it [linguistics] is
still in the sphere of a discourse implying particular modes of assemblage and
types of social power' (7). Part of what the arts practice PhD aims to do is
decentre language and ideas of art as object by valuing the process of practice
and documenting processes, enmeshing it into final written and visually/soni-
cally read arts-based assessment pieces. The folding back in of the rhizome
on to the map is core to the programme design and evaluation.

Deleuze and Guattari (1987) develop their criticism of dominant methods of
thought through suggesting that linguistics '[is] not abstract enough ... [it does]
not reach the abstract machine that connects a language to the semantic and
pragmatic contents of statements, to collective assemblages of enunciation,
to a whole micropolitics of the social field' (7). Where as a method of the
rhizome type 'ceaselessly establishes connections between semiotic chains,
organizations of power and circumstances relative to the arts, sciences and
social struggles' (Deleuze and Guattari, 1987: 7). The semiotic chains I con-
nect through my movement practice are between the work of dancers, some
of whom identify as impaired or having an intellectual disability, the times

and spaces in which the work is created, and the different subjects and experiences the dance texts connect.

Figure 9.4 was taken during a movement workshop held recently at the Centre for the Arts and Learning (CAL), Goldsmiths University of London, that brought together, and created, a community of movement practitioners with diverse bodies, histories and movement practices. While the image is not dynamic, the diverse natures of the bodies moving in the workshop are clear from the image, and the premise of moving together—principles of connection and heterogeneity—are embodied in the image. We are clearly a group, though we are heterogeneous. Barthes (1977) positions the photograph as a captor of space, a compression of reality into a line (or surface) of representation. For Barthes, the image is not the reality, but its perfect *analogon*, and it is exactly this analogical perfection which, to common sense, defines the photograph. Thus can be seen the special status of the photographic image: the photographic message is a surfacing of an event, an opening out into one line of a moment in time.

Photographs form an integral component of this chapter, and the contents of the images are a core part of the overall argument developed, namely, that forms of practice can rupture and remake semiotic systems, and this remaking

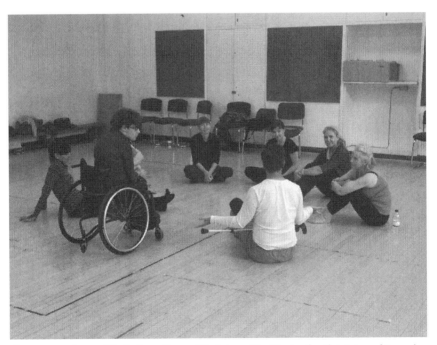

Figure 9.4. Beyond Technique Dance Workshop, The Centre for the Arts and Learning (CAL), Goldsmiths University of London. 2014.

allows us to know the social differently. And, perhaps more importantly, reinvent the social. In some instances, such as visually representing my student's work, reappropriating an image and re-employing it in a context that is different from that in which it was developed literally ruptures the power structures that were originally activated through the image's creation. In other instances, my written responses to a visual image highlight the political or social comments I am making in my theoretical argument. This conscious inclusion of images sits in relation to Deleuze and Guattari's (1987) criticism of linguistic models, as being 'not abstract enough . . . they do not reach the *abstract machine* that connects a language to the semantic and pragmatic contents of statements, to collective assemblages of enunciation, to a whole micropolitics of a social field' (7).

The images reflect the type of research process that informs the development of my students' dissertations, and my work as a practitioner, in the respect that they visually synthesize practical and theoretical examples. Through including the above pictures of dancers and our workshop venue, I am illustrating my concern to acknowledge that practice as research and inventive methods are always, even if unconsciously, based on, and inspired by, collective experiences. The complementary relationship between picture and word that I work to develop is modelled in part on Rodney Sappington's essay *Cracked open by the senses* (1994). Sappington (1994) writes autobiographically about growing up in Texas, and his essay is interleaved with photographs of the landscape in which he grew up. Sappington invites his readers to build relationships between environment, experience and his construction of identity through his combination of words and photographs. Through pictures, I invite my readers to build their own relationships between contemporary creative practices as research and open up the knowledge contained in the written word.

My employment of the principle of heterogeneity takes the first step in 'decentering [language] . . . onto other dimensions and other registers' (Deleuze and Guattari, 1987: 8), as images engage my reader visually with senses of other times, places, bodies, textures, that my words cannot offer. The employment of creative practices as a core component of my students' dissertations is intended to highlight, and bridge, the range of literacies their dissertations embody. My consideration of visual literacies also offers a crucial point of access to Stanhope (2014) and, later in this chapter, Sayal Bennett's (2014) work, highlighting the assumptions contained within the words 'practice as research' as to what research is, and how it might be undertaken or made.

Through referring to art practice as research, the act of making is framed by, and interpolates, a history of understanding knowledge production as an activity located in the 'brain' and hence the 'body' constitutes what the brain is not: irrational, and unknowing. Yet, as advocates of practice as research

know, the brain does not function in isolation from a human body, and a person's consciousness certainly cannot be located in their brain. The act of making itself re-machines the world in which the making occurs. Ingold (2013: 21) suggests that we

> think of making . . . as a process of *growth* . . . to place the maker from the outset as a participant in amongst a world of active materials. These materials are what he has to work with, and in the process of making he (sic) 'joins forces' with them, bringing them together or splitting them apart, synthesising and distilling, in anticipation of what might emerge. (21)

My development of the principle of connection and heterogeneity involves rupturing the power structures that support academic work through introducing rhizomatic text with images juxtaposed against the written word, and re-presenting the ethos of creating and making as a core part of building research-based texts:

> Even when linguistics claims to confine itself to what is explicit and to make no presuppositions about language, it is still in the sphere of a discourse implying particular modes of assemblage and types of social power. (Deleuze and Guattari, 1987: 7)

This chapter draws together the strands of my own, and others' contemporary creative practices as research, to place the creative texts in theoretical and methodological contexts.

MULTIPLICITY

'When a multiplicity . . . changes dimension, it necessarily changes in nature as well, undergoes a metamorphosis' (Deleuze and Guattari, 1987: 21). The concept outlined through this principle is that of challenging singularities through building intra-active relationships between subjects on a range of levels, and in so doing, developing, adopting new perspectives and reinventing. Deleuze and Guattari (1987) suggest that methods of identifying relationships between subjects should be contextually aware and responsive, and they offer the example of the connection between puppet strings and a puppeteer. This connection illustrates their argument that following contextually specific connections between subjects aborts the idea of singularity: 'as a rhizome or multiplicity, [puppet strings] are tied not to the supposed will of an artist or puppet but to a multiplicity of nerve fibers, which form another puppet in other dimensions connected to the first' (Deleuze and Guattari,

1987: 8). They further suggest that 'a multiplicity has neither subject nor object' (Deleuze and Guattari, 1987: 8), but rather, that multiplicities are 'defined by the outside: by the abstract line, the line of flight or deterritorialization according to which they change in nature and connect with other multiplicities' (Deleuze and Guattari, 1987: 9). As Blake and Stearns (2015: this volume) remind us, 'We are ourselves both host and parasite, predator and prey, possessor and possessed, and we consume ourselves as we consume the future.' We change in nature through connections with the outside, the future, and the people yet to come, who reposition us differently at times, over and over again. Collective processes produce different outcomes as they develop. The possible kinds of combination increase as a multiplicity grows (Deleuze and Guattari, 1987: 8) and, in so doing, a multiplicity transforms and makes new connections. The puppet becomes the puppet strings, and becomes the nerve fibres of the puppeteer, as broadening focal points lead to change, development and reinvention.

Practice as research is concerned with these multiplicities, with human-object-space-sound multiplicities, with making relations between people and things. I employ the principle of multiplicity by way of paying attention to the multiplicities that make up subjectivity, my psychological processes, and the impact these processes have upon my work. In so doing, I also acknowledge the contribution made by others to my writing. We are all, already 'dividuals' of a community. Creative ideas reflect different working philosophies; the movement methodology I practise takes the body of the dancer as a primary choreographic source, rather than positioning bodies as vessels that can fulfil a pre-inscribed ideal of dance aesthetic. As a collation of material gathered from keeping a journal of rehearsals and academic research, my movement-based research (Hickey-Moody, 2006, 2009, 2015) can be seen as quite literally embodying the idea that multiplicities transform those who are part of them, changing both those who constitute the swarm and the objects the swarm encompasses in its swarming.

My development of the principle of multiplicity (Hickey-Moody, 2009) offers readers an opportunity to engage with my own creative processes, the locations and events that have influenced them: 'The line of flight marks the reality of a finite number of dimensions. . . . The ideal for a book would be to lay everything out . . . on a single page, the same sheet: lived events, historical determinations, concepts, individuals, groups, social formations' (Deleuze and Guattari, 1987: 9).

The dimensions I inhabit in undertaking practice as research are multiple and varied, and the point at issue for me here is to create an avenue through which I can go on to illustrate different forces of power that shaped research and create spaces between theoretical research, embodiment, creative practices and academic contexts. I cannot transpose all the politics of my research

process on to a page. However, my reading of the principle of multiplicity is intended to voice the presence of politics, the politics of intimate spaces, the politics of formal spaces, bodily politics, politics of praxis and the politics of ideas. The matter of different materialities comes to make matter differently. My employment of the principle of multiplicity has been reworked with a broader focus in the ways I have arranged text and images in this chapter. My method of arrangement is a reworking of the first three principles of the rhizome: connection, heterogeneity and multiplicity, as acknowledgements of the intra-actions between text and reader that are effected through images.

ASIGNIFYING RUPTURE

> A rhizome may be broken, shattered at a given spot, but it will start up again on one of its old lines, or on new lines. You can never get rid of ants because they form an animal rhizome that can rebound time and time again after most of it has been destroyed (Deleuze and Guattari, 1987: 9).

Asignifying rupture breaks off development in one direction and starts up new development in another. Deleuze and Guattari (1987) go on to specify that the lines of development to which they refer must always tie back into one another, and must include the 'good and the bad' (9). This principle speaks to ideas of cross-fertilization through re-appropriation, a changing of purpose when breaking off and starting anew. Deleuze and Guattari make an example of the relationship between viruses and DNA hosts as a method of reproduction that is based around a kind of invasion, or rupture, in which the initial purpose of biological matter is re-appropriated (see also Blake and Stearns, 2015: this volume). Asignifying rupture works in structuring a rhizome:

> every rhizome contains lines of segmentarity according to which it is stratified, territorialized, organized, signified, attributed, etc. as well as lines of deter-ritorialization down which it constantly flees. (Deleuze and Guattari, 1987: 9)

Asignifying rupture is a 'line of deterritorialization', 'a veritable becoming' that merges 'the good and the bad' (Deleuze and Guattari, 1987: 10). These breakaway lines tie back into the body of the rhizome: 'There is a rupture in the rhizome whenever segmentary lines explode into a line of flight, but the line of flight is always part of the rhizome. These lines always tie back to one another' (Deleuze and Guattari, 1987: 9). Asignifying rupture embraces multiplicities and opens up to change: 'Write, form a rhizome, increase your territory by deterritorialization, extend the line of flight to the point where it becomes an abstract machine' (Deleuze and Guattari, 1987: 11).

Asignifying ruptures are a core part of all practice as research methods, certainly my own. In my book *Unimaginable Bodies* (2009), asignifying ruptures open up medical discourses which construct bodies with intellectual disability, and posit performance texts as sites which position bodies with intellectual disability as the authors of their identities, opposed to academic texts that position people with intellectual disabilities as research subjects. Through adopting rhizome as my research ethos, I create space in which the materiality of bodies can be reconsidered alongside medical constructions of bodies, knowledges and the relationships between them. Asignifying ruptures fold together, or mix, different discourses and different conceptual and physical 'spaces'. These include cultural and physical spaces, the metaphorical idea of 'creative space' and the rupturing of conceptual spaces.

For example, spaces created by rehearsal and performance venues are of key importance when rehearsing and performing a piece of dance-theatre. Factors such as wheelchair accessibility, adequate space, flooring, mirrored walls and ballet bars all determine what a space 'speaks of' and what it holds silent. Perhaps more importantly, what a space speaks of is also a determining factor in the kind of work that happens in a space. Bourdieu's (1992) notion of the 'field' is, of course, useful when thinking about the social rules embedded in spaces. Bourdieu (1992: 9) suggests: 'we may think of a field as a space within which an effect of field is exercised, so that what happens to any object that traverses this space cannot be explained solely by the intrinsic properties of the object in question. The limits of the field are situated at the point where the effects of the field cease'. While 'the intrinsic qualities of the object in question' (Bourdieu, 1992: 9) are not quite as easily definable as this quotation suggests they might be, and indeed, are made through the processes via which they are defined, the concept of the effects of a field is useful when looking at the production of difference within space as work, and the construction of capital as an effect of a field.

Dance spaces that are not wheelchair accessible, or which are framed by ballet bars and gymnasium equipment, suggest what dance 'should be', and in so doing, delineate what dance 'should not be'. Integrated dance as a practice ruptures these assumptions and folds them back into dance practice. Rehearsal venues tend to range from community halls and churches to professional 'dance spaces', depending on space availability and rehearsal requirements. The closer a performance piece comes to completion, the more physical space is required in which to rehearse it, as the performance text gradually increases in size as it is composed. This increase in claiming public space speaks to notions of building social capital, as visibility and performativity are literally accorded more space and dollar value.

A fabulous example of re-appropriating the cultural significance of space as constituting work can be found in a project undertaken in Western Australia

titled *Exile*. Facilitated by DADAA (Disability in the Arts, Disadvantage in the Arts, Australia), *Exile* was a site-specific work that developed and performed in a Gothic mansion once known as the Fremantle Asylum.[2] Glen Hayden, the project's director, speaks about the power of re-appropriating cultural space through performance:

> A nice thing about this performance being so site-specific is that, just by the very nature of the environment and the fact that it is a promenade show, there are points where we imagine that the audience will actually experience the feeling of incarceration and scrutiny. So I guess the gaze goes both ways, and that's always an interesting area for artists and audiences to explore. (Van Sanden, 2001: 13)

The functions of spaces are continuously re-territorialized through integrated dance performances.

RUPTURING CONCEPTUAL SPACES

Rupturing conceptual spaces in which material bodies are perceived as unrelated is also a key aspect of practice as research and inventive methods, and is a driving force in my movement work. Irving Goffman's (1961) analysis of the medical model and mental hospitalization illustrates my argument that medical models create a space in which specific understandings of corporeality as devalued and decentred are constructed. In parallel to these practices, in my writing, and my movement practice, I work to create a space in which the body is central, the site at which identity is located. Medical discourses and medicalized readings of bodies create spaces in which a direct correlation exists between materiality, visibility and economies of production. In *Asylums: essays on the social situation of mental patients and other inmates* (1961), Goffman offers an interesting discussion of work practices as defined in accordance to a public/private, or visible/invisible distinction, and locates this distinction as a method of attributing differing monetary values to work practices. Goffman suggests:

> Among tasks requiring the performer to meet the public, two kinds may be distinguished, one where the public consists of a sequence of individuals, and another where it consists of a sequence of audiences, a dentist performs the first kind of task, a comedian the second. (284)

Individuals are the publics accorded to experts and, alternatively, audiences are the publics accorded to service providers, such as entertainers. Skills and social value are attributed very differently in the first and second forms of identification. Of particular interest for me is the way, in the broader text,

Goffman (1961) has chosen to categorize the State as embodied by his construction of the individual as 'expert'. The expert embodies the ideals of the State in his or her practices. Described here as 'the server', Goffman (1961) outlines the particular qualities that define the expert [dancer/academic/Artist]: 'the server's work has to do with a rational competence, and behind this a belief in rationalism, empiricism, and mechanism, in contrast to the more self-referential processes that plague people' (287). While Goffman (1961) is attempting to critique the lack of space for the mediation of embodied experience within the institutional apparatuses of the medical model, and medical codings of bodies, he does so within a very confined theoretical space. The above quotation elucidating the qualities of the 'expert', the medical 'server' or psychiatrist, constructs an ideal that is useful and very true yet, perhaps unwittingly, quite disembodied.

Goffman (1961) writes the body as third person, in an esoteric manner that disconnects bodies and selves. This style of writing ultimately reinforces, or reconstructs, theoretical spaces created by medical models of the body:

> The first issue is that the body is, as psychoanalysts say, highly cathected in our society; persons place great value on its appearance and functioning and tend to identify themselves with it. Individuals are uneasy about giving their bodies up to the rational-empirical ministrations of others, and hence need their 'confidence' in the server continuously shored up by bedside assurances. This problem must not be overstressed, however, not because *persons are ceasing to identify with their bodies* but because of what we are slowly learning about how much they identify with non-corporeal things, such as wrist watches and cars, seeing in a threat to these 'good objects' a threat to self. (Goffman, 1961: 297–8, my emphasis)

We are our bodies. We can only pretend not to identify in some ways with them. Goffman's (1961) point about identity as a process of identification in which people create semiotic regimes of self is useful when considered in light of the fact that such regimes are always created by a body whose identity is in question. The static nature of Goffman's (1961) understanding of 'self', and his description of the ensuing processes of identification, is grounded in Cartesianism:

> The client will find it difficult to treat his body, and have it treated, impersonally, and to overlook the fact that he cannot use it in the usual fashion while it is being repaired. (Goffman, 1961: 303)

The kinds of space that the medical model creates is one in which bodies are not necessarily viewed as the site of a person. Where exactly the person is assumed to be is not elucidated, but the above quote leaves me with the impression that the person might be hovering above the body, watching

bodily repairs with anxious scrutiny. Discussing epidemiology, Goffman also describes spaces as having the potential to be pathogenic (300) and, perhaps the pathology of the medical model is that of the body, which Goffman describes as being the object of a service, rather than a site of embodied subjectivity and a cultural text:

> Whatever the patient's social circumstances, whatever the particular character of his 'disorder', he can in this setting [psychiatric institution] be treated as someone whose problem can be approached, if not dealt with, by applying a single technical-psychiatric view. That one patient differs from another in sex, age, race, grouping, marital status, religion, or social class is merely an item to be taken into consideration, to be *corrected for*, as it were, so that general psychiatric theory can be applied and universal themes detected behind the superficialities of outward differences in social life. (306, emphasis added)

This medicalized coding of bodies, and the critique of 'expert knowledges', are core to my inclusive movement practice, which is by definition always collective and is always about materially and expressively challenging dominant codings of bodies. More than this, though, *practice as research*, and inventive methods as a form of practice as research, challenge expert/layperson binaries. Invention requires openness, awareness, receptiveness. Practice as research requires perception of, and engagement with, matters, states of affairs, materialities, accidents as agents. The expertise required here is a level of receptivity. Attention. Responsiveness. Invention and practice as research are not about performing mastery, a skill which is suggested by dominant cultural constructions of the expert. Rather, invention and practice as research are about engaged responsiveness and ongoing ethical assessment.

Foucault (1980) suggests that the State as a political body can be conceived of as 'an extremely complex system of relations' (62) that cannot be attributed to a particular person, but only to methods of practice and knowing. Goffman (1961) locates State power and ways of knowing within the practices of the 'expert' within medical institutions and their broader social context, mirroring and inverting his construction of public and private space, through isolating medical practices as a means of rupturing the self as located within the body:

> In discussing the medical model in a general hospital, it was suggested that life conditions within the hospital could be divided into an inner and outer sphere: the inner sphere contains the injured area of the organism under conditions of medically indicated control that are highly responsive to the state of injury; the outer sphere provides, in a rougher way, housing for the inner sphere. (313)

Here the person is split into the injured body, and the 'whole' yet disembodied person, an incorporeal autonomous self, who is perceived as

constructing existence around the administration of medical practices and as somehow outside their corporeality. Inclusive movement practices remake bodily knowledges: bodies that might be constructed as divided, broken, in need of repair, can be remade or written over through making performance texts that bring bodies together and imprint different kinds of bodies in space in ways that attach different affects to bodies.

Bodies, ultimately the instruments that write dance, are living testimonies to the fact that all texts are a composition of different times. A scar, the colour of an eye, a person's walk are, among other things, signifiers of different temporalities. Histories are primarily embodied, and the histories of people with disabilities, especially intellectual disabilities (as I have said, community with whom much of my dance work has been concerned), are often *solely* embodied, their physicality constituting the only sites where their stories are recorded. Movement texts created by people with intellectual disability are therefore uniquely representative of their histories, and are in themselves, like all texts, compositions of different times:

> Because dances have no existence except through the body/bodies which pro-
> duce and reproduce them, they can be considered as texts written of and through
> precisely inscribed bodies. (Dempster, 1988: 37)

The concept of bodies as collections of temporalities brings a depth and duration to the work of doing practice as research. The knowledges mobilized by such practices include memories, senses, imaginings. There are few language-based texts *written* by people with intellectual disabilities in which their histories and identities are theorized and, as such, embodied memory needs to be valued and mobilized. Practice as research is a core strategy through which such histories can be employed. Cultural histories of people with intellectual disabilities are lived out through social attitudes, lifestyle options (or lack of) and methods of mainstream representation, all of which fold into bodies to create signifiers of a history. Hence, the histories and identities of individuals with intellectual disability are specific aspects of these individuals' embodiment. Points of a body that tell a particular story—prostheses, shunts, scars, tattoos, piercings, stretch marks and corporeal brandings of various forms, create different intensities, lines of latitude and longitude along which to read and feel life stories.

My concern with temporality is manifest, then, on a number of levels, that of the embodiment of temporality, and also that of the different times that constitute rehearsing and performing dance-theatre:

> A book has neither object nor subject; it is made of variously formed matters,
> and very different dates and speeds. To attribute the book to a subject is to
> overlook this working of matters, and the exteriority of their relations. (Deleuze
> and Guattari, 1987: 3)

I perceive practice as research as an accordion-like compression of a range of different writing times, making times, presenting times, moments of journal writing, discussion and analysis.

I suggest my doctoral students work to create a text that embodies Deleuze and Guattari's (1987) suggestion that a book is a folding of time and space back onto itself, because I am hesitant to believe Peter Brook (1990) when he suggests that 'as you read a book, it is already moving out of date. It is . . . an exercise frozen on the page' (157). While this comment can be seen as having a literal truth, Brook fails to acknowledge his reader, and the reader's subjectivity as the activating agent reading the text. Creating a text is largely about creating what will be a site of convergence for an author's creative processes and those of the reader.

'There is a rupture in the rhizome whenever segmentary lines explode into a line of flight, but the line of flight is always part of the rhizome. These lines always tie back to one another' (Deleuze and Guattari, 1987: 9). Deleuze and Guattari (1987) describe asignifying rupture as 'a line of deterritorialization down which [a rhizome] constantly flees' (9). Deterritorialization is 'a veritable becoming' (Deleuze and Guattari, 1987: 10). A current Arts and Learning PhD student, Amba Sayal-Bennett, who I introduced briefly above, works with accident, or asignifying rupture, as a methodological principle (figures 9.5 and 9.6). A visual and installation artist, Sayal-Bennett collects accidents that occur during her very structured processes of making. She allows the accidents agency in her processes of making and folds these back onto the highly structured tracing of her futuristic work, which critiques domestic life and hospital spaces, mapping interior designs for impossible futures as a performance of this critique. Sayal-Bennett's diffractive methodology begins with 3D sculptures, which are assembled alongside futuristic sketches. These sketches are also projected back into space as a flattening and extension of the initial flat sketch image, and the projection contrasts the textures and dimensions of the sculptures made from found industrial and domestic objects. The projection also has a sonic scape; the projector hums as its fan works to cool its interior light. Accidents occurring during the process of making are left as part of the work. Diffraction across media makes flat projections in space, makes atypical built works, and aesthetics and sensations intra-act across visual media.

POSITIONING: CARTOGRAPHY AND DECALCOMANIA

'A rhizome is not amenable to any structural or generative model. It is a stranger to any idea of genetic axis or deep structure' (Deleuze and Guattari, 1987: 12). Genetic axis and deep structure are 'infinitely reproducible

Figure 9.5 Amba Sayal-Bennett, In The Background of Carlo Collodi, 2014.

principles of tracing' (Deleuze and Guattari, 1987: 12), and a tracing is a text concerned with the logic of reproduction, as opposed to the creative mapping of the rhizome. As with the first two principles, the fifth and sixth principles are listed together, and the concept they explain is that of making a map and a tracing and then putting the tracing back on the map. A map is a rhizome: 'A map has multiple entryways, as opposed to the tracing, which always comes back "to the same"' (Deleuze and Guattari, 1987: 12). The rhizomic map has to do with experimentation, whereas the tracing always involves an alleged 'competence': 'what distinguishes a map from a tracing is that it [the map] is entirely orientated toward an experimentation in contact with the real' (Deleuze and Guattari, 1987: 12).

Decalcomania is a term used to describe transference by tracing, usually from prepared paper onto another surface, such as china or glass. In using this word, Deleuze and Guattari (1987) describe an action of reproduction and repetition, in the sense that to trace is to copy another person's work. A tracing is a text that is concerned with the logic of reproduction, rather than with creative production. Deleuze and Guattari (1987) go on to say that in order to make a rhizome, a person should make a tracing and a map, and that the tracing should always be put back on the map. Through combining the

Figure 9.6 Amba Sayal-Bennett, Narcopolis, 2014

tracing, or the conventional text, with the map, or rhizomic text, differences between the two are highlighted. The point of making a rhizome is to end up in the middle of these two poles of difference:

> It is a question of method: the tracing should always be put back on the map. This operation and the previous one are not at all symmetrical. For it is inaccurate to say that a tracing reproduces the map. . . . A rhizome has no beginning or end; it is always in the middle, between things, intermezzo. (Deleuze and Guattari, 1987: 13–14)

My pedagogy for the PhD programme employs the principle of cartography and decalcomania to enmesh (and emphasize intra-actions of) theory and practice. The various textualities that constitute my students' work must always tie into broader theoretical arguments, each complementing the other, as they position the tracing (theoretical landscapes) back on the map (practice base consisting of visual, performed and written creative developments). In offering readers a range of different positions within their work, my student' roles as the writers of their rhizomatic texts are brought into focus. They write themselves into the text as the body who is accountable, who is desiring readership, who seeks an audience, who has constructed the performative and analytic texts. In writing accountably, my students highlight the differences that occur between tracing and mapping. I argue that rhizomatics

is about making visible the politics of textual construction, through combining textualities and through discussing the *process* of textual construction as a way of inviting readers to ask what the text they are reading 'functions with' (Deleuze and Guattari 1987: 4).

CONCLUDING REFLECTIONS: ON THE ETHICS OF INVENTION

Inventive research methods materially and conceptually perform Deleuze and Guattari's (1987) concept of the rhizome, creating a text that is a site of praxis, a text that explores a range of different spaces, times, territories, locations, points of stasis and lines of flight. In my PhD pedagogies, and in this chapter, I have developed Deleuze and Guattari's (1987) concept of the rhizome to employ a range of textual technologies (Morgan et al., 1997) that have been pioneered by feminist researchers over the past decade. As a manifesto for paying attention to the eclectic ethics of invention, this chapter is 'a moment of problematic linguistic temporality which occupies a pocket of time' (Palmer, 2013: 189) but in so doing constitutes a folding together of multiple pasts and opens up little futures.

Like inventive, or 'live' (Back and Puwar, 2013) methods, the rhizome belongs to smooth space, twisting between points of definition, forming collections, or multiplicities, and oscillating between the arboreous logic of the tree that inhabits striated space and the logic of the ever-changing multiplicity that inhabits nomad, or smooth, space. Bodies, ultimately the instruments that do practice as research, are living testimonies to the fact that all texts are a composition of different times.

This chapter draws together the lines of the rhizome as an ethics of invention and engagement that necessarily requires an agentive understanding of matter. Across practices, and knowledges, we can inform and change happenings of the social through observing and remaking, through showing works that make observers think otherwise. Ethicism and eclecticism are hallmarks of responsive and inventive engagements with practice as research. I invite you to experiment with practice as research as an ethical form of invention, and embodied social critique advanced through aesthetics.

NOTES

1. 'The Research Excellence Framework (REF) is the new system for assessing the quality of research in UK higher education institutions (HEIs). It replaced the Research Assessment Exercise (RAE).

The primary purpose of the REF is to produce assessment outcomes for each submission made by institutions. The REF is a process of expert review. HEIs are invited to make submissions in 36 units of assessment. Submissions are assessed by an "expert" sub-panel for each unit of assessment, working under the guidance of four main panels. Sub-panels apply a set of generic assessment criteria and level' (REF, 2014: scare quotes my own).

2. The Fremantle Arts Centre was known as the Fremantle Asylum from 1864 to 1909.

References

Adichie, C. N. (2013). *We Should All be Feminists: Chimamanda Ngozi Adichie at TEDxEuston*. www.youtube.com/watch?v=hg3umXU_qWc&sns=fb. Viewed on July 24, 2014.

Adorno, T. W. (1981). Cultural criticism and society. In S. and S. Weber (trans). *Prisms*. Cambridge, MA: MIT Press.

Ahmed, S. (2002). Racialized Bodies. In M. Evans and E. Lee (Eds.), *Real Bodies: A Sociological Introduction*. Hampshire: Palgrave, 46–63.

———. (2006). Imagery prohibitions: Some preliminary remarks on the founding gestures of the new materialism. *European Jounral of Womens Studies*, 15, 23–39.

———. (2008). Imaginary Prohibitions: Some Preliminary Remarks on the Founding Gestures of the New Materialism. *European Journal of Women's Studies*, 15, 23–39.

Alaimo, S. and Hekman, S. (Eds.). (2008). *Material Feminisms*. Indiana: Indiana University Press.

Alexander, R. (2011). *Review of Teachers' Standards – Note from Professor Robin Alexander*. University of Cambridge–Director of the Cambridge. Review Available at www.cprtrust.org.uk (accessed 17 October 2014).

Allan J. (2013). Staged interventions: Deleuze, arts and education. In D. Masny and I. Semetsky (Eds.), *Deleuze and Education* (37–56). Edinburgh: Edinburgh University Press.

Allen, G. (2011). *Intertextuality* (2nd ed.). Abingdon, UK and New York, USA: Routledge.

Anderson, A. (2000). Prehension. http://neweverymoment.com.

Anderson, B. (2006). *Imagined Communities: Reflections on the Origin and Spread of Nationalism*. London: Verso.

Archer, L., Hollingworth, S. and Mendick, H. (2010). *Urban Youth and Schooling*. Maidenhead: Open University.

Arendt, H. (1958). *The Human Condition*. Chicago: University of Chicago Press.

Arts Council papers (1939–1945). Published in Victoria and Albert Museum archive catalogue. Available at www.vam.ac.uk/vastatic/wid/ead/acgb/acgb-el1.html (accessed 22 July 2014).

Appadurai, A. (1996). *Modernity at Large: Cultural Dimensions of Globalization.* Minneapolis: University of Minnesota Press.

———. (2004). The capacity to aspire: Culture and the terms of recognition. In R. Vijayendra and M. Walton (Eds.), *Culture and Public Action* (59–84). Stanford: Stanford University Press.

Appiah, K. A. (2010). *Cosmopolitanism: Ethics in a World of Strangers (Issues of Our Times).* New York: W. W. Norton.

Assad, M. (2001). A trajectory of learning: The quest for an "instructed-middle." *Parallax,* 7(4), 40–7.

Atkinson A. and Dash, P. (2005). *Social and Critical Practices in Art Education.* Staffordshire: Trentham.

Austin, J. L. (1962). *How to do Things with Words: The William James Lectures Delivered at Harvard University in 1955.* Oxford: Clarendon Press.

Bacon, F. (2000). *The New Organon.* Cambridge: Cambridge University Press.

Baker-Sennett, J., Matusov, E. and Rogoff, B. (1992). Sociocultural processes of creative planning in children's playcrafting. In P. L. G. Butterworth (Ed.), *Context and Cognition: Ways of Learning and Knowing* (93–114). Hertfordshire: Harvester-Wheatsheaf.

Bakhtin, M. (1984). *Rabelais and His World* (trans. H. Iswolsky). Bloomington, IN: Indiana University Press.

Bal, M. and Bryson, N. (2001). *Looking In: The Art of Viewing.* London: Routledge.

Banks, M. (2007). *Using Visual Data in Qualitative Research.* London: Sage.

———. (2001/2005). *Visual Methods in Social Research.* London: Sage.

Barad, K. (2007). *Meeting the Universe Halfway: Quantum Physics and the Entanglement of Matter and Meaning.* Durham and London UK: Duke University Press.

———. (2008). Posthuman Performativity: Toward an understanding of how matter comes to matter. In S. Alaimo and S. Hekman (Eds.), *Material Feminisms.* Indianapolis: Indiana University Press, 120–156.

———. (2012). Interview with Karen Barad. In R. Dolphijn and I. van der Tuin (Eds.), *New Materialism: Interviews and Cartographies.* Michigan: Open Humanities Press, 48–70.

Barrett, E. (2007). Introduction. In E. Barrett and B. Bolt (Eds.), *Practice as Research: Approaches to Creative Arts Enquiry* (1–13). New York and London: I. B. Tauris.

Barrett, E. and Bolt, B. (Eds.). (2007). *Practice as Research: Approaches to Creative Arts Enquiry.* New York and London: I. B. Tauris.

———. (2013). *Carnal Knowledge: Towards a New* Materialism *Through the Arts* (1–13). New York and London: I. B. Tauris.

Barrs, M. and Cork, V. (2001). *The Reader in the Writer.* London: CLPE.

Barthes, R. (1977). *The Death of the Author, Image, Music, Text.* London: Fontana Press.

Bennett, T. (1995). *The Birth of the Museum.* London and New York: Routledge.

Bennett, T., Savage, M., Silva, E., Warde, A., Gayo-Cal, M. and Wright, D. (2009). *Culture, Class, Distinction.* London and New York: Routledge.

Bergson, H. (2004). *Matter and Memory*. New York: Dover.

Bhabha, H. K. (1994). *The Location of Culture*. New York: Routledge.

———. (1996). Culture's in-between. In S. Hall and P. du Gay (Eds.), *Questions of Cultural Identity*. London: Sage, 53–60.

———. (2001). Unsatisfied: Notes on vernacular cosmopolitanism. In G. Castle (Ed.), *Postcolonial Discourses: An Anthology* (38–52). Malden, MA: Blackwell.

Biesta, G. (2010). Learner, student, speaker: Why it matters how we call those we teach. *Educational Philosophy and Theory*. Special Issue: *Ranciére, Public Education and the Taming of Democracy,* 42(5 and 6), 540–52.

Bingham, C. and Biesta, G. (2010). *Jacques Rancière: Education, Truth and Emancipation*. London and New York: Continuum.

Blackman, L. (2008). *The Body*. Oxford: Berg.

Blake, W. (1956). The Letters of William Blake. In G. Keynes (Ed.). (1980). *The Letters of William Blake*. Oxford: Oxford University Press, 1–260.

Blake, C. and Haynes, P. (2014). Something in the air: An introduction to immanent materialism and the unbounded earth. In *Immanent materialisms: Speculation and critique* [Special Issue]. *Angelaki: Journal of the Theoretical Humanities,* 19(1), 3–14.

Boal, A. (1992). *Games for Actors and Non Actors*. London: Routledge.

Boler, M., Harris, A. and Jacobson, J. (forthcoming). Vlogging as self-curation.

Bolt, B. (2013). Introduction: Toward a new materialism through the arts. In E. Barrett and Bolt (Eds.), *Carnal Knowledge: Towards a New Materialism through the Arts* (1–13). NY/London: I. B. Tauris.

Bolton, G. (1979). *Towards a Theory of Drama in Education*. London: Longman.

———. (1998). *Acting in Classroom Drama: A Critical Analysis*. London: Trentham.

———. (2010). Towards a conceptual framework for classroom acting behaviour. In D. Davis (Ed.), *Gavin Bolton: Essential Writings*. Stoke on Trent, UK and Sterling, USA: Trentham, 19–44.

Booth, D. (2012). Reconsidering Dorothy Heathcote's educational legacy. Drama Research. *International Journal of Drama in Education,* 3(1), 1–19.

Bourdieu, P. (1984). *Distinction: A Social Critique on the Judgment of Taste*. Oxon: Routledge.

———. (1990). Structure, habitus, practices. In P. Bourdieu (Ed.), *The Logic of Practice*. Stanford: Stanford University Press, 52–65.

———. (1992). *An Invitation to Reflexive Sociology*. Cambridge, MA: Polity Press.

Bourne, M. (Director). (2008). Swan Lake, New York. NVC Arts. DVD.

Braidotti, R. (1994). *Nomadic Subjects: Embodiment and Sexual Difference in Contemporary Feminist Theory*. New York: Columbia University Press.

———. (1996). *Patterns of Dissonance: An Essay on Women in Contemporary French Philoopsigy*. Cambridge: Cambridge University Press.

———. (2000). *Metamorphasis: Towards a Materialist Theory of Becoming*. Cambridge, MA: Polity Press.

———. (2013). *The Posthuman*. London: Polity Press.

Brook, P. (1990). *The Empty Space*. Middlesex, UK: Penguin.

Bruner, J. (1986). *Actual Minds, Possible Worlds*. Cambidge, MA, USA: Harvard University Press.

Butler, J. (1993). *Bodies that Matter: On the Discursive Limits of Sex.* London: Routledge.

Butt, Z. (2010). *Scratching the Walls of Memory.* Exhibition catalogue essay. New York: Rollins Fine Art.

Byron, K. (1986). *Drama in the English Classroom.* London: Methuen.

Carpenter, J. (Director). (1982). *The Thing.* United States: Universal Pictures. Film.

Carter, P. (2004). *Material Thinking the Theory and Practice of Creative Research.* Carlton, VC: Melbourne University Publishing.

———. (2007). Interest: The Ethics of Invention. In B. Bolt and E. Barrett (Eds.), *Practice as Research: Approaches to Creative Arts Enquiry* (15–27). London and New York: I. B. Taurus.

Caygill, H. (2013). *On Resistance: A Philosophy of Defiance.* London: Bloomsbury. Retrieved from http://www.bloomsbury.com/uk/on-resistance-9781472526564/.

Chance, S. (2001). Getting past square one. *Lowdown,* 24(5), 6–7.

Charman, H. (2009). http://static.tate.org.uk/1/onlineevents/podcast/mp3/2009_02_26 _Helen_Charman.mp3 (accessed 5 September 2014).

Charman, H. and Ross, M. (2006). Contemporary art and the role of interpretation: Reflections from Tate Modern's summer institute for teachers. *International Journal of Art and Design Education,* 25(1), 28–42.

Cimino, M. (Director). (1978). *The Deer Hunter.* USA/UK: Columbia-EMI-Warner (UK) Universal (US). Film.

Claxton, G. (1999). *Wise-up: The Challenge of Lifelong Learners.* London: Network Educational Press.

Clements, P. (2011). The recuperation of participatory arts practices. *The International Journal for Art and Design Education,* 30(1), 18–30.

Clifford, J. (1988). *The Predicament of Culture: Twentieth Century Ethnography, Literature and Art.* Cambridge. MA: Harvard University Press.

Cohen, R. (1997). *Global Diasporas: An Introduction.* London: UCL Press.

Coleman, R. (2009). *The Becoming of Bodies: Girls, Images, Experience.* Manchester: Manchester University Press.

———. (2014). *Developing Speculative Methods to Explore Speculative Shipping: Mail Art, Exchange and Futurity.* Sociology Department Seminar Series, Goldsmiths University London, 2 December 2014.

Coleman, R. and Ringrose, J. (Eds.). (2013). *Deleuze and Research Methodologies.* Edinburgh: Edinburgh University Press.

Colman, F. (2014). *Film Theory: Creating a Cinematic Grammar.* Wallflower Press/ Columbia University Press.

———. (2014). *The Practice as Research Mantifesto: Senses and Surfaces, Mediation and Objects, Youth and Activism.* Tate Working Papers online, www.tate.org. uk/ (accessed 12 December 2014).

Connerton, P. (1989). *How Societies Remember.* Cambridge: Cambridge University Press.

Connolly, W. E. (2011). *A World of Becoming.* Durham: Duke University Press.

Coole, D. and Frost, S. (Eds.). (2010). *New Materialisms: Ontology, Agency, and Politics.* Durham and London, UK: Duke University Press.

Coppola, F. F. (Director). (1979). *Apocolypse now!,* USA. United Artists. Film.

Cotter, H. (2010). Vietnam voices against a whir of war. *New York Times.* 12 August. http.//www.nytimes.com/2010/08/13/arts/design/13dinh.html?pagewanted=all&_ r=0 (accessed 20 April 2014).

Craft, A. and Jeffrey, B. (2008). Creativity and performativity in teaching and learning: Tensions, dilemmas, constraints, accommodations and synthesis. *British Educational Research Journal,* 34(5), 577–84.

Craft, A., Gardner, H. and Claxton, G. (Eds.). (2007). *Creativity, Wisdom and Trusteeship: Exploring the Role of Education.* Thousand Oaks, CA: Sage.

Cremin, T., Goouch, K., Blakemore, L., Goff, E. and Macdonald, R. (2006). Connecting drama and writing: Seizing the moment to write. *Research in Drama Education: The Journal of Applied Theatre and Performance,* 11(3), 273–91.

Crenshaw, K. W. (1989). *Demarginalizing the Intersection of Race and Sex: A Black Feminist Critique of Antidiscrimination Doctrine, Feminist Theory and Antiracist Politic.* The University of Chicago Legal Forum, 140, 139–67.

Daniels, H. (2001). *Vygotsky and Pedagogy.* Oxon, UK and New York, USA: Routledge.

Darder, A., Baltodano, Marta P. and Torres, R. D. (2009). *The Critical Pedagogy Reader.* London and New York: Routledge.

Dash, P. (2010). *African Caribbean Pupils in Art Education.* Rotterdam: Sense Publishers.

Daston, L. and K. Park (1998). *Wonders and the Order of Nature 1150–1750.* New York: Zone Books.

Daston, L. and E. Lunbeck (Eds.). (2011). *Histories of Scientific Observation.* Chicago: University of Chicago Press.

Davies, D. (2010). Introduction. In D. Davies (Ed.), *Gavin Bolton: Essential Writings.* Stoke on Trent: Trentham, xii–xxi.

Dempster, E. (1988). Women writing the body: Let's watch a little how she dances. In S. Sheridan (Ed.), *Grafts: Feminist Cultural Criticism* (35–54). London: Verso Publishers.

Department for Education (2013). *Teachers' Standards–Guidance for School Leaders, School Staff and Governing Bodies.* DFE-00066-2011. Available at https:// www.gov.uk/government/uploads/system/uploads/attachment_data/file/301107/ Teachers__Standards.pdf (accessed 4 August 2014).

Deleuze, G. (1988a). *Foucault* (trans. P. Hand). Minneapolis: University of Minnesota Press.

———. (1988b). *Spinoza: Practical Philosophy* (trans. R. Hurley). San Francisco, CA: City Lights Books. (Original work published 1970).

———. (1989). *Cinema 2, The Time Image* (trans. H. Tomlinson and R. Galeta). Minneapolis: University of Minnesota Press. (Original work published 1985).

———. (1994). *Difference and Repetition.* New York: Columbia University Press.

———. (1995). *Negotiations.* New York: Columbia University Press.

Deleuze, G. and Guattari, F. (1983). *Anti-Oedipus: Capitalism and Schizophrenia* (trans. R. Hurley, M. Seem and H. Lane). Minneapolis, MN: University of Minnesota Press (Original work published 1972).

———. (1987). *A Thousand Plateaus: Capitalism and Schizophrenia* (trans. B. Massumi). Minneapolis: Minnesota University Press (Original work published 1980).

————. (1994). *What is Philosophy?* (trans. H. Tomlinson and G. Burchell). New York: Columbia University Press (Original work published 1991).

Department for Culture Media and Sport (DCMS) (2003). *Learning to Listen Report.* London: UK Government Department for Culture Media and Sport.

————. (2007). *Culture on Demand: Ways to Engage a Broader Aaudience.* London: UK Government Department for Culture Media and Sport.

Derrida, J. (1987). *The Truth in Painting.* Chicago: University of Chicago Press.

Dewey, J. (1938). *Experience and Education.* New York: Touchstone.

Dimitriadis, G. and Weis, L. (2008). Rethinking the research imaginary: Globalization and multi-sited ethnographic approaches. In G. Dimitriadis (Ed.), *Studying Urban Youth Culture* (81–108). New York: Peter Lang.

Dinh Q. Lê (2001). The Vietnam war, photography and memory. In M. Roth Obdurante History-*Art Journal,* 60(2), Summer, 19.

————. (2006). In Z. Wubin. Engaging the past-*Asian Art News,* November/December, 60–7.

Diprose, R. (2002). *Corporeal Generosity: On Giving with Nietzsche, Merleau-Ponty, and Levinas.* Albany, NY: State University of New York Press.

Doecke, B. (2014). A new beginning? John Yandell's the social construction of meaning: Reading literature in urban classrooms. *Changing English: Studies in Culture and Education,* 21(2), 139–49.

Dolphijn, R. and van der Tuin, I. (2012). *New Materialism: Interviews and Cartographies.* Ann Arbor: Open Humanities Press.

Duffy, S. (2006). *Virtual Mathematics – The Logic of Difference.* Manchester: Clinamen.

Duncan-Andrade, J. M. R. and Morrell, E. (2008). *The Art of Critical Pedagogy.* New York: Peter Lang.

Eagleton, T. (2003). *After Theory.* London: Penguin.

Eglinton, K. A. (2008). Using participatory visual ethnography to explore young people's use of visual material culture in place and space. In R. Hickman (Ed.), *Research in Art and Design Education* (51–66). Bristol, UK: Intellect.

Ellsworth, E. (2005). *Places of Learning: Media, Architecture, Pedagogy.* New York, Oxford: Routledge.

Elster, J. (Ed.). (1998). *Deliberative Democracy: Cambridge Studies in the Theory of Democracy.* Cambridge: Cambridge University Press.

Engels, F. (1888). (trans. W. Lough). *Marx/Engels Selected Works, Vol 1. Ludwig Feuerbach and the End of Classical German Philosophy* (13–15). Moscow: Progress Publishers.

Entwistle, H. (1970). *Child-Centered Education.* London: Routledge.

Falk, J. H. and Dierking, L. D. (2000). *Learning from Museums.* New York: Altamira Press.

Feverabend, P. (1999). *Conquest of Abundance: A Tale of Abstraction Versus the Richness of Being.* Chicago: University of Chicago Press.

Feyerabend, P. (1993). *Against Method.* London: Verso.

Fielding, N. G., Lee, R. M. and Blank, G. (2008). *The SAGE Handbook of Online Research Methods.* London: Sage.

Fletcher, H. (2011). Some thoughts on art and education. In F. Allen (Ed.), *Education: Whitechapel Documents on Contemporary Art* (225). Cambridge, MA: MIT Press.

Fothergill, A. (Producer). (2008). *Planet Earth*. UK: British Broadcasting Corporation (BBC). Television.

Foucault, M. (1972). *The Archaeology of Knowledge and the Discourse on Language* (trans. A. M. Sheridan-Smith). New York: Pantheon Books.

———. (1973). *The Order of Things*. New York: Vintage Books.

———. (1980). *Power/Knowledge: Selected Interviews and Other Writings 1972–1977*. Essex, UK: The Harvester University Press.

———. (1984). Nietzsche, genealogy, history (trans. D. F. Bouchard and S. Simon). In P. Rabinow (Ed.), *The Foucault Reader*. New York: Pantheon Books.

———. (1986). Of other spaces (trans. J. Miskowiec). *Diacritics,* 16(1), Spring, 22–7.

———. (1991). *Discipline and Punish*. London: Penguin.

Fox, A. and Macpherson, H. (2015). *Inclusive Arts Practice and Research: A Critical Manifesto*. New York: Routledge.

Franks, A. (1997). Drama, desire and schooling. Drives to learning in creative and expressive school subjects. *Changing English: Studies in Culture and Education,* 4(1), 131–47.

Franks, A., Thomson, P., Hall, C. and Jones, K. (2014). Teachers, arts practice and pedagogy. *Changing English: Studies in Culture and Education,* 21(2), 171–81.

Freire, P. (1970). *Pedagogy of the Oppressed*. London: Penguin.

———. (1993). *Pedagogy of the Oppressed* (rev. ed.). London: Penguin Books.

———. (2005). *Pedagogy of the Oppressed* (trans. M. B. Ramos). New York: Continuum. (Original work published 1968).

Frost, R. (1923). *Stopping by Woods on a Snowy Evening*. http://www.poetryfoundation.org/poem/171621 (accessed 17 August 2014).

Gadamer, H. G. (1960). *Truth and Method*. New York: Crossroad Press.

Gaine, C. and George, R. (1999). *Gender, Race, and Class in Schooling*. Oxon: Routledge.

Gallagher, S. (1992). *Hermeneutics and Education*. Albany: State University of New York Press.

Galloway, A., Thacker, E. and Wark, M. (2014). *Excommunication: Three Inquiries in Media and Mediation*. Chicago, IL: University of Chicago Press.

Gardner, H. (1993). *Creating Minds: An Anatomy of Creativity Seen through the Lives of Freud, Einstein, Picasso, Stravinsky, Eliot, Graham, and Gandhi*. New York: Basic Books.

Garfinkel, H. (1967). *Studies in Ethnomethodology*. London: Polity Press.

Giddens, A. (1993). *New Rules of Sociological Method*. Cambridge, MA/Malden: Polity Press.

Gillborn, D. (2005). Education policy as an act of white supremacy: Whiteness, critical race theory and education reform. *Journal of Education Policy,* 20(4), 485–505.

Gillham, G. (1974). *Report on Condercum School Project for Newcastle Upon Tyne LEA*. (unpublished).

Giroux, H. (Ed.). (2001). *Theory and Resistance in Education: Towards a Pedagogy for the Opposition.* USA: Greenwood Publishing Group.

Giroux, H. (2012). Can democratic education survive in the neo-liberal society? In *Truthout* (accessed 5 October 2015).

Giroux, H. A. (2003). Public pedagogy and the politics of resistance: Notes on a critical theory of educational struggle. *Educational Philosophy and Theory,* 35(1), 5–16.

Glaveanu, V. P. (2014). *Thinking through Creativity and Culture: Toward an Integrated Model.* New Brunswick, NJ: Transaction.

Goffman, I. (1961). *Asylums: Essays on the Social Situation of Mental Patients and Other Inmates.* Victoria, AUS: Penguin.

Goldman, D. R. (2007). *A ramework for Video Annotation, Visualization, and Interaction.* Seattle: University of Washington.

Gould, S. J. (1980). *The Panda's Thumb: More Reflections in Natural History.* USA: W. W. Norton.

Graham, J. (2010). Between a pedagogical turn and a hard place. In P. O'Neil and M. Wilson (Eds.), *Curating and the Educational Turn* (124–39). Amsterdam: Open Editions, De Appel Arts Centre.

Grunewald, D. A. (2003). The best of both worlds: A critical pedaogy of place. Educational *Researcher,* 32(4), 3–12.

Guattari, F. (2000). *The Three Ecologies* (trans. I. Pindar and P. Sutton). London: Continuum.

Gubrium, A. and Harper, K. (2013). *Participatory Visual and Digital Methods.* Walnut Creek, CA: Left Coast Press.

Guindi, F. E. (2004). *Visual Anthropology: Essential Method and Theory.* Walnut Creek, CA: AltaMira Press.

Hacking, I. (1992). The self-vindication of the laboratory sciences. In A. Pickering (Ed.), *Science as Practice and as Culture.* Chicago: University of Chicago Press, 29–64.

———. (2000). Screw you, I'm going home. Review of conquest of abundance: A tale of abstraction versus the richness of being. *London Review of Books,* 22(12), 28–9.

Hall, S. (1980). Encoding/decoding. In S. Hall and P. Willis (Eds.), *Culture, Media, Language* (128–38). London: Hutchinson.

———. (1996). Introduction: Who needs identity? In S. Hall and P. du Gay (Eds.), *Questions of Cultural Identity.* London: Sage Publications, 1–17.

———. (2000). Who needs identity? In P. du Gay, J. Evans and P. Redman (Eds.), *Identity: A Reader* (5–30). London: Sage.

Hames-Garcia, M. (2008). How real is race? In S. Alaimo and A. Hekman (Eds.), *Material Feminisms.* Bloomington: Indiana University Press, 308–339.

Haraway, D. (1988) Situated knowledges: The science question in feminisim and the privilege of partial perspective. *Feminist Studies,* 4(3), 575–99.

———. (1991). *Simians, Cyborgs and Women: The Reinvention of Nature.* Oxon and New York: Routledge.

———. (2003). *The Companion Species Manifesto: Dogs, People, and Significant Otherness.* Chicago: Prickly Paradigm Press.

Harland, J. and Kinder, K. (Eds.). (1999). *Crossing the Line.* London: Calouste Gulbenkian Foundation.

Harper, D. (2012). *Visual Sociology.* Abingdon: Routledge.

Harper, J. (Pannekoek, A.) (1942). *Materialism and Histroical Materialism. New Essays.* VI(2) Fall. John Gray Archive.

Harris, A. (2014a). Ethnocinema and the impossibility of culture. *International Journal of Qualitative Studies in Education,* 27(4), 546–60.

———. (2014b). *Video as Method.* London: Oxford University Press.

———. (2011). Slowly by slowly: Ethnocinema, media and the young women of the Sudanese diaspora. *Visual Anthropology,* 24(4), 329–44.

———. (2013). *Ethnocinema: Intercultural Arts Education.* The Netherlands: Springer.

Hassan, I. (1977). Prometheus as performer: Toward a posthumanist culture, 205. In M. Beramou and C. Caramello (Eds.), *Performance in Postmodern Culture.* Madison: Coda Books, 201–217.

Haseman, B. (2007). Rupture and recognition: Identifying the performative research paradigm. In E. Barrett and B. Bolt (Eds.), *Practice as Research: Approaches to Creative Arts Enquiry* (147–58). London and New York: I. B. Taurus.

Haseman, B. and Mafe, D. (2009). Acquiring Know-How: Research Training for Practice-led Researchers. In H. Smith and R. T. Dean (Eds.), *Practice-led Research, Research-led Practice in the Creative Arts* (211–28). Edinburgh: Edinburgh University Press.

Haw, K. and Hadfield, M. (2011). *Video in Social Science Research: Functions and Forms.* Abingdon: Routledge.

Hayles, K. (1997). The posthuman body: Inscription and incorporation in Galatea 2.2 and Snow Crash. *Configurations,* 2(5), 241–66.

Heath, C., Hindmarsh, J. and Luff, P. (2010). *Video in Qualitative Research:* Analysing *Social Interaction in Everyday Life.* London: Sage.

Heathcote, D. (1980). *Drama as Context: The National Association for the Teaching of English.* Sheffield: National Association for Teaching English.

Heathcote, D. and Bolton, G. (1996). *Drama for Learning: Dorothy Heathcote's Mantle of the Expert Approach to Education.* Portsmouth, NH: Heinemann.

Heathcote, D. and Lawrence, C. (1973). *Albert.* UK. Ipswich: Concord Media. DVD.

Heidegger, M. (1962). *Being and Time.* New York: Harper.

Hein, G. E. (1991). The museum and the needs of people. *International Committee of Museum Educators (CECA) Conference.* Jerusalem Israel (15–22). October 1991.

———. (1998). *Learning in the Museum.* London and New York: Routledge.

Hekman, S. (2010). *The Material Knowledge: Feminist Disclosures.* Bloomington and Indianapolis: Indiana University Press.

Hickey-Moody, A. (2009). Little war machines: Posthuman pedagogy and its media. *Journal of Literary and Cultural Disability Studies,* 3(3), 273–80.

———. (2013). *Youth, Arts and Education: Reassembling Subjectivity Through Affect.* Abingdon: Routledge.

——— (2014) Little public spheres. In J. Burdick, J. A. Sandlin and M. P. O'Malley (Eds.), *Problematizing Public Pedagogy* (117–30). Oxon and New York: Routledge.

Hirsch, E. D. Jr., (1965). *Truth and Method in Interpretation: Review of Metaphysics.* USA: Crossroad publishing.

Hischhorn, T. and Birrell, R. (2009/2010). The headless artist: Interview. *Art and Research.* Winter. 3.1. http://www.artandresearch.org.uk/v3n1/hirschhorn2.html.

Hohenstein, J. and King, H. (2007). *Learning in and Out of the Classroom.* London: Open University.

Hongisto, I. (2012). Moments of Affection: Jayce Salloum's *Everything and Nothing* and the thresholds of testimonial video. In E. Barrett and B. Bolt (Eds.), *Carnal Knowledge: Towards a 'New Materialism' Through the Arts* (105–12). London and NY: I. B. Tauris.

hooks, b. (1994). *Teaching to Transgress: Education as the Practice of Freedo*m. London, UK and New York, USA: Routledge.

———. (2003). *Teaching Community: A Pedagogy of Hope.* London, UK and New York, USA: Routledge.

Hooper-Greenhill, E. (2000a). *Museums and the Interpretation of Visual Culture.* London: Routledge.

———. (2000b). Learning in art museums: Strategies of interpretation. In N. Horlock (Ed.), *Testing the Water* (136–46). Liverpool: Liverpool University Press and Tate Liverpool.

———. (2007). *Museums and Education: Purpose, Pedagogy, Performance.* London and New York: Routledge.

Horlock, N. (Ed.). (2000). *Testing the Water.* Liverpool: Liverpool University Press and Tate Liverpool.

Hornbrook, D. (1989). *On the Subject of Drama.* London: Routledge.

———. (1998). *Education and Dramatic Art.* London: Routledge.

Hughes, J. (2012). *SAGE Visual Methods.* London: Sage.

Hulson, M. (2006). *Schemes for Classroom Drama.* Stoke on Trent, UK: Trentham Books.

Hyde, W. (2007). A stitch in time: Gender issues explored through contemporary textiles practice in a sixth form college. *International Journal of Art and Design Education,* 26(3), 296–307.

Ingold, T. (2013). *Making.* Oxon/New York: Routledge.

Jacobs, M. J. (2000). *Competing for an Audience: Entertainment Versus Education, Directors Choice: The Sixth Annual Directors Forum Transcripts.* New York: American Federation of Arts.

Jagodzinski, J. and Wallin, J. (2013). *Arts Based Research: A Critique and a Proposal.* Rotterdam, Boston, Tiapei: Sense Publishers.

James, W. (1912). *Essays in Radical Empiricism.* New York: Longman Green.

Jewitt, C. and Jones, K. (2008). Multimodal discourse analysis: the case of 'ability'. in UK secondary school English. In V. K. Bhatia, J. Flowerdew and R. H. Jones (Eds.), *Advances in Discourse Studies.* Oxon, UK and New York, USA: Routledge, 149–160.

Johnson, L. and O'Neill, C. (Eds.). (1991). *Dorothy Heathcote: Collected Writings on Education and Drama.* Evanston, IL: Northwestern University Press

Jones, K. (2003). Culture reinvented as management. English in the new urban school. *Changing English: An International Journal of English Teaching,* 10(2), 143–53.

Jung, Y. (2010). *The Ignorant Museum: Transforming the Elitist Museum into an Inclusive Learning place.* Edinburgh: Museums ETC.

————. (2011). The art museum ecosystem: a new alternative model. *Museum Management and Curatorship,* 26(4), 321–38.

Kafka, F. (1998). *The Trial.* New York: Schocken Books.

————. (2009). *The Trial.* Oxford: Oxford University Press.

Kaufman, J. C. and Sternberg, R. J. (Eds.). (2010). *The Cambridge Handbook of Creativity.* New York: Cambridge University Press.

KEA European Affairs. (June, 2009). *The Impact of Culture on Creativity.* European Commission: European Commission Directorate-General for Education and Culture.

Kenway, J., Craack, A. and Hickey-Moody, A. (2006). *Masculinity Beyond the Metropolis.* Basingstoke: Palgrave.

Kockel, U. (2000). Beyond l'amour d'art: Youth, cultural democracy and Europe. In N. Horlock. (Ed.). *Testing the Water* (39–48). Liverpool: Liverpool University Press and Tate Liverpool.

Knights, B. and Thurgar-Dawson, C. (2008) *Active reading: Transformative Writing in Literary Studies.* London and New York: Continuum.

Knoblauch, H. and Schnettler, B. (2009). *Video Analysis: Methodology and Methods; Qualitative Audiovisual Data Analysis in Sociology.* Berlin: Peter Lang.

Kress, G., Jewett, C., Bourne, J., Franks, A., Hardcastle, J., Jones, K. and Reid, E. (2005). *English in Urban Classrooms.* Abingdon, UK and New York, USA: RoutledgeFalmer.

Krisreva, J. (1980). Giotto's joy. In L. S. Roudiez (Ed.), T. Gora and L. S. Roudiez (trans.). *Desire in Language: A Semiotic Approach to Literature and Art.* Oxford: Blackwell, 210–236.

————. (1984). *Revolution in Poetic Langauge.* New York: Columbia University Press.

Kuehn, M. (2002). *Kant: A Biography.* Cambridge: Cambridge University Press.

Kuper, S. (2014). Why Europe works: It's all about location. *FT Weekend Magazine Special Issue,* Europe. May 24/25, 10–11. Print.

Latour, B. (2004). Why has critique run out of steam? From matters of fact to matters of concern. *Critical Inquiry,* 30(2), 225–48.

Lave, J. and Wenger, E. (1991). *Situated Learning: Legitimate Peripheral Participation.* Cambridge: Cambridge University Press.

Leger, M. (2013). *The Neoliberal Undead: Essays on Contemporary Art and Politics.* Washington, DC: Zero Books.

Levinas, E. (1969). *Totality and Infinity: An Essay on Exteriority* (trans. A. Lingis). Pittsburgh: Duquesne University Press.

————. (1987). Philosophy and the idea of infinity. In *Emmanuel Levinas: Collected Philosophical Papers* (47–60). (trans. A. Lingis). Dordrecht: Marinus Nijhoff.

Lima, E. M. (2009). On the margins of art: The crossover between aesthetic experimentation, clinical actions and political participation in Brazil. *Proceedings of Radical Education Conference.* Ljubljana. http://radical.tmp.si/radical-education-new-texts/.

Lorraine, T. (2011). *Deleuze and Guattari's Immanent Ethics.* Albany: SUNY Press.

Lovat, T. J. (2010). Synergies and balance between values education and quality teaching. *Educational Philosophy and Theory* 42(4), 489–500.

Lubart, T. I. (1999). Creativity across cultures. In R. J. Sternberg (Ed.), *Handbook of Creativity* (339–50). Cambridge, MA: Cambridge University Press.

Lundy, C. (2012). *History and Becoming, Deleuze's Philosophy of Creativity.* Edinburgh: Edinburgh University Press.

Lury, C. and Wakeford, N. (2012). *Inventive Methods: The Happening of The Social.* London and New York: Routledge.

Lynch, M. (1993). *Scientific Practice and Ordinary Action: Ethnomethodology and Social Studies of Science.* Cambridge, UK: Cambridge University Press.

Mac an Ghaill, M. (1988). *Young, Gifted and Black.* Milton Keynes: Open University Press.

MacCormack, P. (2004). The Probe-head and the faces of Australia, from Australia Post to Pluto. *Journal of Australian Studies,* 1(81), 135–46.

———. (2012). *Posthuman Ethics.* UK: Ashgate.

MacDougall, D. (1998). *Transcultural Cinema.* Princeton, NJ: Princeton University Press.

Maharaj, S. (2009). Know-how and no-how: Stopgap notes on method in visual art as knowledge production. *Art and Research,* 2(2), 1–11.

Manning, E. (2009). Taking the next step, touch as technique. *Sense and Society,* 4(2), 211–26.

Marks, L. (2000). *The Skin of the Film: Intercultural Cinema, Embodiment, and the Senses.* Durham: Duke University Press.

Marshall, G. (1998). 'ethnomethodology.' A Dictionary of Sociology. Encyclopedia. com. 21 July 2014. http://www.encyclopedia.com.

Massey, D. (1994). *Space, Place and Gender.* London: Polity Press.

Massumi, B. (2002). *Parables for the Virtual: Movement, Affect, Sensation.* Durham, NC: Duke University Press.

———. (2011). *Semblance and Event: Activist Philosophy and the Occurrent Arts.* Boston, MA: MIT Press.

Massumi, B. and Manning, E. (2014). *Thought in the Act: Passages in the Ecology of Experience.* Minneapolis: University of Minnesota Press.

Marx, K. (1845). Appendix: Theses on Feuerbach. In F. Engels (1888). (trans. W. Lough). *Marx/Engels Selected Works, Vol 1. Ludwig Feuerbach and the End of Classical German Philosophy* (13–15). Moscow: Progress Publishers.

———. (1906). *Das Kapital.* F. Engels and E. Untermann, Eds. (trans. S. Moore and E. Aveling). Chicago: Charles H. Kerr.

———. (1993). *Grundisse: Foundations of the Critique of Political Economy.* USA: Penguin.

Marx, K. and Engels, F. (1998). *The Communist Manifesto.* New York: Penguin.

May, S. (1999). *Rethinking Multicultural and Antiracist Education.* London: Falmer Press.

McAuliffe, K. (2012, March). How your cat is making you crazy. *The Atlantic.* Retrieved from www.theatlantic.com/magazine/archive/2012/03/how-your-cat-is-making-you-crazy/308873/.

McRobbie, A. (1991). *Feminism and Youth Culture: From* Jackie *to* Just Seventeen. London: Macmillan.

McIntosh, P. (2010). *Action Research and Reflective Practice: Creative and Visual Methods to Facilitate Reflection and Learning*. Abingdon/New York: Routledge.

McNulty, T. (2007). *The Hostess: Hospitality, Feminity, and the Expropriation of Identity*. Minneapolis, MN: University of Minnesota Press.

Medway, P. (2003/2004). Show him the documents: Teaching and learning the English method. *The English and Media Magazine*, 47, 4–7.

Meskimmon, M. (2003). *Women Making Art: History, Subjectivity, Aesthetics*. London: Routledge.

———. (2011). *Contemporary Art and the Cosmopolitan Imagination*. London and New York: Routledge.

Meszaros, C. (July 2006). Now THAT is evidence: tracking down the evil 'whatever' interpretation. *Keynote Address at the Visitor Studies Association Conference. Visitor Studies Today* 9(3): 10–15. Grand Rapids, MI.

Mezirow, J. (1991). *Transformative Dimensions of Adult Learning*. San Francisco, CA: Jossey-Bass.

Miliband, E. (15 August 2011). Speech delivered at Haverstock School. http://www.newstatesman.com/politics/2011/08/society-young-heard-riots (last accessed 20 August 2011).

Minh-ha, T. T. (2011). Documentary is/not a name. In T. Corrigan, P. White and M. Mazaj (Eds.), *Critical Visions in Film Theory: Classic and Contemporary Readings* (691–704). Boston: Bedford/St. Martin's.

Mitchell, C. (2011). *Doing Visual Research*. London: Sage.

Moersch, C. (2007). *Gallery Education as Critical Practice and Research at Documenta 12 engage 20*: engage 20 Strategic Interpretation. London: engage.

Moll, L. (2000). Inspired by Vygotsky: Ethnographic experiments in education. In C. Lee and P. Smagorinsky (Eds.), *Vygotskian Perspectives on Literary Research* (256–68). Cambridge: Cambridge University Press.

Morgan, M. L. (Ed.). (2002). *Spinoza: Complete Works*. Indianapolis/Cambridge: Hackett.

Morgan, W., McWilliam, E. and Lather, P. (1997). *Textual Technologies and New Feminist Research,* Teach 'em. Chicago, IL.

Morpurgo, M. (2007 reissue). *Warhorse*. London: Egmont.

Mouffe, C. (2013). *Agonistics: Thinking the World Politically*. London and New York: Verso.

Mulcahy, D (2012). Affective assemblages: Body matters in the pedagogic practices of contemporary school classrooms. *Pedagogy, Culture & Society,* 20(1), 9–27.

Mussen, P. (Ed.). (1983). Piaget's theory. In *Handbook of Child Psychology*, vol. 1 (4th ed.). New York: Wiley.

Nancy, J. (2008). *Corpus*. (trans. R. Rand). Bronx, NY: Fordham.

Nears, C. (Director). (2006). *Tchaikovsky: Swan Lake*, New York. NVC Arts. DVD.

Neelands, J. (1992). *Learning Through Imagined Experience: The Role of Drama in the National Curriculum*. London: Hodder and Stoughton.

Nelson, C., Treicher, P. and Grossberg, L. (1991). *Cultural Studies* New York: Routledge.

Nichols, B. (2010). *Introduction to Documentary* (2nd ed.). Bloomington, IN: Indiana University Press.

Nicholson, H. (2009). Editorial. Remembering conversations: Reflections on research. *Research in Drama Education: The Journal of Applied Theatre and Performance,* 14(3), 323–28.

Nietzsche, F. W. (1984). *Human, all too Human: A Book for Free Spirits* (trans. M. Faber with S. Lehmann). Lincoln: University of Nebraska Press.

Olsen, B. (1990). Roland Barthes: From sign to text. In C. Tilley (Ed.), *Reading Material Culture* (85–103). Oxford: Basil Blackwell.

O'Neill, C. (1995). *Drama Worlds: A Framework for Process Drama.* Portsmouth, NH, USA: Heinemann.

O'Neill, P. and Wilson, M. (2010). *Curating and the Educational Turn.* London: Open Editions and Amsterdam: de Appel.

Orwell, G. (1946). *Animal Farm.* New York: Harcourt, Brace and Company.

———. (1948). *Nineteen Eighty-Four.* USA: Penguin.

Page, T. (2012a). A shared place of discovery and creativity. Practices of contemporary art and design education. *International Jounral of Art and Design Education,* 31(1), 67–77.

———. (2012b). Place and belonging: Ways of knowing and learning in the Australian bush. Doctoral Thesis, Goldsmiths University of London.

Page, T., Adams, J. and Hyde, W. (2011). Emerging: The impact of the MA Artist Teacher and Contepmorary Practices on students' pedaogogical and artisitc practices. *European Jounral of Teacher Education,* 34(3), 277–95.

Palmer, H. 2013. *Deleuze and Futurism: A Manifesto.* London: Bloomsbury Press.

Park, K. (2011). Observation in the margins. In L. Daston and E. Lunbeck. (Eds.), *Histories of Scientific Observation.* Chicago: University of Chicago Press, 15–44.

Pasquinelli, M. (2008). *Animal Spirits: A Bestiary of the Commons.* Rotterdam, Netherlands: NAi.

Pearsall, J. (Ed.). (1999). *The Concise Oxford Dictionary.* Oxford: Oxford University Press.

Peters, D. S. and Weingarten, M. (2000). Organisms, genes and evolution: Evolutionary theory at the crossroads. *Proceedings of the 7th International Senckenberg Conference (Wissenschaftliche Frankfurt Am Main – Schrift).* Stuttgart: Franz Steiner Verlag.

Peterson, R. (1992). Understanding audience segmentation from elite and mass to univore and omnivore. *Poetics,* 21, 243–58.

Pfohl, S. (1992). *Death at the Parasite Cafe: Social Science (Fictions) and the Postmodern.* New York, NY: St. Martins.

Pickering, M. (Ed.). (2008). *Research Methods for Cultural Studies.* Edinburgh, UK: Edinburgh University Press.

Pink, S. (2007). *Doing Visual Ethnography.* London: Sage.

———. (2009). *Doing Sensory Ethnography.* London: Sage.

———. (Ed.). (2012). *Advances in Visual Methodology.* London: Sage.

Post Brothers and Fitzpatrick, C. (2011). A productive irritant: Parasitical inhabitations in contemporary art. *Fillip. 15.* Available at http://fillip.ca/content/parasitical-inhabitations-in-contemporary-art.

Rancière, J. (1991). *The Ignorant Schoolmaster: Five Lessons in Intellectual Emancipation.* Redwood City, CA: Stanford University Press.

————. (2010). *Dissensus: On Politics and Aesthetics*. London and New York: Bloomsbury.

Research Excellance Framework. (2014). http://www.ref.ac.uk (accessed 3 November 2014).

Ringrose, J. (2013). *Postfeminist Education? Girls and the Sexual Politics of Schooling*. Oxon: Routledge.

Rogoff, I. (2010). Practising research: Singularising knowledge. *Makuzine. Journal of Artistic Research,* 9, 37–42.

Rose, G. (1993). *Feminism and Geography: The Limits of Geographical Knowledge*. Cambridge, MA: Polity Press.

————. (2012). *Visual Methodologies*. London: Sage.

Rouch, J. and Feld, S. (2003). *Ciné-ethnography*. Minneapolis: University of Minnesota Press.

Rouncefield, M. and Tolmie, P. (Eds.). (2011). *Ethnomethodology at Work*. Surrey UK/Burlington, VT: Ashgate.

Ruitenberg, C. (2011). Art, politics, and the pedagogical relation. *Studies in Philosophical Education,* 10, 211–23.

Safford, K. and Barrs, M. (2005). *Creativity and Literacy:Many Routes to Meaning*. London: Centre for Literacy in Primary Education.

Sappington, R. (1994). Cracked open by the senses. In R. Sappington and T. Stallings (Eds.), *Uncontrollable Bodies: Testimonies of Identity and Culture* (131–42). Seattle USA: Bay Press.

Sayers, E. (2011). Investigating the impact of contrasting paradigms of knowledge on the emancipatory aims of gallery programmes for young people. *International Journal of Art and Design Education,* 30(3), 409–22.

————. (2014). *Making 'Culture Vultures': An Investigation into the Socio-cultural Factors that Determine what and how Young People Learn in the Art Gallery*. Doctoral thesis, Goldsmiths, University of London.

Schubert, W. H. (2006). Focus on the BIG CURRICULUM. *Journal of Curriculum and Pedagogy,* 3(1), 100–3.

Sefton-Green, J. (2011). The Creativity Agenda. Available at http://dusseldorp.org.au/resource/the-creativity-agenda-2/ (accessed 27 February 2015).

Selwood, S., Clive, S. and Irving, D. (1994). *An Enquiry into Young People and Art Galleries*. London: Art & Society.

Serementakis, L. (1994). The memory of the senses: Historical perception, commensal exchange and modernity. In L. Taylor (Ed.), *Visualising Theory*. London: Routledge, 214–229.

Serres, M. (1995). *Genesis* (trans. G. James and J. Nielson). Ann Arbor: MI: University of Michigan Press. (Original work published 1982).

————. (1997). *The Troubadour of Knowledge* (trans. S. F. Glaser and W. Paulson). Ann Arbor, MI: University of Michigan Press. (Original work published 1991).

————. (2007). *The Parasite* (trans. L. R. Schehr). Minneapolis, MN: University of Minnesota Press. (Original work published 1980).

Serres, M. and Latour, B. (1995). *Conversations on Science, Culture, and Time*. Ann Arbor, MI: University of Michigan Press.

Shaheen, R. (2010). Creativity and education. *Creative Education*, 1(3), 166–9.

Shelley, P. B. (1961). *The Complete Poetical Works of Shelley*. T. Hutchinson (Ed.). London: Oxford University Press.

Shor, I. (1992). *Empowering Education: Critical Teaching for Social Change*. Chicago: Chicago University Press.

Shwalb, D. W., Nakazawa, J. and Shwalb, B. J. (2005). *Applied Developmental Psychology: Theory, Practice and Research from Japan*. New York: Information Age Publishing (IAP).

Slade, P. (1954). *Child Drama*. London: University of London Press.

Smedley, R. (Producer). (1971). *Three Looms Waiting* (Episode 25). UK: British Broadcasting Corporation (BBC). Television.

Sobers, S. (2008). Consequences and coincidences: A case study of experimental play in media literacy. *Journal of Media Practice*, 9(1), 53–66.

Spencer, S. (2011). *Visual Research Methods in the Social Sciences: Awakening Visions*. Abingdon: Routledge.

Spivak, G. C. (1976). Translators preface. In J. Derrida (Ed.), *Of Grammatology* (ix–xxxvii). Baltimore: Johns Hopkins University Press.

Springgay, S. (2008). An ethics of embodiment, civic engagement and a/r/tography: Ways of becoming nomadic in art, research and teaching. *Educational Insights*, 12(2), 1–11.

Springgay, S., Irwin, R. and Leggo, C. (2008). *Being with A/r/tography*. Rotterdam: Sense Publishers.

Stanhope, C. (2013). Beauty and the beast – Can life drawing support female students in challenging gendered media imagery? *International Journal of Art and Design Education*, 32(3), 352–61.

Stearns, J. and Blake, C. (2013). It's been getting under my skin: Paranoia, parasitosis, and the pedagogical imperative. *Cultural Formations*, 2. Available at http://culturalformations.org/its-been-getting-under-my-skin-paranoia-parasitosis-and-the-pedagogical-imperative/.

Stein, M. I. (1953). Creativity and culture. *Journal of Psychology*, 36, 311–22.

Stengers, I. (1997). *Power and Invention: Situating Science*. Minneapolis: University of Minnesota Press.

———. (2000). *The Invention of Modern Science*. Minneapolis: University of Minnesota Press.

Stewart, K. (2007). *Ordinary Affects*. Durham, NC: Duke University Press.

Stewart, R. (2010). *Creating New Stories for Praxis: Navigations, Narrations, Neo-Narratives*. London: I. B. Tauris.

Stone, O. (Director). (1986). *Platoon, USA*. Orion. Film.

———. (2000). *The Invention of Modern Science*. Minneapolis: University of Minnesota Press.

(Director). (1989). *Born on the Fourth of July*, USA. Universal. Film.

Sullivan, G. (2008). Afterward. In S. Springgay, R. Irwin and C. Leggo (Eds), *Being with A/r/tography* (233–43). Rotterdam: Sense Publishers.

————. (2010). *Art Practise as Research: Inquiry in Visual Arts.* London: Sage.

Swain, J. (2006). An ethnographic approach to researching children in junior school. *International Journal of Social Research Methodology,* 9(3), 199–213.

Taguchi, H. L. (2012). A diffractive and Deleuzian approach to analysing interview data. *Feminist Theory,* 13(3), 265–81.

————. (2013). Images of thinking in feminist materialisms, ontological divergences and the production of researcher subjectivities. *International Journal of Qualitative Studies in Education,* 26(6), 706–16.

Tajiri, Y. (2007). *Samuel Beckett and the Prosthetic Body: The Organs and Senses in Modernism.* New York: Palgrave.

Tate. (2011). *Annual Report 2010 – 2011.* London: Tate.

Taylor, P. and Warner, C. D. (2006). *Structure and Spontaneity: The Process Ddrama of Cecily O'Neill.* Stoke on Trent, UK and Sterling, USA: Trentham Books.

Teachertoolkit @*Teachertoolkit.me* (accessed 12 August 2014).

The Bible: contemporary English version, 2000. London: Harper Collins.

Turner, V. (1982). *From Ritual to Theatre – The Human Seriouness of Play.* New York: Performing Arts Journals Publications.

Van der Tuin, I. (2011). New feminist materialisms. *Women's Studies International Forum,* 34(4), 271–72.

————. (2014). On the mode of invention of creative research: Onto-epistemology. In E. Barrett and B. Bolt (Eds.), *Material Inventions: Applying Creative Research* (257–72). London and New York: I. B. Tauris.

Van Sanden, S. (2001). Asylum in art. *Lowdown,* 24(5), 12–13.

Vygotsky, L. (1994). Imagination and creativity of the adolescent. In R. van der Veer and J. Valsiner (Eds.), *The Vygotsky Reader.* Oxford, UK and Cambridge, USA: Blackwell, 266–288.

Vygotsky, L. S. (1978). *Mind in Society: The Development of Higher Psychological Processes.* Cambridge, USA and London, UK: Harvard University Press.

de Waal, E. (2011). With these hands. *Financial Times Weekend,* 12–13 March 2011. London.

Wagner, B. J. (1976). *Dorothy Heathcote: Drama as a Learning Medium.* Portsmouth: National Education Association.

Wallinger, M. and Warnock, M. (Eds.). (2000). *Arts for All? Their Policies and Our Culture.* London: Peer.

Walsh, V. (2008). Tate Britain: Curating Britishness and cultural diversity. *Tate Encounters,* 2, February.

Wenger, E. (1998). *Communities of Practice: Learning, Meaning and Identity.* Cambridge: Cambridge University Press.

Whitehead, A. N. (1926). *Process and Reality: An Essay in Cosmology.* New York: Free Press.

Wilby, P. (2013). Margaret Thatcher's education legacy is still with us – driven on by Gove. Available at http://www.theguardian.com/education/2013/apr/15/margaret-thatcher education-legacy-gove (accessed 27 February 2015)

Woodward, K. (Ed.). (1997). *Identity and Difference*. London: Sage.

Wrigley, T. (2014). *The Politics of Curriculum in Schools*. London: The Centre for Labour and Social Studies.

Yandell, J. (2008). Embodied readings: Exploring the multimodal social semiotic resources of the English classroom. *English Teaching: Practice and Critique,* 7(1), 36–56.

———. (2013). Curriculum, pedagogy and assessment: Of rigour and unfinished revolutions. In M. Allen and P. Ainley (Eds.), *Education Beyond the Coalition: Reclaiming the Agenda*. London: Radicaled, 5–23.

———. (2014). *The Social Construction of Meaning: Reading Literature in Urban Classrooms*. Abingdon, UK and New York, USA: Routledge.

Youdell, D. (2006). *Impossible Bodies, Iimpossible Selves: Exclusions and Student Subjectivities*. Dordecht: Springer.

Zembylas, M. (2002). Michel Serres: A troubadour for science, philosophy and education. *Educational Philosophy and Theory,* 34(4), 477–502.

Zimmer, C. (2000). *Parasite Rex: Inside the Bizarre World of Nature's Most Dangerous Creatures*. New York: Free Press.

Index

Notes on Contributors

Anna Hickey-Moody

Goldsmiths University of London

Anna is the head of the PhD in Arts and Learning at the Goldsmiths Centre for the Arts and Learning (CAL), where she leads the research collaborations of an interdisciplinary team of practitioners and researchers. Anna has developed a philosophically informed, cultural studies approach to youth arts as a subcultural form of humanities education. Through developing a concept of little public spheres, her recent book 'Youth, Arts and Education' theorizes young people's creative practices as a form of civic participation. Her 2009 book 'Unimaginable Bodies' creates a Spinozist concept of an open body, an assemblage of affects made through collaborative arts practice that breaks apart dominant medical and social codings of young people with disabilities. Anna also researches and publishes on masculinity. She is interested in the politics and aesthetics of masculinity read as embodied critique of institutionalized patterns of hegemony. Her 2006 book 'Masculinity Beyond the Metropolis' is a global ethnographic study of the lives of young men in 'out of the way' or hard to reach places. The book considers ways the everyday lives of these boys are mediated by global scapes of media production and consumption, economic globalization, generational change, and spatial and temporal configurations of subjectivity. Anna has edited a number of collected works—recently she published an anthology on pedagogy, media and affect called 'Disability Matters' which explores how ideas and experiences of disability come to matter across assemblages of media, through vectors of affect and experiences of pedagogy.

Tara Page

Goldsmiths University of London

Tara Page, PhD, is a senior lecturer and head of the internationally renowned MA Artist Teacher and Contemporary Practices (MAAT) at Goldsmiths University of London (UK) where she researches the entanglements of practice, pedagogy and the phenomenological and ontological constructions of place and belonging, including the ways in which practice with theory can enable social and educational change: *Place, Pedagogy and Practice: A New Materialism* (forthcoming), *A Shared Place of Discovery and Creativity: Practices of Contemporary Art and Design Pedagogy* (2012, iJADE). Tara worked in community arts and primary, secondary and higher education in Canada and Australia and continues her socially engaged practice as an artist researcher teacher—*Places and Ways* (2013, Performance/ Event), *Statement Field* (2009, Film)—and is the Centre for the Arts and Learning (CAL) Curator of Social Practices (see website). Tara was the co-editor of *The International Journal of Art and Design Education* (iJADE) for five years and served on The Publications Board for the National Society for Education through Art and Design (NSEAD) for four years. Tara has presented at international conferences and published articles, chapters and a book on contemporary arts practice and pedagogy including *Teaching Through Contemporary Art* (2008 with Adams, Worwood, Atkinson, Dash and Herne. Tate Publishing), Finding your way: The purpose and relevance of writing for artist researcher teacher practices (2012 with Areses Huertas, Frimet, Johnston & McGeer. *Journal of Writing in Creative Practices*) and Emerging: The impact of the Artist Teacher MA on students' pedagogical and artistic practices (2011 with Adams & Hyde, *European Journal of Teacher Education*).

Aislinn O'Donnell

University of Limerick

Aislinn O'Donnell received her PhD in philosophy from the University of Warwick and currently lectures in philosophy of education in Mary Immaculate College (MIC-University of Limerick). She is also an associate fellow with GradCAM. O'Donnell has taught philosophy in a number of universities including UCD and the University of Dundee. O'Donnell aims to democratize philosophy and expand our conception of the 'Academy', and the role of the Academy in society. With support from MIC, she has been teaching philosophy classes, developing collaborative research practice and writing with people in a range of informal settings, including closed institutions. Instead

of treating people as research subjects, these spaces become research sites offering opportunities for co-enquiry. This approach is influenced by contemporary art practice and research. She has presented and responded at events related to art practice such as *Terminal Convention* (2010), Re-gathering *on the Grounds of Art* (2008), *Ethics: Politics of Resistance in the Contemporary World* (2009), *2020 Visions: Imagining the Art & Design College of the Future* (2007), *Liminality* (2011), *Truth, Lies and Videotape* (2009). She has been invited speaker and presented at a range of conferences on topics relating to education and prisons and has written and spoken about the work of philosophers such as Deleuze, Spinoza, Bergson, Arendt, Foucault, Oury and Irigaray. Recent and forthcoming articles include 'Beyond Sexuality: Of Love, Failure and Revolutions' (2011), 'Thinking-in-concert' (2013), 'Unpredictability and the pedagogical encounter' (2013), 'Shame is revolutionary' (2013).

Colin Gardner

University of California, Santa Barbara

Working at the intersection of film-philosophy, Deleuze studies and interdisciplinary media theory, Colin Gardner received his PhD in cinema studies at UCLA before becoming Professor of Critical Theory and Integrative Studies at the University of California, Santa Barbara, where he teaches in the Departments of Art, Film & Media Studies, Comparative Literature, and the History of Art and Architecture. His most recent book is *Beckett, Deleuze and the Televisual Event: Peephole Art* (Palgrave Macmillan, 2012), a critical study of Samuel Beckett's experimental work for film and television and its connection to Gilles Deleuze's ontology of the image in Cinema 1 and Cinema 2. Excerpts have appeared in *Deleuze Studies Journal* (2012) and Continuum Books' *Gilles Deleuze: Image and Text* (2009). He is currently co-editing two anthologies with Professor Patricia MacCormack (Anglia Ruskin University): *Deleuze and the Animal* (Edinburgh University Press) and *Ecosophical Aesthetics* (Bloomsbury Publishing). Gardner has also published two books in Manchester University Press's 'British Film Makers' series: a critical study of the blacklisted American film director, Joseph Losey (2004), and a monograph on the Czech-born, British film-maker and critic, Karel Reisz (2006). Most recently, Gardner has expanded his research into the area of Media Geography, including a chapter on Tomas Gutierrez Alea's seminal Cuban film, Memories of Underdevelopment in James Craine, Giorgio Curti and Stuart Aitken's collection, *The Fight to Stay Put: Social Lessons Through Media Imaginings of Urban Transformation and Change* (Franz Steiner Verlag, 2013).

Amanda Kipling

Goldsmiths University of London

Amanda has been the Drama Postgraduate Certificate of Education course leader at Goldsmiths since 2008. She is a voice and speech specialist, and her areas of interest include drama as play, drama as healing, and peer mentoring-critical learning using electronic portfolios and video: 'The Play is the Thing' (2010, *Drama to Inspire*, edited collection, Trentham Books). In 2011 Amanda led on the Centre for the Arts and Learning (CAL) videoconferencing event that featured Drama Education pioneer Dorothy Heathcote. Amanda contributes to the Education, Culture and Society undergraduate degree and was the Senior Tutor and is currently the Disability Officer for the Educational Studies Department at Goldsmiths.

Charlie Blake

University of Brighton

Charlie Blake is currently a visiting lecturer in film at the University of Brighton, musician and performer in the Manchester-based Babyslave Continuum (Valentine Records) and an executive editor of *Angelaki: Journal of the Theoretical Humanities*. He has co-edited studies on Sadism, Masochism and the Philosophical Muse, and on Animality and Transhumanism, and published recently on Georges Bataille and Divine Dissipation, David Cronenberg and the neo-Baroque, Parasite Capitalism and Pornotheology. He is currently working on studies of Immanence and Materialism, Sonic Spectralities, the Politics of Apiasophy and Deleuze and Affect.

Jennie Stearns

Georgia Gwinnett College

Jennie Stearns is an associate professor of English at Georgia Gwinnett College. Her research interests include nineteenth-century US literature, gift theory, African American literature, and the connections between literary texts and their economic contexts: 'Now I Ain't Sayin' She a Gold Digger': *Wal-Mart Shoppers, Welfare Queens, and Other Gendered Stereotypes of Poor Women in the Big Curriculum of Consumption* (2011, Cultural Studies Critical Methodologies), *Resistance on Aisle Three?: Exploring the Big Curriculum of Consumption and the (Im)Possibility of Resistance in John Updike's 'A&P'* (2011 in Curriculum Inquiry with Sandlin and Burdick). A recent president of the Georgia and Carolinas

College English Association, she currently serves on the editorial board of its journal, *Notes on Teaching English*. Her most recent publications have appeared in *Curriculum Inquiry, Cultural Studies <=> Critical Methodologies, and Cultural Formations*.

Maggie Pitfield

Goldsmiths University of London

Maggie Pitfield is a senior lecturer at Goldsmiths University of London and is the head of the MA in Children's Literature in the Department of Educational Studies. Maggie's research interests include: flexible learning models in ITE: the experiences of student-teachers and the role of the school mentor and the perspectives of student-teachers pursuing different routes into English teaching: Routes into English Teaching: beginning teachers' reflections on college-based and school-based Initial Teacher Education programmes (2012 with Jane Coles in *Changing English: Studies in Culture and Education*), Teachers' experiences of mentoring on a flexible initial teacher education programme: implications for partnership development (2009 with Liz Morrison in *Journal for Education in Teaching*), *How Student-teachers Approach the Teaching of Reading: At the Interface Between Personal History, Theory and Practice* (2010 with Vicky Obied in *Changing English: Studies in Culture and Education*).

Maggie was the deputy head of the Department of Educational Studies for four years and contributes to the English PGCE, MA ECL and MA Writer Teacher programmes. Prior to joining the Department of Educational Studies in 2002, she taught Drama and English, and latterly Media Studies, in London secondary schools, a career spanning some 24 years and was a member of the BBC English Education Consultative Group.

Camilla Stanger

Goldsmiths University of London

Camilla has taught English and Dance in post-16 inner-London colleges since 2007, and having completed an MA at Goldsmiths University of London, she is now studying for her PhD in the area of dance, movement and feminist theory. She has presented papers at the IOE, Brunel University and Goldsmiths College, and published on the Gender and Education Association website, and in 2013 was the winner of the SAGE BERA Practitioner of the Year Award 2013 for research-based practice in an under-18 setting.

Esther Sayers

Goldsmiths University of London

Esther Sayers is a lecturer in art education at Goldsmiths College and King's College, London, as well as a researcher for cultural organizations. She was Curator for Young People's Programmes at Tate Modern from 2002 to 2011. Esther's professional experience began as an artist leading workshops in schools, youth clubs and galleries. She has been a gallery educator at Tate Liverpool, Tate Modern and Whitechapel Gallery, lecturer at Loughborough and Staffordshire Universities and Education Assistant at Camden Arts Centre from 1998 to 2000. As an artist, Esther Sayers works predominantly with materials that are transitory in their physical structure: ice, glass, sand and those that rely on light or translucency to leave a trace of their form. Participation has been central to her approach in recent years, and she has designed educational experiences that question existing ideologies in educational settings, particularly those that exist around inclusion initiatives. Publications include *2013 An 'Equality of Intelligences': Exploring the Barriers to Engagement with Modern and Contemporary Art in Peer-to-Peer Workshops at Tate Modern iJADE* (in print); 2012 Gifted by Nature for Seeing Through, published online at tate.org.uk; 2012 Public participation as a tool for museums to take a meaningful place in the city, Mobile Studio, A Display for a Display exhibition catalogue; 2011 Investigating the impact of contrasting paradigms of knowledge on emancipatory programmes for young people, *iJADE* Volume 30, Issue 3, start page 409; 21 October 2011. Pedagogic and artworks included in: Atkinson, D. (2011), *Pedagogies against the State*, Sense publishers, Chapter 3 Subjectivities and school art education; 2000 *Make Magazine*, April/May 2000; 1999 *Nexus: Palpable Signs* (vol. 6); 1997 *Nexus: Engendering the City* (vol. 1); *Iris Women's Photography Project* (Scarlet Press, 1997).

Anne Harris

Monash University

Anne Harris, PhD, is a senior lecturer in education at Monash University (Melbourne, Australia) and researches at the intersection of cultural, sexual and gender diversities, including the ways in which creativity, the arts and digital media can be used for social and educational change. She is currently an Australian Research Council 'Discovery Early Career Research Award' (DECRA) Fellow 2014–2016 researching the commodification of creativity, and she was a funded Australian Postgraduate Award scholar (2007–2010). As a playwright, Anne's work has been presented (in New York) at

The Public Theatre, Primary Stages, New York Theatre Workshop, Soho Rep, Dixon Place, New Dramatists; Perishable Theatre (Rhode Island); Cleveland Public Theatre (Ohio); The Playwrights' Centre (Minnesota); and in Australia by Playworks (Sydney); Vitalstatistix and Adelaide Festival Centre (Adelaide); Red Dust Theatre (Alice Springs); JUTE Theatre (Cairns); Darwin Theatre Company and Browns Mart (Darwin); and at the Arts Centre, Melbourne. Anne is currently co-editor of the journal *Australasian Review of African Studies*, associate editor of the journals *Curriculum and Pedagogy* and *Departures in Critical Qualitative Research*, and on the editorial board of the Palgrave Macmillan book series Gender and Education (ed Yvette Taylor, UK), and the Sense Publishers book series Teaching Writing (ed Patricia Leavy, USA). Anne has published over 50 articles and 6 books on the arts and creativity, culture and diversity, including *Creativity, Religion and Youth Cultures* (forthcoming, Routledge, 2015); *Video as Method* (forthcoming, Oxford University Press, 2015); *The Creative Turn: Toward a New Aesthetic Imaginary* (Sense, 2014); *Queer Teachers, Identity and Performativity* (co-ed, Palgrave Macmillan, 2014); *Critical Plays: Embodied Research for Social Change* (Sense, 2014); *South Sudanese Diaspora in Australia and New Zealand: Reconciling the Past with the Present* (co-editor, Cambridge Scholars Press, 2013); and *Ethnocinema: Intercultural Arts Education* (Springer, 2012).

Printed in Great Britain
by Amazon